OF BIRDS,
BEASTS,
AND
OTHER
ARTISTS

OF BIRDS, BEASTS, AND OTHER ARTISTS

An Essay on the
Universality of Art

BEN-AMI
SCHARFSTEIN

New York University Press

New York · London

L I B R A R Y O F C O N G R E S S
Library of Congress Cataloging-in-Publication Data
Scharfstein, Ben-Ami
Of birds, beasts, and other artists :
an essay on the universality of art / Ben-Ami Scharfstein.
p. cm.
Bibliography: p.
Includes index.
ISBN 0-8147-7881-X (alk. paper)
1. Aesthetics. I. Title
BH39.S325 1988
111'.85—dc19 15309
CIP

New York University Press books are Smyth-sewn
and printed on permanent and durable acid-free paper.

To my mother on her
ninety-fourth birthday

Contents

Preface

I begin with the difficulties, perhaps fatal, into which the Western tradition has fallen. I ascribe these difficulties in part to our increased knowledge of every sort and our increased ability to appreciate the different aims, periods, and traditions of art. I then go on to the biological traits on which art is universally based; I characterize tradition and the forces and persons that disrupt it; and I end with suggestions for an incomplete but universal esthetics.

Because it is an attempt to see art as a whole, my book purposely crosses the boundaries between specialties and between cultures. It is by nature, therefore, a protest against narrowness. In spite of the importance that it attributes to environment, it is also a protest against the view that art created in different environments cannot really be compared, and against the associated view that values in art are merely relative.

To escape the tendency to think of art as if it existed solely in and for itself, I have emphasized that it is rooted in biology and in social life, and I have appealed to many examples, not least among them the song

of a bird. My attempt goes against the grain of those who deny that a nonspecialist can deal competently with such a variety of fields of study. I must say that there is no pretension here to full mastery of each special field, no attempt to summarize it comprehensively, and certainly no attempt to advance it beyond the specialists' conclusions; but I hope to show that it *is* possible to make a reasonable synthesis of information from different fields, and to achieve an understanding deeper and more general than is possible within the bounds of any one of the fields or in the light of abstractions alone.

As the result of my own interests, I shall speak most often of painting and sculpture, often, though less often, of poetry, and sometimes of music, dance, drama, or whatever else the argument may call up. I allow myself this latitude because, despite my desire to draw on a wide range of experience, Western and non-Western, "civilized" and "primitive," I have no desire to be encyclopedic; and because my subject is not this or that art or artist or tradition, but the causes by which all art is animated. As I hope to show, art testifies to powers that are lodged in all human beings but more visibly so in artists, because it is the artists who have learned in actual practice that art is a way of keeping the mind and senses alive and, above all, of remaining in emotional reciprocity with themselves, the world, and other human beings.

My aim no doubt exceeds my grasp; but I consider my book to be an essay, in the original sense of an intellectual attempt or experiment. While carelessness has no place here, neither does the fear to feel, to speculate, and to enter into minds, temperaments, and traditions different from one's own, each of them a world that intersects, in often unsuspected ways, with the others. You can hold a songbird in your hand, but its song is heard in all the worlds.

Acknowledgments

I want to thank Dr. Dan Daor, of the Hebrew University, for his knowledgeable, sensitive, and commensensical advice, and Professor Andrew Plaks, of Princeton University, for his encouraging criticism, which drew on his understanding of art no less than his Sinological scholarship. Professor Wm. Theodore de Bary, of Columbia University, read much of the last chapter and saved me from an embarrassing error.

OF BIRDS,
BEASTS,
AND
OTHER
ARTISTS

CHAPTER ONE

Knowledge, the Great Leveler

A work of art is always a particular sensuous presence. There cannot be a work of art in general any more than there can be a person without an individual face, history, and nature. Because there is no work of art in general, and because art shades off imperceptibly into everything else human, it is hard to arrive at generalizations that explain art without being either trivial or false to experience.

Reflecting as it does the whole of our existence, art defies simple explanations. My stress here on one factor, knowledge, is not meant to devalue others, some of which I take up later. I stress the spread of knowledge, with its leveling effect, not only because I am convinced of its importance, but because the process of universalization I describe makes it easier to appreciate the degree to which art is essentially universal.

The background for a general analysis of art is, inevitably, the art of the present. Before I take up the spread of knowledge and its results, I therefore want to characterize the art of the present, which most easily intrigues, puzzles, and, if we care enough, infuriates, exhilarates, and

depresses us, for it is closest to our own experience. While I cannot undertake a full analysis of recent art, I should like to draw attention to a number of themes, all related to tradition, or rather, tradition's death.

The first theme is that the old desire to be original has acquired a new negative force. The artist has been persuaded that to be worthy of the name he must create something new, and that to do so he must first, in effect, attack something old. The attack on something old, on tradition, is likely to express and strengthen whatever feelings of estrangement to which the artist is vulnerable. Another, allied theme is that the negative element in art has resulted in acts of negation and aggression, most often symbolically but sometimes also openly cruel, for the act of opposing or denying calls on one's resources of anger and cruelty. Another obvious theme is that recent art has shown an unparalleled openness and has therefore fluctuated with a strange, unparalleled speed. One of the reasons is that in dying, tradition has provided intensely fertile ground, in which all kinds of art have been able to grow in the most disordered profusion. Finally, the dying of tradition is related to the regenerative hope of the new art in the same way as alienation or loneliness is related to its own implicit hope of overcoming itself.

To speak very generally, art in the recent present has been an accentuated process of breaking and remaking. That is, it has been the breaking and reassembling or humanizing or dehumanizing of persons or things in order to possess them—to dehumanize them is to possess them by degrading them into counterparts of one's loneliness or pain or, alternatively, by abstracting them from their painful emotionality. To rule over things, one must first wrench them from their context and, if necessary, break them up, so as to weaken their resistance to possession, and then perhaps reintegrate them into a world over which one rules with the sense of emotional plenitude that is the opposite of loneliness.

For all the negativity they involve, such means of creation can be explained by the desire of the artist to enhance his feeling of life: by causing an externally visible change one changes and enhances oneself internally. To become alive in this now accentuated sense, one cannot

simply perpetuate the past, and the artist either cuts himself off from it or creates a counterpart of isolation in the hope of drawing others into it. To gain life, which is to gain company, which is to gain power (to affect others by affecting oneself), artists animate whatever is inanimate and, to coin a verb, inanimate whatever is animate. They deform what is already well formed and give good form to whatever is unformed or deformed, and they try endlessly to re-form everything by subjecting it to their fingers and desires, by permeating it with themselves. Then, if the world they have made or changed resembles themselves as they intended, sometimes they are pleased and sometimes not, and rather often both. For them, in order for the world to remain true to the will, the promise, they have imposed upon it, it must be kept poised between possibilities and must never finally crystallize into any of them, because a shape too fixed to change is the end of the ability to create and, by means of creation, to hope.

When such an aim becomes dominant, the old vocabulary of criticism loses its usefulness. Artists reject the old terms, most notably "beautiful" and "ugly," though it is hardly possible to do so consistently. If they are painters, they may say that painting has become exhausted, and what they desire can no longer be satisfied by mere painting. As many of them have said or implied, their object is to change art or, better still, life, by means of radical questions and radical acts of creation.

Given this aim, it hardly makes any difference if one says that they propose to makes changes in art, in society, in nature, or in man's consciousness. Out of the desire to make life, especially their own life, into a series of creative acts that affect the artists by affecting others, they try to force themselves through the membrane that separates them from us and to coerce us into communion, holy or profane. Often their originality, their personal way of negating tradition so as to affect us, is expressed in quick magnifications of anything that a human being may care about.

One result of the aim, above all, to affect others is that it is no longer clear how or even if an artist should be formally trained. In the nineteenth century, even the academic ateliers (at least in France) laid in-

3

creasing stress on freedom, originality, and individuality. This stress has become so pronounced that it has become difficult to argue that a prospective artist will gain by studying any accepted principles and techniques in an art school. Many well-known contemporary artists have had little or no formal training in art. A casual list might include, in the order of date of birth, Mark Tobey, Max Ernst, Jean Dubuffet, Archile Gorky, Francis Bacon (born, it is true, "into a milieu of painting"), Wols, Alberto Burri, Pierre Soulages, Karel Appel, and Yves Klein.

When an artist has taken the trouble to study in an art school, its influence may be predominantly negative. To the question why he rejected "modernism," the neorealist Philip Pearlstein (born in Pittsburgh in 1924) answered that "this modern stuff was as foreign to me as Florentine painting or Greek art." Another neorealist, Chuck Close, says that he found it easy to paint in the then dominant style of Abstract Expressionism, but that, disturbed by the predictability of his paintings, he turned to figurative art, just because he had not been taught it. In his own words, "If I'd had to look around and find something about which I knew absolutely nothing, it was figuration."

Formally educated in art or not, the ambitious young artist faces difficult choices. The path no longer leads from apprenticeship or study in an academy to recognition as a master. The variety of possible styles and esthetic attitudes is so great, the emphasis on originality so pervasive, and the changes in fashion so rapid, that the future must appear very uncertain. As a result, it has become much less likely that the artist will invest work in slow, long-term improvement than in whatever is possible in technique, attitude, or subject, to draw attention. To speak in economic terminology, the artist invests in short-lived, dramatic projects that promise a quick return. Hope for the future becomes concentrated in the immediate future, hardly more than the extended present.

The career of Jasper Johns illustrates the present-centeredness of contemporary art, which requires the artist to cut himself off from the past and also, in a sense, from the future. Johns's early life fitted him especially well for living in the present, because he had nowhere to live for long. His parents were separated soon after he was born, and he lived successively with an aunt and uncle, with grandparents, with his mother and stepfather, with an aunt, and again with his mother and stepfather. After undistinguished studies in a commercial art school, he stayed here

4

and there, working at various jobs. One great day in his life, he decided to stop becoming an artist and to be one. "I decided to do only what I meant to do," he said, "and not what other people did. When I could observe what others did, I tried to remove that from my work. My work became a constant negation of impulses."

Johns hesitates to speak of his past, which he claims is irrelevant to him, and he tries, by his own admission, to keep his work from betraying his feelings. Talk of the future, he says, bores him. He explains that when he was young he had so many desires and wishes that he trained himself to think only of the present. (Andy Warhol said, "Every day is a new day because I don't remember the day before. Every minute is like the first minute of my life.") When Johns goes down a street, he sometimes decides which way to turn only when he gets to an intersection; and in art, his notebooks say, he deals with an object by doing something to it, then doing something else to it, and so on. His success began with a one-man show given him by the dealer Leo Castelli, whose first sight of Johns's work led him to say in retrospect, "I saw evidence of the most incredible genius, entirely fresh and new and not related to anything else."

The act of cutting oneself off and beginning anew is illustrated time and time again in modern and contemporary art. Contemporaries express themselves with the same incisive radicalism as the Futurists and Expressionists. For example, when questioned in 1970, Robert Smithson insisted that existing art forms ought to be undermined. If the undermining succeeded, as he (ambivalently) thought it would, the artist would come to realize, he said, "that only a real primitive would make something as icon-like, as obviously pagan as a painting." In 1977, Karel Appel, who had earlier said that painting was the destruction of what had gone before, said that his aim was to destroy the education he had received, all the "cultural wealth" he had learned and soaked in. In his words, "I wanted to annihilate myself, wipe myself out, in order to get right back to zero. I started off painting white canvases with white paint. . . ." More recently, the Korean Lee Seung-taek expressed the desire to cut himself off not only from the past but also from his own past selves. He said, "Once I've finished a work, I always try to free myself from it. In other words, I keep striving to destroy and change myself. To me, the process of self-destruction is inherent in the nature of the artist. . . ."

5

As Appel reminds us, one of the means by which a painter can cut himself off from the past is by painting monochromes, nothing or very little more than uniformly applied paint of the same color. Such monochrome paintings are the end product of an interesting regression. Long ago, a sketch was valued as the preparation for a painting; later, it came to be valued because it was spontaneous and not finished; but monochrome painting, into which category I should like to include, by legitimate extension, a raw canvas put up for exhibition just as it is, returns us to what used to be no more than the prepared surface upon which the painting was made. The old beginning becomes the new end.

It is said that the earliest monochrome painting was made by Kasimir Malevich about 1918. He had been searching for a "zero point," totally separated from tradition, from the mere conglomerations of things painted by Raphael, Rubens, Rembrandt, and their likes, because such paintings conceal their true value, which is the feeling that gave rise to them. His hope was that the classics, and with them estheticism, would die and the "savage mind" be reborn. Whiteness became an equivalent of light to him, and whiteness applied to itself, white on white, was meant to help him experience a new, transcendent reality. In 1923, to embody the sensation of infinity, two squares of white cloth were exhibited stretched over a white ceiling.

Malevitch's ambitions did not, of course, go unchallenged either by the scornful opposition or by other pretenders to the absolute. Alexandr Rodchenko produced a counterseries of *Black on Black* paintings, interrupted and superimposed black circles on a black background, meant not to express a philosophical concept but to demonstrate the invention of a new way in painting. In 1919, having arrived at the absolute, Rodchenko announced the idea of "last paintings," reduced to single colors without opposition or contrast. In 1921, he did his part to "murder painting" by declaring the three primary colors "for the first time in art." The three monochromes in question, *Pure Red Color, Pure Yellow Color,* and *Pure Blue Color,* each without internal opposition or contrast, outlawed apparent recession, he declared, and so outlawed illusionistic space. His aim was color in itself, at its highest, unique intensity.

Since the time of Malevitch and Rodchenko, a large number of monochromes has been painted: all-white by Lucio Fontana, Robert Rauschenberg, and (exhibited along with virgin canvas) by Piero Manzoni; all-blue by Yves Klein (after various "unicolor paintings"); all black, on

6

torn newspaper glued to canvas, by Robert Rauschenberg; an all-almost-black by Ad Reinhardt, who made matte, barely perceptible crosses on an oblong background; and all-some-color-or-other by other artists. Each of the artists had his own justification. Klein's blue was his identification with space, in which, like Malevitch in his white, he felt free, and his pursuit of the indefinable; Rauschenberg's white was for him a hypersensitive reflector into which life entered by itself, while his black was meant to show a complexity of "much to see" despite "not much showing"; Manzoni's no-color ("achrome") exhibited empty, self-sufficient matter, not needing the artist's touch to establish its existence; and Reinhardt's black, barely tinged with blue, green, red, or other colors, was meant to be both no- and all-color, absorbing everything so as to be invisibility, purity, and the end of painting, "luminous darkness, true light, the undifferentiated unity, no divisions, no consciousness of anything, no consciousness of consciousness." Similarly, but with more radical means, Robert Irwin tried to get people to perceive their own perception and, in the process, to show them the limits of painting. The result was an "empty" room illuminated so as to draw attention to its edges, corners, shadows, textural differences, and whatever else had always been there but had remained essentially unseen.

Much of this monochromaticizing was a war of egos. Rodchenko challenged Malevitch; Klein, who knew better, insisted that he was the twentieth-century father of monochrome painting; and Manzoni painted white to overcome Klein's blue. All of the monochromists I have mentioned voiced at least quasi-mystical sentiments and invented or reinvented the monochrome in order to go beyond the possibilities of painting, and, most said, to free themselves and enter the universal energetic continuum. In trying to go beyond painting, these artists were also necessarily returning to the beginning of painting, a state in which nothing had yet been done and the future, like the canvas, lay completely open before them; and, in Irwin, the canvas itself vanished, to leave variably lighted, variably continuous space, reduced to what might be considered immateriality.

The desire to cut themselves off from the past has been characteristic of all the arts, though only visual art shows so prolonged, merciless, and

publicly successful an attack on the means and ends of traditional art, on everything but the need to be somehow interesting. The shared radicalism has encouraged a common going to what may be called anatomical extremes, an emphasis on one of an art's components at the expense of all the others. In writing, the emphasis may be laid as heavily as possible, not on the meaning of the words, but on their sound alone, or even on their appearance alone; in visual art, the emphasis may be laid on color alone; and in music, on pitch or rhythm alone. Along with such anatomical extremism, there is often an attempt to compromise between consciousness of tradition and immediacy or spontaneity. In every art, the compromise attempts to diminish the past to controlled quotation, and when quotation as such is burdensome, to parody, which is the aggrandizement of the present at the expense of the past and the use of the familiar to draw attention to the unfamiliar. Lastly, the desire for freedom encourages the abolition of all conscious rules, for which chance-procedures have been widely used. The abolition of rules encourages the breaking down of the boundaries between art and everyday life by the pursuit of a paradoxical ordinariness opposed to professional education or skill, of an evident subjectivity, or of an extreme, sometimes anarchistic, social reform.

Like opposition to change, the desire for radical change in art has implications that go beyond the limits of art as such. In writing, extreme radicalism has been resisted, I think, because it has interfered too seriously with the intelligibility of language. People cannot bear to have language tampered with too seriously even in a novel because the tampering recalls the difficulties they have in understanding and living with one another. Their resistance to great linguistic change is sign enough that art, perhaps especially verbal art, cannot be isolated from nonartistic life—the more or less simultaneous functions of language cannot simply be divided from one another. The secret languages used in "primitive" cultures are sanctioned by tradition. Lacking this sanction, people are likely to resent the use of an unintelligible language because it implies their exclusion and inferiority. As for music, the tolerance of people for unpleasant sounds is low because they cannot shut them out and because sounds affect mood deeply and immediately. The reasons appear to depend as much upon neurology as upon social habit. A researcher claims that musicians who are required, as members of orchestras, to play much of the new music react not only by hating the music but by

suffering from psychogenic illness. Maybe painting and sculpture now tolerate radicalism more easily than do language and music because their effect is weaker or less direct. Maybe the eye is more accustomed to oddity and more easily detached from emotion. Philosophers and theologians have often regarded the eye as a noble organ, the most distant from base desire. Certainly the eye is easier to turn aside or close than the ear. At any rate, the ability of the public to tolerate or accept visually radical art has shown itself to be relatively high, though my impression is that people more often suffer the existence of such art than take a deep, genuine interest in it. If I am at all right in distinguishing between the different levels of receptiveness to radicalism in the different arts, the moral is that art has a whole complex of causes, neurological, psychological, and social.

I return to painting and to the difficulties faced by the artist in the pursuit of his career. Keeping up with the times is of extreme importance. Artists who cannot or will not do so are likely to be regarded with scorn by the more fashionable, who are themselves regarded with scorn by the young rebels who aim to displace them. The unspoken question seems always to be, "What is new in your art today?" and the artist feels compelled to find some novelty that, like a poster, draws attention. Drawing attention to oneself may require doing the opposite of what might reasonably have been expected. To become famous for a day or more, the artist and the dealer need showmanship and publicity. Bribery, whether in money, art, or some other medium, is not at all unknown. If you sell your art cheaply to collectors who have good ties with museums, you assume that the art will be lent to the museums, and once exhibited by any one of them, the others want it, other collectors want it, the price can be raised, and a rush begins to buy before the price is raised still higher. With artists and dealers striving in such ways for even a day's success, the artist's innovation may be not only ephemeral, but defiantly so.

Most artists find it painful to bargain with a gallery, kowtow to a prospective patron, and smile deferentially at the critic or curator. Even under the best conditions, Degas hated the business of selling his work, which he felt demeaned him. Ad Reinhardt insisted that art stay free of

the corruption of the business world. To avoid this corruption, he remained a full-time teacher all his life. The sharp-tongued "conscience of the art world," he drew on himself a lawsuit by Barnett Newman because he had described him and twelve others as avantgarde hucksters and holy-roller explainers-in-residence. However, Andy Warhol, making a characteristic virtue of necessity, did not hesitate to say that the artist needed a gallery that would make the "ruling class" notice him and create enough confidence in his future to inspire collectors to buy his work.

Success, though naturally less painful than failure, can be painful enough. It is said of Mark Rothko that when his work became a valuable commodity he was no longer able to evaluate it. "He did not know whether people were buying his paintings because they were good or because they were Rothkos"—perhaps the people themselves did not know. Despite his success he complained that no one understood his work any longer, and he found his fame unpalatable.

The way down can be as swift as the way up, and the pressure on the artist to satisfy critics can be brutal. How this pressure may be translated into words is exemplified by a 1964 review of Jasper Johns that said, "It seems ridiculous to speak of the decline of an artist not yet thirty-five years old. Yet such is the conclusion one has to draw from Jasper Johns's retrospective. . . . Where Johns is really vulnerable is in his dependence on ideas which are rapidly exhausted."

What makes life easy for the artist is also what makes life hard: practically no imaginative response is outlawed. In theory he has only to succeed in being demonstrably himself (or she in being herself); and when he has succeeded in being himself to the satisfaction of others, he has to continue (as she does), in an always demonstrably different way, to try, in the words of the French artist Nicholas de Staël, to arrive at "a continuous renewal," a continuous zig after every surprising zag. Reasoning or logic is unlikely to help because, as usually construed, they begin from conventional assumptions and lead to results that have none of the departures that mark "genius." The artist may therefore say, as de Staël said:

For me to renew myself, to develop, to go on differently from one thing to the next without an *a priori* esthetic . . . I lose contact with the canvas at every instant, lose it, find it, lose it . . . I can't

imagine any progress except from one accident to another. As soon as I feel a logic in it, I get annoyed and I veer naturally to the illogical.

By an inevitable paradox, however, the young artist, having nowhere else to begin, begins with ready-made models and with standards that, to revolt against, he must partially assimilate. Art has usually given to the imagination precisely what actual life has lacked, but as I have said, artists now often prefer to annul the distance between art and life, an attitude prefigured in the German Expressionists, the Italian Futurists, the Russian Constructivists, the Surrealists, and others. In attempting to integrate art with life, artists take into art everything previously excluded from it, including silence, noise, private associations, actual cruelty, actual blood, and actual excrement, and, sometimes, actual revolt. Resentment can come to be their cultural ideal.

The often resentful encroachment of art upon life, the attempted fusion of art with life, the publicly exhibited nostalgia and immoderation, seem to me to indicate, as I have said earlier, a state of loneliness as well as a hunger for whatever feels real, that is, unqualified, uninfected by the sense of illusion, fortified (made more immediate) by intimacy. Because the need for response is so strong, intimacy-hunger transposes into its own medium the tactics of ordinary life, in which what is wanted but not otherwise given is demanded by means of a joke, shout, slap, or direct question, so that art now jokes, shouts, slaps, and questions directly, in the ways at its disposal.

The more the art-object is meant to be a self-justifying fragment of life or a direct influence on it, and not art in the more detached, traditional sense, the more it shifts an old balance and needs to be interpreted and set consciously into context. Paradoxically again, perhaps, the more simply lifelike or simply personal or associative the art, the more elaborate its justification must become, because, apart from the very act of exhibition, it is often no longer clear what there is about the object that makes it worth looking at. We obviously want too much. In art, both as artists and spectators, we have come to want to be as innocent and direct as little children, but also as subtle, as circumlocutory, and as omniscient, as a god-artist-scholar-critic.

Art is now so varied that everyone should be able to discover artists with whom there is an instinctive sympathy. But this helpful pluralism

makes things all the more difficult for the conscientious person, who assumes the obligation to appreciate all the artists whom art historians or critics have praised, even though it is not possible for anyone to appreciate (that is, in some sense to identify with) so many different, often antithetical artists.

In the past, one learned to appreciate art by learning the tradition, with its teachable standards, that art exemplified. Now, what one learns about tradition, and learns generally in an appreciative spirit, defines exactly what is *not* useful for appreciating the present, except for revulsion from it. Tradition is the danger the artist must learn to avoid. And so the artist learns the past in order to learn what he may dismember for raw material but must avoid entering into creatively—only parody with its ridicule and distance is easily accepted. Now, lack of appreciation for a current artist signifies less esthetic ignorance than the lack of desire or ability to identify oneself with a particular person or his or her group. Lack of "understanding" has become equivalent to unfriendliness rather than ignorance, or to ignorance in the limited sense of lack of knowledge of the ways of a particular individual or the small group to which he belongs. Every artist demands to be understood in a special, personal way, and, as a result, almost no one is understood, technically speaking, very well or for very long. Our art is rich, various, and demanding. It remains, however, very needy and truculent in its neediness. It is always saying or shouting, "Pay attention to me!" But even when attention is paid to it, the response is likely to be insufficient and the need to persist. Maybe, however, it is not recent art I am speaking of, but only the human condition made more obvious than in some of its other contexts.

So far I have been describing the nature of modern art, especially as it has reacted against tradition. Now I return to this chapter's basic theme. The simple idea I shall pursue for the while is that knowledge has acted as an enormously powerful stimulant to art, but one that has grown burdensome and confusing, and sometimes destructive. It has grown burdensome in the West, as for many it grew in China, in suggesting too constant a reference to the past, in posing too many differently attractive models, and in threatening art's vitality. It has threatened art's vitality

by at least implying that every subject, style, and value is merely relative; by pushing artists and spectators towards an unconvincing artificiality or eclecticism; by arousing an aversion towards the past as such; and by giving the feeling that everything worthwhile has already been done. The knowledge that we have gained and are continuing to gain has revealed itself to be a promise, a problem, and a threat.

Knowledge in the sense of a conscious awareness of tradition sustains traditional artists by making their value self-evident. It is clear, however, that the very richness of a tradition can become threatening to them. The evidence comes mainly from two civilizations, those of China and Europe, both with long historical memories. The Chinese memory has been the more obviously continuous, because tradition in China was never broken in as prolonged and drastic a way as in medieval Europe.

I think it was the sixteenth century when the Chinese tradition, by then extraordinarily well-documented and scrutinized, began to appear overwhelming and even oppressive to many artists. It is easy to picture how the great collections of calligraphy, painting, and bronzes (the region of Suchow was especially famous for its collections) increased the pleasure of artists and gave more substance to their connoisseurship, but also confronted them with a problem of competition with this extremely rich past. The problem was compounded by the scholars and critics, all themselves probably artists, and their increasingly elaborate efforts to classify, evaluate, and authenticate works of art. The activities of these scholar-artists naturally gave rise to a good deal of theorizing and intensified an already acute self-consciousness. There was simply too much to be assimilated.

The culture of China from the sixteenth century on is marked by the struggle of many of its bearers with their own tradition. Each artist or writer had to find his place somewhere within or on the margins of the tradition—his art was his conscious placing of himself in and sometimes (almost) out of history. Perhaps the most usual result was a deliberate eclecticism, that is, the study of many different styles in order to make each painting in the style or styles best fitted to it. For this reason, it can be quite difficult to determine the oeuvre of a master-eclectic of the seventeenth or eighteenth century. Even when there is little doubt if the pictures are his or not, what exactly of the styles can be attributed to

him personally, and does he have, submerged in these styles, a style that is his alone? The problem is somewhat like that of sorting out Picasso's pictures by style. If all direct evidence of his authorship were lost, to how many different artists would the experts attribute them?

Another, noneclectic response to the richness of tradition was a proud egalitarianism according to which artists of the present could be as spontaneous, forceful, and essentially creative as those of the past, so that similarity to a past artist did not diminish the originality of the present one.

Still another possible response was a conscious eccentricity. The artist would stress some quality to the point that he would be named an Eccentric, a category that might or might not be the same as that of Individualist.

An apposite example of an Eccentric is that of Kao Ch'i-p'ei, of the early nineteenth century. He is said to have been so afraid that he would prove unable to create a style of his own that he agonized and went sleepless. However, a dream brought him relief. In his dream, he saw himself painting, not with a brush, but with one of his fingernails; and he therefore split the long nail of his fourth finger and used it as Europeans once used a quill pen. The devotion of Chinese artists to their brushes made Kao Ch'i-p'ei notably eccentric, although, as we can see, his paintings were as Chinese as they were expert and attractive.

The Western response to the richness of tradition is well known to us. The riches of the museums that so often inspire Western artists also convince them that they are working, or rather acting, as artists against the background of all human culture. Even if they are concerned only with the West from the time of the Renaissance, they soon discover that everything that has been conventionally thought of as art, everything possible in terms of their immediate tradition, seems already to have been done, and done superlatively well. Because they cannot abolish the past, which is more and more imposingly preserved, they feel that they have to leave their marks, so to speak, on a background of innumerable superimposed masterpieces. Is it any wonder that their marks have so often come to be graffiti, the artist's crude but personal "I love you" or "I hate you" scrawled on that crowded record of human experience?

14

They have to be crude, or at least bold, if only to see themselves and be seen by others.

Suppose we go back a while in history and observe how knowledge was accumulated in the West and what the results were of the different kinds of accumulated knowledge. Without trying to document the whole process, I should like to give a number of decisive examples. I shall begin with a brief word on a well-explored subject, the desire of the Renaissance artist to make his art more scientific and culturally respectable. I shall say a brief further word on the camera, the invention of which gave art a powerful helpmate and an equally powerful rival, and in both of these roles, a great deal of new or newly precise information. I shall then give a particular example of the way in which the observation of the past of art has led to a reevaluation of the artistic present. I shall go on to the impression made on the West and on Western art by the art of other cultures, principally India, Japan, and the so-called "primitives." I shall end with two problems. The first is that of the multiplicity and heterogeneity of foreign influences on contemporary art. The second is the widespread contemporary tendency to rework traditional art by means of parody, which, by mocking the parent-art, absolves the artist of dependence on it.

In Europe, from the Renaissance until roughly the first decades of the twentieth century, an artist, to be respectable, had to acquire certain kinds of knowledge. For one thing, the appearance of the body had to be mastered. Flemish painters were the first to allow themselves to paint from the nude; but Italian artists, notably those of Florence, were not satisfied with external observation and insisted on a knowledge of the body's mechanics, which could be acquired only by means of dissection. Soon the study of the nude and of anatomy became indispensable to the training of painters and sculptors, though the cadaver was replaced by sculptured models. The laws of perspective, which proved no less indispensable than anatomy, were first applied in full consciousness to painting in Florence some time close to 1425. They were a scientific means for unifying paintings and lending them greater verisimilitude, and no artist could be regarded as master of his art unless he applied them correctly.

15

The new, proud, knowledgeable artist came to flower in Leonardo. In the context of the painter's new knowledge, Leonardo was bold enough to repeat the old comparison of the artist with God:

"He who despises painting loves neither philosophy nor nature," for painting is "a subtle invention which brings philosophy and subtle speculation to bear on the nature of all forms—sea and land, plants and animals, grasses and flowers, which are enveloped in shade and light. . . . Truly painting is a science," the grandchild of nature, "since all visible forms were brought forth by nature and these her children have given birth to painting. Therefore we may justly speak of it as the grandchild of nature and as related to God."

After anatomy and perspective, there was photography. The passion to see better had been growing. In Italian Renaissance art it was to see in a way at once scientific and ennobling. In seventeenth-century Dutch art it was to see in a way at once intensive, extensive, and lovingly factual, as encouraged by telescope, microscope, camera obscura, new map and geographical exploration, all of which increased the range and accuracy of the eye and aroused the appetite for the world in fact.

So sharpened, the eye was ready for the camera. To be sure, the testimony of eye and camera was not and is not identical. The relation between testimony and testimony and between them and what the painter sets down is extremely interesting, and it is difficult, though necessary here, to resist the temptation to enter into details. The comparison is hindered by our ignorance, especially of the synthesis of vision in the central nervous system. Yet we know that perception by the eye and the camera is different in perspective, degrees and areas of sharpness, degrees and areas of distortion, color, and in other qualities that cannot be summarily named; and the perceiving eye, unlike the camera, must dance around continuously in order to continue to see. Granted all these differences, however, the similarity of eye and camera remains striking. The gross truth is that photography allows, even compels, the world to show itself with a previously unknown independence of the interpretive will, individual or collective, imposed by the artist. A painter begins with a completely blank surface, a photographer with an image chosen within an already existing field of view. The relative objectivity of the photograph can make it affect us more as does brute fact, that which is not responsive to merely human desire.

16

Painters who accepted the usual aim of moralistic realism found the new device to be a stimulating and helpful ally. The mutual influence of photography and painting was such that black and white reproductions of some of the paintings of the time are hard to distinguish from photographs, and many of the photographs hard to distinguish from reproductions of the paintings.

Reactions were various. Baudelaire denounced the new industry and the ideal of the exact reproduction of nature. He was afraid that if the "results of a material science" were accepted as the model of beauty, the ability to judge and feel the immaterial qualities of art and life would be sadly diminished. However, Delacroix, Baudelaire's model of the true contemporary artist, used photographs freely to help with drawing and painting. Although he learned soon enough that the camera could falsify, he felt that if a man of genius used the daguerrotype as he should, he would raise himself to unknown heights; and he himself, he wrote, might have had a fuller career had photography been discovered a generation earlier.

Successive technical improvements made photography more wide-ranging and more competitive with painting. Brief exposures became possible; a simple way of projecting photographs directly onto canvas was found; and (by the 1870s) photographs in roughly natural colors began to appear. As a competitor, photography came near eliminating the art of portrait miniatures; as an ally, it supplemented artists' memories, gave them a cheap substitute for live models, and, as Delacroix said, corrected errors of vision, showed nuances of tonal recession, and, all told, initiated the painter into "the secrets of nature."

Painters of every style and aim were apt to make use of photographs. Ingres used them to help with portraits. Corot may well have shifted to his blurry landscape style because of the soft, blurry appearance of landscape photographs, which was caused by the motion of trees during the necessarily long exposures and by the encroachment of light, usual in the glass-backed emulsions, onto the edges of the dark forms. Millet used photographs as notes, as did Degas, who loved and practiced photography. There is evidence that Degas enlarged photographs and worked on them directly with pastel, and that he too used photographs to guide him in portrait painting. Like other painters, he learned from Muybridge's pioneering photographs of human and animal motion how

17

to represent a trotting, cantering, or galloping horse. All told, the camera sharpened the painters' visual sensitivity and tended to force them out of old and into new conventions.

Despite those French painters, especially prominent from about 1850 to 1859, who emulated the realism of photographs, the prevailing view came to be that photography and painting were not and should not be rivals. The nature of the one was to capture objective reality; of the other, subjective reality. Although this distinction was interpreted at first in a conservative way, it contributed to the radicalization of art. To André Derain, Fauvism was likely to have been a reaction against anything that looked like a photograph. "The idea," he said, "that everything could be lifted above the real was marvelous in its pristine freshness. The great thing about our experiment was that it freed painting from all imitative or conventional contexts." A Futurist manifesto of 1918 said, "Given the existence of photography and of the cinema, the pictorial representation of the truth does not and cannot interest anyone." An Expressionist manifesto said, "Today photography takes over exact representation. Thus painting, relieved from this task, gains its former freedom of action." André Breton said, "The invention of photography has dealt a mortal blow to the old modes of expression, in painting as well as in poetry. . . ." Most succinctly of all, Picasso said that now, after the invention of photography, "we know at least everything that painting is not."

Such a sharp splitting of photography from painting conceals the ability of photography to inspire painters by its explorations, which add so much to the ordinarily visible world. In spite of their denials, the Futurists' paintings of motion depended upon photographs, as did Duchamp's. Even such a highly imaginative painter as Francis Bacon is inspired by such photographs. I am referring primarily, however, to the sheer richness of visual information that photography gives us, of sights too small, too distant, or too concealed from ordinary vision to be seen with the unaided eye: the paths of subatomic particles as they move, collide, and swerve; strange microscopic plants; polarized light making newly-seen patterns glow with color; patterns of heat, sound, and vibration made visible; and exotically false-colored images arrived at by computer processing. All these, and the sights I have not recalled, can easily inspire painters. Klee spoke for them when he said that the artist should acquaint himself with the fantastic images of the microscope and

18

should concern himself, as well, with history and paleontology, "to free his thoughts and to develop a cosmic consciousness."

Briefly, photography aids, supplements, and rivals painting, in some ways, as in speed of response, excels it, and raises esthetic questions to which, I think, there is no categorical answer. In terms of our present concern, however, the essential thing to note is the extent to which photography informs and informs surprisingly. Of course, it also makes possible reproductions of works of art, by means of their reproduced (and degraded) echoes gives them universal currency, and is therefore responsible for the fact that all human art is being assimilated into a single history, which will eventually, I predict and hope, take form as a single tradition.

Perspective, anatomy, and camera have all caused far-reaching changes in art. Another, often subtle, agent of change has been the progress of art history, by which I mean the sheer quantity, precision, and detail of the information that art historians have made available. It is true that many art historians, like historians of other sorts, have been more interested in establishing facts than in thinking about them to any effect. Perhaps the neglect of so many art historians to raise the more searching esthetic questions is based on a latent fear that the questions have no easy answer or even no satisfactory answer at all. The historian's response to this fear may lead him to submit to whatever happens to happen and then, after the fact, to explain why it was inevitable. This acquiescence fits in well with the old tendency to read the history of art as a history of progress. Such a view, although distinctly less prominent in contemporary historians than in, say, Vasari, is still alive, and it was certainly invoked in the usual defense of Cubism and abstract art. The nature of contemporary art and the current readiness to accept the art of "primitive," early, and alien cultures as all of possibly high esthetic value, make the unilinear theory, to which Marxists still cling, particularly hard to accept.

The scholar's pertinacious curiosity reveals to us that officially accepted art in nineteenth-century France was not always conservative. Although the Academy rejected Delacroix, the state gave him important commissions. Likewise, the state bought the work of Millet. Nor were

the academics always as academic as they have been pictured. In fact, they had an increasing respect for originality, were often friendly with Impressionist painters, and were sometimes influenced by their style. The influential academic teacher Couture urged his students to concentrate on pure color, spontaneity, and self-expression.

Apart from their protest against the exaggeration of the contrast between "official" and "revolutionary" art, the art historians have made it easier to appreciate such painters as Bouguereau, Meissonier, and Gérome. But the art historians' main contribution to the never-ending attempt to define and validate artistic preferences is their reconstruction of the milieu in which art was appreciated in the light native to it. When repeated often enough, these reconstructions heighten the sense of the never-ending changes that evaluation undergoes.

As an example of the relativity that art history may teach or preach, consider the period in Europe between roughly 1790 and 1870, which the historian I am following contends was the scene of "the most extreme reversal of which we know in the history of art after the Renaissance." He recalls the praise lavished by Ruskin, the greatest English art critic of his time, on Orcagna, who has since been transformed by the art historians into a composite of other painters, none of whom appears to us as memorable as Orcagna appeared to Ruskin. The historian also recalls that Francesco da Imola was all the fashion in Rome about 1819, but is not even found in present histories of art. And the historian adds that the veneration of Luini and Carlo Dolci was replaced by veneration of Fra Angelico and Memling.

The most radical change of all in appreciation was of a group of statues that represented the art of Greece and Rome. One of these was the Apollo Belvedere. Dug up in the latter part of the fifteenth century, this large Apollo became, and for over 250 years remained, "the most admired piece of sculpture in the world." The Christ of Michelangelo's *Last Judgment* was borrowed from him. Goethe recalled that the Apollo Belvedere had swept him off his feet. Yet 350 years is far from eternity, even on our short time-scale. Ruskin, who had expressed great respect for the Apollo, came by 1846 to think it "unspiritual"; and ten years later it had become "a public nuisance" in his eyes. "Before another

generation was out, the authority of antiquity itself had been called into question." This meant that the judgment of such artists as Michelangelo, Titian, Bernini, Canova, and Goethe had been merely an aberration of taste. The art lovers of the mid-nineteenth century who implied this judgment were generally sure that the art they preferred was eternally worthy of the praise they lavished on it; they did not appreciate that their standards were as corrigible as those of their predecessors. Old master after old master was "rediscovered," to the pride, justified or not, of the "rediscoverer," whether of eighteenth-century art (Edmond de Goncourt), Le Nain (Champfleury), early Italian art (Ruskin), or Tintoretto (Ruskin again). None of these "rediscoverers" could have anticipated the "rediscovery" of Caravaggio and his followers in the mid-twentieth century. Artists once spoken of with contempt are investigated, exhibited, and bought and sold, with rising interest. History teaches us that there is every reason to believe that our own evaluations of artists will be subjected to extensive reevaluation.

Not surprisingly, the prevalence of a given fashion influences the choice of exemplary works from the past. When the curves of Jugendstil were favored, so were those of Botticelli; when the more angular compositions of Cézanne were favored, Botticelli's curves fell out of favor; and once geometrical structure had come into fashion, Piero della Francesca came into fashion as well, while Raphael and even more Murillo went down in favor. A comparison of what an art museum exhibits with the contents of its storage rooms is always instructive.

Writing some time before 1976, the historian from whom I have been drawing for the most part remarked:

> In the Metropolitan Museum, Gérome hangs beside Corot and Regnault next to Courbet. Bourguereau is exhibited more often than Degas. Regarded as comic foil only a few years ago, the Salon artists are now hailed as brethren. . . . Tomorrow the Louvre will be theirs.

The historian's prophecy is as questionable as any other's. There is, however, more than enough evidence of the mutability of fashion, even as it affects the art that we consider great beyond question. This is certainly as true of the other arts as of painting. Even during Bach's lifetime someone wrote that he spoiled his composition with bombast and confusion; and except for a small number of pupils and devotees, he

was forgotten until rediscovered in the early nineteenth century—the first composer to be rescued by a later generation. Banal though the point may be, it must be reiterated that both short-term and long-term fashions change and that there is no way in which the persons of one age can convince those of another. The truth is, as an African (Congolese) proverb says, "Those who are absent are always wrong," and so it is the present that always wins, for itself. Yet this law of the always-victorious present leaves disturbing inconsistencies. If Michelangelo is the great sculptor we still take him to be, on what grounds can we fault his judgment of the Apollo Belvedere or the Laocoön? We may disregard the praise of Bernini and Canova, although their reputations seem higher than they were not long ago; but what of the kind of sculpture that Michelangelo internalized and emulated?

So far, the sources of knowledge I have discussed—perspective, anatomy, photography, and history—have been those developed within the confines of European culture. I will go on to the non-European sources, the art of the Indians, Chinese, Japanese, and "primitives." Here, too, there seems an almost lawlike process at work: first ignorant curiosity, countered here and there by persons with the courage of their own intuitions; then a sometimes slow, sometimes spasmodic, gathering of information; then a sudden passion, born probably of revolt, for the exotic; and then, at long last, the ability to see things in context, as they were seen in their own time and place; but never, of course, a definitive judgment, but only each interested person pressing his case, and perhaps, for a brief while, a near-consensus. First, that is, come the travelers, traders, explorers, and missionaries; the rare independents, such as Dürer, who marvels at the wonderful Aztec art brought to Europe, and Rembrandt, who owns and copies Mughal miniatures, or as the official of the Dutch East India Company who builds up a collection of Chinese, Japanese, Muslim, and other Oriental drawings; the disparagers, who say Indian and Chinese painting shows ignorance of anatomy, perspective, and color; and the enthusiasts for, perhaps, Indian architecture, who admit that it is neither Greek nor Roman, but magnificent all the same. Fashionable or rebellious persons are seized by manias: everyone bourgeois or better wants porcelain; Louis XIV and his courtiers and

then all France want Chinese lacquerwork and silk hangings; German, French, English, and American writers want Indian poetry and wisdom; Frenchmen want everything Japanese, including kimonos, erotic prints, and food; and French and German artists want African or Melanesian sculpture. The protest comes, maybe the letter to *The Times* in 1910 that says, "We the undersigned artists, critics, and students of art . . . find in the best art of India a lofty and adequate expression of the religious emotion of the people and of their deepest thoughts on the subject of the divine." The scholar-enthusiasts have their say. Havell argues that Indian artists felt none of the Greek and Roman need to imitate nature, because to them the only realities were spiritual; and Coomaraswamy, the scholar-mystic, adds that the Indian maker of images was engaged not in self-expression but in identification with the divinity he meant to infuse into matter. The esthetician Roger Fry agrees and explains the ways in which Indian sculpture and cave-paintings are high art. In England, Aubrey Beardsley, and in Austria Gustave Klimt and Egon Schiele, collect and are influenced by the decorativeness, the bold areas of color, and the eroticism of Japanese prints.

All this happened and can be recited in detail, with the names of the arts and crafts and artists I have omitted; but the fact to keep in mind is that Japanese prints alone (at the time) exerted a fateful influence on European art, mostly in France, from which the influence spread in every direction. Everything about the prints attracted the French painters estranged from their own tradition. They were attracted by the affectionately simplified episodes of daily life, the rocks jutting out of the ocean, the rounded bridges and straight waterfalls, the delicately bold flowers, the heroically enlarged sexual organs, the bright, hardly modulated colors, the decorative patterns on kimonos, the freely undulating curves, the waves made of imaginatively varied linear undulations. The French also appreciated the long, narrow Japanese formats, the division into diptychs and triptychs, the silhouetted foreground masses, the dramatic diagonals from one to another corner, and the dramatic truncations, especially of foreground figures. Both the diagonals and the truncations were similar to those observed in photographs, Japan and Europe converging in this instance as if by providence.

The first well-known French artists to feel the influence of the prints were Théodore Rousseau (1812–1867) and Jean-François Millet (1814–1875). Rousseau, a sensitive landscapist, was moved by the prints to

reduce the graduated depth of European art to the bolder, flatter, more Japanese silhouettes of trees against the sky, while Millet learned from the prints that he could defy the anthropocentrism native to European art and relegate a human figure to one side of a composition.

Of the older Impresssionists, Degas and Monet showed the deepest influence. Both loved and bought the prints, which were cheap, and had access to large collections, and both looked to the prints for new subjects, compositions, and points of view. Degas's women bathing, drying themselves, combing themselves and being combed, are borrowed from Kiyonaga, whose diptych of women bathing hung in his bedroom, from Hokusai, and perhaps from Utamaro. The near-parodic nudes he drew in monotype also recall the Japanese. From the Japanese and from photography he learned to break the time-honored centrality of human figures, to cut figures off at the frame, to show them from behind, above, below, at close range, and reduced to shadows; and from them he learned to create depth by means of sharply opposed diagonals. Monet, like Degas, adopted the Japanese downward- or upward-viewing; he cut boats off at the frame; and he extended boats over more than one leaf of a print. It was perhaps from Hokusai's series *Thirty-six Views of Mount Fuji* that he learned to paint things—poplars, haystacks, water lilies, cathedrals—in series. His masses of water lilies growing in a pond are composed in Japanese asymmetry. However, the most profound of the influences or parallels was the dissolution of man and nature in one another, experienced as the intermingling of cosmic forces.

It is difficult to know to what extent Gauguin, Van Gogh, Toulouse-Lautrec, and the rest of the new generation of artists got their Japanese qualities from Degas or Monet or directly from Japanese prints. Gauguin borrowed figures quite literally from Kuniyoshi and Hokusai. Van Gogh, who at one time planned to go into business with his brother selling Japanese prints, copied three paintings and many themes from them. Influenced by the Japanese space-filling techniques, such as Hokusai's dot-and-stroke method, he drew with reed pens on absorbent paper. "I envy the Japanese," he wrote, "the extreme clearness which everything has in their work. Their work is as simple as breathing. . . ." He preferred to live in the south of France because he saw a "second Japan" in its sunlight, color, and simple inhabitants; and he dreamed of a community of artists who would refresh their spirits and humanity by returning periodically from the city to live in Japanese fellowship. Like

Van Gogh, Toulouse-Lautrec found in the Japanese a dream-ideal. His portraits of actors and his erotic scenes, not to speak of his style and mode of composition, are reminiscent of the Japanese; and Hokusai's *Manga* stimulated him to portray momentary and yet typical gestures, precarious equilibria, and people stretching, lying, and lolling, in every pose.

I must mention Bonnard, Vuillard, and Cassatt, though I cannot go on with the influence of Japanese prints on French art. This influence, which remained powerful for almost fifty years, explains the judgment that between 1860 and 1905 the prints played a role comparable to that played by Greek and Roman antiquities in the creation of Renaissance art. Yet by 1905 the turn of Africa and of "primitive" art had come.

"Primitive" art was never art to begin with. The "idols," pelts, ivory, weapons, stools, and ornamented spoons that mariners brought back from their voyages were kept in "curiosity cabinets" as mementos of a distant and, to many, damned and benighted world. It is true that the voyages of Captain Cook widened European perspectives; and Cook did express admiration for the tall curving sterns and the ornamentation of Tahitian canoes. Yet when he said of some large statues, "A European would have been ashamed of them," he said what almost anyone of his time said about any "primitive" art. He was as right for the eighteenth as Ruskin was for the nineteenth century when he assured those who might hesitate, "There is no art in the whole of Africa, Asia, or America."

However, art or not, the work of "primitives" was exhibited in great expositions in London and Paris. It was the Universal Exposition of 1889 that introduced Gauguin to "primitive" art. Thanks to European empire building, contact with the impatient, antitraditional artists was at last being made; but the reaction of Gauguin shows with what difficulty. Although he was the first important European artist to live among "primitives," in whose company he hoped to find something between ecstasy and calm, his praise of "primitivity" was indiscriminately for Gothic, Quattrocento, Persian, Cambodian, or ancient Egyptian art. Life among the Tahitians made him wonder whether they had any sense of beauty. What he knew about their religion was mostly from a travel

book, and the local gods and spirits he inserted into his paintings were there to serve his own associations and lend an air of mystery. Only later, in the Marquesas, did Gauguin show enthusiasm for any Polynesians' decorative sense or gift for harmonious forms.

African art was discovered to be art during the first years of the twentieth century, by Ensor about 1900, and by Kirchner (who put the date earlier) and by Vlaminck in 1905 or 1906. Vlaminck passed the discovery on to Derain, Matisse, and Picasso, each of whom reacted artistically in his own way. Picasso, who is reported to have said of an African sculpture, "It is more beautiful than the Venus de Milo," collected African statues and masks enthusiastically. His surviving paintings from 1906 to 1908 show apparent borrowings, though it is argued that some or all of these are really fortuitous "affinities" with sculptures that he could not in fact have seen. His friend Max Jacob insisted that the geometry of African sculpture helped Picasso to move from naturalistic to Cubistic art. Much later, Picasso told André Malraux that to Matisse and Derain, African sculpture had been sculpture, nothing more; but to him, viewing it at the Musée de l'Homme, it had consisted of magical objects, made to ward off unknown, threatening spirits:

> I understood what their sculpture did for the Negroes. Why they carved them that way, and not some other. After all, they weren't Cubists—the Cubists didn't exist yet! Of course certain men had invented the models, and others had imitated them—isn't that tradition? But all the fetishes did the same thing. They were weapons—to keep the people from being ruled by spirits, to help free themselves. Tools. *Les Demoiselles d'Avignon* must have come that day, not because of the forms, but because it was my first canvas of exorcism.

Unlike Picasso and his friends, the German artists, the Expressionists, wanted to follow the example of Gauguin and return to the authentic life of "primitives." Nolde actually accompanied an anthropological expedition to the South Seas. Moved by the "absolute originality" and intense expression of life he found, he was ready by 1920 to declare that "primitive" art was superior in value to the art of the Greeks or of Rapahel. That same year, Roger Fry wrote that some "primitive" art was greater than anything produced in medieval Europe. He was especially taken by the ability of Africans to conceive form in three dimen-

sions. Neither then nor later, however, did he see much in Oceanic or Precolumbian art. The Oceanic was the province of the Surrealists, who found in it the same free reflection of the subconscious mind for which they were striving.

Of the two influences, Japanese and African, it was the African that proved the more radical. The Japanese accentuated tendencies that were already clearly present, while the African accentuated more hidden, even alien attitudes, antagonistic to naturalism, and certainly antagonistic to European notions of beauty or grandeur. It is true that Picasso himself had been prepared by his interest in Egyptian sculpture and his "Iberian" style; but no one knows what would have happened in European art in the absence of the African influence, and so it makes good dramatic sense to date the beginning of the end of the European tradition at about 1910, with the influence of African sculpture on Picasso. Picasso genuinely admired "primitive" art, and in at least one instance he expressed his admiration for an aboriginal Australian painter. I am referring to the letter he wrote in 1920 in which he told Mawalan, a successful painter, hunter, and warrior, that he envied him the ability he showed in his bark paintings. I find it touching that this great European artist should think himself to be in the same world of artistic discourse as the aboriginal and should want to congratulate him.

I have finished my painfully brief account of the process by which Europeans became aware of other traditions and began to learn to accept and value them. If we turn our attention from the historical process to its result, which is the variety of art that now tempts the artist, we shall find it easier to understand the present condition of art. There is surely nothing new in change or in the acceptance of influence from the outside. I do not know of a single art tradition that has been genuinely static for a long time, not even the Egyptian, or on a shorter time scale, the Tibetan, and certainly not the Indian or Chinese. Our own modern art is no different from the art of any other time or place by virtue of the fact that it has changed in the past and is still changing. Nor is our own art different in reflecting the influence on art of what might be supposed an alien culture. In the distant past, Scythian art came to terms with Greek art, Greek art had its early Orientalizing phase,

Egyptian art was in the end almost overwhelmed by Greek art, Buddhist art was affected by Greco-Roman sculpture, the purposeful simplicity and roughness of Japanese tea-ware reflects Korean qualities, Chinese pottery designs in blue may reflect Persian influences, Persian miniatures certainly show Chinese influence, eighteenth-century Japanese prints are affected by European perspective, and so on. In the past, however, influences were fewer in number and more limited by the nature of the receiving culture. An influence cannot exert itself unless the artist or patron is ready to accept it. We are uniquely receptive because our own tradition has been demoted to the position of our own perpetual antagonist, and because, correlatively, every other tradition attracts us as an alternative. Once the barriers are down and anything of any place or time has acquired equal or superior legitimacy, the field of choice expands enormously.

Let me begin to document what I am saying by recalling the contents of *The Blue Rider,* published by Marc and Kandinsky in 1912. To help revitalize European art, which they thought moribund, they drew illustrations from a very wide variety of sources: children's drawings; Russian folk art; Bavarian votive pictures and glass paintings; medieval ivories, tapestries, mosaics, and paintings; Japanese paintings and prints; Chinese paintings and masks; African masks; Precolumbian sculpture and textiles; Egyptian shadow-play figures; Malaysian and Easter Island sculpture; and El Greco, Cézanne, Van Gogh, Matisse, and German contemporaries. I picture the eager young artist hovering over the illustrations with the question, "Which of these, alone or in combination, can serve me best in the development of my own art?" Perhaps the artist would respond like the editor Marc, who was to write in a preface to a planned second volume that this repudiation of the European tradition in favor of every other might show that it was time "to cut loose from the old world"; or perhaps the artist, faced by such a dazzling multifariousness, might find it all paralyzingly rich.

Since the time of Marc and Kandinsky, we have grown more knowledgeable in art history, and our increasing discrimination between cultures and cultural stages has increased the number of possibilities even more. I can demonstrate this richness convincingly only by the use of examples. Anyone who wants to look for them on his own might begin with such members of the New York School as Pollock, Newman, Motherwell, Stamnos, Baziotes, de Kooning, Gorky, Rothko, and Gott-

lieb. To make the point more economically, I shall limit myself to the sculptor Henry Moore, who has written in convincing detail on the art that influenced him, and to a few artists who have experienced a sometimes paralyzing tension between the attractions of Eastern and Western Art.

Early in his life as an artist, Moore tells us, he was strongly impressed by Roger Fry's book *Vision and Design*. Fry opened his eyes to the "three-dimensional realization" and "truth to material" of African art. Fry's book led to others and to the British Museum. Moore recalls that his first year in art school, when he was twenty-one, passed in a dream of excitement—not because of the school (the Royal College of Art), but because every room in the British Museum revealed a new world of art. With everything before him, he says, he was free to find his own way and, after a while, to discover what appealed to him most.

At first, Moore was most impressed by the monumentality of Egyptian sculpture, which was closest to familiar Greek and Renaissance ideals; but the hieratic stylization, academic obviousness, and "rather stupid love of the colossal" ended by alienating him from much of the Egyptian. Other rooms remained attractive: the Archaic Greek, with life-size female figures, "grand and full like Handel's music"; the Sumerian, with its bull-monsters and contained sculptural energy; the prehistoric and Stone Age, with the free but very human richness of its female figures (and its tender, thumb-nail-sized carving of a girl's head); the African, its figures statically patient, resigned to unknown powers, vertical and rooted in the earth like the trees they were made from (and its Sudanese figure, as deliberate and, to the sculptor who made it, as pleasurable an achievement, as the writing of a poem); the Mexican, its figures tremendously powerful and yet sensitive, astonishingly fertile in form-invention, and notably three-dimensional; and the Oceanic, more two-dimensional and pattern-conscious than the African, but in its New Ireland examples with a unique, bird-in-a-cage form.

Moore says that the deepest impression was made on him by early Mexican art, although Romanesque or early Norman also spoke deeply to him. He could not, however, assimilate these influences in peace. Instead, he underwent a crisis, the result of a six-month trip during

29

which he was exposed to the masterpieces of European art. He could not shake off the new impressions without denying everything he had believed in before, and he found himself helpless and unable to work. Only gradually did he begin to feel his way out of his quandary, the way out leading back towards ancient Mexican art. Of his tension then he writes:

> It seems to me that this conflict between the excitement and great impression I got from Mexican sculpture and love and sympathy I felt for Italian art represents two opposing sides in me, the 'tough' and the 'tender,' and that many artists have had the same conflicting sides in their nature.

Moore does not admire all non-European art. He is not moved by perfectionist art, such as he takes Chinese painting to be, and he sees it, compared with painting like that of Rembrandt, as more craft than art. Yet he is glad that the sculptors of Greece no longer blind us to the sculptural achievements of the rest of mankind. When he adventures in a museum, he may find a non-European sculpture he would like to but cannot equal. Of the Egyptian head of a woman he discovered in Florence, in the Archaeological Museum, he says:

> I would give anything if I could get into my sculpture the same amount of humanity and seriousness, nobility and experience, acceptance of life, distinction and aristocracy. With absolutely no tricks, no affectation, no self-consciousness, looking straight ahead, no movement, but more alive than a real person.

We have not finished with Moore's sources. There are at least two others of note: one science, and the other nature. To science he ascribes the stringed figures he made in 1937, which were inspired by mathematical models he saw in the Science Museum at South Kensington. Among the natural forms that interested him there were pebbles and rocks, bones, trees, shells, and plants, all part of the "limitless variety of shapes and rhythms" with which the sculptor can enlarge his experience of form.

As examples of the interaction of Eastern and Western art, I choose Mark Tobey, Zao Wou-ki, and Tsing-fang Chen. Morris Graves would

make another good example, as would Isamu Noguchi, with his American mother, Japanese father, and belated but effective experience of Japan. The first of my artist-examples, Mark Tobey, was almost entirely self-taught. A Chinese friend initiated him into the subtleties of calligraphy, which he pursued briefly in China itself and later in a Zen monastery in Tokyo. While in the monastery, he was disturbed by his inability to mediate and felt himself all the more Western. However, when he returned to England, the calligraphic impulse he had absorbed inspired him to paint in his "white writing," by means of which he tried, Zen-like, to make space penetrate form and dematerialize it. During a period when he practiced making rapid sumi-ink pictures, he wrote to a friend, "Standing as I am here between East and West cultures, I sometimes get dizzy as I find I can't always make a synthesis and also that I admire both paths which should and will, I suppose, merge." Looking back in 1971, it seemed to Tobey that all he was able to assimilate from Japan was rhythmic power, because it was the only thing that, as an American, he could take. "I'll make no claim," he said, "to finding anything else. But I did very much give my attention to this rhythmic power and its generation."

Zao Wou-ki was born in Peking in 1921. Despite the opposition of his mother, who wanted him to become a doctor, his father, a banker, encouraged him to take up painting. He entered art school at the age of fourteen and studied both Chinese and Western methods, but was neither happy nor successful. "You cannot imagine the degree of backwardness and conservatism of Chinese painting at that time," he recalls. "I was very unhappy about that." Influenced by reproductions, especially of Matisse, he painted in the contemporary French manner, and when critics ridiculed his work, he reacted defiantly. The great tradition of Chinese painting ought not, he felt, be suffocated at the hands of the conservatives. In reaction, he and his wife moved to Paris. The art he found in the Louvre flooded him with joy; but though he lingered over the classical paintings, he was most drawn to avant-garde abstraction. Excited and torn by conflict, ashamed to display what he had painted in China, he stopped painting for a whole year. His first exhibition, in a mixed Chinese-French style, aroused little interest, but an avant-garde gallery signed him to a contract. Zao then tried to turn completely French, but discovered to his dismay that he kept on using traditional Chinese colors. He gave himself the permission to remain Chinese only

after the paintings of Franz Kline, with their Chinese air, convinced him that he must penetrate intuitively to the essences of both Chinese and Western culture. To penetrate into the Chinese, he studied the ancient painter and calligrapher Mi Fei, *The Book of Changes,* and Lao-tse; and to penetrate into the Western, he toured the museums and ancient sites of Italy and Spain. Yet the exhibition of his works in 1952 led to a renewed agony of self-examination. "My paintings have become unidentifiable," he mourned. "No more flowers bloom in them." It took some four years for Zao to overcome this renewed spell of anxiety. The paintings that followed showed the influence of ancient Chinese stone-rubbings, engraved Chinese characters, oracle-bone writing, and Chinese calligraphy. Since then, his paintings have become more realistic. They are often large vistas seen from above, their colors suggesting both Monet and Turner. Zao works in his garden and reads the poems of Li Po, Tu Fu, and Wang Wei, and the other authors, ancient and modern, in his collection of Chinese books. Critics have been both favorable and unfavorable, but he says that he no longer pays much attention to them.

The last of my East-West examples, Tsing-fang Chen, again shows an artist in a crisis of choice between traditions and between conceptions of art. Born in Taiwan under Chinese rule, Chen was educated in Chinese and, perforce, in Japanese. Attracted to the West, he got a scholarship from the French government and simultaneously attended the Sorbonne and the Ecole des Beaux-Arts. The ruling style in Paris of the 1960s was Lyrical Abstraction. Prominent artists, such as Soulages, Hartung, Michaux, and Zao Wou-ki, showed the influence of Oriental calligraphy and Zen, and so Chen, while in the process of adopting Western attitudes and techniques, was driven as well to reevaluate his own tradition. He remembers the traditions quarreling and then making up:

> East and West lived side by side in me like two sisters but I couldn't get along with both of them. Dispute and quarrel, confrontation and conflict between them caused me to fall into a profound crisis which reflected itself in my painting. One day, my work would look like Matisse, tomorrow, like that of Cézanne, the third day I tried doing abstraction. Chinese archaic characters and Formosan folklorics also served alternately to my changing mood.

As Chen explains, he was freed by the revelation that contemporary painting was right in trying to fuse all the different sources of art.

Suddenly he realized that he belonged to the generation towards which all traditions were converging. Neither Eastern nor Western, he belonged at once to both traditions and to their union. Released from his crisis, he began to paint in a new style, Neo-Iconography, which is an attempt to synthesize East and West and past and present. I leave it to each person who encounters Chen's work to determine how successful he has been. My interest here is in the kind of crisis he underwent.

Our knowledge of preceding art, I have emphasized, is wider and more detailed than ever before, and the determination not to be bound to our own tradition is much stronger than ever before. A curious double tension is created. One tension is the desire to show one's freedom from the past one is so well aware of; the other is the desire to show one's awareness of the past that one rejects. Rejection of the past is harder than it may seem at first. Something always remains in one's conscious or unconscious memory, and, consciously or not, artists take figures, poses, compositions, and techniques, from their predecessors. Chinese poets, calligraphers, and painters, with their capacious, trained memories, came to enjoy what may be called in calligraphy and painting as well the art of quotation. To the connoisseur the painter kept saying visually, "I am alluding to the work of my great predecessor So-and-so and assimilating it into my art (and mastering my predecessor); but only I and persons such as you, those in the know, can recognize and enjoy my allusions." The immediacy advocated by Ch'an (Zen) artists was in part designed to counter this sort of erudition, but Ch'an art too could hardly escape the historical comparisons it evoked.

Although less erudite and with a shorter usable tradition from the Renaissance onward, Western painters, like Western writers, have naturally quoted a good deal from their predecessors; but quotations in painting were in the past usually quiet and, as in China, visible only to those in the know. Most often they were simply a taking over of something the painter saw and needed. It is in the nature of things that such quotation is still practiced; but it is also in the nature of art now to be extremely self-conscious about quotation, as if it were indulgence in a forbidden pleasure. The result is that conscious quotation now tends to be what is called "demystification," which is also, more simply, parody.

The very techniques of art become the direct subject-matter of art. In the United States of the 1950s and later, an artist (Jasper Johns) might leave a brush and palette knife sticking to a painting (*Field Painting*) as a reminder of the tools used in making it; might portray or incorporate a canvas with a stretcher-frame as seen from the back (Jasper Johns, Roy Lichtenstein); might imitate a do-it-yourself picture with numbered sections (Andy Warhol); might draw his drawing paraphernalia (Saul Steinberg); might make a realistic painting of tubes of paint (Audrey Flack); might use paintbrushes, palettes, or even brush-strokes as a subject (Jim Dine, Roy Lichtenstein); or might incorporate the word *art* into a painting (Roy Lichtenstein, Robert Collingham, Robert Rauschenberg, Robert Arneson).

As for quotation by way of parody, the subjects or victims have included, as gallery goers or art-book readers know, Pisanello, Da Vinci, Michelangelo, Vermeer, Velasquez, Rubens, Rembrandt, and the most famous moderns. As might be expected, the Mona Lisa, reputedly the most famous painting in the world, has suffered an endless number of parodic quotations: inserted into an abstract collage and marked by large red *x*'s, presumably to indicate that she is no longer valid; distorted into sadness, transmuted into Jackie Kennedy, Golda Meir, Stalin, and a gorilla, and even deprived of her famous head.

Describing the situation as he saw it in 1982, an art critic complained of a belated avant-gardism, a promiscuous borrowing that does not engage either the past or the present:

> To see other *periods* as mirrors of our own is to turn history into narcissism; to see other *styles* as open to our own style is to turn history into a dream. . . . The freedom of art today is *forced* (both false and compelled): a wilful naiveté that masquerades as jouissance, a promiscuity misconceived as pleasure.

I should like the artists themselves to summarize the situation of art today, with its extraordinary range of reference, its usually housebroken rebelliousness, and its stylistic chaos. Eduardo Paolozzi sees the situation in an optimistic light. Anyone, he says, can now become a poet, musician, or sculptor. All that is needed is an open mind and the liberation

of the faculty of choice. Just as the aerodynamicist does not build his own wind tunnel, so the artist does not have to execute what he has conceived—others have the practical skills. It no longer makes sense to shut oneself away in some artists' colony with a sack of plaster or a box of oil paints. Now art is biology, ethnology, everyday things, anything and everything seen in a certain light. Francis Bacon may not disagree. He is said to be pleased by the idea that he may end up as the last man in the world who still believes in painting.

Bacon's belief and his pleasure lead me to recall that in 1919 Malevich exhibited paintings some of which were crosses. The exhibition was meant, the artist announced, to end Suprematism as a movement in painting, and so, no doubt, to end painting. Malevich told a fellow artist that the cross was his cross, "so personally did he feel the 'death of painting.' " That other painter of cross-shapes, Ad Reinhardt, said in 1956, "I'm just making the last painting which anyone can make." De Kooning, though he does not prophesy the imminent death of painting, argues for eclecticism and stylelessness. He says of the twentieth-century painters and schools that have influenced him, "I have learned a lot from all of them and they have confused me plenty too. One thing is certain, they didn't give me my natural aptitude for drawing. I am completely weary of their ideas now." He considers himself an eclectic by choice. He says, "I can open almost any book of reproductions and find a painting I could be influenced by." After experiences he describes as tormenting, he has arrived at the conclusion that "there is no style of painting now." To this conclusion he adds, "To desire to make a style is an apology for one's anxiety." To him, art today is "a style of living." Beginning with anything, the artist lives on canvas, he says, alert to the possibility of a new coherence.

The evidence lies everywhere around us. In art (and perhaps elsewhere) knowledge releases, knowledge levels, and knowledge kills. Is it reasonable to hope that the release will compensate for the death? Is the leveling more a gain of freedom than a loss of discrimination? Or are the death and the leveling less than they seem?

CHAPTER TWO

Prehuman Intimations

Because the problems of contemporary art are reflections of old human dilemmas in a new human context, they are unlikely to have a direct solution, and certainly not an easy one. However great our nostalgia, the solution is not a return to the past, if only because we cannot, either individually or collectively, abolish the knowledge and the doubts that we have acquired. It is convenient to accept everything in art just as it occurs, in effect to abandon ourselves to whatever happens, on the principle that it is better to enjoy than to denounce the inevitable; but such self-abandonment is not natural for long to a thoughtful person. Because we have already accumulated so much knowledge, because we cannot wilfully decide to forget, and because we want to retain some power to think, choose, and influence, I suggest that we search for whatever measure of salvation we can reach by trying to understand still more than we now do, not primarily by accumulating a still larger number of facts, but by broadening, deepening, and steadying our grasp of art, and in this way learning what we may reasonably hope to experience and accomplish by its means. Even if some of the problems

that art poses will appear insoluble in a purely intellectual sense, we may learn to take a more reasonable attitude towards them.

In attempting to understand art so, I should like to return to an old point of view and, by way of restating it, to consider the biological, or more narrowly the ethological, background of art. I shall do this by considering the artlike activities of three creatures different from ourselves. Those of the first kind, the birds, are so different that there is little temptation to try to grasp their nature from within as if it were part of our own conscious experience and we were as somewhat birdlike as birds are human. Regardless of what will be said of birds' plasticity, intelligence, and sensitivity, the value of the comparison will lie precisely in their great difference from us. The creatures of the second kind, the apes, resemble us closely enough to tempt more incautious human beings (among them, in this instance, I include myself) into comparisons of simian and human experience, so that the value of the comparison will lie in the narrowing and consequent highlighting of the difference that remains. The creatures of the third kind, young children, embody a condition through which all of us have passed, and this historical relationship may inspire us to remember childhood and grasp it as continuous with and in some ways contained within our present condition of adulthood. In the instance of children, the likeness is so close and the continuity so far beyond doubt that even when the difference is emphasized, the very emphasis may force us to think more carefully about the nature of art.

It is obvious that some people prefer to affirm and others to deny the analogies between human beings and animals, or, as I think preferable, between human and other animals. Having sympathized from childhood on with what I had best call the underanimal, I side with the analogy makers. It does not follow that I take human and animal mentality to be essentially the same, but only that the analogies may be instructive and allow us to see into our own nature more closely. Later in this chapter I shall say what little I can about the necessity of a human self-consciousness for art, and about the degree to which consciousness can plausibly be denied to all other animals. I shall certainly have to make qualifications, but not, I think, such as will destroy the value of the analogies. My choice of creatures is not, I know, self-evident. That of children should arouse no question aside from the propriety of classifying them as prehuman; but it may seem curious that, of all other animals, I have chosen

37

to speak almost exclusively of birds and apes. However, in an essay that deals with many subjects in order to clarify the nature of one, I have to choose my examples economically, so I have chosen one for a kind of animal with which we cannot really empathize, and another for one with which we can or can almost do so. I hope that after I have developed these examples, the choice will have justified itself.

It appears to me that the relationship between human art and the art or "art" of birds would be enlightening even if birds were the instinctive, that is to say, automatically acting, organisms they were often taken to be even in the recent past.

The most unmistakably artlike behavior of birds is their singing. The singer, more usually a male than a female, has two primary reasons for which to sing: one to defend its territory against other males, and the other to attract females. The same song or call, which is shorter or simpler than a song, may have different meanings, depending on its context—the call that in the mating season both defends territory and attracts females serves after the season only to defend territory. As against such general signals, there may be specific ones, some of them graded in structure, length, and other characteristics, so that different intensities may evoke different intensities of response. The occasions that have been said to evoke distinctive songs or song-variants are many, from the search for a nest site to the building of the nest, the incubation of the eggs, the spelling of the female in her incubation duties, the leaving of the nest by the young, migration, and autumn and winter. Calls too have many varieties and functions. Observed closely, as the ornithologist Peter Marler discovered from the two black-and-white cockerels he kept in his office, the repertoire of calls may be puzzlingly large. Because the number and functions of songs and calls vary from species to species and, to some extent, from time to time, area to area, and individual to individual, any general list of functions is misleading. Let me therefore begin to particularize.

The song of a bird develops in a given sequence. The recording of sixteen infant swamp sparrows led a researcher to divide the formation of song into four stages: subsong, which is amorphous babbling; sub-plastic song, which is somewhat organized; plastic song, which is better

organized; and full song. This development is not unlike that of speech in a child, which begins rather amorphously and goes on by means of experimentation and learning. Rather as a child may produce many kinds of sounds (though far from all possible ones) that it will later fail to use or even be able to make in speech, so a bird, a swamp sparrow, for example, may at first produce four or five times as many kinds of syllables as it actually uses in full song. Perhaps it is this early variety of sounds that is drawn on by birds like the canary and the red-winged blackbird, which change their repertoires from year to year. Marler has said, "You might think of some stages of subsong and plastic song as vocal play," to which he has added with an engaging lack of caution, "a search for inventiveness—novelty for its own sake."

The development of a bird's singing can be followed through the stages characteristic of its species and of itself as an individual. Not only does the song of a bird grow better formed until it is full, but, even in adulthood, it may show a clear seasonal development. Consider a certain European blackbird, which was observed to have an early-spring repertoire of twenty-six basic phrases and almost as many variants, some of them ending in a flourish of squawks. In the early spring, this blackbird's song was no more than a few successive repetitions of the same basic phrase, followed sometimes by its variant. Gradually, however, the blackbird complicated its song, merging and recombining phrases, as if it were experimenting, until the song was both varied and highly organized. At least externally, the bird resembled a composer learning how to write music. Towards the end of the season, when the song had lost its overt sexual function, it reached its most highly organized, in the human sense most musical, form. It was observed, incidentally, that a phrase of the blackbird's song was similar to the opening one of a Bach suite.

Birds sing by nature, but some of them must also learn to sing. While ringdoves sing the same song even if isolated from others of their kind and even if deafened, canaries, song sparrows, and other species of birds do not arrive at normal song unless they can hear themselves and, in some species, unless they have companions. A captive young chaffinch isolated from other chaffinches sings with many fewer distinct kinds of syllables and much simpler syllables than a wild chaffinch, and often it omits the final chaffinch-flourish. The effect of early isolation makes it evident that some essential learning takes place long before the chaffinch

itself begins to sing. The company of an adult wild chaffinch stimulates the isolated ones to sing almost normally, with complex syllables arranged in phrases and ending with a flourish, the song of each bird being simultaneously chaffinchlike and individual.

Some species of birds repeat themselves incessantly, others have a small, and still others, a large repertoire of songs—central California song sparrows have a repertoire of perhaps ten songs or song-forms, all of which they go through before they repeat themselves; a long-billed marsh wren, with a repertoire of perhaps one hundred songs, may go through fifty without repeating itself; and a brown thrasher has a repertoire of perhaps ten thousand recognizably different songs. It should be added that even when the repertoire of a bird is known, the order in which it sings its songs may well be unpredictable.

In the song of birds such as vireos, the smallest elements may make up more complex ones, and element within element, form a hierarchy that suggests human speech. The song of any bird is likely to respond to changes in the singer's condition and environment by a change in tempo, pitch, or loudness. For instance, in canary courtship, low degrees of excitement are expressed in pure tones, excitement and the tendency to attack in harsh sounds, and "the intimacies of sexual motivation" in soft, short sounds.

It should be kept in mind that a bird can sing and hear a much greater number of distinct sounds in a given time than a human being. A bird's perception of pitch is not unlike ours, but it can hear lower sounds, localize sounds better, discriminate them more quickly, and in at least some species, resolve certain complex ones more acutely; and some birds, such as reed warblers, can sing and no doubt hear two different tunes at the same time. An inadequate human analogy is the music of Anton von Webern, in which a great deal happens in a very short time —one of his *Five Pieces for Orchestra* (1913) takes just nineteen seconds to play. Although there is some likeness between a dawn chorus of birds and Mahler's Eighth Symphony, I know of no avian rivals to Mahler in duration of song.

Like human speech, birdsong has dialects. Often a local song-dialect is formed and then transmitted from one generation of birds to another; but this tradition is weakened or destroyed if birds too young to have assimilated it go off to territories where there are no older birds to maintain this particular song-tradition. As among humans, the spread of

a dialect may be predominantly geographical, or, again as among human beings, small groups of birds and even single individuals singing in one dialect may be found side-by-side with others singing in another dialect. Birds, for example white-crowned sparrows, may be, so to speak, bilingual, and they may mate with birds using either their own or a different dialect.

I should like to postpone the comparison of birdsong with human song and other art until later and go on briefly to bird display. The displays of birds may resemble human dances, whether static dances, ring-dances, line-dances, or place-changing dances, each type with or without spectators or vocal accompaniment. In terms of the motion involved, the dances have been classified as convulsive, mimetic, reciprocal, and complementary, terms I report for their interest but cannot go into. In terms of the emotions they may be supposed to express, the dances have been classified, with an obvious danger of anthropomorphism, as excited or ecstatic, erotic, bellicose, and sociable.

Whatever the type of dance, the synchronism may be complicated and exact. Grebes give spectacular joint performances, which may be those not of rivals, but of mates. A male and female crane dance spectacularly, pirouetting, bowing, and hopping and skipping, together. Japanese cranes, symbols of marital love and fidelity, dance at any time of the day, in any season, and at any age. They dance alone and in couples; and when one pair dances, another and another may do the same, until an entire field is covered with black-and-white dancing pairs, bounding gracefully and at times, to our eyes, comically. The crane-dance can be a courtship or a postcoital dance, one of the pair dancing gracefully around the other. Often it appears that these cranes dance out of the pure joy of living.

Dancing cranes, graceful and comical, are always plain-colored. In contrast, birds of paradise become shimmering ornaments when they dance. Yet although so beautiful, birds of paradise are not as interesting as their drabber relatives, the bowerbirds, natives of New Guinea and Australia that build and decorate what might be considered either dance pavilions or private museums.

When a bowerbird clears an area, builds a twig-structure on it, and decorates the area, his object is the seduction of the female. Soon after

41

the mating, the female leaves—she may be driven out—and nests else-where. It is this distinction between the act itself of mating and matri-mony that inspired Robert Graves to compare the courting customs of the penguin and jackdaw with those of the bowerbird, which seduces the hen with parrot-plumage, orchids, bones, and corals, and then aban-dons or drives her out. Graves's comment is, "It was the Bower-bird contented me/By not equating love with matrimony."

Every species of bowerbird has its favorite color—black, or red and yellow, or blue—while some appropriate glass, colored paper, and other decorative materials from human beings. Some individuals of some spe-cies, the satin bowerbirds, for example, paint and repaint the inward side of the walls they have erected. For paint they use a berry held in the beak or a mixture of saliva and charcoal or other vegetable matter, and for a spongelike brush, crushed leaves or bark.

I cannot resist a certain description of the display of an orange-crested gardener, a starling-sized New Guinea bowerbird that weaves a domed structure more than halfway around the base of a sapling. The base, visible through the open front of the structure, is covered with moss, on which the particular though nameless bird of which I have read lays glittering blue beetle-skeletons to the left, a line of yellow flowers down the center, and fragments of shiny snailshells to the right. It decorates the fence surrounding the whole area with yellow and with red fruit. When the bird returns from a collecting trip, he looks at the display, picks up a flower in his beak, inserts it in place, retreats and looks again. The observer says, "A yellow orchid does not seem to him to be in the right place. He moves it slightly to the left and puts it between some blue flowers. With his head to one side he then contemplates the general effect once more, and seems satisfied."

It is hard to resist an anthropomorphic response. Even a professional ornithologist cannot keep himself from remarking, though he appends a warning, "I see no reason, provisionally, to deny the bower birds an aesthetic sense. . . ."

I shall not go on and describe a bowerbird's actual display-movements, but add only that bowerbirds continue to tend their bowers for many weeks after they have mated. They repair the walls of their structures, keep their lawns clear, replace wilted with fresh flowers, and rearrange the colored objects in their display. It is possible that they are waiting for additional mates, as it is possible that they continue to mate in sub-

bowers; but many of them appear to mate only once a season. Even if they mate elsewhere, the keeping of the main bower may have acquired what I shall call a consummatory value. That is, the bower's importance may survive and exceed its direct use as a sexual lure. Careful observation reveals situations that are difficult to explain in the most usual biological terms. At least one romantic-sounding case has been recorded in which a female bowerbird preferred the crude bower of an immature suitor to the well-constructed, richly decorated bower of a mature one. Things would have gone badly for the older bird if he had not destroyed the younger bird's bower and stolen his ornaments. The younger bird put up no opposition, and the female entered the victor's bower and mated with him. Something in the victor's mature presence, his color, maybe, or his boldness, made him dominant; but it is not clear that his dominance depended on the elaboration of his bower, which was not, in any case, what attracted the female. Victory does usually go to the best collectors and builders. In the case of the satin bowerbirds, it has been demonstrated that females prefer the males with the biggest collections of ornaments and the best built, neatest, most symmetrically walled, and most highly "sculptured" bowers.

Male bowerbirds are always competing with one another and, as the preceding example shows, are thieves and vandals in relation to one another. In some species of birds, the competition is even more direct. Male hummingbirds may gather and sing as visiting females make their choice from among them. Male mallard ducks, which gather on a river or lake and await the females, fight in order to take over the most visible positions. Females prefer the more dominant or more brilliantly colored males. However, in at least some species of such lek (playground) birds, the victory, which is the mating, does not always go to the strong or handsome. For reasons difficult for us to fathom, the female may prefer a male that loses the battle for her possession.

Although I cannot myself play the expert, I find it necessary to repeat the basic explanations that ornithologists give for birds' singing and displaying. Like displaying birds, the explaining ornithologists compete with one another, and one often feels that they are straining to accommodate awkward facts. They tend to assume that every nuance of song

or display has had survival value or disvalue, and they try with often conspicuous cleverness to turn each apparent exception into further evidence for the truth of their theses. There is no lack of general hypotheses to explain why, for instance, certain male birds have distinctly larger song-repertoires than others: the larger repertoire is favored by the females because it is a sign of prolonged survival; the larger repertoire may be more effective in getting and holding territory; the larger repertoire may allow a bird to communicate his needs, dominance status, and location more effectively, and, by avoiding monotony, draw attention to himself. Yet a person cautiously observing the song of, perhaps, sage sparrows somewhere in particular may not be persuaded by any of these hypotheses. The observers whose work supports the hypotheses may have been careless, may have chosen unrepresentative areas or birds, and may have fallen victim to statistical artifacts. Maybe the observed traits are the outcome of chance vagaries of bird-history, which may resist scientific explanation as much as our own human history. However, in spite of such doubts, there often *is* good evidence, experiment and field-observation complete one another, and theory penetrates increasingly into the detail of a bird's life.

Whatever the final truth, I take it to be reasonable to adopt ordinary ornithological views and assume that whatever traits a female prefers are to her own or her offspring's advantage—the female goes to the male who promises her life. The nature of the promise is not always clear. The long wings that in one generation promised life in the sense of stronger flight may in the course of generations have become wings so long that they entangle their possessor in the surrounding branches and make his flight heavy. Yet the very burdensomeness of the wings may have become the seductive evidence of the bird's ability to survive despite them. Who can resist the attractions of a bird wearing a glamorous load of feathers?

To return to song, field-observation and experiment have shown the possible advantages of prolonging it or making it more ornate. When the recorded song of male canaries was artificially deprived of syllables, listening females were less industrious in building nests and laying eggs, compared with those that heard full song. The reason may be that full song recalls the father's song, imprinted on the female in infancy. An increased number of syllables is also a good measure of the age of the male, and his age of his experience and ability to survive. His song is

grossly and delicately expressive. When a canary or other bird sings, he is proclaiming his abilities and needs. He sings both as a species and as the individual he has become, and his song is the equivalent of "I, and not some other bird, I, I."

Before I go on to my second kind of creature, I should like to develop the analogies between the song and display of birds and the art of our own species. First, however, I must deal with a persistent, natural objection. The objection is that we cannot attribute art to any creature unable to reflect on its own experience. Animals, says the objector, are incapable of the imaginative synthesis, the transcendence of the immediate, that is essential for any art. This lack is most easily evident in arts, such as music, that require time for their expression. A bird hears sequences of sounds, but these, unlike musical sequences, belong to the material world. It follows that although birds make songlike sounds, they cannot sing in any esthetic sense.

Up to a point, I agree with this objection; but I find it much too categorical. Although it serves human pride, it is not compelling, and it rests on assumptions the force of which have been weakened by research. The often complicated animal reactions that we think of as automatic or "instinctive" are not well understood, and cannot, for the most part, be adequately explained in terms of humanly constructed mechanisms.

The communication of birds, with which we are now most concerned, is a good example of our exaggerated tendency to deny ability to animals. In the not-distant past, researchers assumed that a bird could not be intelligent because there was no location for intelligence in its brain; but it has since been discovered that a bird's ability to learn is primarily located not, as in mammals, in the frontal cortex, but in the hyperstriatum. It has further been discovered that when judged by the psychologists' usual tests, birds may be distinctly intelligent. Not only can some of them learn quickly, but can learn to learn, that is, learn to generalize from one situation to another, at times better than any primate but a human being. The likeness between human speech and birdsong is paralleled by a likeness in brain structure. Just as the speech-controlling area of the human brain is especially developed, so are the song-control-

ling areas of a bird's brain, at least in some species. The larger the male canary's repertoire of songs, the larger the relevant brain areas; these areas shrink in the bird's silent, autumn season and swell with the spring, when he begins to sing again. The limits of a bird's ability to communicate may not yet be known. There is a researcher who is sure that her African grey parrot is no mere mimic, but has a genuine grasp of language, including the ability to identify new objects by combining the already learned sounds for others. Though parrots do naturally well with a vocabulary of sounds and apes with one of gestures, we find it difficult to see the intelligence of nonhumans because we identify intelligence with our own anatomical structures, needs, and values. Analogously, we subject animals to tests irrelevant to their ways of life. But ethologists have been learning better.

To help weaken the objection that birds, like other animals, are in no way and to no degree capable of art, I must go from the subject of intelligence to that of emotion, and then to that most elusive of subjects, consciousness. To judge by external signs and physiological states, animals show fear; those that attack members of their own species show signs of what appears to be anger; and signs easy to interpret as joy or happiness are frequent. To say more and go beyond the signs themselves and their neurological accompaniments is difficult; but to decide that animals are not capable of emotion or consciousness of emotion is simply to transform our ignorance into a dogma. As for birds, we know that they remember and anticipate, and if they are capable of fear, they may also be capable of anticipating with fear, and so of having something of what in human beings we call imagination. To this conclusion, it should be added that if we judge by the brain waves that are correlated in human beings with dreaming, then animals, including birds, dream. An ingenious experiment with a monkey suggests that monkeys, like ourselves, see visual images in sleep.

Such observations make it not unreasonable to assume that animals may have intelligence, emotion, and even dreams. That leaves the problem of consciousness, which we associate in ourselves with intelligence, with emotion, and perhaps especially with the combination of both. It would be easier to assume consciousness in animals if we could separate it from self-consciousness, which experiment allows us to attribute, as I shall later say, only to apes. However, there are conditions, whether of

psychosis, brain injury, or the different functioning of the two halves of the brain, that suggest the separability to some degree of consciousness from self-consciousness. I find it therefore reasonable to assume that consciousness, like other biological abilities, has developed from one species to another in a relatively continuous way. Impenetrable as we find animal "minds" to be, it is as least as reasonable to assume that the more intelligent among them have something like consciousness as to assume that they are unconscious automata.

Briefly, we mislead ourselves if we insist on an absolute distinction between the conscious and the automatic. So, too, we mislead ourselves if we insist on an absolute distinction between the conscious and the unconscious. Both experience and research show that there are all kinds of intermediate states. Human art as we know it would be impossible if we were not intelligent and self-conscious; but it would be equally impossible if we were purely conscious or self-conscious beings, with nothing of what, lacking better terms, we call the "instinctive," the "unconscious," or the "intuitive." Much art is more nearly spontaneous than reflective—"inspiration" usually engages reflective intelligence, but is quite different from it.

Even, however, if animals or, to take the more immediate subject, birds, were never either intelligent or conscious, the likeness of their song and display to our art would still be revealing. This is not only because of the ways in which birdsong and human art function for the individual and the group, but also because human art too has biological grounds.

Having justified the drawing of analogies between animals and humans, I go back to the analogies themselves, beginning with song. With respect to the song of birds, I should like to draw five broad analogies. The first is that birdsong and human art are both ways in which the individual self is made external or given an external form. The second is that birdsong, like human art, may come to have a value in and for itself. The third is that birdsong and human song have similar uses, to establish intimacy, to court, and to claim, warn, and war. The fourth is that birdsong, like human art, creates a relation of challenge and response, a

kind of cooperative competition. The fifth and last is that birdsong, like human art, helps to create the interdependence of individuals and so to make a group cohesive.

First, then, birdsong and human art are ways in which the individual self is made external. It is undeniable that birds, like human beings, produce and are attracted to sounds organized, as human conventions specify, in a musical form, that is, in a pattern of rhythmically organized, motif-constructed phrases. In certain species of birds, this musical form allows a great deal of variation, and much of its interest, to birds as to human beings, lies in the balance it preserves between that which is fixed or predictable and that which is spontaneous or unpredictable. Such a balance establishes the general nature of the bird, by which I mean its species, sex, and age, and, against this background, its particular state and its individuality. Reflecting both its common and individual nature, the bird's song may be said to reflect its entire being and, in this sense, to make possible an accurate, deep form of communication. A bird's song externalizes its entire self as a motion of sounds. In this it resembles the expression, especially the concentrated, artistic expression of human beings, who proclaim in their art, as birds do in their song, "*I* am here," or "This, really, is what I am." The French composer Olivier Messiaen, who loves the song of birds and has noted down thousands of examples of it, says that each song is as individual as music heard at a concert, when one says to oneself, "That's Mozart! That's Debussy! That's Berlioz!" He does not hesitate to say, "Birds alone are the great artists."

The second analogy is that birdsong may come to have a value in and for itself, like human art. In a species that sings more flexible, complex songs, an individual's song grows out of a repertoire of phrases and phrase-variants that is complicated until it reaches a relatively high degree of organization. Especially at this stage, having perhaps outlasted its obvious sexual or territorial use, it may come to have its own, consummatory value. In its growth out of phrases or units, its tendency to become more complex, and its tendency to become detached from obvious practical ends, it resembles human song and human art in general.

The third analogy is that the song of both birds and humans has similar uses: to establish intimacy, to court, and to claim, warn, and war. Even if a human being chooses rather than composes poetry or music, this art, like the song of a bird, is effective as a preparation for

intimacy because it identifies the individual both by general kind and particular inwardness. No one really knows why certain species of birds —parrots, mynahs, crows, starlings, mockingbirds—have such an ability to imitate sounds, often including those of human speech; but it has been supposed that this ability helps the mates to sustain the closeness that is so characteristic of them. That is, their ability to imitate enriches their vocabulary of sounds, enables them to create their own, private sounds or sound-combinations, and enables them, by means of their private language, to find one another more easily and live more closely as a pair. The singing out of both birds and humans creates a dialogue between individuals that is personally and emotionally exact and (for humans) essentially deeper than prosaic words can convey. In an unanalyzable measure, it allows individuals to sense and, if they desire, to develop their intimacy and reach whatever natural sequel it may have.

It is my impression, derived from life and artists' biographies, that art, and especially its creation, can for many reasons have a strong aphrodisiac effect, and that this is an essential reason for the existence of much art. It is unnecessary to point out how much of human art is a form of courtship. Love certainly awakens poetry in the poet, as it awakens pseudo-poetry in others, and it has certainly often been a form of sexual persuasion, the poet pledging himself to be the eternally attentive, protective husband, or the eternally attractive, attentive lover, who will not lapse into a husband's inattentive possessiveness. The poem as sexual persuasion promises emotional fulfillment and emotional and physical safety. A protective husband is of course to a woman's advantage, while a persuasive lover who invades the life of a married couple may increase the woman's vitality and promise increased genetic richness, like that promised a bird by a stranger-bird, from another area and perhaps singing in another dialect.

The lover's nature of the poet or musician may be expressed in relation to art as such or to the instruments by which it is created. Yehudi Menuhin tells would-be violinists that the shape of the violin is inspired by and symbolizes "the most beautiful human object, the woman's body." After enumerating the violin's parts, from its head down to its belly and bottom, he evokes the varnish like sun on "the silken texture of human skin," and the voice of the violin, to him like a woman's. He adds, unembarrassed, "I have always kissed the head of my violin before putting it back to sleep, as it were, in its case."

Even if I limited myself to art as the direct expression of sexual needs, the subject would quickly grow beyond the limits I must set it here, so I can do no more than give a few reminders. Examples that spring to my mind without prompting are Rodin, Renoir, Vlaminck, Picasso, and Eric Gill. Rodin caressed the marble flesh of his statues as if they were women and apparently wanted to have sex with every woman who sat for him. Renoir, who said "I paint with my penis," showed his erotic interests in his paintings. Vlaminck is credited with the statement that he painted with his "heart and loins." Picasso's sexuality and art were often mirror-images of one another. Eric Gill's case seems to veer into pathology, because he collected and copied erotic photographs, studied and drew his own and others' penises, complete with side and front elevations, loved pubic hair and showed it to loving advantage in his drawings, and watched and drew lovers in Hyde Park. He preferred to see art, not as a Freudian sublimation, but as a means for enjoying the "white smoothness of the flesh" between a woman's thighs. Of photographers who come immediately to mind, I can cite Lucien Clergue, who began to take photographs as a pretext to see naked women, and Minor White, who testified, "Photography is the sublimation of my own inability to have the sex I want," though he added that sex was only the foundation upon which the cathedral was built. The whole subject of sex and visual art would be most easily approached by means of a psychologically alert history of the nude in art.

From love to property, warning, and war. Like birdsong and like language itself, human art is associated with ownership and territorial claims. As we need not be reminded, it is used to strengthen the purpose and whip up the emotions of each side in a war. In ancient Greece, poets wrote war songs, Tyrtaeus, for instance, urging the young men to stand firm and spare no thought for fear; in ancient China, poets wrote war songs, for example, Wang Ts'an (A.D. 177–217), whose words, "My body serves the mission of shield and spear," are as Greek as Chinese; and in ancient India, whose epics are filled with extraordinary wars, the Blessed Lord's Song, the *Bhagavadgita,* both preaches the nullity of death and exhorts warriors to fulfill their martial duties. And "primitive" peoples composed martial poetry or music. Native North Americans rallied their warriors with the sound of flutes. I hesitate to go on with examples because there is no clear end to them.

The fourth analogy is that birdsong, like human art, creates a pattern of challenge and response, a sort of competition for the sake of cooperation and cooperation for competition. Like a bird that sings at large to attract a still-unknown listener, an artist tries to attract or otherwise communicate with someone as yet and perhaps forever unknown. When a bird succeeds in arousing another with its song, the result may be a duet or a duel in which the responding bird sings either a countersong (a duet) or a matching (antiphonal) song. In dense tropical vegetation, both male and female are likely to sing in a duet, presumably to keep in contact. When one or more neighbors join in, a trio, a quartet, and even a quintet may be created, the original singers adjusting the pattern and timing to allow others to participate. When one member of a pair is absent, the remaining partner may sing the whole duet pattern, only to yield part of it to the returning mate—the survivor of a pair of captive Australian magpies sang the whole fifteen-note melody, which had always previously been shared. Sometimes there are "bird assemblies" in which each individual sings to the others around him, these neighbors-in-expression eventually acquiring a subdialect of their own.

The most literal human analogy, two or more voices or musical instruments answering one another, seems to exist and to have existed everywhere. African drummers played against one another, creating a statement-and-response pattern embracing musicians, dancers, and listeners. Eskimos sang against one another, and so did Tanzanians. Polynesian poets competed with one another. Sanskrit, Chinese and Japanese poets engaged in improvised verse-capping or verse-completion contests. Japanese winners of poetry contests could become famous and, as a sign of the highest glory, be included in an imperial anthology. Sometimes the Japanese poet, like the bird with an absent partner, took two different poetic roles and competed against himself, the winner to be decided by an outside judge. Influenced by the Chinese, Japanese poets wrote *renga,* poems the last lines of which were shared, three lines being answered by two being answered by three, and so on, for as long as a hundred, a thousand, and ten thousand responses. Cut off from its preceding lines, a link-line set the next poet a puzzle, the solution to which marked the degree of his cleverness and placed him competitively. In imitation of arrow-shooting contests, Japanese poets also competed in the number of *renga* they could write within a set time. Ihara Saikaku

(A.D. 1642–1693) became famous for writing 1,600 in twenty-four hours, which, exceeded by a competitor's 3,000, led to a 4,000-poem record and still greater fame.

To these examples, too, there is no clear end, and it would serve no reasonable purpose to heap them up. I shall content myself by adding a number of examples of competitions and competitiveness in Western music. The duel that every student of music remembers is the one between Mozart and Clementi, organized to amuse the Emperor and prove which of the two was the better sight reader, improviser, and performer of his own compositions. To continue with verbally expressed competitiveness, Berlioz was a mordant critic of other musicians, and Wagner a malicious one. Historians have often recalled that Debussy came to hate the works of Wagner. Hugo Wolf hated those of Brahms and Berlioz. Chopin, too, was repelled by Berlioz's music, though not by his person; and Tchaikowsky thought Brahms unbearably cold and pretentious. In recent times, Schönberg and Stravinsky were at such odds that mutual friends avoided mentioning the name of the one in the presence of the other. Boulez attempted to displace both Schönberg, his teacher, and Stravinsky. The initial friendship of Boulez and Cage turned to envious enmity on the part of both, Cage being criticized by his rival as unintelligent and ignorant, and Boulez by his as too committed to the past and as too much the "animal waiting for the kill." The initial friendship of Boulez and Stockhausen was succeeded, as well, by envious enmity, Stockhausen more or less displacing Boulez as a composer.

Among painters, the most famous Renaissance contest held was between Leonardo and Michelangelo on the theme of the Battle of Anghiari, while the rivalry between Michelangelo and Raphael embittered the former and provoked him into anger and contempt. Should I repeat what El Greco is reported to have said of Michelangelo (he was a good man but did not know how to paint), or what Blake said of Titian, Corregio, Rubens, and Rembrandt (we have to get rid of them), or what Cézanne said of Gauguin, Whistler of Cézanne, or Ruskin of Whistler or, for that matter of Rembrandt (vulgar, dull, impious)? Each such instance of denunciation or incomprehension was also, of course, a declaration of superiority.

The fact is that Western art has long consisted of direct and indirect competitions, and so it for the most part remains, as is keenly felt by every competitor for a musical, literary, or artistic prize and by every

competitor for publication, gallery space, reviewers' praise, or buyers' price. We may sometimes fall into the illusion that we are superior to all this. The illusion brings to mind the discovery by Peter Townshend, lead guitarist and composer of the rock band The Who, that "every artist needs a platform. And that no artist is *given* a platform. He has to *claim* it. He has to *demand* it." Like a bird at a lek. This brings to mind that the American poet Theodore Roethke once pulled a friend aside, the friend tells us, dragged yards of galley proofs out of his pocket, sat the friend down to read them, and said, "I've got a book coming out that is going to drive Wilbur and Lowell *into the shadows."* In spirit, just like a male bird at a lek.

The fifth and last analogy between birdsong and human art is that both help to create the interdependence and emotional closeness of the members of a group. Like artistic dialects among humans, the dialects of birds are transmitted by one generation to the next. Dialects of either sort make those who use them more intimately responsive to one another, make of them, if they are humans, more of a family, clan, tribe, or nation. The dialects also make strangers of those who do not use them. It has been observed that grown male birds adapt more readily to a new dialect than females. Sometimes the foreignness of his dialect appears to make a bird sexually less acceptable, sometimes it appears not to have much influence one way or another, and sometimes it may prove a sexual advantage. Because strangeness is important to all the complexities of human conformity and rebellion, I should not like to confine my notion of human responses to those hypothetically made by birds and imperfectly understood even in relation to them. I shall take up the subject later; but I do suppose that human beings are repelled and attracted by strangeness, for reasons similar to those that attract and repel birds.

As a coda to the discussion of birdsong and human art, it seems only just to mention that the artistic debt has been one-sided. Jackdaws and bowerbirds steal ornaments from humans, some birds imitate the sounds produced by humans or human devices, and canaries are trained to sing in accord with human notions of music; but humans have borrowed far more, artistically, in return. The literature of India is filled with birds' sounds and colors. And birds have inspired many dances. The crane dances of the Australian aborigenes, ancient Greeks, Chinese, and Japanese may be recalled—the borrowing of dances and feathers will be

recalled on a later page—and the many borrowings of music: in the West from the Greek poet Alcman, who knew, he said, the tunes of all the birds, to the medieval, Renaissance, and Baroque composers who imitated birdsongs, to Messiaen, who believes that birds express the transcendent and finds their song to be essential to his own music. To fit the dullness of human perception, his birdsong-imitations are lower than the originals in pitch, slower in speed, and use larger intervals, of a semitone or more. Messiaen says that birdsong can be far more versatile than human beings can imagine.

From birdsong in relation to human art, I go on to the analogies that can be drawn between bird display and human art. The desire to collect suggests itself quickly. The bowerbird displays in order to achieve a brief mutuality, enough to ensure mating, and perhaps, by the content and manner of his display, to ensure a mate as genetically compatible as possible. The glittering objects and bright colors, such as a human being might consider to be emotionally charged, are used in a composition that is adjusted to species and individual. It is possible that the display acquires a value independent for a while of its immediate sexual aim. What the bird does is clearly reminiscent of what the collector does. I do not know how, precisely, to analyze the human impulse to collect and display, but I assume that it has some likeness to that of the bowerbird, as well as of the crow, pack rat, and other animals. Surely, we human beings use collecting and mutual viewing to test and strengthen compatibility. I cannot pursue the analogy further, but I think it is plausible.

Bird display is like human self-decoration and the dancing or ceremonial of which it is so often an integral part. To understand self-decoration, we should remember that our intimacy with our bodies, which we regard as in a sense both identical with and different from ourselves, and our use of our bodies as a medium of intimacy, make us more sensitive to their appearance than to that of anything else. Their appearance tells others how to relate to us, because it marks our age, sex, temperament, perhaps our status, and certainly our uniqueness. Our bodies' ability to attract and repel is of supreme importance to us, as none of us has to be reminded, during the years when we are in the most acute need of love and sex.

The shaping and decoration of the body have often constituted a detailed code of social identification. The Native Americans of the Northwest Coast distinguished the members of one tribe from another by the angle of head-flattening, the flattening having been carried out in everyone's childhood. The Bambara of West Africa, who ascribe their origin to the man-beast Chi Wara, mark their faces with eight small scars to acknowledge their common ancestors and allegiance. African hairstyles and ornamentation may distinguish a little, still unmarriageable girl, a mother, a mother who has lost a child, and a widow. Initiation rites, in which a person undergoes a radical change in station, may require circumcision, the rooting out or filing of teeth, and changes in hair-style or bodily decoration.

Whatever its exact purpose, the decoration of the body stimulates pride and, in those of a fitting age and status, arouses desire. The bodily decoration of the *arioi*, the revered Polynesian entertainers, indicated their high status, their profession, and their sexual bravado, which added to their compelling beauty in the eyes of the Polynesian women. When the scattered tribes of the Bororo Fulbe of the Niger join in their great yearly festival, the climax is the beauty contest in which the young men paint themselves meticulously and ingeniously for the dance in which they compete before the girls. During the competition, the old women mock the men who do not meet their standards of beauty. In Mount Hagen in New Guinea, self-decoration is the great art, and the primary works of art are therefore decorated human beings. The older men, the big-men as they are called, act as critics of the dance, and the younger ones extend the dance's exuberance into nocturnal courting parties. The success of the decorations is judged in part by their conformity to the show of the group in which they appear. The most valued elements of the decorations are the feathers of birds, for birds are symbols of sexual attraction and also of the growth and death of the human generations. An inhabitant of Mount Hagen explained "that when men dance, they imitate the actions of birds of paradise in the forest."

The bodily decorations of the Mount Hageners are unquestionably art, for they intend and criticize them as such; but the social context makes our usual idea of art too narrow to suit them easily. At times, however, bodily decorations may become, in our terms, predominantly esthetic. A convincing example is given by the Southeastern Nuba, who live in three small Sudanese villages. Like the ancient Greeks, the Nuba

are proud of their bodies, the beauty of which their art, pure design or recognizable animal, is meant to enhance. Each form is adjusted to its place on the body—the bulge of a back muscle may become the rump of a giraffe. As a practiced body artist, the Nuba has many terms for the visible muscles and the depressions between them, not to speak of the different human postures, gaits, steps, prances, and skips, all of which he has observed with analytical care. He both gives and accepts criticism. A poor or poorly placed design is likely to elicit disapproving comments, and an older man may even tell the artist to wipe the design off. Although he still acts as a critic, an older man no longer regards his body as attractive and, except for ritual purposes, usually stops decorating it. If he does not, he faces ridicule.

For all the differences between birds and human beings, the displays I have described are notably similar in aim and effect. The Nuba give the example of a narrowing and humanizing of self-decoration, its confinement to what we might call a fine art; but many artists of our own time have become interested in erasing the difference between art and life. To the extent that they succeed, they return to a unity that makes the bird-human comparison the closer.

In shifting our attention from birds to apes, we meet beings whose resemblance to us is enough to interest and amuse both us and them. Although their brains are much smaller than ours, and although an inexperienced observer may easily misread their facial expressions, they sense the world and react to it much as we do. The apes (it is mostly chimpanzees I am thinking of) give facial and bodily expression to sadness, anger, amusement, satisfaction, reassurance, friendship, and love, much as we do, though our faces are, I think, more flexible. An analyst of what he calls chimpanzee politics speaks of chimpanzee social life as "a market in sex, affection, support, intolerance, and hostility," and he says that its basic, though inconsistently observed, rules are "a tooth for a tooth" and "one good turn deserves another." The pigmy chimpanzees, who share food, often walk upright, and often mate face-to-face, and whose fathers as well as mothers bring up the children, make a particularly human impression.

Experiments, which are of course not immune to criticism, have

shown that apes are capable of abstraction. Given a medley of objects, they can sort them by function (distinguishing implements for eating from those for writing), by shape, and by color, and can distinguish, in effect, between *same* and *different, half* and *whole,* and *on top, in the middle,* and *on the bottom.* When tested, they show a grasp of causality in the sense that they put a cut apple (rather than a cut orange or nail-pierced apple) after a whole apple and a knife, and a wet sponge after a dry sponge and a bowl of water.

I do not want to go deeply into the now detailed and sometimes very emotional debate on whether apes have been taught a "true" language, with true syntactic structures, or whether they have merely learned to associate certain word-gestures or plastic symbols with certain objects or actions and have responded to questions by merely imitating their teachers' question-gestures. Also at issue is their reported ability, denied by critics, to make spontaneous combinations of words, such as "drink fruit" for watermelon or "cry fruit" for radish. The difficulty in setting up fully convincing experiments resembles that in experiments with chidren too young to speak clearly. The use by most of the apes of Ameslan, the American Sign Language for the Deaf, has made interpretation difficult, for the undoubted subtleties of this cryptic, telegraphic language depend on context and on the body's ability to complement the disciplined dance of the speaking hands. Interestingly, the taught animals can transmit what they have learned—Washoe, the chimpanzee pioneer in Ameslan, now talks or "talks" freely in it with her adopted son Loulis.

Whether or not apes can learn syntactic structure, they have shown abilities we might suppose confined to human beings. They have imagination enough to deceive on purpose, for example, by pointing in the wrong direction to mislead a human searching for food they want to keep for themselves. In another striking instance of imagination, a young chimpanzee, which had progressed from pulling real toys on a string to pulling imaginary ones on an imaginary string, sat with her pulling hands extended helplessly until her human foster mother freed the imaginary string from the object in which imagination had entangled it.

Imagination is also implicit in the ability of apes—inferior to that of humans—to recognize pictures for what they are. An ape experienced with pictures can ask for something by pointing to its picture. Pictorial preferences come to light. In a monkey experiment, the monkey, which

preferred a Mondrian to a landscape and unfamiliar animals to bananas, preferred above all a Mickey Mouse film. Apes can also recognize photographs of themselves and, as experiment with chimpanzees and orangutans (but not gorillas) has verified, can recognize their own mirror-images. This ability of practiced apes, which is denied to monkeys, may possibly justify the conclusion that "apes and men have entered a cognitive domain that sets them apart from all other primates." Their consciousness and self-consciousness must play a role in establishing the kind of emotional ties that sometimes unite apes and humans. Imagine the photographer working in a tropical forest when a young orangutan put its warm hand in his and walked with him along the forest path!

What of the artlike abilities of apes? The call of the gibbon, small piping sounds that rise to a crescendo and drop to small wails, has a structure and rhythm that make it comparable to the song of birds. Chimpanzees may drum on themselves or on resonant trees, or may participate in a "rain dance" composed of charging and rhythmic swaying of tree branches. Captive chimpanzees have been known to trot rhythmically around a post, sometimes after decorating themselves with strings, vines, or rags; and a young pet gorilla has been described as stamping and pirouetting in time to music.

That brings me to drawing and painting. A researcher, who had named the chimpanzees he was observing in the wild, says:

> I remember watching Fifi toss clouds of dust into the wind and watch it drift away. Goblin came towards her and tried to copy her; he could not do it well but succeeded in tracing patterns in the dust with his fingers. On another occasion Goblin made scratch marks in the mud and even traced the edge of a leaf's shadow with his finger.

The evidence from the wild is meager. There is much more from the observation of captive apes. It is worth recalling that a young chimpanzee brought up with a child scribbled pencil marks on paper, just as the child did, and traced marks on a window pane in the mist deposited by her breath. There are two startling reports of apes that make them seem to have been trying to draw particular objects. A three-year-old "speaking" chimpanzee named Moja called the unusual marks she had drawn "bird," and when asked to draw a berry made some parabolic marks that she later identified as "berry"; and she remained consistent in such

identifications. The second report concerns the gorilla Koko, who is credited with linguistic abilities far beyond those I have reported. Koko is said to draw from a picture or model and reach vague resemblances. When she draws "from imagination," her favorite subjects are birds and alligators, which she identifies clearly.

It is hard to evaluate these reports; but we are told, and need not doubt, that the chimpanzee named Nim, brought up by human beings in order to test his ability to learn and speak, developed a strong interest in drawing with colored crayons and paints, and learned to make the signs for *paper, red, black, blue,* and other colors. When two years old, Nim learned to make three-dimensional constructions with aluminum foil, on which he put colored shaving cream. Nim would persist in this activity for all of forty minutes.

I recall these last observations as a preface to the more systematic and extensive ones made by Desmond Morris in experiments in which captive apes engaged in scribbling or painting. Some apes, he recalls, showed no interest; but some achieved, for apes, prodigies of concentration. They were not interested in the finished product and had no reward but the pleasure of the act. If anyone tried either to interrupt them while they were still in the process of drawing or to persuade them to go on when they had lost interest, the result might be a screaming tantrum.

Morris concentrates on a two-year experiment with Congo, a small, exceptionally bright chimpanzee, to whom he was a kind of substitute mother. When Morris switched from pencils to colored paints, Congo was delighted; his concentration, strengthened by the appeal of the bright colors, was intensified; and, as the weeks passed, his confidence grew and he painted with a minimum of hesitation. The balance of his pictures was important to him. Morris once snatched away a half-completed picture. After protesting, Congo turned his attention to a new one. "Next day," says Morris, "I offered him his half-completed picture, in which he had begun a fan picture on one side of the paper, but had only managed to take it halfway across the page. He promptly went on to complete it. There was no doubt about it, he knew what he liked."

Over the two years during which he was observed, Congo underwent a distinct stylistic evolution. It was characteristic of him to paint a radiating fan pattern, to which he would sometimes add a subsidiary fan. Later, he tried distortions or extensions: he boldly spotted the fan's base; split the fan with a blob; he shortened the fan's center lines and

curved its base; he added horizontals; and he went on into loops and spirals. Zigzag or wavy lines were rare, as were the spirals, the appearance of which was apparently a sign of the intensity with which he had been painting. Multiple loops occurred only toward the end of the prolonged experiment.

Although I have described Congo's stylistic development very briefly, I hope something of its dramatic quality has come out. Closely examined, it is dramatic because the observer shares the experience of what is, in human terms, esthetic maturation traced out by the muscular tensions of a chimpanzee's arm and whatever corresponds to this in its mind. How would it be if Congo were declared, for the purposes of art, an honorary member of the human species? Granted that all his paintings are of the sort we call "abstract," there is nothing at all to distinguish them from many examples of human art in an analogous style, that of "Lyrical Abstraction," "Tachisme," or "Abstract Expressionism." To describe his art as if it were human would require us to set it in some context, such as that of the "Lyrical Abstractionists" of his time. On the evidence of the paintings alone, we might say that the painter was self-assured, which is to say, spontaneous, and that he created orderly but not mechanical compositions marked by their convergence toward a common center, the converging lines being interrupted, varied, and extended in various ways.

Years ago, when the styles I have named were in fashion, I showed reproductions of Congo's paintings to a number of artists, all of whom, as it happened, liked them. When it sank in that the paintings were the work of a chimpanzee, one or two of the artists looked shamefaced, I thought; but there was a painter who said with enthusiasm, "I never knew that an ape could paint so well." When the paintings of Congo and Betsy, another painting ape, were exhibited in London in 1957, the president of the Royal Academy launched an attack on the presumption of those who had organized the exhibition. Someone naturally interpreted the exhibition as an attack on modern art, meant to demonstrate that it was less than human. A painting by Congo gave Dali the chance to jibe at a human upstart. He said, "The hand of the chimpanzee is quasi-human; the hand of Jackson Pollock is totally animal!" Two great artists felt no disdain. Picasso expressed delight at the gift of one of Congo's paintings, and Miró, who went through them carefully before

choosing a pair, insisted on giving a pair of his own sketches in return. A psychologist undertook an intriguing experiment. He showed a painting by Congo, by a child, and by two professional artists, one with an outstanding reputation, to groups of adults, one English, one French, and one Indian. In each case, Congo was preferred to at least two of the professionals, and one group preferred him to all the human beings.

These responses can be taken humorously and might serve an attack on contemporary art, but they can be taken, as I should like to take them, as evidence that human art has prehuman origins. Here, human and prehuman were interestingly near. Morris noticed that Congo resembled a human being in controlling the placement of his pictures, in painting with balance and rhythmic repetition, and in arriving at thematic patterns that he repeated, varied, combined, abandoned, and sometimes returned to with a difference. Morris concluded that there were six universal principles of picture making, five of which applied as much to the art of chimpanzees as of humans. Without any further explanations, the five principles are: self-rewarding activation, compositional control, calligraphic differentiation, thematic variation, and optimal heterogeneity.

Morris's sixth principle, the only one to which, he found, apes were not equal, was that of universal imagery, by which he meant that young children everywhere draw a human figure, house, and the like, in the same basic way. Congo came to draw excellent circles, in one of which he carefully placed several small marks; but he never drew a face. Yet although incapable of becoming a child, he was able to achieve what might be taken for art in a recognizably human sense.

I cannot restrain myself from telling of the experiment's tragic end. Congo grew too big to be treated as a pet and was therefore transferred to a zoo; but he had been so strongly humanized that he refused to have anything to do with female chimpanzees, which he pursued, when they became importunate, with lighted cigarettes begged from visitors. Before long, he grew somber and introverted, and then he died. Morris, who felt a powerful sense of bereavement, ascribed the death to depression. "Congo and I," he wrote, "had shared moments of discovery that had almost bridged the gap between our two species." Although Morris had planned to continue experiments in picture making with other young apes, Congo's fate made it emotionally impossible to go on.

Let me now sum up the relation between ape and human painting in three points:

1. Even though painting by an ape reveals its potentialities and is possible only because of the ape's own interest, the activity could not be carried out without human materials and perhaps human example. The activity is therefore the result of a simian response to human curiosity and the attempt to see how an ape might fit into a human tradition. However, the ape showed its near-humanity by painting without any external reward; or perhaps its corresponding *in*ability to paint in return for an external reward was a sign that the ape was up to human ideals but not, in this instance, to human reality. Apparently, the ape that wants to paint is motivated by the desire to see and cause perceptual changes. I assume that this desire is related to the need, shared by the human artist, to keep the senses and mind interested and alive.

2. Each ape has its own expressive style and would, I assume, have its own stylistic development. Like the song of birds and art of humans, the ape's art shows balance, rhythm, and thematic patterns, all together constituting an expressive vocabulary. As these develop in the course of time, one sees the trend, present in human art, toward an optimal heterogeneity.

3. If we do not consider realistic or regularly structured art, as long, that is, as we consider only informal abstraction, the painting of an ape cannot be distinguished from that of a human being. This may be evidence of the basic primitivity of such art; but it surely is evidence that it is impossible or at least inadvisable to try to divorce art from its human context for long. The fact that Congo and other captive apes were not interested in anything but the activity itself of painting made them similar to some bygone Chinese and some contemporary Western artists; but the interest of the apes was more radically confined to the activity than is possible to human beings, because their need to contemplate, compare, and judge was absent or extremely undeveloped. I do not know what close observa-

tion in the wild might show about the esthetic dimension of an ape's life, but an ape's relation to the paintings it makes is too simply immediate, too confined to the moment of execution, too divorced from the need for communication with others, to be thought artistic. Art in the full human sense requires its full cultural context, its webs of associations, words, and memories, which give art its human resonance. What looks exactly like art may be something rather different.

I come to the art of children and its likeness to fully human art. I begin with the child before it becomes one, when it is still a fetus immersed in the amniotic fluid and surrounded by the womb. Life there in the womb is not merely dark and calm, a slumbering in preparation for the troubled wakefulness of life outside. If we are to trust the evidence of its beating heart, its turning eyes (as imaged by ultrasound), its movements, and its excretions, the fetus undergoes emotions or precursor-states of emotion such as fear, pain, excitement, and satisfaction or calm (when it "sleeps" and "sucks its thumb"). The fetus may even be supposed to engage in proto-dreaming, the evidence being the same rapid eye-movements that go with active dreaming in children and adults. And the world penetrates into the womb as light and sound. A hydrophone inserted into the uterus of a woman about to give birth picked up the sound of her loudly beating heart, her doctor's and her own voices, and Beethoven's Fifth Symphony. The sound of a waltz, claims an English psychologist, made a fetus move as if it wanted to get up and dance. For all we know, some preferences may begin there in the womb, maybe for rhythms like those of the mother's heart or breathing. Some preferences show up soon after birth. A child only twelve hours old already shows the preference for sweet over sour tastes, and, at the age of eight weeks, the preferences for red or blue. There are signs as well of an early preference for music over noise, vocal over instrumental music, and the mother's voice over that of another woman.

The even or uneven flow of our earliest existence is interrupted by the most dramatic event, apart from dying, that we undergo in life, the emergence from our mother's body. Yet this emergence and separation, the greatness of which is only emphasized by our at least conscious forgetting of it, gives the child little independence at first. What can the

newborn child do at first but appeal by its very presence to be cared for? Luckily for everyone involved, the child usually awakens the devotion of its parents, both by the immediate pleasure it gives them and by the prospect that it will bear their likeness; for we are, by our nature as never-quite-expected variations on our parents, the most deeply rewarding and subtly surprising of all human creations. We are psychologically, for that reason, the prototypes of every other deeply felt human creation. That we are experienced by our parents as their creation means that creation can be experienced as a largely involuntary process. No technical separation between such biopsychological creativity and the intentional creativity of art can weaken their experienced closeness.

For a long time, in a sense forever, the child remains incompletely separated from its mother. As a rule, the needs and pleasures of the two are complementary. The child, appealingly weak, clings to its appealingly strong mother. The bond between them, which implies a constantly reawakened sensuality, a less- but more-than-verbal understanding, and a growing mutual incorporation, has no adequate name. For a child, the closeness of the amniotic fluid is replaced by that of its mother's arms; the security of her heartbeat and breathing is available when needed; and her petting exhilarates and invites affection. This mutuality of mother and child is essential to the being of art, because it initiates the mirrorlike process by which one perceives oneself in the responses of others. If I am right, it is for the sake of these self-enhancing responses that art largely exists.

At first, child's play is mostly a prosaic imitation of adults' everyday activities, but in time the child escapes from literality and engages in play that is imaginative. Although child's play mimics the life of adults, it must also controvert it, because it is, as it must be, a conspiracy against the difficulties imposed by the world and the domineering giants who rule it; and so children arm themselves with imagination, stretch the actual into impossible shapes, and invent the world more malleable and dreamy.

After these general words on children's art, I should like to dwell on their drawing and painting. My use of "the child" and "children," which will continue, leads me to begin by asking to what extent the art of young children is the same everywhere. The studies I have read do not allow a confident answer. One of them, which argues for similarity, is

based on the pictures chosen for an international exhibition; but their choice appears to have been only laxly controlled. Another, better-controlled study, of children from a Hopi village and an American city, shows the same beginning stages; but the study is too narrow for general conclusions. A third study finds evidence that all children use the same basic plastic language, and a fourth, very careful one, which compares drawings from Bali, Ponape (a small Micronesian island), Taiwan, Japan, the United States, and France, finds notable differences, but favors the view that there are innate likenesses.

What little I know about drawing in particular "primitive" tribes allows no decision one way or the other. Central Australian children, who draw in the sand to accompany the stories they tell, use the same graphic symbols as their parents; and Eskimo girls, who imitate their mothers and cut story-illustrations into the snow or mud, use a style (as best I can judge from a few illustrations) only remotely like that of our children. I have read, without corroborating detail, that in a certain primitive culture, children do not draw at all, and that such nondrawing children may pass through stages that take our children years in half an hour, a rapidity that suggests that the stages by which drawing develops are universal stages of maturation.

Since the evidence is inconclusive, it remains possible to believe, as I prefer, that the early development of children's drawing is more or less the same everywhere. The early development of music and language out of a free babbling may also be universal. Yet "the child" involved is mostly the one investigated in Western culture, and I feel uncomfortable at this limitation.

I return to my indeterminate, perhaps only Western child (switching the while from the too-impersonal "it" to "he," which must do duty for both sexes). The child begins to scribble, uncertainly at first, at about the age of two. He does no more than swing his arm so as to leave a streak; but this imprint of his motion is important to him because the imprinted surface exhibits his action and represents and joins him. Like the chimpanzee Congo, the child usually fits his scribble to the paper on which he makes it, and, as with Congo, the scribbling itself becomes a stimulus, to be added to and varied. When the child's motions become broad and assured, the scribbles tend to assume regular shapes, the kind that perception favors and that memory retains most easily. It is there-

fore not surprising that scribbles, while often irregular and nameless shapes, are also often approximate circles, ovals, arches, rectangles, squares, triangles, and crosses.

When the child is about three years old, his multiple-line scribbles become single-line, diagramlike ones having much the same configurations. Before long the child acquires a whole graphic vocabulary: approximately geometrical shapes; unclassifiably ragged or ameboid shapes; regular lines, which may be solitary or joined by parallels, and which, solitary or not, may be intersected at various angles; and lines that for lack of a better word I shall call "wandering," for their movement is capricious, their aim the pure pleasure of moving now this way now that, as the crayon, the hand, and the child all will together. At this stage the child's art is arguably abstract. I do not mean that the child makes abstractions in conscious contrast to representational drawings, but that the child reflects the look and feel of things in general rather than in particular. The shapes, lines, colors, and relationships he draws at this stage therefore suggest many things but represent nothing.

Now, moving within the confines of a sheet of paper, the child wins a great deal of freedom. The indetermination of his shapes and lines allows them to be anything, and so, by a process too intimate for us to follow, the child comes to infuse his drawing with the sense of whatever dominates his imagination at the moment. His still unreadable composition stimulates him to explain, and his explanation takes on a life of its own; or someone else asks him to explain and he makes up a tale he has perhaps not intended at all. Sometimes he stares at his drawing to find a hint of what it may represent, as puzzled for the moment as any grownup looking at it—the incomprehensibility of art is not a purely adult invention, nor is the subsequent discovery of meanings. (I should like to interpolate that among the Sepik of New Guinea, artists often refuse to identify what they are painting until they are finished; they may change their minds when they are halfway through; and collaborators in a joint painting may argue about its meaning. To the Sepik, as to the child at a certain stage, there is no precise translation into concepts of what he draws.)

At about the age of four, the child progresses to the drawing of clearly recognizable objects. The word "progresses," which has come easily to my mind, requires a brief comment. For reasons already made clear, the idea of progress in art has become difficult to defend. I have made use of

it here, however, without compunction, because I think that art is not always and in every respect exempt from relation to a distant and even transpersonal goal. However, the senses in which progress is made should be distinguished from one another; and it should be remembered that progress is likely to entail the loss of some quality the absence of which reveals its attractiveness. The child, I am sure, pays for his progress, though he pays more if he fails to make it. Sometimes, representation and a paraphrasable meaning become a burden. Even long before adolescence, he may complain that his painting is inadequate to his intentions, and then he may become the momentary predecessor of the artist nagged by artistic ambitions too difficult to fulfill.

The objects the child comes to draw are structural equivalents of the big, three-dimensional ones that surround him. I do not know if his new-found ability strikes him, as it strikes me now, with wonder; but it must give him great satisfaction and often, when he feels that he is progressing, a renewed sense of mastery. Of all his new creations, the most notable is, without doubt, man himself, the at-first sexless, unarticulated human being, whose generality fits him for every human purpose. This human being is created by a process too unliteral to be considered representation, but with overtones too sensuous to be considered merely symbolic.

It appears that the shape most easily available for man's creation is the circle or oval. This shape can be made by an easy sweep of the arm; its roundedness suggests the rounded, organic nature of the body and its parts; and its isolation of the internal from the external endows the internal with a self-containment easy to sense as "thinghood" or substantiality. To become more human, the circle must be given eyes and other facial features. To extend the body's contour or suggest feet, the child may add a line on each side of the human circle. Linear models of man are also possible; but the child-made man, whatever the basic model, eventually gains a separate torso, two arms, two legs, and, later, the fingers, buttons, feet, and other appurtenances the child feels to be necessary.

Careful attention to the child's drawing shows the graphic means he is stimulated to invent. I say "stimulated" because his main problem must be the poverty of his means as compared with the richness of his imagination. Certainly he is parsimonious and uses the same basic shapes for as many purposes as possible. The circle with which he constructs a

whole human being or, more modestly, a face, serves for suns, buttons, flowers, wheels, treetops, and fruit; and with added, projecting lines, the circle serves for flowers, for suns with rays, and for heads with hair; and, stretched into an ellipse, it serves for bodies of both men and animals, and for fingers, petals, even houses. Squares and rectangles are put to their obvious uses as houses, windows, doors, and so on; and triangles make roofs, dresses, triangular bodies, pine trees, and so on. Little if anything of the child's abstract past is lost—the old scribbles, for example, are especially useful for hair.

A child has his own graphic devices. A person who looms large in his consciousness is drawn large. The ground is below the child, on the bottom, and so he draws it as a line along the bottom of the paper, while he draws the sky, which is above him, as a line along the top of the paper. More distant things usually look higher to him, either because of the effects of perspective or because distant low objects are hidden from view, and so he simulates distance, or rather intends it, by drawing distant things along secondary ground-lines high up on the paper. To a creature as used as he is to stumbling, perpendicularity cannot be ignored, but perpendicularity creates a graphic problem when it has to be reconciled with, for instance, the roundness of a lake or the crookedness of a road, which must be drawn as round or as crooked as he knows them to be. His solution is to disregard perpendicularity in relation to the bottom of the paper and to draw each house, tree, or other object, perpendicular to the section of the lake-front or road-margin on which it stands.

The kind of line a child makes and the color he prefers give some evidence of his state and nature. To read the evidence is not always simple. Let me report the conclusions of one study with respect to lines. According to the study, a child who draws with particularly many circles is likely to be more than usually submissive in public but more than usually resistant internally. The circle fits such a state or nature because it gives way everywhere along its circumference but closes in on itself. Likewise, a straight-drawing child shows confidence as compared with a zigzag-drawing one. Also, a vertical-drawing child is assertive and outgoing as compared with one who uses horizontal lines more.

I have omitted the study's reservations and complexities. I have not spoken of its procedures, which are careful, or its assumptions, though both procedures and assumptions are, as usual, open to question. Every-

thing taken into consideration, however, the study supports the commonplace conclusion, which seems intuitively acceptable: a child's art expresses his observation of the world and his pleasure in recording and imagining it after his own fashion; but it also expresses his emotions, which change, and his nature, which, though it changes, is likely to change slowly and in some ways hardly at all. It stands to reason that the art of a child, like that of an adult, is more than its subject-matter or story, for its expressiveness is embodied in the nature of its lines, colors, and composition. For all its surface crudeness, the art of a child is apt to coincide with its state of being, for the child, like the singing bird, is proclaiming his very own existence.

I have now characterized children's art in as much detail as I can afford, and I go on to some controversial remarks on the relationship between their art and the art of adults. Before I make these remarks, I want to mention two disconcerting experiments or sets of observations. The first is the subject of a book, *The Innocent Artists,* published in 1980. It is the account of a teacher's experience in the newly independent country of Papua New Guinea. The subjects of the experiment were twelve- to sixteen-year-old high school students, already somewhat Westernized, but barely a generation removed, the teacher says, from the Stone Age. Their own artistic tradition was strong in body decoration, but not in any other kind of art.

For the experiment, the teacher told the students about her pleasure in art and her feeling that art springs from visionary insight, and she showed them drawings made in other, similar schools. To her amazement, the students did not hesitate, but drew images more fantastic and detailed than those she had showed them, for instance, a great hooknosed head embellished with birds, fish, shells, snakes, pigs, axes. Natural forms, whether cows, pigs, dogs, men, or plants, were made with great ease. Nothing was copied from a book or another student. The artists proferred no explanation except for such laconic remarks as "It's from my imagination." Although the process of drawing was carried on intently, no student ever held up his finished work to look at. Once finished, a drawing was forgotten; only the activity mattered.

What is striking and disconcerting in this account is not only the

interest of the drawings themselves, but the spontaneous ease with which the youngsters were able to draw what they wanted, even though they had little or no experience in drawing. These Papuan adolescents had retained the untrammeled imagination and spontaneous ease that we often assume must vanish with childhood.

The second experiment or set of observations pertains to Nadia, the autistic girl whose remarkable ability to draw was revealed in a monograph published in 1977. It is known that autistic children may have high I.Q.'s or, like Nadia, low ones. Like mentally retarded children, from whom they are in principle distinguishable, they may have a great if circumscribed talent, such as to construct mechanical devices or to play, sing, or even compose music. Nadia herself cannot be fitted into any of the schemes of childhood development. No one understands how, at the age of six-and-a-half, when she could say no more than ten separate words, she could unhesitatingly draw realistic three-dimensional animals, especially horses, in motion. The drawings look as if they were made by a spontaneous, rather disturbed adult, one whose style I should feel tempted to classify as semi-Surrealistic. They were usually inspired by children's picture books, but, except for the rare occasions when she drew from life, were all from memory. By the age of fourteen, Nadia, still clumsy, slow-moving, and unable to hold a normal, even childish conversation, still drew with a skill in astonishing contrast with her other abilities. It has been speculated that the realism of her drawings came easily to her because she was unable to conceptualize her subjects and make the normal child's symbolic substitutions. This guess does nothing to make her drawing less astonishing.

Poor gifted child! Her case is a warning against the overfacile identification of art with abstract intelligence or a highly developed self-consciousness. The greatest art may have rich intellectual content, but intellectuality as such is not strongly involved in a spontaneous sketch, an attractive melody, or an eloquent sequence of movements. This partial dissociation has become the more evident in the past few generations. While we wonder at Nadia because of her premature adulthood in art, we no longer want children to become adult as quickly as possible. When we come on such a wonder as the Chinese girl Wang Yani, who between the ages of three and six made paintings, mostly of monkeys, assured, filled with life and movement, and beautifully, often complexly

composed, distinguishable in nothing or almost nothing from the work of an observant, humorous adult artist, we feel astonished, but also sorry, as if Yani had been robbed of some precious primal clumsiness. Reversing an old preference, artists now want to remain childlike in their directness and sincerity (a desire taken up in the following chapter). The desire transforms childhood from a stage of life to be outgrown as quickly as possible into a conscious source of inspiration. Now an artist often tries to return to something like his child-self, in the hope that it is latent and can still be drawn upon. A little of the child *must* persist, not only in imagination, or in color preferences, but in the basic geometry of paintings.

It is by the persistence of child-geometry that I explain what I see when I leaf through the pictures made by a child (my daughter) between the ages of about three-and-a-half and four, when she was just on the verge of figurative drawing. On one page and then another I see a freely wandering, that is, Klee-like line. On still another page, I see roughly parallel lines crossing one another and creating a Mondrian simulacrum, the lines less careful than his, but the intervals appearing as subtly establishing. On still another page I see a chaste single line cutting the page into near-halves. Could the line, the spots, or the page with a single large round spot, be a kind of Miro? I see wide bright stripes of different colors covering a whole surface, not unlike those painted by Morris Louis or Kenneth Noland, and I see a page of undefined but organic-looking shapes that remind me of Miro or a sort of Kandinsky; and I see a Kandinskian scattering of colored shapes; and a Tachiste-like page with bright, clear blocks of colors; and a cluster of slightly curved, slightly converging strokes, almost like a Hartung; and a page covered with large swirling scribbles in different colors that is like enough to be a Pollock.

I have not made these comparisons to belittle the artists I have named —the differences between them and the child remain clear—but the likeness is provocative. One reasonable moral is the one drawn from the comparison of chimpanzee and human painting: the sheer appearance or structure of paintings is not enough to explain their human, which is their contextual, significance. Yet I believe that the child is not alone the father to the grown artist but to the culture. I mean that if we turn to the cultures that were not bound by Greco-Roman and Renaissance

conventions, we find that their alternative conventions resemble those of children's art. I cannot go far into these resemblances here, but I should like to choose one culture, the Egyptian, as a particularly open example.

Unlike European art, which subordinates the appearance of each thing to the position from which it is viewed, Egyptian art is "aspective," by which is meant that everything has a two-dimensional, diagrammatic form that represents the view or aspect by which it is most easily identified, its visual essence, so to speak. As in children's art, therefore, round things such as ponds, lakes, and tabletops, which are most naturally identified by their top views, are shown round, as if viewed from directly above. The verticality of objects is shown by drawing them at right angles to the immediate edge of whatever they are standing on; and the distance of an object is indicated by its distance from the basic ground-line. In contrast to the Europeans from the Renaissance on, who are bound by perspective to a particular time and point of observation, the Egyptians, like children, represent the passage of time by showing the same characters at different stages of their activity. In their more static way, they express what the Chinese and Japanese express with their picture scrolls and we with our motion pictures.

We have reached the question of the kind previously asked about birds and apes, but this time more intimate and, in the climate of modern art, more difficult. The question is, "Everything considered, is it reasonable to think of children as artists?"

I have asked the question naively, as if it were self-evident what an artist must be, but we use the word *artist* in many ways: for anyone who does anything with grace or skill; for anyone who exercises a profession that is considered a "fine art"; for anyone who shows that he or she is a remarkably original or inspired practitioner of such an art, a "true" artist; or for anyone designated an "artist" in the simultaneously liberal and stringent sense of contemporaries now speaking of contemporaries.

Each of the meanings of *artist* leads to a different comparison. The comparison of children with ordinary craftsmen can show only the deficiency of the children in skill and their superiority in childish freshness, making the conclusion foregone and uninteresting. Likewise, the comparison of children with artists in the traditional sense of those who

combine great technical skill with a high degree of imagination or "inspiration" can lead only to a foregone conclusion. The chief interest of the comparison, that is, of the question I have asked, is in the relation of the child to the contemporary artist, whose freshness or boldness is often valued irrespective of technical competence—competence in the traditional sense, not in the circular sense of "fitted to his aims." The comparison becomes most interesting when we compare the child with the artist, the Klee or Dubuffet, who has been consciously influenced by the child's art.

My own attitude toward the comparison cannot be fully expressed at the moment because it depends on evidence and problems still to be discussed. My final attitude will be implicit in my later conclusions. All the same, I want to give an answer now, an answer that remains aware of the possible variations of the question.

First, then, let me try out the affirmative answer, "Yes, it is reasonable to think of children as artists." The answer is yes because art in the sense I have chosen is distinguished as such by a ruling vision that expresses and defines the nature of its creators. We find this vision in the art of children, which is as expressive of them as Egyptian art is of the Egyptians, Chinese art of the Chinese, and our own, adult art of ourselves. A child has little culture, but he is in a child's state of being, which he can bring to expressive light in what, to be consistent, we should call "art."

The affirmative argument goes on. The "yes" is encouraged by the stress we now lay on sincerity and spontaneity, by the now usual conception of art as self-discovery, and by the esthetic qualities of children's art, among which are clarity, rhythm, and emotion. When I speak of these esthetic qualities, I mean to say that children organize their pictures with an unmechanical symmetry or balance, which, though unconscious, can be subtle; and that their use of relatively fixed geometrical forms and their combination of them into diagramlike persons and objects make their art clear, which is to say, easy to grasp, and rhythmic by the rhythm that varies the analogous forms and disposes them over the surface. Emotion, which children are unable to express by the alteration of facial features or the display of muscular strain, is expressed by color, relative size, and grouping, as well as by the changing direction and intensity of the lines they make.

Surely, children can show a very attractive combination of conventionality, inventiveness, esthetic control, and interest in life. Especially in

their prefigurative art, they draw a good deal that can stimulate us, as we are stimulated by music and abstract art, by its combination of determinateness and indeterminateness. Surely, to anyone open to the imagination of children their art is fresh and evocative, and, surely, their art deals with essential human concerns. If all this is true, why should the art of children, especially of the more imaginative among them, be denied the status of true art?

So much for one side of the argument. Now let me try out the negative. In its support, André Malraux once said, "Artists do not stem from their childhood, but from their conflict with the achievements of their predecessors; not from their own formless world, but from their struggles with the forms which others have imposed upon life." Although, as I think, artists do stem in part from their childhood, and although children's art is anything but formless, Malraux is right in distinguishing between art and impulse and in insisting that artists become what they are by using and reacting to their predecessors. It takes time for an artist to discover his aims, refine his skills in keeping with these aims, and arrive, step by difficult step, at his own distinctive mastery. This progress no longer demands mastery in the traditional sense; but even though an artist need no longer master the old Renaissance skills, he must deploy skills of some sort. Children, says a contemporary esthetician, have no sense of outward intention, no striving. "A child paints simply in order to grow up; and his pictures are therefore almost natural objects. . . . The adult artist paints in order to create something outside of himself, in order to add to . . . life." Still unformed, the child can express himself only in an unformed, artless way. Art in the true, that is, most useful, sense of the word cannot be created by children.

The positive and negative answers to the question are both defensible. Nothing, however, compels us to cling exclusively to either. As so often, the reality we are dealing with is too complex to be put into an unqualified answer. Answers given by some modern artists will be reported in the discussion of spontaneity. For myself, I can begin by saying that although it is reasonable to deny that the child can be an artist, it is undeniable that it is the child who comes on the means that make art possible. True, his coming on these means is part of his normal development and is similar in most children; but he does not develop his ability to draw in the same unconscious way as he grows taller. On the con-

trary, his conscious interest is engaged, and often so deeply that it seems fair to say that, as an individual, he discovers or even invents these means. In this restricted but fair sense, he invents the means for expressing his impulses imaginatively, for he very much wants to imagine as he pleases, and so he invents the devices that help him to imagine; but for his pleasure, he also repeats himself, to reexperience what he wants; and he therefore may be said to have discovered the artistic effectiveness of both innovation and repetition.

There is no doubt that the child's style is severely limited and not clearly distinguishable at first from his mere impulse. Yet the artist, whose style is a more conscious accomplishment, and whose expression, far more than the child's, is meant to be shared (and bought) by others, can go on creating only as long as he retains the expressive urge of the child he once was. Like that child, his most serious business, if he is free, is to play and, in playing, to make imaginative revisions of everything that pertains to human life. Like the child, his self must be committed to his imagination. This, I take it, is the meaning of Valéry's maxim, "It is necessary to grow up. In that case, however, it is necessary to remain a child all one's life." Growing up is also a process of creation. To grow up, a child has to make constant discoveries, sensory, factual, and emotional; he must discover himself and his relationships with others, must preserve his curiosity, and must experiment with logic and with illogic. All this, which can give rise to a passionate, obsessional intensity, makes the child, if not the artist, the artist's precursor and indweller.

After birds, apes, and children, I go on to the subject of play, the self-rewarding activity in which birds probably and apes and children certainly engage. The relationship between art and play was once widely and, to my mind, rightly considered a key to the understanding of art, and it deserves to be explored again as such.

Like art, play is hard to define usefully. It is too fluid and multiform, and the line between playfulness and curiosity is too elusive. Yet the main biological purpose of play is evident: to give practice, rewarded by pleasure, in everything a mature animal or person needs to have mastered. Not all animals whose behavior is complex engage in play, and even some primates may engage rather little in social play. One observer

has said that gorillas are not playful, on the whole, and the same has been said for howler monkeys and Borneo orangutans (in Sumatra and in zoos they play more). It is also useful not to play, for play makes lavish use of energy and causes social friction by upsetting elderly animals and humans. It is an extraordinarily versatile teacher, however. It exercises the young in the use of their senses, limbs, and minds; it mimics and prepares adult cooperation, friendship, and love, just as it does disharmony, enmity, hatred, and attack; and it teaches many particular modes of coordination or skill. When intense, it may court a loss of balance that swamps the individual in its dizzying, gratifying sameness. In an apparently less emotional but often compulsive mood, it turns everything into a puzzle to be investigated; and investigation by play leads to the testing, the repeated sensing, and the rhythmical use of the object, motion, or emotion that is being investigated.

The deepest, most general subject of investigation by play is behavior itself, which is repeatedly analyzed and synthesized in different ways. The animal at play does not forage for food, build a nest, or do anything that a human being classifies as work, but changes at random, it seems, from one sequence of acts to another. Judged by simply useful activities, the playing animal jumbles the sequence of its movements, exaggerating, diminishing, repeating, breaking off, just as it pleases.

Open only to its own impulses, play generates and regenerates its own forms. By teaching how behavior is built up in increasingly long sequences, which are then varied, broken up, rebuilt in variations and variations of variations, and in the end more or less abandoned, play becomes the medium of invention, or becomes, perhaps, invention itself. To put it somewhat differently, play is an exercise in the creation, disruption, and recreation of order, or in the generation of one form of order out of the destruction of a preceding one. Even the repetitions in this process are pregnant with the likelihood of change, its small differences suddenly enlarging into great ones, which may subside again into small ones; and so on and on.

Even though it is hard to give play a useful definition, its main characteristics are easy to summarize: play is an activity that serves no clearly pressing vital need; play constructs innumerable sequences of life, as if giving the experience of innumerable lives in one; play at its height is totally absorbing; and play is satisfying in itself, so much so that endless time, energy, and emotion are expended on it.

Let me concentrate on this last quality, which has made play the model of the self-justifying activity, that which is in itself a perfection or consummation. Although this quality has been used to define both play and art, it is present everywhere in life in varying degrees, as the most homely examples show. Think of the infant or of the puppy sucking milk. The sucking is undoubtedly for the sake of nourishment; yet if nourishment is given in a form that does not allow sucking, the infant or puppy, though no longer hungry, goes on sucking. The pleasure of sucking, which is the satisfaction of a semi-independent need, lends the act a consummatory quality. Monkeys and apes love to groom one another, mainly because the grooming is pleasant to them. It of course brings them close to one another both physically and emotionally, and the need for closeness may account for their love of grooming; but closeness too is consummatory if it is the closeness itself that attracts. Fully adult chimpanzees play together only rarely, and grooming occupies them as play once did. A bird that continues to sing and even to elaborate mating songs after the mating season is expressing the need to sing in and for itself.

Although the idea of consummatory experience is essential to the understanding of play, art, and much else, it is misleading if taken in an absolute sense. To apply the word "consummatory" may only indicate that the usefulness of the experience in question has been too subtle, diffuse, or distant to grasp. Biological explanations for it have been given. Take the birds again. A bird that continues to sing after the mating season may be teaching younger birds to sing; he may be quickening the growth of the listening females' reproductive organs; or he may be encouraging them to lay more eggs. A bird's song can also establish its status among the other male birds. When experimenters used a loudspeaker to amplify the song of a submissive marsh wren, he became dominant.

I do not intend to give as blatantly a physiological or social explanation for the whole range of human art. Yet it seems to me inherently likely that the countless songs, poems, and dances that express lust or love enhance the sexual readiness and perhaps also the sexual development of human beings. There are so many direct examples that only a few reminders need be given. One reminder is the "spring-picture" album designed to teach young Japanese how to have intercourse. Indian erotic literature was as minutely descriptive and sexually exciting as its

77

authors, some of them geniuses of eroticism, could make it; and the more puritanical the upper castes became, the more striking and perhaps educational this literature became. Something similar is true of the erotic Chinese stories. Human sexuality is hardly conceivable in the absence of music, poetry, and dance. Painting too has its role. Is it a mere vagary of Western culture that the nude, usually idealized, has played so great a role in the history of its art? Is the hunger of adolescents for novels, films, or pop music not also a hunger for sexual experience? I am referring particularly to sex because it makes such a convincing illustration; but art does a great deal to maintain all bonds between human beings; and because they belong to a social species, art is extremely useful to them.

Now let me turn from play's consummatory nature, enhanced by play, to its ability to create, disrupt, and recreate order. The order that is most relevant is that of tradition, the nature of which will be explored later. As before, I mean my generalization to apply to social animals, including human beings but excluding (as far as I know) fish and social insects. The sociability of social animals requires them to be able to fix traditions; but it is equally necessary for them to be able to alter or violate them. This need is self-evident in our lives, but nonhuman animals must also sometimes violate their traditional responses.

Tradition educates by transmitting information from the more to the less mature. The young ducks that learn to follow the migration route flown by older ones are partaking of a kind of tradition, as are the baboons that have learned cooperative hunting techniques. In order to survive, animals learn a traditional fidelity to types of food, to potential enemies or prey, to territories, game trails, feeding grounds, courting grounds, shelters, and migratory routes. Much of this fidelity must be genetic, built into the nervous system; but to the extent that the nervous system remains plastic, it may be varied by social experience; and when the social experience is passed on repeatedly, it is what we call "tradition." The very ability to maintain a tradition must be related to the ability to alter or violate it, and the ability to alter or violate it is strongly related, I believe, to the sort of plasticity of action that is shown in the ability to play. It is hardly more than a tautology to say that the more

78

an animal has played inventively and the more it remains able to invent as if playing, the more easily it can change the way it behaves. The ability to play enhances intelligence, it seems plausible, and the ability to survive.

The lives of chimpanzees and human beings can attest to the usefulness of this speculation, as can those of certain species of birds. In stretching the speculation to include birds, I am stretching the notion of play to include the play-related ability to experiment with and change communicative behavior. As I have already said, the ability of a bird to play with sound allows it to sing more individually, to find a more individually suitable mate, and to keep in easier touch with its mate. For such a bird, an enhanced individuality is a fine-tuning of potential or actual mates. The analogy with art is this: like birdsong, art-play distinguishes the strangers with whom it is easy or safe or interesting to become intimate with from those with whom it is not.

The ability to play with or change the way of expression not only marks individuals as such and allows a more sensitive pairing, but it makes it easier to unite local populations, by creating a local dialect and a local way of living. Among birds as among humans, it may be assumed, local tradition creates a sense of familiarity and emotional closeness and support. Among humans, the local language and local art function alike, except that the art both vents and controls rebelliousness by allowing an imaginative latitude that cannot otherwise be expressed or acted on. Art is particularly useful to humans because it is by nature fitted to balance conflicting emotions, to use ambiguity and ambivalence in a constructive manner, and to allow a restricted and therefore tonic intoxication of body or mind. By signaling both the intimate likeness and the intimate peculiarity of individuals and by both venting and restraining the expression of their fantasies, art helps to create an interdependence of emotions and ways of behaving.

Much of the usefulness of art therefore lies in its localizing influence. As a result, whoever wants to appreciate art fully can do so only by becoming acquainted with the local tradition, or, if his interests are wider, by paying attention to the way in which the encompassing tradition is made up of smaller, interdependent groups, and these in turn made up of still smaller, familial groups. In a sense, contemporary art violates the principle that art is and is meant to be local. However, although contemporary art largely escapes geographical localization and

has an unprecedented openness, it remains historically local. That is, whatever is created in the current style is quickly relegated to the past.

I concede that an immigrant bird or a bird that lives on a dialect-borderline can learn to sing in more than one dialect, and I concede that a human being can learn to appreciate more than one artistic locality and, within limits, more than one artistic culture. If it were not so, my whole book would be in vain. But unless the human being, like the bird, lives on a literal borderline, or unless he sinks himself into the culturally distant art, he will be blind to the finer points of the art, even when he intuitively takes pleasure in it; and to the extent that he, more than others, lives in several worlds at once, he will be (though more discerning and self-conscious in all of them) a partial stranger in all, partially blind to the degree to which a nuance matters; he will be unable to feel that the local style is the only normal, fully human one, the only way of distinguishing the self-expression that is truly intimate. At its most sensitive, appreciation demands distinctions so local and fine that to an outsider they must appear incomprehensible or absurd. A connoisseur, someone deeply sensitized to the fine distinctions, sees more than anyone else. Yet it is precisely this minute establishment of tradition, which requires and rewards a connoisseur's familiarity, that creates an internal demand for change.

I have already cited the burden of the past created by tradition in China and the West, and I shall give further examples of how traditions generate an internal need for change. Described abstractly, what happens is that the known number of remembered small variations grows so numerous that additional small variations lose their ability to stimulate. They drown in the sea of past variations. Then all the natural basic possibilities of the tradition may seem to have become exhausted, and the past shows itself to be a heavy drain on memory, ingenuity, and above all spontaneity, in the absence of which art gives too little satisfaction. Tradition has effective mechanisms of regeneration, but, whatever happens, life in time changes, the new generation becomes more consciously the rival of the old, and the tradition that once allowed people to attune their sensitivities to one another reveals itself as too familiar to answer the need for expression that is its reason for existence.

When an art tradition undergoes great changes, whether or not for internal reasons of the kind I have mentioned, the changes take a form not unlike that of biological evolution. A successful tradition radiates

into divergent paths, each drawing a particular group together by making strangers of the other, related groups. Hybridization with members of another tradition may both add vigor and increase the distance from the mother-tradition; small but quick changes may add up to great ones; and now and then, for whatever reasons, the changes may be both large and quick. All this interplay between the relative fixity of tradition and the changes it undergoes can be regarded as an inclusive kind of game or succession of games, a prolonged demonstration of the need to create, disrupt, and recreate order, for art is an imaginative ordering of life and an imaginative rehearsal of its disordering.

Everything I have been saying in the present chapter implies that there are revealing analogies between the expressive behavior of certain animals and of human beings, the behavior that in its most concentrated human form we call art. Why otherwise should we, like the birds, sing, dance, and build, and like them, exhibit ourselves, our structures, and the treasures we gather? Why otherwise should we, human beings, dance crane dances or, in the person of such as Messiaen, gather and recast birds' songs into human forms? Why otherwise should we, like apes, call out rhythmically, dance alone and together, and scribble expressively? Like the birds, apes, other animals, and children, we are pushed to self-expression by our personal and social needs, and like them, we try to repeat consummatory experiences and vary life so as to retain our interest in it. True, as compared with other animals, we are always trying to excel in explicitly human ways, to be humanly individual and humanly social, to play and invent humanly; but under our humanized sensitivities and aspirations, we remain animals in our human way. To deny this is to diminish our humanity and deny ourselves an understanding of our nature and the art we create. As for the children, they cannot be artists if artistry must reflect adult experience, but they are at least protoartists. This does not distinguish them absolutely from other intelligent, expressive animals; yet it is in the form of a child that each human being first creates an emotive fusion of person and world. We create to remake the world, unite with it more intimately, and become in a measure what we imagine ourselves to be.

CHAPTER THREE

Spontaneity Pursued

The bird, ape, and child, the protagonists of the previous chapter, cast their shadows over this one, on spontaneity and the craving for it. To ordinary persons, constrained by conscience, a truly spontaneous life is likely to seem good for holidays or utopias. Elaborated into an ideal, the spontaneous life is imagined to dispense with forethought and after-thought, and so with ambition, inhibition, and shame. Those who accept the ideal assume that human beings are inherently good and the unin-hibited, uncorrupted life is naturally benign.

Nourished by legends and amplified by travelers' tales, the ideal is ubiquitous. In India, those who illustrated the ideal were the persons, replete with goodness, of the first (Krita) age; in China they were the most ancient ancients, who lived simply, silently, dreamlessly, imper-turbably, and impregnably; in Greece they were the vanished golden race and the crasser, more visible followers of Diogenes of Sinope; and in later Europe they were the "savages" whom Columbus called timid, intelligent, generous, and loving, or whom a pilot described as beautiful

naked people living innocently in a perfect climate surrounded by birds and animals. Critics immune to the Golden Age or the Noble Savage were apt to see the real "savages" as merely backward and quite probably depraved. The ideal, however, was tenacious, persisting in anarchistic attitudes and artists' dreams, in Van Gogh's plan for an artists' colony and his praise of the artist who worked as the nightingale sings, in Arp's desire to create as the plant creates fruit, and in the hope of everyone who tried to emulate the art of a child.

Dispensing with shame, spontaneity is an unconstrained taking of pleasure in our natural functions. I am referring, first of all, to the pleasure that each organ of the body gives by means of its own hunger, so to speak, and its own satiety, to the pleasure of bodily motion, of muscles stretching, contracting, and returning to rest, to the pleasure that mild pains can give, and to the quite different pleasure of memory and recognition. As long as we are healthy, nature seems always to be rewarding us for remaining alive; and its repeated rewards recall the ideal of a life that is solely composed of them. We often take art too solemnly to see that it is not all exalted, but also appeases elementary hungers and serves the sensuality without which our pleasure in life would end. The pleasure of manipulating materials and instruments is basic. Chopin testified to the physical pleasure he got from playing the piano, and Menuhin testifies that mind, emotion, and body must interact as the violinist's intentions are translated into minute movements not only of his fingers but of the muscles in his back.

Exploration, too, is a primitive source of pleasure, often indistinguishable from the pleasure of spontaneous play. We human beings are the most novelty-loving of the novelty-loving animals, those that pay attention to everything that promises the senses or mind the stimulation of something new, which is so attractive because it counters the displeasure, the danger even, of lethargy and boredom. Given any chance, many kinds of animals, including human beings, stimulate themselves by exploring their surroundings. They may not have far to go, because they can explore by looking, listening, touching, scratching, bending, breaking, smelling, mouthing, tasting, and so on. To remain alert, in a state of spontaneous reactivity, they are willing to risk some danger. Things far away seduce by their promise of novelty, just as they repel by their threat of danger. How the seduction and repulsion work we see, to speak only

of primates, in the young of langurs, squirrel monkeys, baboons, chimpanzees, and human beings, when they venture away from the security of their mothers and when, alarmed, they retreat to it.

As resourceful animals, we have discovered many ways to counter boredom and its dangerous quasi-twin, depression. We intensify our pleasant everyday activities, either by indulging in them more persistently or by varying them more excitingly; and to make the intensification acceptable, we designate certain exciting techniques as permissible by naming them "fun," "joking," "sport," "entertainment," or "art." Whatever the excitement that accompanies them, they are understood not to pose any danger either to neighbors or to basic social conventions.

Under the sanction of these techniques, we enjoy as much as we dare or are allowed of the questionable, immoral, or illegal, in play or imagination, because it excites us to life. To excite us to life we use sex in all its forms and all the kinds and degrees of violence that are available for art or amusement—to distinguish them from those available to the criminal, to whom the feeling of risk or sport may also be essential. In renewing us, such excitement returns us to a state of pleasure that recalls and underlies the image of the ideally spontaneous life. If we can return to the moral carelessness of childhood, it is easier when excited to do as we please—maybe that is why Delacroix wanted to become a big cat— a tiger, jaguar, or lion. Flirting spontaneously, like children, with everything socially negative, from the satirical or rebellious to the cruel, morbid, or disgusting, we may raise excitement to exhilirating and even orgasmic extremes. However, whether moderate or extreme, all the means make the same attempt to restore life by restoring pleasure in it. At the same time they are an attempt to create intimacy, for the intimacy that arises between those who experience the same art or entertainment, or between them and the artist or entertainer, is an antidote to the loneliness that often causes and always characterizes depression.

Having already discussed the spontaneity of children, I go on to that of "primitives," as shown in their verbal art. The legitimacy of the term "primitives" will arise later; at the moment, it is enough to note how difficult it is to generalize about those so named in ways that are neither obvious nor misleading. A generalization that appears to meet the test

says that "primitives," preliterate by definition, are even more dependent on speech and even more sensitive to its forms and nuances than we are. Lacking the extension and the competition of writing, speech is to them of more importance than we can easily imagine. It is their sensitivity to speech that may in part justify the stereotype that they excel us in spontaneity.

Given my own knowledge and the scholarly literature I am familiar with, I do not dare to generalize about all "primitive" literature. I shall therefore remain satisfied with particular instances of spontaneity. Certainly, the requirement that literature must be performed encourages improvisation. African storytelling, for example, is the collaborative recreation of well-known tales. A story once begun, sometimes in unplanned response to something done or said, the members of the audience "fatten" the narrative with their own dialogue, mimicry, bird-calls, and descriptions. Instead of being outraged, the narrator may be delighted with the ideas he is getting for future bouts of story-performance. Like the Africans, the Indians of the South American rain-forest perform their stories with excitement and humor, the drama being heightened by imitations of animal sounds, mockery, extreme changes of voice, and elaboration of the absurd to the point of slapstick.

There is a great deal of spontaneity in preliterate poetry or song. It should not be supposed that it is necessarily spontaneous, for much of it is traditional and ceremonial, and exact repetition may be thought to be essential. Not infrequently it shows genuine literary sophistication, characteristic of the Polynesians and the Incas and Aztecs, for instance, and sophistication is at some odds with spontaneity. Professionalism and semiprofessionalism are common. Yet the evidence given by travelers and anthropologists, as well as that of the poetry itself, even unsung and undanced, even translated into a very different language, should be persuasive.

I begin with some of the evidence put down in much the same disorderly way as I came on it. I must warn that the past tense should often be substituted for my "anthropological present." The warning given, I repeat, pell-mell, that "every Dobuan is a song-maker"; that the Meo of Laos are "a people of poets"; that the Lolos of southern China improvise songs on everything, "personal griefs, torn clothes, a sprain, good weather, tiredness"; that all the young men and women of the Ila and Tonga of South Africa are expected to compose personal songs; and

that almost all the Nuer, who live in the Sudan, compose poetry, the youths breaking into songs of praise for kinsmen, sweethearts, and cattle, whenever and wherever they feel happy. Among many African peoples, as among Polynesians, anything interesting, from gossip to politics, makes its way quickly into songs, which may be forgotten as quickly as they were composed. To the Tartars, emotionality leads directly to poetry, the words, regardless of subject, falling into poetic form and the voice rising to a chant. Similarly, the Tsimshian Indians of the coast of British Columbia sing about everything, from magic, victory, defeat, and hospitality, to birth, love, and death, the songs often vibrating with passion and rising in pitch, and then descending "like cascades of sweet and remote sound." In the Andaman Islands everyone composes his own songs, even the small children. To end this disorderly paragraph, I repeat the sneer of an Eskimo woman at a rival, "She can't dance, she can't even sing," the latter part of the sneer meaning, "She can't even compose songs."

Courtship naturally lends itself to both song and competition, and there are tribes of Tartars, Tibetans, Polynesians, and Eskimos, that conduct it in the form of song-contests. Among the Eskimos, the rivalry of a song-contest can be friendly or not. To begin with the friendly, a Netsilik Eskimo may choose a "song cousin" from another camp, whom he meets in the winter for a friendly contest in the composition and performance of songs. But the mild ridicule that enters into an Eskimo song-contest sometimes takes an acrimonious turn and ends as a bitter, mocking duel in which each contestant accuses the other, in song, of impotence, failure in hunting, stinginess, adultery, incest, murder, or any other weakness or fault. The victory in the estheticized quarrel goes not to the more just, but to the contestant who shows himself, in Eskimo fashion, to be the better artist. Perhaps some half-magical equivalent is assumed between the vigor of the attack and the essential righteousness (the vital power) of the cause.

Eskimo quarreling, singing, laughing, and art are all concentrated in a long ceremonial in the snow dancing-house. Singing and dancing go on hour after hour, and everything merges into a wave of shared emotion; but the individual is not forgotten, and almost everyone sings songs that he himself has composed to express his own experience. One man remembers and sings that he drifted out in his kayak but lived to see the light that fills the world. *The Song of Ulipshialuk's Wife,* which is

remembered and sung again, is about the fear of loneliness, when the mind is turned away and the longing arises for the loneliness one fears; about the joy in feeling the warmth come to the world and seeing the sun follow its old footprints in the summer night; and about the fear in feeling the cold come to the world and in seeing the moon, now new moon, now full moon, follow its old footsteps in the winter night, Iyai-ya-ya. The song ends in the lonely memory of the uncle with whom the singer could once share her thoughts, the man to whom her mind longs ineffectually to be revealed, Iyaiya-ya-ya.

The difficulties in translating from "primitive" languages are exceptionally and sometimes, no doubt, fatally severe; but I think no harm and some good will come of it if I follow the paraphrase of the Eskimo poem with a minuscule anthology of "primitive" poems that appear to reflect their poetic force in translation as well as to express spontaneous emotion. I begin with a Chippewa (Ojibwa) song, which is still briefer in the original, for each line translates a single Chippewa word. The song is for a death or funeral:

> *Whenever I pause*
> *the noise*
> *of the village.*

Native American songs often reflect loneliness and suffering. Witness these two lines by a Nootka:

> *It is only crying about myself*
> *That comes out in song.*

The reverent stillness that Native Americans are taught prepares them to evoke songs and visions that express the individual and belong to him. Like a Japanese, a Native American may spontaneously compose a song at the moment that death is felt to approach:

> *The odor of death,*
> *I discern the odor of death*
> *In front of my body.*

The Bantus of South Africa sing old and improvise new songs for everything in life. The two brief Bantu songs that follow create a riddle-like juxtaposition of sharply different images, which the poetic imagination is required to join. The resemblance to Japanese haiku is plain:

The little hut falls down,
Tomorrow, debts.

The sound of a cracked elephant tusk.
The anger of a hungry man.

Such songs, constructed on slight riddles, may suggest deliberation; but the following Otomi song from central Mexico is nothing but the comparison of the sky at night with a face:

In the sky, a moon;
On your face, a mouth.
In the sky, many stars;
On your face, only two eyes.

The fullest descriptions I know of the context of unwritten poetry are those of the "aboriginal" tribesmen and the peasants of India. Certain groups of mystics among them, for example the Bauls of Bengal, sing songs with an unusual poetic and erotic fervor. Tattered wandering minstrels, the Bauls live on whatever is given to them by those who listen to their songs. They pursue the "contrary" path, in contradiction to the accepted social norms, and reject the world's praise or blame. "When I remember," the Baul sings to himself, "I have no fear of shame before the world."

In Chattisgarh, a great, mostly arid plain of northeastern India, every subject goes into poetry, much of which, for that reason, is prosiac; but much is sensitive and eloquent. Many of the songs are known to everyone, and gifted individuals continue to augment their number. "Life in Chattisgarh is hard, dusty and unrewarded: it might well be hopeless were it not for the happiness that song brings to the meanest hovel."

Many of the poet-musicians of Chattisgarh are professionals. The men among the Pardhans, for example, are seasonal wandering musicians. I cite the Pardhans because, despite their professionalism, they admire and display spontaneity in both their conduct and their art. A Pardhan is likely to be charming, wayward, generous, and poetic, to be always preoccupied with sex, and to treasure, in what order I do not know, his freedom, his songs, and his kisses.

Chattisgarh poetry makes use of many symbols of a kind native to India. No particular understanding of them is needed for the three poems that follow, all of them imbued with spontaneity. The first of the

poems is a joyous phallic promise; the second, a lament on a husband's impotence; and the third, a welcome to a child about to be born:

Since I saw your thing like an anklet
My mind has not left it
Like a fiddle your thing plays sururu sururu
Like a trumpet it sounds tiriti tiriti
Like a drum it sounds damdam damdam
Like a kettle-drum it goes tangtang tangtang
Now I have seen your thing
I will go with it to life's end.

My mind is on fire
Yet my heart is sad
I stand in water
Yet I die of thirst.

The sun is red in the sky
The crows are talking
Call the midwife
My darling is weary
He is fighting to escape.

Love, an unassuaged thirst, and a welcome to the world. The old Yakut women of Siberia sing death, but their song, unlike that of the Native American quoted above is one of anticipation that verges on happiness. During a wedding ceremony, the young Yakuts dance, and the unkempt, emaciated, fantastic, often blind old women emerge to improvise passionate songs, one of which (in the prosaic but moving translation I have read) welcomes the sun to the singer's aged bones, prophesies that when the dancers next come, her old body will lie under the young grass, and ends that she will hear the songs in her grave and her happy bones will dance to them.

Even in tribes whose members are spontaneously poetic, there are individuals who stand out as poets. In Melanesia and Micronesia, as in other places where poets become famous, poetic originality becomes a value in its own right. When poets are singled out as such, technique is likely to

become conscious and perhaps painstaking, and songs to be composed over a period of time and then memorized. This happens in the southern Sudan, in the South Pacific, and among the Eskimos. There may even be a conscious effort to fuse technique with inspiration without relaxing the demand for either. The Gilbert Islands poet is said to make this double demand of himself, and he has learned a way to further its success. When first stirred by inspiration, he moves out of the village to some lonely place, where he lives for three days on nothing but coconuts and water. On the fourth day he marks out on the ground the square, the "house of song," in the confines of which he intends to compose his song. After a ceremonial invocation, he goes to the village, recruits a few friends, and returns with them to his "house of song." There he sits, the acrid smoke of a fire blowing on him, while his friends, who face him in a semicircle, listen to him recite his nascent poem, comment and criticize, and help him search for the right words, balance, and music. After they leave, the poet remains alone, perhaps for several days, and goes on polishing his song, the final responsibility for which is his alone.

Eskimos, who distinguish between merely clever songs, like those composed in song-contests, and songs meant to cause good weather, success in hunting, or the like, use less elaborate but nevertheless impressive techniques to summon inspiration. The serious songs, which have magical force, belong to individuals, those who have composed, inherited, or bought them, and must be used with ceremonial care. The explorer Knud Rasmussen met an old woman diviner who told him that in the old days there had been a great annual festival for the soul of their great prey, the whale. To summon the whale, worn-out songs could not be used, and so everyone, old and young, sat together in the special silence of waiting for something to break forth. Their forefathers believed, she said, that the songs were born in stillness while everyone tried to think only of beautiful things. In this atmosphere the songs come, "they take shape in the minds of men and rise like bubbles from the depth of the sea, bubbles seeking air in order to burst."

As Rasmussen explains, an Eskimo poet believes that it is a sacrilege to impose his own merely subjective words, for the right words, those imposed by reality, have the magical power to create. A Netsilik Eskimo, the gifted hunter, shaman, and poet Orpingalik, compared the poet to an ice floe sailing here and there in the current, his thoughts, joyful or sorrowful, being driven by a flowing force. "Thoughts can wash over

him like a flood, making his blood come in gasps, his heart throb."
Sometimes, although the poet is afraid, the words he needs come of
themselves, shoot up of themselves, and there is a new song. How many
songs are there? The number is countless, said Orpingalik, adding, "All
my being is song, and I sing as I draw breath." Loneliness, too, played a
creative role, as Orpingalik implied when he exclaimed that songs were
"comrades in loneliness."

The subject of spontaneity has taken us from the widespread ideal to
biological and psychological needs that underlie it, and from these to the
sometimes truly spontaneous song of "primitives." The stereotype of the
spontaneous "primitive" is not wholly misleading; but the desire that
created the stereotype is characteristic of formalized and bookish cul-
tures. The pursuit of spontaneity was therefore characteristic of China
and Japan long before Europe. For the time being, I shall say nothing of
the circumstances in which spontaneity became so exacting an ideal in
China, but shall only recall some of its expressions in Chinese caligra-
phy, painting, and poetry.

The stage may be set with the remarks of a pioneering esthetician of
Chinese calligraphy, Ts'ai Yung, of the second century A.D.:

> Calligraphy is releasing. If a person wishes to write he must first
> release what is in his heart. . . . By first sitting in silence with quiet
> thought he may grasp ideas as they come. Words no longer issue
> from his mouth; the mind no longer thinks. Deep and mysterious,
> spiritual and beautiful, nothing could be more perfect. The charac-
> ters may appear to be sitting or walking, flying or moving, going
> away or coming back, sad or happy. . . . Such is calligraphy.

From about the fourth century A.D., the most intimate medium of
Chinese calligraphers was the cursive script. The freedom it encouraged
came to its extreme in "mad" or "wild" forms, in which artists got their
pleasure from dancing on the verge beyond which their writing would
be unreadable.

"Mad" script went well with an impetuous, eccentric personality. The
eighth-century calligrapher Chang Hsu, called Mad Chang, accompa-
nied the drunken dance of his brush with yelling and laughter, though

he was able to keep a link with the calligraphic past, as his admirers pointed out. His student Huai-su, called the Drunken Monk, moved his brush with such abandon, said an eyewitness, that a storm seemed to have suddenly broken out. Mi Fu, of the eleventh century, practiced calligraphy that, like his opinions, was unpredictable, for it ran, stopped, and turned, in a constant adventure of spontaneous movement. "The over-all effect is enchantingly beautiful, powerful, unexpected, and lyrical."

Spontaneity in painting has often been referred to by the term *i-pin*, for which "untrammeled" is an accepted translation. Originally the term referred to a superlative innate talent so unusual in kind that it escaped classification. As applied to spontaneity, it was associated with ink-washes and the spattering or splashing of ink. The eighth-century painter Wang Hsia made landscapes so unconventional in method that some people refused to see them as paintings at all. A source says of him that when he had prepared by getting drunk enough, he would begin spattering his painting. "Then, laughing and singing all the while, he would stamp on it with his feet and smear it with his hands, besides swashing and sweeping it with his brush. . . . Responding to the movements of his hand and following his inclination, he would bring forth clouds and mist, wash in wind and rain, with the suddenness of Creation."

In its own way, Ch'an (Zen) painting inherited the *i*-quality of spontaneity, which Chinese artists related to sincerity, while sincerity (as will be described) was related to lack of ostentation and to expressive "clumsiness." To illustrate the attractions of spontaneity as exhibited in clumsiness, I should like to tell the story of the painter Kao Fen-han (1638–1749). When he was fifty-five, his right hand became paralyzed by a sudden attack of rheumatism. Unwilling to give in, Kao struggled stubbornly for three years to learn to write and paint with his left hand. The result, he wrote in a letter to a friend, was "extraordinary and fascinating. The crudeness, the resistance, the sluggishness and awkwardness of the brushwork are totally unequaled and unattainable by the right hand. As artist who devotes his whole life to the mastery of the brush should not be a stranger to this fascination." This was surely the fascination felt by Paul Klee when he gave and followed the advice to paint sometimes with the left hand because "it is not so deft and for that reason of more use to you"; and felt by the sculptor Eduardo Chillida when he tried to

escape mere facility and by drawing with the left hand, achieve as much as possible with the fewest possible lines.

With respect to spontaneity in poetry an old Chinese source says:

> Poetry is where the intent of the heart (or mind) goes. Lying in the heart, it is 'intent'; when uttered in words, it is 'poetry.' When an emotion stirs inside, one expresses it in words; finding this inadequate, one sighs over it; not content with this, one sings it in poetry; still not content, one unconsciously dances with one's hands and feet.

One of the notable advocates of poetic spontaneity was Yang Wan-li, who lived in the twelfth century. As he said, poetry came to him of itself when he was walking in his backyard; and he was sure that the ideal poem was natural and artless. His explanation of his "live method" is reminiscent of the paradoxes of Ch'an Buddhism:

> What is meant by the live method is that all of the rules are observed but you are able to transcend the rules; that is to say, the changes and transformations in the poetry are unfathomable, yet you do not turn your back on rules. This Path is a set method, yet it is without set method.

Yang opposed and made fun of poetic stereotypes. His own poetry is filled with perceptual-poetic transformations: some flowers fly away and show themselves to be butterflies; some mountain-shaped clouds remain where they are and show themselves to be cloud-shaped mountains. Like the poets he praises and like Ch'an masters, Yang tries to shock his readers into renewed awareness; and, more than any scholar-poet before him, he brings the common man's language into poetry.

Yang's desire for spontaneity was no doubt related to his love for children. He is said to have been the first Chinese poet to make a serious attempt to enter into the world of children. He ended by feeling that they lived within their own kind of unprosaic reality, which, though he tried, he was unable to enter.

After undergoing Buddhist enlightenment, Yang rejected the whole of learned culture. "Don't read books! Don't chant poetry!" he exhorted:

> *If you read books, your eyes become so withered you can see the bones.*

*If you chant poetry, each word must be vomited from your
heart . . .*
There's a flavor in listening to the wind and rain;
When you're strong, walk, when you're tired, sleep!

Although the stress on spontaneity and inspiration was early in China,
it came to be subordinated in literature to a moralistic, equally Chinese
standpoint. It was revived by the three Yüan brothers, the most famous
and intense of whom, Yüan Hung-tao, wrote in a letter:

> There is no fixed pattern for the expression of newness in litera-
> ture. You must only put forth something which others could not
> have put forth. The lines, the individual words, the music: each of
> these must flow from your own heart.

Yüan Hung-tao insisted that, to be authentic, he had to be true to his
own nature, not that of someone else. In keeping with this respect for
authenticity, he defied the opinion of the literati and attributed true
literary value to fiction, drama, and folk poetry; To him, the songs sung
by women and children were the words of "true people," without
knowledge or learning. He went so far as to predict that nothing of
contemporary lierature would survive but the poems, "full of true voices,"
of the village alleys.

The influence of the Yüan brothers soon waned (the conscious attempt
to be spontaneous surely verges on the paradoxical); but their school
had a spiritual heir in the unorthodox Chin Jen-jui (also called Ching
Sheng-t'an), a critic of the first half of the seventeenth century. Although
much concerned with technique, he had a fundamental belief in spon-
taneity. Once, in a style more extreme than usual with him, he said,
"Poetry is only a sudden cry from one's heart; everyone, even a woman
or child, has it, in the morning or midnight." Suppose, he continued,
you come on a child still too young to turn its eyes or open its fists, but
who stretches its arms, twists its feet, and utters a sound. "When I look
at it carefully, I find this is really poetry." By definition, "What moves
the heart and is uttered from the mouth is called poetry."

There were partisans of spontaneity in Japan as well. Two of them,
the writer and the actor of *No* dramas, Zeami Motokiyo (1363–1443),
and the poet Matsuo Basho (1644–1695), were themselves great artists.
Zeami was struck by the possibly great accomplishments of innocent,

untrained children. The transcendent ability of a child-actor passed after a time, he observed, but while it survived, unhindered by conscious skill, it could match the performance of a great virtuoso. Basho, who had too often experienced the "disease" of the skilled, was ready to entrust the art of *haiku* to a young boy, for he preferred poetry that was the fresh, immediate result of one's own perception.

Yang, Zeami, and Basho have returned us to the theme of childhood spontaneity and the art that is genuine because it is not yet artful. In China, Taoism, which urged would-be sages and immortals to make children of themselves, is a child-cult of a sort. The child-cult of the West, which has affected Western artists no less powerfully than Taoism has affected Chinese and Japanese artists, has roots in the distant past. I will not return there, nor more than mention Rousseau, Wordsworth, Coleridge, Blake, Thoreau, Novalis, and Schiller. I begin with the mid-nineteenth century and with the comparison that Baudelaire makes of child and genius:

> The child sees everything in its *newness;* he is always drunk. Nothing so much resembles what is called inspiration as the joy with which the little child absorbs form and color. . . . The man of genius has solid nerves; the child has weak ones. In the one, reason has a considerable place; in the other, sensitivity occupies almost the whole being. But genius is no more than *childhood recovered,* childhood now endowed, so to speak, with virile organs and an analytical spirit that allows him to put into order the sum of involuntarily amassed materials. It is to this profound and joyful curiosity that one should attribute the fixed, animally ecstatic eye of children in the face of the *novel,* whatever it may be.

From the middle of the nineteenth century, one begins to hear the now conventional praise of children's art as the source of all art and as valuable in itself. Of the educators who agreed, the most remarkable was perhaps Franz Cizek. When he was a student at the Viennese Academy of Fine Arts, the children of his landlord used to come to his room to draw and paint, and he was struck with their ability, as he was struck, in the course of time, with the artistic ability of all children.

95

Cizek regarded it as his mission to liberate the child from "art instruction," which, he thought, deadened spontaneity and endangered genuine talent. For this reason, and because he believed that children's art expressed eternal laws of form, he confined himself as a teacher to challenging the child. To him, the child was creative when struggling to create form. "When I say to the child: 'Make a design which you have never made before,' then the result is a really childlike design."

Cizek was a member of the Viennese Secession and a friend of Klimt, Schiele, Kokoschka, and other artists, among whom he fostered an interest in the art of his favorites, the children. In Germany, the artists of the Brücke and the Blaue Reiter were also interested. It was Kandinsky's view that children were able to express what is internal with direct forcefulness and to reveal "the inner resonance" of objects. He wrote that when an adult criticizes a child and says, "Your man cannot walk because he has only one leg," the child only laughs, but he, Kandinsky, could cry.

In assessing the influence of children on modern artists, I shall confine myself, for the most part, to Matisse, Klee, Miró, and Picasso. All four were impressed by the child's freshness of vision and not a little envious of him. Matisse argued that it was essential for the artist to see things without distortion, as he did when a child. Otherwise he could not be original, that is, personal, in art. To paint a rose, a true painter has to forget all the roses that were ever painted. This remark of Matisse's recalls that Picasso once said:

> Critics are always talking about this and that influence on Matisse's work. Well, the influence on Matisse when he painted this work was his children, who had just started to draw. Their naive drawings fascinated him and completely changed his style. Nobody realizes this, and yet it's one of the keys to Matisse.

Klee's borrowings from children reflect his ambition to be "as though new-born." Once he said that the paintings made by his little son Felix were better than his own, which he was too often unable to prevent from "trickling through the brain." Although he later objected to the "legend" of the childishness of his drawings—in his diaries he noted,

96

"Will and discipline are everything"—he wanted his art, like a child's, to be integrated effortlessly into the universe. Often he made the child his protagonist; but he marked him out, as the child himself would not, for future sorrow. The forehead of his *Child Consecrated to Woe* (1923) is marked by the *w*-shaped frown of *Weh, woe*. In the etching *Height* (1928), the child is a tightrope-walker. In the painting *Overexcited* (1939), a stick-figure girl is balancing herself on a queerly, alarmingly anchored tightrope, which is also, as a tree shows, the horizon. This painting says that life, along which the child walks, is as narrow, precarious, and hard to balance on as a tightrope. Klee's comment, set high in the middle of the picture, is a large exclamation point. At the time he painted the picture, the rope had grown as precarious as it looked, for he was dispossessed, ill, and soon to die.

The distance from Klee to Miró is like the distance from a child in the figurative stage of art to the time just before the stage is reached. I am referring to the Mirós in which there are large bright-colored spots, alone or with other lines or shapes; or a scattering of approximately organic shapes; or relaxed, often geometric designs over the whole surface. Miró of course also goes beyond this stage. His human beings are likely to be ovals or balls resting, like the child's first human beings, on straight extensions, which may or may not be feet. Filled with imagination, his world seems to have the optimistic interest in life that is usual in children's art, though his is much more erotic and consciously grotesque. He adopts a tactic that has been attributed to childrens' art, though I do not remember having seen it: hair, eyes, and nose are scattered on one side of a picture, while the head to which they belong is somewhere else. He also uses the stick figures drawn by or attributed to children; and his art, like theirs, often has a handwritten, semicalligraphic effect.

Miró has often expressed the desire to be spontaneous. In explaining himself and his need for sensual immersion in the process of painting, he says that he has often painted with his fingers, that he needs to steep himself in the physical reality of paint and ink and to be covered with dirt. In a note to himself he writes that if materials run out, he should "go down to the beach and make lines in the sand with a bamboo stick, draw on the ground with a stream of piss, draw in the empty air the pattern of birdsong, the sound of water and cartwheels and the humming of insects, and let the wind and water sweep it all away afterwards,

but act from the conviction that all these pure devisings of my mind will magically and miraculously find an echo in the minds of other men."

Among other notebook-reminders to himself on how to develop paintings from his sketches, Miró writes that the canvases should be "done without any apparent effort, like birdsong," so as to avoid the impurities, contradictions, and expediencies of Picasso's canvases. Miró's explicit criticism of Picasso as only impurely spontaneous prompts me to describe how in old age Picasso achieved the kind of spontaneity at which he had always aimed.

By his own account, Picasso missed what he called the genius of childhood. The exactness of his first drawings frightened him when he saw them in his maturity. But while these first drawings had almost nothing of the awkwardness and naiveté of childhood, the art of his maturity was always filled with his spontaneous response to life—with the women he was falling in love with, was loving, or was falling out of love with; with his poets; with his circle of friends; and with his dog-companion. A change of wife or mistress signaled a change of direction in all his art. Highly impulsive in art, he said at the age of ninety that he still did not know where a work would lead him. He would start in the corner of the sheet, a little dog or something would appear, and the drawing would leap ahead from page to page and canvas to canvas.

The unreflective spontaneity that Picasso missed in his childhood and exhibited in his maturity was arrived at most fully in his old age, when so many of his paintings seemed to be no more than quick, repetitive attempts to ward off death by the sheer persistence of creative effort. "By his eighties, let alone nineties, fear of death overshadowed everything else in life and made inward looking unthinkable." Yet there *was* success in the midst of fear and failure. Let me try to explain the success by trying to enter into Picasso's mind, beginning with the end of his Cubist period, when life, which had almost disappeared into the broken planes and crystallized fragments of his Cubistic figures, emerged again.

Now, having learned not to care how nature had constructed things, he reconstructed them for himself, enlarging, diminishing, and reshaping eyes, ears, heads, breasts, bodies, arms, and legs. Having made all the parts of men and women, he decided again each time how the parts should be put together, and he fitted together anatomically impossible but emotionally plausible monsters (like himself). A woman he loved began sweet-looking and plausibly built, but usually ended, like him, as

a monster. Yet though he was always making and populating the world, he felt alone. In a frenzy of drawing, in the loneliness of a man whose woman and children had just left him, he drew the painter and the woman. The woman was self-sufficient, a graceful body the painter could reproduce but never capture: she was there by herself. As his mood changed, his paintings and drawings changed. Sometimes he was pathetic, sometimes not, shrunken or not shrunken, and more or less distant from his model. Often in the pictures the mere presence of beauty diminished the painter.

"In the end," he said, "there is only love." But love is hard to win and harder to keep. Not only because of the woman, but also because of the connoisseur. The woman you cannot possess you try to remake, but the connoisseur, who does not really understand anything, is always standing by and criticizing, hanging on to the painter's brush, which gets very heavy.

What, finally, does the painter want of a picture but the emotion it gives off? For the sake of emotion, he does not want to limit himself, not even in style. Style, he thinks, locks the painter into the same vision and technique, the same formula for a whole lifetime. But then he hesitates and criticizes himself. "I thrash around too much," he says, "move too much. You see me here and yet I'm already changed, I'm already elsewhere. I'm never fixed, and that's why I have no style."

Now he has grown old, and in order to ward off tiredness, he paints constantly and tries to make everything he and others need. "You know, it's just like being a peddlar. You want two breasts? Well, here you are —two breasts."

He does want them. Life is running out, and he paints quicker and more roughly. He does not want to kill the life in a painting by finishing it. He wants to spend his time observing the creatures he makes and thinking about the mad things they are up to. They are theatrical soldiers-of-fortune who remind him, at once, of his childhood, his beloved Dutch and Spanish painters, and, of course, himself; and they are a motley assortment of persons assembled in circuses; children and families; and beautiful women, perhaps his own pictures, the artist falls in love with. The painter, the Raphael-Michelangelo-Degas-Picasso, spies on his creatures, taking voyeuristic delight in the antics of the life that has emerged from him.

Often he paints a man and a woman, either separate or alone. The

sex is carnal, the bodies are gross, they are human life in the flesh. The heads of the man and woman now fill the canvas. Whatever their position, they are always kissing. As usual, the eyes migrate to any empty space in the head. Sometimes they are closed, sometimes staring into space. The contours of the faces fit together closely as if made of clay. The man and woman are straining to get as close as possible. Her nose fits into the contour of his nose and brow, mouth fits into mouth, the man's tongue goes into the woman's mouth. Once, the woman lies enclosed like a child in the man's arms.

Now his painting is almost what he has always demanded of it. There is nothing any longer that can be called technique, but neither is there anything technically clumsy to disturb his intention. Everything is the direct longing for closeness (unlike the painting, however, the longing itself is clumsy, the life is clumsy). Finally, Picasso-Anguish and Picasso-Death appear, as direct as the longing they corrupt.

Old Picasso has become Picasso the child he never was in art, having at the end of his life achieved the perfect spontaneity in art with which almost all of us begin but hardly anyone ends.

I conclude the discussion of the artist's attempt to be spontaneous with the reflections of Karel Appel and Robert Motherwell.

When Appel was reminded, in 1977, that he had said that his art was a kind of toy for adults, he answered:

> I think that men will realize one day that their life in the world is a sort of play. I don't mean by that that life is just having fun! But maybe we'll learn one day to express our desires and our labors —even the most serious of them—in the form of play. Like so many 'pieces' in a game of magic, tragedy or comedy.

Robert Motherwell summarized:

> Modern art is much more closely rooted in children's art than is generally recognized. . . . The child in the African bush, the Eskimo child, a child in Manhattan, a child in Iran, a child in Moscow, a child in Berlin, all do the same thing at the same time. . . . The same images at the same moment in human development. . . .

100

That's one of the reasons I think art is really profoundly basic or generic to the human being. . . . I much prefer things that are deeply rooted, to contemporary aesthetics such as the Constructivist party line or the Minimalist party line, or the cliché parodies . . . which, I think, are quite superficial.

Spontaneity has been identified not only with the art of children, but with the unreserved and visionary art of the insane. Dubuffet, who built up a large collection of the art of the mentally ill, prefers it to the art of children. He sees the child's psyche as less rich, concentrated, and energetic than the psyche of the adult, and finds artistic weakness in the tendency of children to exhibit themselves and assimilate themselves into society. Western society having become mechanical and insensitive, the true artists are those, such as the insane, who withdraw from it. Dubuffet, who has studied the art of the insane in hospitals, finds it to be forceful testimony to human experience, superior in its directness to art in the usual sense.

Psychiatric interest in the art of the insane is said to have begun in the 1870s. The most influential study of their art was Hans Prinzhorn's *Bildnerei der Geisteskranken (Artistry of the Mentally Ill),* published in 1922. His psychiatry tempered by his love of music and his Freud by Nietzsche, Prinzhorn was a rare combination of psychiatric acumen and artistic sensitivity. Most psychiatrists of his time thought avant-garde art to be a mental aberration, but Prinzhorn was drawn to it, as he was drawn to African and Oceanian art. In the psychotic art he studied, he found autonomous modes, even whole systems, of unique, individual expression.

The art of the insane interested many artists, possibly some Symbolists, and among others, Klee, Dali (defined by himself as a paranoiac), Picasso (interested in the works of Ernst Josephson, a schizophrenic artist), and the Surrealists, who envied the schizophrenics' ability to go emotionally naked, like so many infants in the bodies of adults.

As Prinzhorn saw, the schizophrenic tends to be the universal person. The reason is that everything in him tends to be reduced to basic functions and to images of psychic pain, though the exact form the images take is incorrigibly, insanely private. This is no less true of "primitives," it seems, than of the "civilized." A study shows that psychotic natives of New Guinea, persons who have had very little contact with Western

civilization, resemble Westerners in shedding more and more of their acquired culture as their personalities continue to disintegrate. At their most deeply schizophrenic, they express themselves in art with only the most impoverished, abstract, universal, geometrical forms.

Schizophrenic universality and schizophrenic privacy are each a rejection of tradition. This rejection, this openness and closedness, creates a parallel between the art of schizophrenics and much of recent art. The parallel argues a likeness in the suffering that may be assumed to underlie it. This suffering is exemplified among the practitioners of every art. Among modern playwrights it is easy to name Strindberg, Artaud, and Beckett, and among poets, Baudelaire, Rimbaud, Mayakowsky, Pound, Eliot, and Lowell. Eliot's staid public face made it possible to see *The Waste Land* as an impersonal image of the dissociated sensibility and spiritual desolation of the time; but it was also he himself who was dissociated and desolated. Even after his conversion to the Anglican Church, his friends saw him as "constantly on the verge of a nervous breakdown, peevish and complaining, oppressed by self-pity, weakened by weariness, and preoccupied with fears of poverty."

If I were to choose an epigraph for what I am now writing, it would be taken from the words of an Eskimo shaman named Igjugarjuk. Like others of his kind, he wanted power to see into life's riddles. To gain this power, he had to undergo an initiation that required suffering. He chose to suffer by hunger and by cold, and as a result he learned that "wisdom is only to be found far away from people, out in the great solitude, and it is not found in play but only through suffering." His following words, my epigraph, are, "Solitude and suffering open the human mind." I think, of course, that wisdom can also be found in play. Perhaps the art I have been speaking of is play in and with suffering, suffering-play.

Visual art gives an indefinite number of examples of the power, often essentially spontaneous, that can issue from suffering. Munch's *Scream* is the memory of an experience in January of 1922, when the artist saw the sunset as coagulated blood and, trembling with fright, "felt a loud unending scream piercing nature." Often the suffering must be guessed. This is true of George Grosz, who later admitted that his cruelly satirical drawings were made to get rid of his "burning hatred." The suffering that one may guess in Michelangelo becomes certain after one reads his poems. Suffering is both clearly and enigmatically present in Goya; and

Picasso keeps painting, etching, lithographing, and drawing it, as also its opposite.

The art of psychotics shows that their perception of the world has been overpowered by what I am calling, for the sake of brevity, their suffering. They often humanize inanimate objects, even by giving them faces or facial expressions; they distort and formalize; they fill surfaces with a plethora of detail; and they hide and reveal with their symbolization. Yet the freedom of art has erased the once clear distinction between psychotic and nonpsychotic art; artists have learned to use all the means of the psychotic, which are, after all, the means invented by imagination when detached from the standards given by tradition. In the case of both psychotics and modern artists, self-expression, private though its meaning may be, is likely to be an attempt to form, to integrate oneself, and in doing this, to create a sympathetic contact with others. The very schizophrenics whose behavior is disorganized may be organizing themselves in their art. In this respect they resemble Munch, Van Gogh, and de Chirico, all of whom were hospitalized for their mental conditions.

It is evident that psychosis can impoverish and disintegrate the ability to express onself; but it can also reveal and strengthen it. Briefly, mental illness can make persons either articulate or inarticulate, and it is able to create all kinds of fusions of articulateness and inarticulateness. There are certainly instances in which an otherwise latent talent is liberated by psychotic suffering. The great weakening of the traditional criteria for art and their replacement by more diffuse, liberal, and nearly universal ones has made it especially hard to decide when the effect of psychosis on art has been constructive and when destructive. I find some grim amusement, however, in the complaint that the praise now lavished on schizophrenic art arouses the same affectations and imitativeness in its creators as we find in professional artists. Originally, says the complainer, schizophrenic art derived its strength from its opposition to the prisonlike atmosphere of mental hospitals; but now this strength is neutralized by paternalistic benevolence, while the mind and art of the insane are degraded by antipsychotic drugs.

Psychotic or near-psychotic suffering appears in the recorded history of Chinese as well as European art. Examples are the painters Hsü Wei, of the sixteenth, and Chu Ta, of the seventeenth century. Both seem to have been schizophrenic, at least at times, and driven to unusual spontaneity by unusual suffering. Both proved organized enough

esthetically to remain honored, though eccentric, members of their tradition.

Hsü Wei's father, a retired official, died the year he was born. When he was nine, his mother, a concubine, was driven from the family, after which his stepmother raised him adoringly; but she died when he was fourteen. Hsü was extraordinarily precocious—at seven he was composing poetry and essays—and many-sided, with ability in music, swordsmanship, calligraphy, and painting. He was struck, however, by two Chinese forms of disaster: he repeatedly failed advanced examinations for the civil service, and later he became politically suspect when his employer, the provincial governor, was accused of plotting against the government. As the story goes, Hsü, afraid of being implicated, pretended he was mad; but the pretension was or became reality, as he showed when he drove a nail into his ear, cracked his head with an axe, and smashed his testicles. In a poem he said of himself, "He wore the ancient sage's outfit and simulated madness/Fought time and again to be a normal being." A year later he stabbed his wife to death. His friends got his death sentence commuted to a long imprisonment. During his last decades, he was poor, drunk, and mentally ill, though admired as a writer, calligrapher, and painter. Having alienated a son and friends, he died, altogether poor, at the age of seventy-three.

Hsü's surviving masterpiece, a scroll of a succession of flowers, fruits, and trees, is said to be overpowering in the original, which is an extraordinary reconciliation of "the excitement of ink-and-paper calligraphy with a deep commitment to the object, its underlying nature and its visual properties." The momentum of Hsü's brush is sometimes so violent that the object he means to represent can hardly be made out. However, extraordinary as it may seem, the impetuous release of the brush and mind gives no open sign of suffering. (In the so-called Heiligenstadt Testament, Beethoven wrote that if not for his art he might well have committed suicide; but the first movement of the Second Symphony, composed, it seems, at just the same time, is in a mood of relaxed serenity.)

Of Chu Ta, also called Pa-ta-shan-jen, an old biography says, "His mind became confused and he was no longer master of himself. Later he went mad and he spent his days now laughing aloud, now crying out in agony. . . . One day he suddenly wrote the character *ya* [dumb] very large and attached it to his door. From this moment on he never again

104

exchanged a word with anyone, but he liked laughing and drinking even more." Another, later biography, tells that his father, a well-educated man skilled in painting, was unable to speak. "When his father died after the fall of the dynasty in 1644, he pursued his father's intention and also became dumb" for a time, communicating with people by nodding his head and using his hands. His character, the first biography says, "was at once ebullient and melancholy; in addition to this he was unable to relax and seemed like a river bubbling up from a spring that is blocked up by a large stone or like a fire smothered by wet leaves."

It has been suggested that Chu Ta's mad behavior was meant only to shield him from political retribution; but his biography makes this suggestion implausible. His most individual paintings are of birds, rocks, fish, and flowers. His birds are strangely alert and sullen, his fish appear to swim in the air, his sharply bent flower stalks seem almost pulled down, and his "mad" calligraphy is "exceedingly remarkable and strange." His poetry, too, is strange, and must, if it is to be grasped at all, be grasped intuitively. Altogether, he is strange, spontaneous, paradoxical, and (who knows?) perhaps humorous. Humor, I must add, is difficult to reconcile with psychosis.

Those who have wanted to be spontaneous, whether like children, or somehow like the insane, were antagonistic to convention. In or out of art, their antagonism might be expressed in a general defiance of social norms. Baudelaire had a horror of tedium or world-weariness, *ennui* in his vocabulary, but found it was creative in that it mobilized his imagination, which made him an armchair virtuoso of crime. To keep his imagination in a state of creative excitement, he teased himself, played with his desires, and imagined erotic and sadistic fulfillments.

Baudelaire's attitude had a good deal in common with that displayed in more drastic forms by the Dadaists and Surrealists, who hoped to unite sexuality with primal innocence, though not without outraging the sanctimonious. The Surrealists were taken with de Sade and accepted his principle that everyone had a right to the pleasures of sadism, perversion, and revolt. Some of them preferred "elective love" to "libertinage," but their art played with everything desired and forbidden.

Such play has an aura of Indian and Taoist mysticism because it

recants moral scruples in favor of salvation. It is closer to Taoism when it advocates absolute naturalism, an easy abandon. With nature and naturalness as the ideal, conscious choice is apt to be regarded as separating the chooser from nature and from everything that happens naturally, by itself. In opposition to the artificiality of social and moral demands, nature in itself, or chance in itself, becomes the source of action. I therefore turn to the achievement of spontaneity by means of chance, and I begin with China.

In China, one often probed the future by using the chance method of *The Book of Changes*. To be exact, one learned to read the balance of cosmic forces by allowing nature to show its intentions spontaneously, the "chance" result being the opposite of the merely accidental. Such faith in nature's self-disclosure was expressed esthetically by an intense, empathic interest in natural forms, among which I shall later single out old trees, and in the collector's passion for odd-shaped rocks, pitted and cut through by natural forces. To the Chinese, these rocks were works of art produced by nature; and because they saw the artist as the concentrator of natural forces, who focused them rather as a lens focuses light, the creation of works of art by nature did not pose them any metaphysical problems. Esthetes who collected "dream-stones," interestingly marked, perhaps landscapelike pieces of marble, might sign, title, mount, and inscribe poems on them.

In Chinese painting, the purposeful use of chance goes back at least to the eleventh century, when a painter advised that a natural-looking landscape painting could be inspired by the appearance of white silk spread over a ruined wall. Struck by this idea, Kuo Hsi, also of the eleventh century, built "shadow-walls" with protuberances and hollows that suggested landscapes as natural as those "made by Heaven." The method both stimulated the painter's imagination and strengthened his collaboration with nature.

Europeans exploited chance in similar ways: striations of gems suggested the lines on which the gems should be carved; images discovered on freshly cut marble showed what nature, the artist, had devised within the stone; and polished agates were seen to contain landscapes that encouraged the painter to complete them. Among the painters, Botticelli exploited chance by painting landscapes on the lines of stains made by throwing a color-saturated sponge at a wall, while Leonardo searched for compositions in wall-stains, stones, clouds, and mud, for their pat-

terns resembled, as he said, "the sound of bells, in whose pealing one can find every name and word you can imagine." Later, in the eighteenth century, Alexander Cozens taught landscape painting with the help of "artificial blots." He advised that "a great variety of the smaller accidental shapes" could be produced by the crumpling of the paper on which the blot was to be made; and he added that, when the blot was retouched, its persuasively natural, because accidental, form should not be compromised.

As our art histories all repeat, the Futurists and Dadaists escaped logic by making collages of torn scraps of paper fixed where they fell, and poems of words drawn at random out of a hat or chosen with closed eyes from a newspaper. The Surrealistic solicitation of chance had more positive intentions. André Breton insisted at first that the only authentic way to produce art was by dreaming and automatic writing. Drugs were used but in time interdicted, as were also work and money, which interfered too much with the natural pleasure of creation. Love, the contrary of work, was recommended, along with the revolution that was destined to free love, and along with eloquent suicide.

I no more than mention John Cage and his aim to become as indeterminate and purposeless in creation as nature, and his friend Robert Rauschenberg, who tries to make his pictures more interesting by weakening his control over them.

It is evident that the Dadaists' interest in chance, oddity, and accident, or their interest in what to others is obscene or revolting is not a singularity in the history of art, something that uniquely characterizes our own time for reasons connected with the First World War and other unique social phenomena. On the contrary, the Dadaists, Surrealists, and the others who resemble them, have been fulfilling an ancient, ubiquitous, and apparently quite necessary function in both a social and artistic sense. It is a function that relates logic to illogic, order to disorder, morality to immorality, peaceableness to violence, and restraint to unrestraint. The function itself expresses the feeling that to be safe one must first be endangered, and that to be redeemed one must first fall; but it expresses more.

To begin the explanation of what is a well-known sociological and anthropological theme, I should like to recall a Yoruba folk tale. The tale is about two gods: Eshu, who may inadequately be called Accident, and Iku, who is Death. Eshu is by nature hard to understand. Whenever

107

he appears, something unexpected happens. He lurks at gateways, on the highways, and at the crossroads, and at each of these places he introduces accident or chance into the lives of human beings. It need not be said that he causes them a great deal of trouble. He is, however, a great and complex god, "a confusion of images and a fusion of powers," an embodied, deified paradox, who is invisible except for his enormous size, all black and all white, and all mischief and destruction; but who is also instinctual energy and masculine strength, the potentiality for change, the gods' messenger, and the guardian of the way of life.

Now to the tale. In spite of Eshu's power, there was one being who did not fear him. He was Iku, Death. Hearing what Eshu did to harass people, he asked why he went unpunished. The answer was always that anyone who tried to berate him would suffer disaster. Iku, Death, was not afraid and said he would deal with Eshu, and he sent a message throughout the land that he would meet Eshu in battle. In Yoruba fashion, each god came with his retinue of singers and drummers, and people came from everywhere to see the battle. I omit the battle itself as too stupendous to recount here; but at last Iku, Death, threw Eshu, Accident, to the ground and was about to club him to death when Eshu's friend, the god who could see the future, came forward, took Death's club away from him, and saved his friend. Although Eshu was defeated, he lived on. People said, "One cannot take life away from Death"; but Accident, who is also Uncertainty, continues to live along with Death and continues to interfere constantly in our lives. There can be no better explanation for our inability to understand the reasons for whatever happens to us. (As Euripides says at the very end of the *Bacchae,* "God finds a way that none foresaw.")

The Yoruba god Accident, like the Dadaist and Surrealist, has much in him of what anthropologists call the "trickster" or the "clown." The trickster exists everywhere among African and Amerindian tribes. In Africa, the Azande know him as the Spider (Ture), he who by his own description "tricks people all the time." Being quite without inhibitions, Spider breaks every Azande rule. He kills his father, tries to kill his wife, sleeps with his mother-in-law and probably his sister; is vain, greedy, ungrateful, and treacherous; lies, cheats, seduces, and murders; and brags about everything. When, however, his feathered hat on his head, he becomes absorbed in singing and dancing, when he teases whimsically, or when he breaks conventions recklessly, he shows himself to be

an endearingly innocent monster, and the Azande sympathize with him in his many frustrations. After all, he is only an Azande, with more-than-Azande powers and fewer-than-Azande inhibitions.

The best-known of the Native American tricksters is Coyote, who is in equal measure the clever deceiver and the stupid blunderer; he is also the culture hero, and sometimes the primary Creator. The trickster is variously named Old Man, Raven, Mink, or Blue Jay. The Winnebago's trickster, whose name means "The Tricky One," is known to us in some detail. We know that until briefly tamed, he accepted no responsibility for his actions, and he was such that the laughter he excited was tempered with awe. An old, conservative Winnebago said of him:

> It is true that he commited many sins, yet he never committed any sins at all, because through him it was fulfilled that the earth was to retain for ever its present shape, that nothing interferes with its proper functioning, that men die, that men steal, that men abuse women, that men live, are lazy and unreliable—yet he never waged war. He roamed about the world and loved all things. He called them all brothers yet they all abused him.

The trickster is a mythical figure, but the clown gives him a human actuality. Among the Native North Americans, clowns wear rags, beg or steal food, make fun of themselves and their religion, and talk sex, sing sex, and act out sex. It was and is the clown's business to be extreme. Pueblo clowns used to drink urine and eat feces; Kwakiutl clowns' practical jokes were sometimes fatal; and Navajo clowns still show up the priests' sleight-of-hand and disrupt their ceremonies with ridicule. The newly initiated clowns of the Dakota (Sioux) Indians still illustrate the deceptiveness, the awesome contrariety of life by speaking in a contrary manner, doing the opposite of what is expected, and, fittingly enough, riding their horses backwards.

Like the tricksters, the clowns are voracious, sly, mocking, sexual, disorderly, inconsistent, ambiguous, ambivalent. They are the Eshus who add disorder to life and mingle the forbidden with the permissible, as it must be mingled if the world is to continue to function. It is they who, in defying all that is orderly, acceptable, and sacred, connect mankind with all that is disorderly and therefore incomprehensible and therefore also sacred. They confuse and conflate sacred, secular, and profane. They are Hermes, Loki, the medieval jester, Reynard the Fox,

Gargantua, and Felix Krull. They are the Hindus who break every most sacred rule of ordinary Hindus, they are Shiva in his dark, graveyard-haunting guise, perhaps they are Japanese fox spirits. And they are the "crazy" Romantics, "crazy" Taoists, Dadaists, Surrealists, Neo-Dadaists, and the louder, rawer, more obscene participants in Happenings or Rituals of Cruelty. To descend from the cruel to the trivial, they are also Nam June Paik cutting off mens' ties during theater intermissions, and Charlotte Moorman playing the cello bare-breasted, and whoever else in art goes far beyond the limits of decency.

It is the tricksters and the other kinds of unpredictable, negative or negative-seeming, surprising, cruel artists, who make of art not the orderly rendering, for human purposes, of whatever in the world is alien or chaotic, not the neatly controlled substance that artistic tradition wants to impose, but a representation of the alien by the alien, the cruel by the cruel, the unpredictable by the unpredictable; and so they create a rawer, more disconcerting, perhaps truer nature-simulacrum, and so take us back to an immoral indifference that sinks us into the amoral, indifferent universe, the great ocean in which we can swim most easily by mystical identification with it.

This tricksterism represents an unending tension that can never be thought or legislated away or fixed in its due strength. In more or less recent art there are many witnesses to this tension, notably the Dadaists, some of the Surrealists, and individuals such as Yves Klein, Piero Manzoni, and Joseph Beuys.

Let me evoke some artist-witnesses:

The Dadaist Hugo Ball justified his new, plastic, illogically constructed language by arguing that although people might smile, language would be thankful, for he had "charged the word with forces and energies which make it possible to rediscover the evangelical concept of the 'word' (logos) as a magical complex of images."

The sculptor César (César Baldacci) said, "I think ambiguity is the very meaning of life, it's the flow of intelligence in the animal state, the pure state."

The artist Claes Oldenburg wrote:

> I am for an art that does something other than sit on its ass in a museum. I am for an art that grows up not knowing that it is art at all, an art given the chance of having a starting point of zero.

. . . I am for an art that takes its form from the lines of life, that twists and extends impossibly and accumulates and spits and drips, and is sweet and stupid as life itself."

As we have been seeing, there are many reasons for wanting spontaneity and many methods for summoning it up. For the creative individual, the disappearance of spontaneity or of its twin, inspiration, is a cause for great anxiety. This is true even if he belongs to a group, such as the Eskimo, that may be supposed to be constantly and easily spontaneous. No, inspiration is summoned actively. In the Gilbert Islands the poet calls for inspiration to come from above and below; in Mexico the Aztec poet calls the flowery songs to bud within himself and, like rain, to refresh other persons; on the plains of North America the Native American seeks power-giving inspiration with the help of dreams, drugs, isolation, and selftorture; the Eskimo poet finds his words as he walks alone in the snow; Stockhausen rejoices in the purification that allows him and his musicians, though unrehearsed, to play superlatively well.

Oppressed by the absence of inspiration, the Netsilik Eskimo Piuvkaq chants that it is lovely to put together a bit of song, but that he often does it badly. As he fails in hunting, avya, his wishes all slip past him, for it is difficult, avya. "I recognize what I want to put into words,/ but it does not become well-arranged,/ It does not become worth listening to;/ Something that is well-arranged, avayaja!" It is often difficult, chants Piuvkaq, to put together something in haste worth listening to, and he has, maybe, put together something awkward.

Spontaneity, nothing to begin with but unpremeditated, heightened self-expression, turns into the conscious need to reexperience the surge of creative power that, coming as if from nowhere, seems to lodge in the artist, use him as its instrument, and make him more than himself. After it has become this conscious, troubling need, one searches for it and tries to restore it even, as we see, in the complaint one makes of its absence.

To enjoy the pleasure of spontaneity, to want and sometimes to miss it, creates the unending search for it and evokes the anxiety that it may never return.

There is no need to give Western instances of such anxiety, so I take one from China. It is an excerpt from the long and brilliant *Exposition*

111

on Literature (Wen-Fu) composed by Lu Chi, who lived in the latter part of the third century A.D. When inspiration comes, he says, it cannot be checked, and when it goes, it cannot be stopped. Sometimes it vanishes like light, and sometimes it stirs like the sound one becomes aware of. At its height, fountains of words flow from the lips and teeth, the brush and silk capture the luxuriant, powerful splendor of the words, and the brilliance of the words inundates the eyes as their rich music fills the ears. But when the emotions run sluggish and the will strives but the spirit delays, feeling withers like a withered tree, the mind empties like a dried-up stream:

> *Even though this matter rests with myself,*
> *It is not within my power to control it.*
> *Thus, often I stroke my bosom and sigh,*
> *For I have not understood the causes of its ebb and flow.*

CHAPTER FOUR

Selfless Tradition

Now that contemporary art, with its love for the new, and spontaneity, with its love for the immediate, have been discussed, I should like to take up their opposite, tradition, which sets fixed rules, lives by imitation, and considers the individual artist to be only the agent of old, authoritative doctrines, symbols, and methods, any of which (barring authoritative inspiration) it is wrong to alter and destructive to abandon.

The dramatis personae of my argument have already been introduced. Aside from ourselves, the heirs of the tradition stemming from the Greeks and Romans, they are the "primitives," the Indians, and the Chinese and Japanese, the last two most economically grasped as belonging to a single though varied tradition. I do not want to become involved in a discussion of the entire cultures of India and China, because I hesitate to begin an analysis that could easily overflow the bounds of this book, which I regard as an essay; and so, in relation to India and China, I must rely less on explanation and more on the context of the argument. In relation to the "primitives," however, the need to charac-

113

terize and the difficulty in characterizing are so great that I feel I must confront them directly.

My consistent use of quotation marks around the word *primitive* is a sign that the word is both misleading and necessary. Some anthropologists seem to have abandoned it, but those (the majority, I think) who have continued to use it have tried to rid it of its directly prejorative associations. The people they designate as "primitive" are assumed to live in small groups (hence the also misleading designation "tribal"); they are taken to be innocent of writing and, of course, of our exact, mathematics-related science and machine-based technology. But the term *primitive* is perhaps irredeemably freighted with negative associations, such as "simple-minded," "wild," "crude," "undeveloped," "barbaric," and "savage." There are also, to be sure, positive associations of a romantic kind, such as "primal," "natural," "basic," "attuned to nature," and "uncorrupted."

One of the more blatant difficulties in using the term *primitive* is that there are so many kinds of people labeled with it. Furthermore, we have learned that their "preliteracy" cannot be taken to mean "insensitive to literary values." As the chapter on spontaneity has intimated, some "primitives" have had rather elaborate literatures, including what may well be considered epics. The "primitives" who had relations with Islam did often have literate persons among them. Without going further into the status of literature among "primitives," I find it easy to say that the criterion of preliteracy is misleading. So, too, is the criterion of tribal organization. This is not only because of the many meanings the word *tribe* has been required to bear, but because there have been many African "primitives," among the Yoruba, for instance, whose lives have been more or less urban for centuries—in West Africa, towns and cities came into existence long before Islam.

A pervasive shortcoming of earlier anthropology, as I see it, has been the constant tendency to make biased comparisons: a "primitive" folk belief or practice is compared, not with a folk belief or practice of the anthropologist's own culture, but with the attitude of a positivistic scientist to his own science or with an idealized account of the application of scientific method. Things look different when the comparisons are made of the ideas of ordinary with ordinary persons, of philosophical with philosophical persons, priests with priests, faith healers with faith healers, herders with herders, craftsmen with craftsmen, and so on.

Writing has given our literature and thought a cumulative complexity, a copresence and mutual dependence of texts, that has been mostly denied to "primitives," I assume; yet there are revealing comparisons to be made, not necessarily to the disadvantage of the "primitives." I have yet to come on a partisan of the Western intellectual tradition who has made a serious comparison of the early, searching, inconclusive Socratic dialogues with the sharp, inconclusive dilemma tales of the Africans, which engage the Africans in extended discussion, or of these tales with Jesuit or Kantian casuistry or with Zen koans; or a comparison of Western existentialistic views, whether those of Heidegger or Sartre, with those reported by Rasmussen, for example, of Eskimo shamans; or, for that matter, of the views of god, destiny, or life that have been expressed by more intelligent "primitives" with those we ourselves cherish. The balance is being redressed, sometimes with a natural vengeance, by African and Native American writers and anthropologists who have assimilated Western culture enough to measure or attack it in its own terms. (The Angolan poet Antonio Jacinto writes, "my poem is I-white/ mounted on me-black/ riding through life.") But whatever we think of the response of Western-educated descendants of "primitives," it remains true that the anthropologist often compounded his shallow understanding of the "primitives" he studied with a shallow, insufficiently qualified understanding of his own people.

The older view that "primitives" think only mythically or magically has been abandoned for the most part, and when it is still held, it is with the caution born of long controversy. At present, even the anthropologist who believes that "primitives" are unaware "of the possibilities of purely logical deduction" qualifies by adding, "There is no evidence that primitives use a *different* logic from that recognized by Western philosophers." He also adds that their thought is well adapted to the size of their communities and their largely homogeneous lives, and is capable of profundity in spite of the relatively simple cognitive processes that underlie it.

There have been reports, it is true, that "primitives" cannot at first make out the content of realistic drawings or photographs, or, if they can make them out, give them peculiar interpretations. There have also been contrary reports; but even if some Africans have had difficulty with photographs, I should suppose that it was the result of inexperience compounded by culturally different habits of perception. In other words,

their difficulty, if accurately tested and reported, was also a sign of the "primitives' " humanity, that is, of their acquired culture and not their "primitivity." After all, as I have pointed out, even apes with suitable experience have been able to make out the content of photographs and make out the difference between them as representations and whatever it is that they have represented. A recent survey of psychological studies of "primitive" Africans says, skeptically, that the studies show how great the variety is between different African groups, but that the understanding of personality in Africa "is still in a delicate and uncertain condition."

Let me be quite subjective for a moment. To judge by my own reading, it is rare to find an anthropologist who has actually lived in some "primitive" group for a considerable length of time who has not learned to respect at least some of his hosts as able and intelligent persons. Anthropologists who keep returning to the field keep being reminded that "primitive" tribes are individual and that the tribesmen who make up each tribe are all individuals in their own right. Even though the social relations in a tribe or village are close, there is no single tribe- or village-soul or temperament that can be grasped all at once. How could there be, when each tribe is composed of individuals, every one of them with his own nature and history, and when there are so many hundreds or thousands of different tribes, speaking so many different languages and living in so many different environments?

The material poverty of some "primitive" life is easily misunderstood. The Australian "aborigines," to whom I shall return, were, as they are, very poor in a material sense. They never wove or made pottery, their shelters were of nothing more than grass or bark, and, before the coming of the white man, most of them wore no clothing. Yet, poor as they were materially, they had a vigorous sense of craftsmanship and beauty, their memorized literature was rich, their ceremonial dancing was complicated and precise, and their religion was sensitive, imaginative, and not at all simple. They were and remain extraordinary trackers. They had and have a good sense of humor. There is no obvious reason to look down on them as persons or as artists—I have reported Picasso's message of respect to one of them.

Although we have learned so much about "primitives," we know so little about them in detail and in general, that it is best to particularize a good deal before trying to generalize. For the record, then, I particularize

a little to show how one well-researched study of a "primitive" group led to an unexpected conclusion, and how, in another instance, a favorite romantic stereotype concerning "primitives" was verified, or rather, rejuvenated.

The first study is of the !Kung, a San- or Bushman-speaking people of southern Africa, more precisely, of the Republic of Botswana, who live by hunting and gathering. It appears that the life of the !Kung, though it has its times of crisis, is (or was recently) on the whole easy, and that they have a good deal of leisure and that a fair number of them live relatively long. The !Kung have been described as happy (at first with a degree of romantic exaggeration), and the anthropologists investigating them have remarked on how often they laugh (at least part of the remarked-on laughter has been caused, an anthropologist reports, by the anthropologists themselves, whose oddity the "primitives" find very entertaining).

A woman anthropologist who has made a painstaking study of individual !Kung women reacts against the dismissal of "primitives" as too foreign for us identify with. She writes:

> This study has carried us beyond this prejudice by presenting the !Kung as *people*: reluctant to leave friends, sometimes loving and sometimes angry with those they love, sad and happy at the changes of the seasons, wanting to live good lives. Underneath all the obvious differences, they are, after all, not so different from ourselves.

The most unexpected observation on the !Kung is their ability to think along lines we identify with the "logico-deductive model" of science. This observation is based on prolonged, careful discussions between !Kung hunters and anthropologists, the latter having enlisted the help of ethologists. The discussions show how careful the !Kung hunters are, in discussing the animals they are familiar with, to distinguish between hearsay and reliable data, and between reliable data, their actual observations, and reconstructions from tracks or theories of animal behavior. The !Kung report new behavior, conduct skeptical discussions with one another, and admit ignorance readily.

Their "animal seminar" impressed the anthropologists with the "primitives' " patient, accurate observation, "breathtaking" volume of knowledge, and elegant deducation from animal tracks. Even the poor

theoretization of the !Kung was considered to be the same in kind as that still made by many highly educated Western scientists. In brief, "Just as primitive life can no longer be characterized as nasty, brutish, and short, no longer can it be characterized as stupid, ignorant, or superstition-dominated." Whatever exaggeration there may have been in the estimate of !Kung happiness, by our usual standards of humanity the !Kung are (or were recently) decent, sensitive, and civilized.

The second instance, the one that I said fitted a romantic stereotype, concerns the Dogon. These "primitives" inhabit cliff villages in West Africa, in the central bend of the Niger River. The study in question was made by a group of psychoanalysts who took as their subjects a number of Dogon from the villages of Sanga. How really adequate the study was I do not know; but the researchers had more psychological perception than ordinary anthropologists. They were deeply impressed by the ability of the Dogon to use their masked dances to sublimate and control their deep fears. The Dogon life, lent assurance by the long period of closeness to the mother, proved less troubled by doubt and disappointment than that of ordinary Westerners:

> The Dogon who participated in our interviews are not childish or primitive. They are more exposed to external dangers than are Occidentals, but they experience less anxiety. They are more dependent on human company but are in contrast less solitary. They are less pursued by their internal conflicts and they get along better with their likes than we with ours.

The least moral to be drawn from the preceding evidence is that we should be cautious in generalizing about "primitives," should anchor generalizations in carefully considered examples, and should understand that the generalizations, though they fit the examples, may still be questionable in relation to the whole heterogeneous category of "primitives." If we hope to be exact in speaking of "primitives," we must ask which "primitives," at what point of their existence, and in what respect, we want to understand. We should forbear to think of them as living in automatic conformity to the generalizations that anthropologists have made about them as a whole or as any particular tribes. We should remember the great difficulties under which anthropologists have done their research and the fallibility of their observations and, even more, of their conclusions.

Despite all these cautions, I should like to begin my discussion of traditions by ascribing to "primitives" the set of attitudes that may reasonably be called "traditionalism." I shall have to qualify this later; but it makes sense to precede the qualifications with an attempt to characterize traditionalism, to which primitives, too, mostly adhere (ignorance of their history may make their adherence seem more complete than it has in fact been). Traditionalism is a world-view that is simultaneously metaphysical, religious, and esthetic, and by design and nature, prescriptive. According to this world-view, philosophy, or set of attitudes, the universe in all its variety is present in each of its fractions or manifestations. Each of these can influence all the rest, and such influence, in varying degrees of potency, is expressed in the endless, vacillating tension between the poles of cosmic order and chaos. Order is equivalent to all that is constructive and beneficient, but it is not enough to constitute the universal process, which requires chaos as well. Chaos, varying degrees of which are inevitable, is equivalent to destruction and evil, even though, as part of the unceasing universal process, it is essential to its creative ferment. Traditional priests and thinkers side with and try to augment the order; but there are always those who, openly or secretly, identify themselves with the nonmoral whole of order-and-chaos, or even with the chaos forces.

According to the predominant view of traditionalists, human wisdom and goodness consist in performing the acts, individual and collective, that strengthen order and diminish chaos; for everything that is done, not done, or undone reverberates in the field of reality and has its ordering or disordering effects.

In the context of such a view, every form of human expression has a direct or potential effect. The word, the gesture, the tone of the voice or the musical instrument, the movement, the mask, the costume, the role in the ceremony—all, if right, are a participation in and a strengthening of the invisible power, which is perhaps redirected, or reconcentrated, to the benefit of those who are attempting to strengthen the order that encompasses and protects them. Because the world is deeper than people can ordinarily fathom, the meaning of everything is augmented by its secret sense—the ceremonial words the meaning of which has become obsolete are the more sacred for their obscurity. They may be fully explained to those who want to know; their meaning may be kept secret

from everyone who has not been specially initiated; or the deep sacred meaning may be kept as a revelation for the rare persons who will pass it on from generation to generation. Whatever the degree of secrecy, understanding is known to take persistent effort, intuition, no doubt, and sometimes the unpredictable favor of the spirits, the gods, or (in the absence of a better general name for them) the cosmic sensitivities.

In traditionalism, especial power is attributed to the word or formula, the chant in which it is conveyed, and the music that is inseparable from it or is its nonverbal equivalent. Creation itself is often attributed to the power of the word: the word by which the Egyptian god Ptah created, the word by which the Jewish god Jehovah created, the *bhuh* by which the Indian god Prajapati caused the earth to be. In ancient India, Syllable, Name, Speech, and Formulation are given the status of creative gods. Speech, the goddess and mother of the Vedic hymns, says of herself that she is the first of beings worthy of reverence and that, like the wind, she pervades everything. The efficacy of the Vedic rites depends on the power of their words, properly intoned. In later India, a philosophy of grammar was conceived according to which there is a Supreme Word, beyond time, which is the self-luminous principle that dispels ignorance, for which reason the science of grammar was held to be the doorway to the soul's emancipation. Because of the supreme status of the word, vocal music was said to be pure sound, but instrumental music only sound's manifestation.

I add two further "primitive" examples of the traditional power of the word or chant, one from the Navaho, the other from the Dogon. Among the Navaho, the song is known to preserve order. When anyone is alone and fearful, the sound and words of a song dissipate the surrounding evils. The primal teacher of songs to the Navaho had warned them that the day they forgot the songs she had taught them would be the last of days. "There will be no others," she had said.

Among the Dogon, everyone regards words as the universal key to understanding, for the universe is taken to be a book the texts of which must be deciphered. Each person learns the symbolic relations of words to the organs of the body, the crops that are cultivated, and the cloths that are woven, and specialists learn the relations of words to the objects they deal with, such as, in the case of a tool maker, the iron implements that are forged. With the help of the sage, "he who knows the word," the person impregnates self, crops, and possessions with the vital force.

Words, the person's most refined and potent creation, give the ability to understand and master the symbolic correspondences of nature and maintain human rule over nature.

To show the traditional power of music, I begin with Chinese and go on to African beliefs and practices. Throughout the history of traditional China, music was ascribed such moral, ritual, and cosmological importance that an imperial Bureau of Music busied itself with its regulation. Confucius himself was said to have played music, to have recommended music for self-perfection, and to have been entranced on the occasions when he heard beautiful moral music. In the Confucian *Book of Rites,* music is taken to reflect human emotions and character directly. Therefore a country's joy, turmoil, sorrow, lewdness, effeminacy, dullness, or harshness are reflected in its music. "Music is the one thing in which there is no use in trying to deceive others or make false pretenses."

The musical instrument most closely related to the traditional Chinese art and attitudes is the *ch'in,* a long seven-stringed zither commonly known in translation as a "lute" (the true lute was looked down on because of its Persian origin). The life-spirit of the *ch'in* was enhanced by strings twisted of silk drawn from living silkworms and was demonstrated by its ability to purge from disease, deepen meditation, and elevate character. The favorite instrument of Taoist and Buddhist monks, its purity was maintained in the Ming period by forbidding anyone to play it in the presence of uncultured persons; and women were (unsuccessfully) forbidden to play it. The beauty of its music, which required years of difficult practice to attain, resided less in the succession of notes than in each note with its own exact timbre. No fewer than twenty-six kinds of vibrato were enumerated; and because suggestion and "unheard sound" were aimed at, the vibrato was continued long after the heard sound had come to its end. A fourteenth-century work on lute-tones shows with what subtle solemnity the instrument was invested. I quote a few sentences from its description of The Clear Touch *(Ch'ing):*

The movement of the fingers should be like striking bronze bells or sonorous stones. Slow or quick, no secondary sounds shall be produced, so that when hearing these tones one gets an impression

121

of purity—as of a pool in autumn, or brilliancy—as of the babbling water in mountain gorges, of profundity—as of a resounding valley. These tones shall in truth freeze alike heart and bones, and shall be as if one were going to be bodily transformed into an immortal.

For Africa, I depend upon a researcher who actually learned to play in an African group. As he makes clear, African music, unlike that of the Chinese lute, is for communal pleasure, and yet, like Chinese lute music, it is consciously meant to express the heart, for it is an emotion-speech, to be spoken steadily, cooly, and subtly. To play-speak this language for oneself, one must learn from others, for each musician's style is the modulation of the well-known, deeply felt tradition. Those who become master drummers have spent years playing the simple rhythms of supporting drums. The familiarity of the music makes each variation stand out as a testimony to the individuality the music inspires, assimilates, and grows by. As one of the musicians, Ibrahim Adulai, said, "When you make some music you add something to it, it means you have increased the whole music: you have added something which was not in the original music in order to keep up the music." Speaking like a Chinese, he said, "As you are beating it is your heart that is talking, and what your heart is going to say, your hand will collect and play."

Like the Chinese painter, the African learns different styles; and he earns more praise by the slight but significant variation of the known form than by simply fancy drumming. His hands guided by those of drummers already dead, he derives his strength from their support, just as his music derives its individuality from its respectful relationship to theirs.

Traditionalism requires everything to be constructed in accord with rules. Because they are known in detail, I shall concentrate on the rules of construction of buildings and statues in traditional India and Europe.

Building in India was subject to many rules. The very earth on which the building was to be erected had to be fertile, and its consistency, taste, smell, and color had to be propitious. I do not think it necessary to

repeat the building rules, but only that the science of architecture was a holy emanation from the gods. The master builder or architect was considered the earthly equivalent of the universal god-constructor, Vishvakarma. Each one of his four faces, tradition said, had given birth to another kind of architectural specialist: the master builder, the drawer or tracer, the painter, and the carpenter or assembler. For each of these, minute obedience to the rules promised good fortune and neglect of the rules fitting punishment. So, if the staircases were of the wrong size, "the master would be crippled," without any doubt.

Holy images, which were objects of veneration, supports for meditation and complete microcosms, were also subjected to many rules. The chief unit of measurement by which proportions were fixed was the palm of the hand, taken to be equal to the length of the face from scalp to chin. The purpose of some of the measurements is clear, though I forbear repeating it, while that of others seems enigmatic. I do not understand why a holy image should not have any "sharp definition of the muscles connecting the joint between two bones, however correct anatomically." A theological reason can no doubt be given, and it must be based on the desire to distinguish between celestial and human anatomy.

It should be understood that the rules allowed the sculptor some latitude. It is more interesting, however, that the rules were all subject to a paradox: despite the categorical wording of each text, there was in fact no universal canon, for Indian tradition is made up of many local traditions. Under the circumstances, it is hard to distinguish between conformity to an unknown local canon and deviation from it. In any case, application of the rules for temple building varied greatly; temple symbolism seems never to have conformed exactly to the rules we know; and actual measurement shows that practice varied considerably even from the canon supposed to have been applied to particular temples.

In Greece, there was a similar distance between rule and practice. The Roman architect Vitruvius projected his modular building method far back into Greek history; but the ruins of every Greek temple we know have different measurements from every other. Vitruvius claims that the proportions of the columns were based, to begin with, on those of the human body, and he agrees, as the Indians did, that the proportions of buildings should be human:

Since nature has designed the human body so that its members are duly proportioned to the frame as a whole, it appears that the ancients had good reason for their rule, that in perfect building the different members must be in exact symmetrical relations to the whole scheme.

Impressed by Vitruvius's ideal of perfect building, Renaissance architects measured classical buildings to discover the proportions that underlay their beauty; and they supplemented the ideal of human proportions with that of musical ratios, also supposed to reflect the harmony of the universe. Doubts expressed by eighteenth-century thinkers did not prevent the rise of neoclassical architecture. Today the ideal of human proportions continues to exist at least in the modular system of Le Corbusier.

To return to ancient Greece, the sculptural canon has been shown, after a good deal of controversy, to have been based upon an Egyptian canon, the influence of which was extended, through the Greeks, to the Renaissance and beyond. As every art history repeats, Polykleitos constructed a statue, *The Canon,* and wrote a treatise by that name to recommend "symmetry," a structure in which finger, palm, wrists, forearm, upper arm, and everything in the body are in definite proportion to one another, so as to reach "perfection through many numbers." The Greeks obviously had the same need as the Hindus to measure and set rules and to proportion the human being and the universe to one another. The Greek sense of human beauty tended for a time more to the ideal than the real. This is aptly illustrated by the report that when Zeuxis decided to paint a superlative Helen, he compounded his painting from the appearance of five beautiful virgins, "for he did not believe that it was possible to find in one body all the things he looked for in beauty, since nature had not refined to perfection any single object in all its parts."

Like Renaissance architects, Renaissance sculptors measured the surviving works of classical art and devised canons. The most interesting of the canon devisers were Leonardo, who investigated how human dimensions changed in the course of movement, and Dürer. The old analogy between musical harmonies and visual proportions received endless rhetorical embellishments and was extended by virtue of the new doctrines of perspective. The art academies that soon developed made the canon

of proportions an integral part of their teaching, as many generations of art students have experienced.

The classical Greek style, revived in the Renaissance, and revived again in neoclassicism, had a vision of beauty that has been called "ephebism" in honor of the youth, vigor, and beauty of the young Greeks who furnished its ideal and model. The ideal fitted the Greek reverence for well-fashioned human beings, athletes in particular, and the Greek opinion that physical and spiritual beauty implied and echoed one another. Greek gods could therefore be sculptured as human in form but godlike in perfection.

I do not suppose that ephebism marks every culture that may reasonably be thought traditional. However, it occurs often enough to show that it is a natural expression of a classicistic type or phase. Among the Egyptians, for example, portraits and other representations of human beings are usually idealizing. This holds true especially of representations of the pharaoh, who is shown in the full prime of life, healthy, alert, confident, his face unlined and free of any disfigurement. For a time, during the Twelfth Dynasty, the faces of the reigning pharaohs may reflect age or disillusionment, but even then there is no sign of ill health or deformity. The ephebic ideal is not consistently applied to captives and not at all to the occasional crippled or starving figures, who are mostly either peasants or serfs.

Much the same holds true of traditional India. In its art there is no old age and relatively little disease or physical deformity. Artists and patrons want well-made, fresh, flexible, sexually responsive youth. Gods and goddesses are young, the goddesses remaining an eternal, canonical sixteen years of age. For traditional reasons, elderly persons or dwarfs may be portrayed; but threatening, bloody, morbid images are the historically late results of the prominence of Tantrism.

Ephebism can occur in "primitive" sculpture as well. To be specific, it has been discovered in the sculpture of the Yoruba. Their rough, glaring, monstrous masks are designed to harass enemies; criminals, fools, and foreigners may also be represented as ugly by Yoruba standards. But the Yoruba ideal is neither realistic, nor expressionistic, nor abstract, but in between. A sculptor who would show his patron's warts or infirmity

would risk his displeasure and that of his family. Yet a human being is not be sculptured as something else, and a particular human being should retain something of his individuality. Age itself can be be symbolized by dress, hair-style, or ornaments, but may not appear in the features themselves, whose ugliness might be transmitted to the next-born of the family's children. This human agelessness agrees with an esthetic and a whole philosophy of equilibrium. An image should strike the mean between abstraction and resemblance, between childhood and old age, between faint and overconspicuous carving, and between light and shade. In keeping with the ideal of the mean, the Yoruba prefer a statue to be shiningly, but not excessively, smooth, which is to say, to have an only moderate polish and to be partly cross-hatched or otherwise cut into. They also prefer judicious proportions, proper roundness and proper angularity, and overall symmetry.

Moderation appears generally important in African tradition. The tradition of the Bassa, who live in the interior of Liberia, tell of a carver so infatuated with his wife that he secluded her and carved a mask with her exact likeness. When the mask was revealed in order to perform its ceremonial function, the elders were outraged that the carver had lost his equilibrium to the point of subjecting the clan symbol to merely human emotion. They punished the carver and "retired" his mask from use.

Traditionalism, with its stress on continuity from generation to generation and on reverent orderliness, is likely to diminish or erase the line we have learned to draw between the crafts and the fine arts. In accord with fixed standards, work is organized so as to protect its quality and its old forms and to rule out cheating, rebelliousness, and unfair competition, often simply the competition provided by a stranger. Whole specialized communities or organizations may be set up, often like enough to our medieval guilds to be called by the same name without serious misrepresentation. Apprenticeship is inculcated by ceremony, accentuated by personal service, and recalled by a gratitude that lasts in theory throughout life.

Consider an African apprenticeship. Among the Dan and Kran tribes, the apprentice carver learns by simple imitation. After two or three

years, when the apprentice has learned enough, his master frees him to go back to his home town; but the new master continues to bring his teacher gifts and to consider him his superior. When a master dies, his inheritor, usually his son, steps across the corpse four times, bows to it, and makes motions symbolizing the taking over of the dead man's skills, saying, as he does so, "Give me your skill in carving." Together with the master's skill, he inherits that embodied in the master's tools.

In some African tribes, the process seems more fixed and the person of the craftsman more stringently regulated. Such may be the case among the Senufo, where the practitioners of each craft live in their own craft village and do the work that is passed on to them by their chief.

In India, too, a craftsman often inherits his craft from his father, and he, too, must be reverent to his teacher, his guru, and to his tools and materials, or rather, to the powers that lodge in them. He memorizes the traditional craft rules, put into rhymed form, learns the relevant craft mythology, absorbs his teacher's craft formulas and perhaps secrets, and participates in the many ceremonies of consecration. If he lives in the usual variegated village, he exchanges his services for those of others and continues to do some farming, as he must. In the larger cities there may be life-encompassing guilds, which lay down conditions of work and standards of quality, and which may also have their own houses of assembly, temples, pools, gardens, and monuments. Such guilds help members in need, convene their own courts, and expel undisciplined members.

In writing the last paragraph I was unsure to what extent I might still use the present tense. The great traditional work seems all to have been done in the past. To judge from the building records of a thirteenth-century temple in Konarek, complex work was organized like that on medieval cathedrals, though perhaps more fully. Not only were there distinctions between ordinary stonecutters, assemblers of stone into architectural forms, sculptors, and architects, but there were also doctors, barbers, waiters, torch replenishers for night-work, officials to maintain order, and Brahmans to perform the numerous and indispensable ceremonies.

In China, some of the craftsmen or craftsmen-artists (their control over materials sometimes verges on the unbelievable) were bound to their work in imperial workshops. Guilds, with functions like those in India and Europe, seem to have been confined to towns and cities.

127

Japanese craft-guilds, organized in family-centered schools, developed in the thirteenth and fourteenth centuries. Each constituted a world in itself, with careful genealogies recording the succession of masters and the subschools with their successions of masters; and with their own instructional manuals, craft secrets, and more or less philosophical or religious precepts.

With the organization of Western craftsmen I must deal even more summarily than with that of the East, by no more than a hint. In ancient Greece, crafts often ran in families. Much of what we know about the continuity of tradition from master to student comes from evidence relating to sculptors. It appears that freeman-apprentices were bound by agreements drawn up between masters and the apprentices' parents. In the Middle Ages, building workers were exceptions, no doubt because they moved from site to site, and masons were often free to make their own terms. The guilds, which were more solicitous of the master's than of the journeyman's advantage, established a full framework for the lives of their members. From the second half of the thirteenth century, demonstrations of skill, masterpieces, began to be demanded as a sign of full competence. The demand was made not only of painters and sculptors, but also of tailors, locksmiths, rope makers, cooks, and philosophers, the philosopher's test being the defense of his master's thesis. In 1516, the painters' guild of Strasburg even demanded originality. Was this a sign of changing times, or a recognition of what has often been tacitly understood? The relevant statute read:

> The candidate shall make his masterpiece an independently designed one, without using any model pattern and skill, but rather out of his own intelligence and skill; for such a one as makes the masterpiece in this way is one who can also make others after it, which may then be proper to him.

The rules and attitudes that characterize tradition may appear to be either harsh or forgiving, rigid or flexible. But when tradition is strong, its strength is not derived from a merely sacralized repetitiveness, but from the spontaneous participation it evokes. Tradition may exercise its power even in the absence of any pronounced feeling of social coercion,

because its ceremonial may be felt to be not a limitation of the individual's freedom, but the best means by which to express it. When I say this, I am thinking primarily of prolonged, elaborate ceremonies. These form a part of every tradition, but I find it easiest and least prejudicial to illustrate with "primitive" ceremonial. My illustrations are taken from the Elema, who live around Orokolo Bay on the head of the Papuan Gulf, and from the Dogon.

I should like to stress that among the Elema, individual freedom is more respected than among ourselves. Among them, no one, not even a child, is ordered about. When you ask about someone who is not present, the answer is, "His desire; he himself," and no person will speak for another. The chief does not expect or exact obedience, but voices collective decisions. This individual freedom makes the ability of the Elema to conduct their ceremony-cycles all the more surprising. A seven-year cycle is considered quick. Some cycles are still incomplete after twenty years, and a person cannot expect to experience more than three cycles in his own lifetime.

The program of an Elema ceremony-cycle was as elaborate as the years of its production were long. Of its many colorful and dramatic situations, the climactic one was the coming of the Magic People, after some twenty years of confinement, to fulfill their existence in dancing and merrymaking, led by "a tall fantastic figure, silvery white, its colored patterns in the atmosphere of the dawn appearing pale and very delicate."

This ceremony-cycle, which may be the longest dramatic performance ever given, contained everything: fellowship of rehearsal, brilliant spectacles, solemnity, tragedy, humor, and blissful dancing. Although it was believed to placate certain spirits, it was not primarily religious, at least not by the time when Europeans observed it, but was undertaken because of its great dramatic interest, its enlistment of every Elema ability, its uniting of the Elema in pride, and because, as the Elema said, it was "the fashion of our ancestors."

My illustration from the Dogon is also a prolonged ceremony, called the Sigui. It is repeated once in sixty years, when the Great Mask is rotting and a new one must be carved. This Great Mask is of a flat serpent, its rectangular head pierced by two eyes and crowned with a huge, perhaps twenty-foot-high finial. The mask is far too large for anyone to wear, and it is hidden in a cliff-cave known to only a very few

authorized persons. The ceremony repeats the first, primal disobedience and the first death, which resulted from the disobedience, and the process by which reparation was made and the life-force, *nyama*, once again made to prevail. The mythology presupposed is intricate and partly recalled in a language unintelligible to most people; but the ceremony involves everyone, and it gives everyone the feeling that he or she is integrated into the same half-sensed, half-understood universe. The rules of the ceremony, and the cosmetics, sculpture, painting, poetry, and choreography that it requires, make the ruling Society of Masks into a kind of regional government and create a collective work of art, which is more than art because it is both the expression and mainstay of social and individual life. The mask maker must satisfy the elders who have instructed him, and the elders dominate. Yet some woman-masks are carved and worn because they are beautiful; some masks of new subjects are made; the members of the Society of Masks are eager to show themselves to be clever and elegant; and everyone recognizes his work and that of the others. Tradition, group, and individual, obedience and egoism, all are integrated and reconciled.

The flexibility of tradition in practice can be surprising to anyone who thinks of it as rigidly fixed. A student of Yoruba life finds their tradition to be constantly dynamic: the same god gets different names, new gods appear, and every place and person gives the received tradition a new form. He insists that even in a single town and even among the apprentices of a single master carver, traditional sculpture shows diversities that are both subtle and rich. However, tradition rules in the sense that significant departures from the customary must be justified by the nonhuman power, the *ashe*, that maintains the beneficent order of human life and prevents the intrusion of chaos.

The flexibility and integrative power of "primitive" tradition should not obscure the fact that ceremonial art has often been used to compel obedience, and that rites of passage often enlist pain and fear to drive home the lesson of obedience. Among the Mano of Liberia, groups of boys isolated and taught in the forest learned a lifelong awe of the spirits that dwelt in the mask and spoke through them in human voices. The owner of the Great Mask could walk into a turbulent session of the secret Poro Society and with a word, backed by the threat of death, make everyone prostrate himself until touched with the bundle of small sticks that the mask owner held. The masks could be passed on, with

their power, to new owners; but tradition kept their power within traditional bounds.

Apart from long and intimate experience, there is no way to get to know the web of connotations that makes traditional art so sensitively dense. However, I should like to give four examples, each of them developed only enough to hint at the depth that a tradition accumulates. My first example, a "primitive" one, is that of the Rainbow Snake of the Australian Aborigine's Dreamtime. The second, which illustrates Indian tradition, is that of Shiva as the Lord of the Dance. My third example, for China, is that of the Old Trees and their related themes. My fourth, for the Western tradition, is that of the nude standing male often called, to begin with, Apollo.

To understand the Rainbow Snake one must go back to the time when, the Aborigines believe, the earth was all a flat, unmarked plain under which their totemic ancestors were sunk in sleep. When these ancestors awoke to the work of creation, each one sang and created his particular rocks, hills, springs, rivers, or other landmarks, and his particular plant or animal and particular human beings, the life of all of which he in a sense constituted. The work finished, each ancestor sank back into sleep; but even while asleep he must be appealed to, by the creation songs he sang and the designs he revealed and continues to reveal in dreams, to renew the forms of life that issue from him. The vitality of each design depends on the vitality of the song that accompanies it, and the vitality of both together can be heightened by dancing or dramatization. Properly sustained, the design's vitality can keep children healthy, attract lovers, and make plants and animals fertile. Drawn on a human being's body, a design draws him more deeply into the cosmic and communal web of vitality.

The Rainbow Sanke is the great totemic ancestor who created and lives under the rock pools and waterholes. The lightning is his shining body. So, too, is the rainbow, which arches so strikingly over the desert plain. His signs are everything that glitters, from the quartz crystals and pearl shells that medicine men use to heal or kill, to the drops of water that hang over a waterfall. If his rules are not respected, the result is flood, disease, or infertility.

131

As late as 1974, there was at least one site, in central Australia, where annual Rainbow-Snake ceremonies were performed by the members of the Walbiri tribe. Their Rainbow Snake, whose paint was and may still be renewed at intervals, is nearly twenty meters long and is surrounded by inverted U-shapes, the symbols of child spirits, which can take animal form. Australian rock paintings, among them the Rainbow Snake, may go back some twenty thousand years. If they do, the Rainbow Snake may be an object of the oldest continuing religious belief and art in the world. Likewise, the ceremonial music of the Aborigines, which is unique in its structure and manner of production, may be the oldest still-practiced music in the world.

The Indian God Shiva is enormously powerful in all of his (to human beings) contradictory manifestations. As the power of generation, he is the phallus, and his spouse, his female counterpart, is the energy of the world; but he is also the universal celibate yogin, a haunter of grave-yards, and a dancing beggar. Our concern is with him as Nataraja, King of the Dance. He is not simply the King, but is dance and music in themselves, their indwelling energies, expressive forms, and constructive and destructive powers. In theological schematism, his dance is fivefold: of world-creation, world-preservation, world-destruction, illusive veil-ing, and salvation. His dancing is given sometimes baroquely eloquent descriptions—how can one describe the universe itself pirouetting and dancing? His great traditional performances include his dance as the world-activating Lord of Yogins; his superlatively erotic dance in the Pine Forest; his awesome cosmic dance; and his dance at the end of time, when he tosses mountains into the air, causes the oceans to rise, dis-perses the stars, and dances the world out of existence, though he also scatters the ashes and emits the rivers by which the world is recon-stituted.

In the Shiva-doctrine of Kashmir, on which I shall draw in discussing Indian esthetics, Shiva dances and *is* the dance of bliss in the hall of consciousness, the human heart. A seer, who is able to see inwardly, savors perfection when he witnesses and experiences this dance; for there, in the heart, Shiva dances and undances the cosmos. His raised leg is liberation, his raised drum sounds creation, his flame is the flickering of destruction, and his foot on the ground suppresses the demon and shows the god to be the cosmic axis. The circle of flames that may

surround his head is his flaming energy, or the flickering of his *maya*, his endless playfulness of creation and destruction.

The different forms of Shiva and their iconography are too complicated to be described here. Although the idea of his dance is very old, its representations in art become numerous only during what is called the "medieval period" of Indian history. The theme appears and reappears in the caves of Ellora.

I end what little I have been able to say about Shiva with the words of an Indian scholar who has studied him with reverent devotion, and who says that the Indian craftsman "who conceived and fashioned the form of Nataraja has undoubtedly created the greatest masterpiece of Indian art."

In China, the old tree was made a symbol of freedom and long life by the philosopher Chuang Tzu. Recalling the gnarled old tree he had seen in the mountains, he said that everyone had left it in peace because it was useless, its wood too soft, rotten, and crooked for timber, and its branches bare of edible fruit and attractive flowers. Recalling these words, an eighth-century Confucian poet wrote that a tree that had lost its leaves and branches still kept its wood-substance and ability to support fire; and a Ch'an poet wrote of a fabulous tree, older than the forest itself, that had lost everything but its core. Both Confucian and Buddhist made the old tree the image of human integrity and endurance.

Given this meaning, the old tree became a picture of the human being, or, more intimately, a self-portrait. At first it most often took the form of the pine and rock, later often of the wintry tree, and still later, in the thirteenth and fourteenth centuries, of the old tree with bamboo and rock. The pine was chosen because it was regarded as the king of trees and the symbol of upstanding strength, while the rock, its natural companion, was an enduring, stoical bone of the earth. By the tenth century or so, the pine and rock had become the symbols of the artist who painted them. The wintry tree recalled Confucius's statement that winter demonstrates that the pine and cypress do not fade. In Chinese poetry, wintry trees were sorrow, hardship, and old age, while the snow that lodged on them was their purity of spirit; and painting, too, adopted the theme. The tree of the tree-rock-bamboo combination was usually leafless, that is, wintry. The rock lent its immovable strength, while the bamboo, a favorite of the scholar-painters, lent its strength in pliancy.

During the Ming period, there were two especially memorable portraitists by way of trees, Shen Chou (1427–1509) and Wen Cheng-ming (1470–1559). Shen's art was the more mystically poetic, Wen's the more austere. To Wen, nothing in life came easily. Toward the end of his life, which ended at the age of eighty-eight, he became more and more preoccupied with old trees and rocks, the trees sometimes twisted and lonely and tangled in one another. In 1532, he painted his most famous version of the picture called *The Seven Junipers of Ch'in-chu*. Although I have read a somewhat deprecating comment on this picture, I have not seen even a reproduction of the one said to be its superior, and I remain impressed by its somberness and graphic daring. In his colophon, Wen writes of the trees, "Their branches sweep the lonely night like brooms," and "ten thousand oxen will not pull out their spreading roots, anchored in primeval soil."

So the old tree, upright and twisted, leafy and barren, represented the Chinese artist, his rectitude, his endurance, his pain, his refusal to betray his faith to an alien government, his premonition of death, and his sense of his natural existence.

The Rainbow Snake, the Dancing Shiva, and the Old Tree would be easy to compare with some motif taken from the Christian tradition, a motif with perhaps pre-Christian origins. I have, however, chosen a vaguer figure, the actual mythology of which soon lost its sense of conviction. I have chosen this figure because of its venerable age, its innumerable variants, and its penetration, too difficult for us to discern, into our habits of perception. I am referring to the standing male nude, which in its first appearance, in Archaic Greece, has been named "Apollo."

None of the Apollo-figures, which are Greek youths or *kouroi,* is a cult statue, and none is certainly a god. Because most of them are from sanctuaries of Apollo, they may represent the god's devotees. Those that are grave markers call up the dead man in his youth and vigor. Just why these figures are naked no one knows, though nakedness was usual in athletics. As these figures grow more realistic in the sixth century, they may well be related to the prevailing, though ambivalent, pederasty, which ascribed bravery in warfare to the desire of the male lovers to prove themselves worthy of one another. As the figures grow smoother and more pliant we begin to feel the devotion of the ancient Greeks to the beautiful human body, especially of the male. This male body is given ideal proportions by Polykleitos; it makes its appearance as the

figure of the athlete; and Phidias makes of it a great, beautiful, serene Apollo.

In the earlier Middle Ages, there is hardly any Apollo. He appears again, as strength, in Nicola Pisano; and then, nakedly beautiful, as Donatello's *David;* and then, upstanding, stalwart, and brave, as Michelangelo's *David.*

The standing male nudes of the Greeks suggest concern with manly strength, with pederasty, and with the ideal of the harmony of mind and body. The Renaissance nudes that draw on those of the Greeks tend to a spirituality with a Christian, Neoplatonic tinge; and so the resurrected ancient nudes, with whose help the human body was once again made flexible, given a clear articulation, and endowed with an inner structure as well as an outward presence, showed the artist how the human body could be a privileged object, the instrument of the soul, and the harmonious reciprocal of the universal harmony. "The philosophic love for boys" was reinvigorated for the sake of the aristocratic culture of the Medici period, and the nude figure, especially of the male, came increasingly to interest the Florentine ateliers. The adolescent nude of Donatello evolved into a sexually indeterminate adolescent that Botticelli, Leonardo, and others could associate with angels, a form that was an ideal combination of human perfection and delicate, almost asexual sexuality.

For its historical importance, I again mention the discovery of the Apollo Belvedere. I have already recalled the universal praise with which it was greeted, but for historical reasons I quote from the fulsome reaction of Winckelmann, who in the presence of this Apollo felt himself pass from admiration to ecstasy, and who urged the spectator to let his spirit "penetrate into the kingdom of incorporeal beauties . . . for there is nothing mortal here, nothing which human necessities require."

There is no good reason to follow the history of the European male nude any further, neither to the suppleness and sensuality of Bernini, nor to nineteenth-century academicism, romanticism, or realism, nor to Cézanne's bathers, nor elsewhere. Whoever the artist, the Western tradition was such that every standing male nude was experienced by anyone with knowledge of the tradition as a variant of a figure going back to the Greek kouros and perhaps to its Egyptian predecessor. I am not sure how this experience influences our reactions to the art of other traditions; but I think it has been bred into our bones so long that it has become our second nature, which we confuse with our first nature. This

remains true in spite of our passionate artistic revolt against tradition, for the passion of the revolt is still a kind of dependence.

So far, traditionalism has been considered as if it were an unbroken though flexible devotion to old, slowly developed forms and ideals. In historically conscious societies, however, traditionalism can require a return to a tradition that has been deviated from. The result is a conscious classicism, neoclassicism, or archaism. Signs of it are visible in ancient Egypt, and it has been a powerful force in China and India, where it was accentuated by foreign conquest. In discussing classicism and archaism, I shall confine myself to China and Europe, for which the documentation is fullest.

Chinese classicism, like Chinese thought in general, is moralistic. To Confucius, the study of the lyrics contained in the *Book of Songs* not only stimulated the mind, trained one in social intercourse, and taught one to complain if necessary, but also taught obedience to the immediate and the distant father, the ruler. To orthodox Confucians, this evaluation embodied an eternal principle, and they took the Confucian classics to be the source of all morally efficacious literary forms, the only forms they would countenance.

Such moralism was not always acceptable to poets. During the late fifth to seventh centuries, Chinese court poetry was an elegant diversion, neither a sermon nor an emotional outburst. Bowing under the weight of the literary past, the court poets, like those of the European Renaissance, tried to achieve what grace they could within the accepted rules of rhetoric and decorum. They were sad, awed, led to wonder, they extemporized quickly and wittily, but all within the limits of aristocratic decorum.

The opposition to these poets' "decadence" and "lasciviousness" can be summarized in the words of the great fifth-century critic Liu Hsieh:

"As times grew remote from those of Confucius, literary forms decayed. Rhetoricians loved the unusual and valued the frivolous and bizarre; they decorated feathers merely for the love of painting and embroidered patterns on leather bags. They have gone too far from what is fundamental in pursuit of the false and superfluous."

The debate on allegiance to the past and its forms and decorum never

ended in Chinese literature. Some compromise between imitation and inspiration was usually sought. I can illustrate the compromise by means of the answer given by Li Meng-yang (1472–1529) to the accusation that he was no more than a shadow of the ancients. Carpenters, he said, need their squares and compasses, and writers need their rules and models. To understand literature, one must follow the formal styles of the ancients, which are those of literature itself. Having pledged his allegiance to the past, Li added in his defense that if he had merely stolen the ancients' ideal, forms, or words, it would be right to consider him a shadow. "But if I take my own feelings," he said, "and describe contemporary events while following the rules of the ancients foot by foot and inch by inch without plagiarizing them. . . . why should this not be allowed?"

Japanese literature felt similar warring impulses. The social chaos of the twelfth to mid-fourteenth centuries made neoclassicism attractive. To turn to Chinese literature was to give the chaotic world stability. Originality might remain a goal, but only within the limits that experience had set down.

Early Chinese writers on painting were as moralistic as those on literature. Hsieh Ho, of the fifth century, was sure that pictures all illustrate some exhortation or warning or show the causes for a dynasty's rise or fall. The ninth-century *Record of the Famous Painters of All the Dynasties* says that painting "perfects the civilized teachings" of the sages and supports social relationships, and that "it proceeds from nature itself and not from human invention." Because the prestige of writing was taken for granted, painting too was assumed to be important because it showed good in order to warn against evil and showed evil in order to make men long for wisdom.

Some time in the twelfth century, there began a classicistic scholar-painting, discovered more easily at first in painters' exhortations than in paintings themselves. Among those responsible for establishing classical or neoclassical attitudes, Chao Meng-fu (1254–1322) stands out. This statesman and man of all talents, including painting, was as inspired by China of the T'ang dynasty as Renaissance artists were by classical Greece and Rome. Chao was consciously retrospective rather than imitative, and the past he recalled was not intended to nullify the personality of the artist. He is quoted as having written on one of his paintings that an artist can be skillful and get a good likeness but lack the spirit of

antiquity, without which skill goes to waste. He said people in his own time who knew how to draw at a fine scale and lay on rich, brilliant colors thought themselves competent. But, he complained, "they quite ignore the fact that a lack of the spirit of antiquity will create so many faults that the result will not be worth looking at. My own paintings will seem to be quite simply and carelessly done, but connoisseurs will realize that they are superior because of their closeness to the past."

This was the point in time, of which more will be said later, when the growing technical ability of Chinese painters was put into question and the resonance of spirit was preferred to likeness of form or sensuous beauty. From this point on, a new movement in art was likely to be a variety of classicism, each variety turning to its preferred ancient period and paradigmatic old masters.

Of the later champions of classicism in painting, the most influential by far was Tung Ch'i-ch'ang (1555–1636). His reverence was for "the soul and life of a picture" and not for precise copies or tracings made from it. He advocated learning from each ancient painter that in which he was most skillful. "Willow trees should be made after Chao Po-chü, pine trees after Mo Ho-chih, and old trees after Li Ch'eng. These are traditional and cannot be altered."

To Tung and his followers, everything had its rule or inner logic (fa), which had to be investigated and mastered. To them, even a great master had to begin by conforming or imitating, conformity or imitation undertaken in the proper spirit would lead to virtuosity, and virtuosity would lead to individual variation and spontaneity, in which the true old method and the individual variation would become indistinguishable.

Though a classicist, Tung was influenced by the opponents of classicism. He was friendly with the Yüan brothers, whose love of simplicity and spontaneity I have mentioned. His answer to them was that in returning to the rule of nature, he was returning to the nature in himself and awakening to his own innate sensibility. Like Leonardo, he praised "the painter who controls the universe in his own hands" and even surpasses nature. "If one thinks of strange scenery," he said, "then painting is not the equal of real landscape; but if one considers the wonders of brush and ink, then landscape can never equal real painting." What, he asked, did mere eccentricity have to do with originality, awakening, or penetration?

A recent historian has argued that Tung lacked the technical ability

to make close imitations of the past styles he favored, and that as a result he elevated his lack into the paradoxical virtue of the "transformation" that proved its higher conformity to a master's style by its differences from it. Tung's pictures are perhaps forceful rather than beautiful. He constructs his landscapes of large separate units, each made up of smaller units, the force of each balanced by that of its neighboring units, subjected to the pervasive lines of force that the Chinese call "dragon veins," and pushed and pulled together. Individual brushstrokes tend to be laid down similarly and, as in Cézanne and Van Gogh, to have a uniform expressive direction. Tung integrates heavy moist with dry inking and texture-strokes and washes. Individualistic painters tend to violate this harmony, which became orthodox, by making paintings that were brushed all over either dryly, wetly, sparsely, or densely.

I should not like to end with the reverence of the Chinese for their artistic past without illustrating the different uses to which this reverence was put. Among the many possible illustrations, I shall choose the work of Mi Fu and Ch'en Hung-shou, and I shall append some instances of collector's mania.

Mi Fu or Mi Fei (1051–1107) is notable for fostering Chinese connoisseurship. He is said to have examined art styles so intensively that it became impossible thereafter to paint in a new manner without justification drawn from the history of art. Connoisseurship as intense as this might have developed of itself, but it was made the more necessary by the growing sophistication of forgers, who perfected their methods and did their often talented best to recreate the spontaneity of the original while preserving its inconsistencies. A master calligrapher, Mi often copied works to enable him to study them at leisure. His copies, he proudly tells us, were sometimes taken for originals; and he was most apt, he says, at forging the works of the calligrapher he knew best and most admired, Wang Hsien-chih. In his capacity as an expert, Mi established Wang's authentic oeuvre, which he used as the basis for his own calligraphic style. There is reason to suppose that the Wang Hsien-chih of art history was a partial creation of Mi Fu, whose method of preserving the past must have led to its change. (If I may insert a parenthesis on a similar forging of tradition, I will add that much of Muslim calligraphy is based on the cursive script invented by Muhammed ibn Muqlah, of the tenth century; but the examples attributed to him are in most and

perhaps all cases forgeries, so that Muslim calligraphy has been more influenced by the forgers than by their eminent model.)

To return from this parenthesis, my second illustration of Chinese inspiration in the past is Ch'en Hung-shou, a notable eccentric in both life and art. Using an archaic "iron-wire" line, he invented a mock-archaic style that appears serious enough, though he must have meant it also to amuse his contemporaries and counter prevailing styles. His "schematic archaism" is more a retreat into his own resources than a recreation of the past.

The reverence for the past and for art was so great in China that the time and place at which art was being most vigorously created were likely to be the time and place at which collecting was most vigorously pursued. In the absence of museums, the knowledge of art had to be acquired from private collections. The collector's passion is evident in a prose poem written by the great scholar-artist Su Shih (Su T'ung-po), in which he warns of the calamity brought on by an excessive fondness for calligraphy and painting, which has caused people to endanger their health, dig the dead from their graves, and estrange ruler from subject. Art treasures, he says, have even been taken along on military expeditions in specially made boats or stored away in secret rooms. But he himself has exchanged his mania for a near-equanimity. The prose-poem (simple prose in translation) goes on:

> I have come to look upon these thing as if they were clouds that pass before the eye or the song of birds coming to the ear; one loves those things while one perceives them, but once they are gone one does not long for them. Thus my treasured autographs and paintings are now for me a constant source of joy while they have lost their power to cause me sorrow. Written on the 22nd day of the 7th moon of the year 1077.

The collector's passion is recalled with equal eloquence by the T'ang scholar Chang Yen-yüan, who says that he sells his clothes and economizes on his food in order to pay for a valuable scroll, and that he has had to suffer the derision of his wife, children, and servants. He tells them, "If one does not do useless things, how can one enjoy this limited life?" His love for scrolls has grown to be a true passion:

"Among all those outer things that bother us there is none that possesses real value; there are only these antique scrolls that never pall

on me. Completely absorbed by them I forget speech, I go on looking at them in a mood of perfect serenity."

The classicism of Greece begins with Homer and secondarily Hesiod, and with the duly ranked iambic and lyric poets. These and the great dramatists were the inspiration of the Alexandrian poets, poet-scholars, and plain scholars, with their grammars, glossaries, synonym collections, and every other scholarly aid to preserve the precious old writers, the great figures, said a later Greek, "presented to us as objects of emulation and, as it were, shining before our gaze." The attempts of the Alexandrian Greeks to revive the old language were paralleled by those of the Romans to return to their primitive virtues, including the linguistic ones.

By a process I have merely hinted at, the Greeks and Romans adopted their old literature as classic; and Greek and Roman literature became entwined in one another and equally classical in the eyes of Petrarch and his friends. Then, in the early Renaissance, precious manuscripts were discovered, annotated, and, in an age when books were scarce, memorized as far as possible. So began and developed the possession of the classic literature that was the background, the source of memory, allusion, quotation, theme, and style, and the touchstone of worth for the new literatures of Europe.

The history of European classicism in sculpture might begin with the rapacious acquisitiveness of Roman collectors, or with the thirteenth-century statues at Reims Cathedral; but in an account as economical as this must be, I begin with the collection established by Pope Julius II soon after 1503 in the Belvedere of the Vatican. His collection, which took away the breath of those who first visited it, was a dramatic confrontation with a past known mainly by literary testimonies. It contained a great Apollo and a great Laocoön, both restored with the archeological insouciance of the time; but it contained, above all, the great Torso Belvedere, which embodied in its broken and unrestored stone the pathos of a vanished past and a vanishing present. Donatello's sculptures had already assumed the classical spirit; and now Michelangelo, who in his youth had forged an antique sleeping Cupid, set himself with all his querulous concentration to emulate the classic past.

From the sixteenth century on, the antique past came to dominate the

141

education and, to a varying extent, the imagination of artists. Sometimes, as in Poussin, the figures in paintings look like antique statues, their faces having the same masklike inexpressiveness usual in ancient Greece and frequent in Rome. The philosophical justification for dependence on antique models was expressed to great effect by Giovanni Pietro Bellori in his oration *Idea,* published in 1672. Reasoning Neoplatonically, he said that the author of nature constituted the forms of every species in accord with his Ideas; but that the inequality of the matter of the sublunary species, especially of human beings, disarranged their beauty. Noble sculptors and painters therefore tried to imitate the first maker by forming examples of perfect beauty in their minds and creating art that excelled nature. Common people, said Bellori, approve of novelty and praise art for its realism because they do not appreciate beautiful forms. But innovations only deform the Idea. He said, categorically:

> Since the Sculptors of Antiquity used the marvelous Idea, as we have indicated, a study of the most perfect antique Sculptures is therefore necessary to guide us to the amended beauties of nature and with the same purpose direct our eyes to contemplate the other outstanding masters.

It was in this spirit that Winckelmann wrote the high-flown fantasies of his history of ancient art. His mentor in Rome, the painter Mengs, spelled out what this meant in a student's education. The beginning must be an unquestioning imitation of beautiful paintings. Only later, after his eye has been trained, should the student begin to question and differentiate, gather beauty, as the bees do honey, from many sources. The ancients will give him the taste for beauty; Raphael, for expression; Corregio, for grace or harmony; and Titian, for truth or color.

Copying was never regarded as an end in itself. The aim was, rather, the exercise of the imagination, the "continual invention" by which the modern could "imitate," that is, work in the spirit of, the ancient models. Reynolds, who stressed this continual invention, required the artist to "become possessed of the idea of that central form . . . from which every deviation is deformity." The investigation of this form was painful, he granted, and there was only one way of shortening the road: "By a careful study of the work of the ancient sculptors; who, being indefatigable in the school of nature, have left models of that perfect form

142

behind them, which an artist would prefer as supremely beautiful, who had spent his whole life in that single contemplation."

The neoclassicism of the eighteenth century was rather different from the classicism of the Renaissance. Its serious aim could not be exhibited in paintings of frivolous mythology, but of the actions, recorded in history, of great men, the "exemplars of humanity, generosity, grandeur, courage, disdain for danger and even for life itself, or passionate zeal for the honor and safety of the country." Shades of ancient China!

As in China, so in Europe, the dependence on past models was formalized in lists of paradigmatic artists and works of art. In the seventeenth century, Roger de Piles graded artists for composition, drawing, color, and expression. Perfection in all categories is unattainable by any artist, he said; but in the High Renaissance, Raphael fares best, Leonardo (whose color is less than great) comes next, and Michelangelo (who is relatively deficient in composition, expression, and particularly in color) comes third. For a later period, Rubens is first (his total score equals that of Raphael), Rembrandt (who is relatively low in drawing) is second, and Teniers is third.

Although I have not spoken of the institutions, notably the Imperial court, by which Chinese art was controlled to a varying extent, I hope to be forgiven the asymmetry of a brief description of European academic training. In Europe, a compulsory system of education was first set up in the French Academy of Painting and Sculpture, the life of which began in the mid-seventeenth century. The Academy's esthetic theory was basically that of Renaissance classicism, which it attempted to work out in systematic and practical detail. The main point was that in applying the known rules, which encompassed proportion, perspective, and composition, one was reducing the disorder of nature to the order of art. Keeping to these rules had a more than esthetic or even moral usefulness, for a member of the Academy was favored by the patrons on whom the career of an artist depended.

The influence of the Academy was by degrees replaced by that of the Ecole des Beaux-Arts, which had much the same kind of power. Entrance was by examination, and it was only reasonable of a student to choose an official examiner as a teacher. The training given by an Ecole-

143

master, the painstaking inculcation of a conservative technique and way of seeing, was the fulfillment of the process by which European academicism had kept itself alive. As in China, there was much copying and the piecemeal study of fragments meant to be finally integrated. In Europe, however, the emphasis was primarily on the human body. One learned the body by first copying engravings or prints, then plaster casts, then paintings, and only then live models, whose unfamiliarity and unexpected tendency to move made them very difficult subjects to master. Eyes, noses, and lips were learned separately and later combined into profiles and front views; and chins and ears were learned separately, by the same method of copying. The whole head followed, after which came separate studies of hands, feet, legs, and finally of entire figures. Modeling, the representation of light and shade, was something more to be learned separately.

Students also sketched the masterpieces in the Louvre. Some teachers, among them Delacroix, advised the students to make quick painted sketches as well as finished copies; but sketches were regarded as mere preliminaries, and artists who exhibited sketchy work were rebuked. Ingres declared that the artist's touch, no matter how skillful, ought not to be apparent. Only a charlatan, he said, would draw attention to himself by this device. "It shows us the method instead of the object, the hand instead of the brain. Where do you see the touch in nature?"

Towards the end of his training, the student was encouraged to study the old masters who most appealed to him and to combine the best features of each of them. It was understood that an artist could achieve a respectable style of his own only as the result of the analysis of the styles of the old masters. The advice that Ingres gave his pupils was, "Go to the old masters, talk to them—they are still alive and will reply to you. They are your instructors. I am only an assistant in their school."

To end this discussion of traditional art, I should like to review two of its defenses. Both argue in favor of the anonymous craftsman, but the second is more openly intellectual. Because both involve attacks on modern industrial civilization, they should be prefaced with a word on their common European sources—their non-European ones differ, the

one leaning to Buddhism in its Japanese guise, and the other to Hinduism.

Both defenses are indebted to the succession of moralists, including Carlyle and Burckhardt, who warned of the growth of materialism and the decline of intellect, virtue, and taste. More than one of the early nineteenth-century moralists believed that mechanization had deprived life of its humanity and art of its nobility, but it was John Ruskin who was most effective in arguing against mechanical perfection. Ruskin made his point by praising the Gothic style for its living and life-enhancing beauty and by explaining why the desire for perfection had caused the style to decay. Life, he explained, is always marked by irregularity and deficiency. "No human face is exactly the same in its lines on each side, no leaf perfect in its lobes, no branch in its symmetry. All admit irregularity as they imply change; and to banish imperfection is to destroy expression, to check exertion, to paralyze vitality." The imperfection in Gothic work and its perpetual change in both design and execution show that the workman must have been free and that the Gothic spirit delighted in the free invention of forms that were both new and capable of renewing themselves endlessly. However, the growing skill of the carver led him to defy the nature of the stone he worked, and his virtuosity, indulged in for its own sake, led to the demand for technical perfection, a demand that prevented the draftsman from being natural and individual. The upshot was that art was led to perfection, and from perfection to the inhumanity, luxury, and vice that accompany it.

The views of Ruskin and those who agreed with him led in the late nineteenth century to the Arts and Crafts Movement, which looked backed fondly to medieval and rustic work, and which was also affected by the art of Japan. For some reason, potters seem to have had a special affinity for the Movement. Among these potters there were the Englishman Bernard Leach and his friend, the Japanese potter Shoji Hamada. Leach and Hamada are the most seductive exponents of the craft-ideal in recent times.

The first of the defenses of traditional art may begin with Hamada's views. He refused to sign any of the pots he made or to stamp it with his seal. He refused, that is, to emphasize himself as an individual, found himself offended by the egocentricity common to artists, and preferred

145

that the buyer of a pot buy it for what it was and not for the potter's name. In his opinion, an unknown craftsman deserved to be put on a level with the best artist, "provided that humility and life are given expression." He acknowledged that we cannot go back to anonymity, but saw modesty as the salvation of art. According to him, Oriental craftsmen were unconcerned with natural flaws and irregularity. They were careful, but nonchalantly so, in freedom. Perfection's very smoothness, he said, makes us yearn for the imperfection that signals life, which goes beyond all arts and artists.

This defense of traditional art may be completed and given a more philosophical aura by the defense offered by Leach's and Hamada's friend Soetsu Yanagi. An admirer of Blake and Whitman and an exponent of the folk arts, Yanagi embraced the spirit of Zen and tried to go towards something, beyond beauty and ugliness, that if put into words might be said to be the unchanging formlessness beyond all forms. Yanagi expressed great admiration for the Sung ware, which he said was painted by mostly illiterate and perhaps rather unwilling boys of about the age of ten. How does it happen, he asked, that these boys were able to draw so superbly? His answer was that because each boy had to draw the same picture hundreds of times a day, the result was an easily moving brush, a bold composition, and a miraculous quickness of hand, all testimony to the absence of anxiety and ambition. Working with complete disengagement, the boys forgot that they were drawing, were liberated from the opposition of dexterity and clumsiness, and no longer had to think of the distinction between beauty and ugliness. In their unhesitating unawareness, they exceeded the artist who supplied them with the design they painted. (I am reminded that the fashion designer Paul Poiret, who worked with Dufy, "sold materials and objects designed or hand-painted by teenage girls especially chosen for their lack of formal artistic training.")

Yanagi's craftsman-ideal requires beauty that is identified with and born of use, but not in the materialistic sense that separates mind from matter. Since he uses natural materials and processes and works with an accepting heart, the true craftsman is saved, Yanagi explained, not by himself, for he does not have the power to save himself, but by nature. In the works of the true, humble craftsman, there is nothing false. Today, in the absence of such a craftsman, we must be satisfied with the

artist-craftsman, who, though an artist, may copy himself until awareness of the original dies away and the design becomes far more beautiful.

Yanagi's references to "formlessness beyond phenomena" and to liberation from dualism and egoism are all, as he said, in the tradition of Buddhism, especially Zen Buddhism, which relates in turn to the paradoxical attack on reason and language of the "emptiness' (Madhyamika) school of Buddhism. The integrity and humbleness for which he argued makes his approach, in the end, distinctly antirationalistic. The more ostensibly intellectual defenses of tradition in art have other sources and intellectual tactics, which I should like to illustrate by means of the views of Ananda Coomaraswamy, whose evaluation of Indian art has already been mentioned, for he was to my mind the most interesting and forceful of his philosophical kind.

Some words on Coomaraswamy's life and personality will illuminate at least the intensity with which he held his views. He may be described, not quite fairly, as a duality striving to become a unity and a restlessness striving to become a state of calm. The son of an Englishwoman and a learned, politically active Ceylonese who died when his child was two, Coomaraswamy returned to Ceylon, the country of his birth, in order to write *Medieval Ceylonese Art*. This book, published in England in 1908, is a learned hymn to traditional craftsmanship, that is, to its reverential attitudes, its training methods (which required a fatherly master and reverent apprentice), and its authenticity.

Coomaraswamy settled in the United States, where he made his reputation as a scholar, mostly of Indian art, and as the compiler of the catalogue of the Indian collection at the Boston Museum. His attitudes were influenced by William Blake, a representative, along with Whitman and Nietzsche, of what he for a time hoped would be the new philosophy of the West, Idealistic Individualism.

It was only in his later years that Coomaraswamy himself lived in a way even approaching the Indian ideals he came to preach with all the resources of his learning and eloquence. A man in bondage to love in its most directly sexual forms, his metaphysical attitudes were to him the conclusion and reaction to the contrary aspects of his character. A sympathetic friend, himself a considerable scholar, said of Coomaraswamy, "His marital career was inappropriate to a man who wrote of marriage as a sacrament, and some of his financial dealings seem no less

inappropriate and incongruous with the view of right livelihood which he expounded." Yet "he lived habitually in his intellect in a much higher degree of concentration than other men. As that was perfected, other things fell away. This made the personality exciting and memorable, and edifying in a sense which the character, the whole psychic complex, was not."

The contrary aspects of Coomaraswamy's nature helped to explain why his scholarship was put at the service of an unrealistic, half-mythical reading of Indian history and character. He adopted the preaching of his contemporary, René Guenon, against the material and spiritual decay of Europe, which, quite unlike the East, had been continuing, Guenon proclaimed, ever since he thirteenth century. Two neoscholastics, Etienne Gilson and Jacques Maritain, gave Coomaraswamy an abiding interest in the Christian Middle Ages, and especially in the mysticism of Meister Eckhart. To these influences there was added the influence of Carl Jung, whose writings Coomaraswamy began to follow in the 1930s. In pursuit of the truth as they and he saw it, and in pursuit of his own heritage, he made an intensive study of Indian iconography and philology, as well as of the Vedas. His interest, which had shifted from the history of art to iconography, shifted once more, to the metaphysical meanings transmitted by the visual symbolism of art.

As a traditionalist and believer in a single, universal, perennial metaphysics, Coomaraswamy was content to say, "I have nothing new to propound; for such as I am, the truth about art, as well as about many other things, is not a truth that remains to be discovered, but a truth that remains for every man to understand." Sometimes Coomaraswamy made lists of the cultures he considered to be traditional, which included the "Indian, Egyptian, early Greek, medieval Christian, Chinese, Maori, or American Indian." India he took as the epitome of traditional civilization, and he used his knowledge of Indian art and thought as a touchstone for the study of other traditional civilizations. In his mind, the perennial philosophy was such that "as long as the tradition is transmitted without deviation, as long in other words as the chain of teachers and disciples remains unbroken, neither inconsistency nor error is possible. On the other hand, an understanding of the doctrine must be perpetually renewed; it is not a matter of words."

It was important to Coomaraswamy to stress that the formal element in art represented a purely mental activity, for which India had devel-

oped a highly specialized technique of vision. The maker of an icon, he said, used the technique of yoga to eliminate anything distracting and egotistical, then visualized the form of the sacred image according to the received canon and drew it to himself as if from a great distance. It was only after he had realized a complete self-identification with the image he was to make, had known the image in an act of nondifferentiation, that the imager could proceed to translate it into stone, pigment, or other material. All this, said Coomaraswamy, is a process in which worship is paid to a mentally-conceived image, which is obtained not by merely empirical observation, but by true knowledge. To drive this lesson home, Coomaraswamy quoted Dante's pithy words, "He who would paint a figure, if he cannot be it, cannot paint it." To drive the lesson home still more firmly, he quoted Plotinus's statement that in contemplative vision the thinker makes himself over into the matter that is shaped and takes ideal form under the influence of his vision, although potentially he remains himself all the while.

According to Coomaraswamy, Indian tradition implies the existence of types or archetypes, though not as Platonic absolutes external to the universe in which they are reflected, but as types "of sentient activity or functional utility conceivable only in a contingent world."

Coomaraswamy criticized democracy as a form of life that condemns each man to the exhibition of his own imperfections and to the vanity that we describe, with uncomprehending complacency, as self-expression. He preferred by far the traditional, immanent culture that endows every individual with the grace or typological perfection that only very rare beings can achieve by their own efforts. Only in a traditional culture does art reach its true aim, for "heaven and earth are united in the analogy of art, which is an ordering of sensation to intelligibility and tends toward an ultimate perfection in which the seer perceives all things imaged in himself."

CHAPTER FIVE

Egocentric Intruders

However flexible it is, tradition is challenged again and again, either by founders of new traditions or by persons who are unwilling to suffer any yoke but the one they set on their own shoulders. A tradition may repel or assimilate their challenge; it may break or appear to break under it; or it may live with it in sharp, unresolved tension, which time changes but may not abate. The situation in fact is endlessly complicated, and the balance between conformity and revolt is both more brittle and more resilient than can easily be described. Sometimes the members of a tribe, a social group, or a whole culture have been described as living in a state of traditional self-abnegation. Such self-abnegation has been ascribed to the Zuni Indians, to various tribal groups, to traditional Hindus and Chinese, to Christians of one century of another, or, to take a sharply focused example, to Ch'an (Zen) monks. But every time that someone probes more deeply, the devil will out: the Zuni Indian will be seen to compete in at least the degree of his uncompetitiveness; the exquisitely deferential Chinese will compete before a superior in the depth of his self-abnegation, will modulate his deference even into derision when

facing an equal in rank, and (like a Hindu) into possible harshness when facing a woman or other social inferior; and the Ch'an monk will break off his training, be dismissed from it, go mad with it, or show by his actions that his professed ideals hide a personality incompatible with them. The perfectly traditional society, in which everyone accepts his function whole-heartedly and fulfills it reverentially, has never existed as more than an ideal, however powerful.

Because the situation in fact is so complicated, I shall try to simplify it with the help of an antithesis between tradition and egocentricity, and I shall picture egocentric intruders trying to evade, bend, or destroy tradition. I shall not qualify as egocentric the willfulness of the person, the head priest, emperor, or the like, who acts as the necessary apex of the traditional hierarchy. The case is somewhat different with the organizers of work projects, those one might name "masters of the works" or "architects," who were indispensable in traditional societies, but whose social importance and pride in creation combine to make them possible models of egocentric intruders. The social position of the architect is known to have been high in ancient Egypt, ancient India, imperial Rome, medieval Europe, and Islam (at times). But the first unmistakable intruders are those who share two beliefs, essentially in themselves, the first that they are inspired by a higher source, and the second that they are performing unique, uniquely important acts of heroism. The inspired heroism may be as much physical as artistic, heroism being coequal or conjoined with heroism.

The conjunction of physical with spiritual, including artistic, heroism seems to me the natural ideal of the bold, independent, spontaneously self-expressive person. The ancient Taoists, as I have said, idolized the spontaneously creative and fearless characters that they themselves, I suppose, had created and endowed with a near-immortality. Chinese who were both cultured and rebellious found it easy to identify themselves with these carefree paragons. I have already described Chinese artists famous for their spontaneity; but I should like to draw attention to those, mostly professional, of the fifteenth and sixteenth centuries, who were called and called themselves "crazy ("crazy–stupid") or "wild." One such artist was Shih Chung (1438–c.1517), an irrepressible man "who rode around on a buffalo, his feet bare, wearing Taoist robes, with yellow flowers tied to his waist." Not only did the "crazy," "wild" artists produce art so spontaneous that it was barely controlled, but they

151

exhibited, or were reputed to exhibit, boldness in both manner and act, sustained by physical strength, skill in the martial arts, and great pride. Although scholars might disdain them for their professional, so-to-speak artisanal, status, they were celebrated in song and story for their enchanting, willful, powerful selves, and the politically mighty, the socially grand, and the merely rich were happy to be their patrons.

The equation of physical with artistic heroism occurs in a subtle manner among the Japanese, to whom the firing of a bow, the cut-and-thrust of a sword, the motion of a brush in calligraphy, and the composition of a poem are separately and together the absolute indices, the heart-signatures, of the individual (as the Chinese had long believed). This individual, the tradition says, achieves his heroism in the course of losing his sense of self in the being or "non-being" of something greater; but his negation of self is achieved in an unmistakably personal style and earns him the status of a culture-hero. His heroism is mingled with antiheroism and remains heroic all the same. His killing, if he kills, is so dispassionate and so well synchronized with nature itself that its artful self-surrender is an act of transcendence rather than anger.

I should like to pursue the theme of the artist's inspiration, heroism, and uniqueness by first recalling how the desire for this combination of traits was developed in the two cultures for which we have the fullest historical records, the European and the Chinese. By an often exercised license, I begin the account of European or Western culture with the Egyptian.

Egyptian art often seems to be influenced by the will of the king, not only in the choice of monuments to be erected, but in the tendency of all sculptured heads to adopt his generalized features. During the period of the New Kingdom (1580–1085 B.C.), the individuality of the king's will, assuming it is that, grows stronger and evidences of freedom grow more frequent. The most spectacular evidence is given by the style and subject-matter of the reign of Akhenaten, whose sculptor Bek insists that he learned his art from the king himself. There is a new will to distort, to be expressive, and to be individual. In relief and painting, the figures' hands become longer and more dramatically expressive. The King's children act in a more childlike way. Faces remain stiff, but emotion breaks through in gesture—courtiers raise their eyes to their King and

Queen, as the King and Queen raise theirs to Aten, the power of which is concentrated in the sun's disc and extended, life-giving rays.

In view of the whole range of Egyptian art, a contemporary scholar rejects the old complaint that the Egyptian artist was simply a worker and had no sensibility of his own:

> Egyptian art, which seems to the uninitiated so similar, often even monotonous, amazes even the connoisseur by the constant variablility of its forms of expression. It must therefore be concluded that the 'craftsmen' of this distant past were not less sensitive and creative than the artists of the last centuries.

At first sight, the Greek potter, painter, and sculptor may appear to be the same kind of unpretentious artisan as the usual Egyptian; but many of the Athenians who made or painted pots were individualistic enough to sign their work, and by the fourth century B.C., painters and sculptors had proved sufficiently interesting for a historian to devote a book to their lives. If we are to believe the anecdotes that have come down to us, the pride of artists could take challenging, ostentatious forms. An anecdote told in one place about Zeuxis and in another about Apollodorus says that the painter wrote the words, "Easier to criticize than imitate" on one of his works. Zeuxis is said to have become too wealthy to go on selling his paintings, to have had his name woven on his cloak in golden letters, and to have issued the following challenge to other artists, "If any man says that he has reached the boundaries of our art, let him show it and defeat me." His equally flamboyant rival Parrhasios is said to have written on a painting, "The limits of art have been discovered by my hand," though with the addition, dictated by modesty or fear of divine wrath, "but nothing done by humans escapes criticism."

Such anecdotes, along with the stories that Praxiteles and Apelles fell in love with their shapely models, recall the egocentric, romantic artist. While there is no way to test the anecdotes' accuracy, they do testify at least to the attitudes of those who told them. Certainly rhetoricians of the early centuries of the Christian Era, such as Dio Chrysostom, Quintilian, and Pausanias, were ready to compare the sculptor's or painter's inspiration with the poet's. This favorable estimate of the artist may never have become dominant—literate people might echo Plato's and Aristotle's contempt for the artisan—but collectors grew avid for works

of art, emperors such as Nero and Hadrian themselves took up painting and sculpture, and, in an age enthralled by the virtuoso performer, neither decent emperors nor wicked ones could resist the temptation to sing or to play a musical instrument. The dignity of the imperial office may have led Severus Alexander to abandon the trumpet, but he continued with his lyre, pipes, and organ.

Like Egyptians and ancient Greeks, medieval Europeans saw painters and sculptors as artisans; but the medievals too had their pride, and many of them signed their work. True, signatures on French Gothic sculptures, unlike those on the Italian, are rare, and the illuminators of France and Germany in the tenth and eleventh centuries signed much less frequently than their Spanish colleagues. No reason is known for these differences, which we can attribute, without understanding them the better, to different social habits; but the names at least of thousands of medieval artisan-artists are known. In the twelfh century, there is more evidence of their self-satisfaction. The facade of Modena Cathedral bears an inscription reading, "How worthy you are of honor, Wiligelmus, to be famed among sculptors for your sculpture." In the same century a sculptor named Natalis inscribed on a carving, "God has created everything. Man has remade everything. Natalis made me." And in the Canterbury Psalter, the scribe Eadwine identified himself triply, by means of his name, his full-page self-portrait, and his description of himself as "the prince of scribes."

These examples of artists' pride were exceptions for their time. But there was enough conscious innovation to arouse Bishop Luke of Tuy to attack its supporters, whom he accused of saying, "In order to avoid the dullness of accustomed formulas, the artist needs freedom to devise unusual motifs and to invent new ideas . . . to deepen love for Christ through the emotions they arouse."

I place the Islamic artists, who were geographically both Eastern and Western, non-European and European, between the artists of medieval and Renaissance Europe. The Muslims had an intense love for beautiful books, in which they invested great effort and large sums of money. Painting was ennobled, as in China, by its association with calligraphy, the most highly regarded of the visual arts. The Muslims' reluctance to

make images of living things was countered by the "theory of the two pens," which stated that the Koranic approval of the calligrapher's reed applied to the artist's brush as well. Of course, art sometimes became a consuming passion. We experience it as such in a verse "Epistle" written by the calligrapher Maulana Sultan-'Ali in 1514, at the age of seventy-four. Looking back at his youth, Maulana recalls that his love for calligraphy led him to forget food and sleep and spend day and night practicing; but the effort did not earn him the recognition he desperately needed, and at the age of twenty he lapsed into depression. Speaking to himself, he said, as the old man remembered it:

> Oh my heart! It is better to say 'farewell' to
> writing
> And to wash the traces of script off the tablets of
> my heart,
> Or to write in a way that people should talk of it
> And entreat me for every letter.

In a renewed access of zeal, Maulana withdrew from all human company and perfected his art, which at last earned him fame.

Although generally discouraged in Islam, figurative art flourished in places where the Shiite tradition dominated. In the sixteenth century, paintings and drawings were often signed. The artist Sadiqi Bek, who rose to high position, wrote biographies of contemporaries including painters, poets, and calligraphers. The seventeenth century saw a heightening of connoisseurship and artistic individuality in both Iran and Mogul India. The pictures kept in albums were now almost emancipated from the texts to which they had once been only illustrations. Because the careers of artists were now recorded, we learn of temperamental, neurotic, and even psychotic ones. Thus the artist Hasan Baghdadi was malevolent, attempted to kill his father, counterfeited the seal of the Shah, and made off with a slave girl of an innocent young man who had befriended him, while Riza let his talent go to waste, spurned the Shah's attempts to help, and lived on, "ill-tempered, peevish, and unsociable." Sadiqi Bek, who for a time had led the wandering life of a dervish and who had displayed foolhardy courage in battle, never neglected his art, became a great designer, and with a hair-fine brush painted marvelous portraits. Yet though the Shah favored him with the high position of librarian, he was disagreeable, jealous, suspicious, self-seeking, and ex-

tremely discourteous. He fell out of favor and was dismissed from office, a victim of his own temperament.

The development of European esthetic attitudes from the time of the Renaissance is relatively well known. Research is always adding details and changing emphases, but because I am interested in broad generalizations, I shall content myself with examples of changes related to artists as egocentric intruders. The changes I shall take up are those that call most attention to themselves: the rise in the artist's status and, with it, the stress on his originality and genius; the idea that art should be practiced for its own sake, not for an ulterior reason; the affirmation, by means of portraits, self-portraits, and biographies, that the artist was both an individual and an individual of a peculiarly sensitive, superior kind; and the assumption that the artist's genius was marked by a tendency toward melancholia or madness.

Some historians prefer to see the Renaissance in the light of the later Middle Ages, and some through the eyes of its early Italian partisans. The old and new remained mixed, artists were for a time still guild members, and their work was usually done, like as not by family members, in small workshops; but the ambitious artist studied the new subjects he thought imperative for art, and sometimes, as in the case of Leonardo, dressed and acted in accord with the status he thought was his due. The still unclear position of the artist—between that of the craftsman, noble's retainer, and independent scholar-gentleman—aroused friction, which exacerbated the natural touchiness of Michelangelo, Cellini, and doubtless others. Vasari in particular gives many examples of artists' touchiness and fosters the image that was in time to become that of the Romantic artist. From him and other Renaissance writers we learn that Masaccio's passion for art made him careless in everything else; that Christofano Gherardi's similar passion kept him from noticing that his shoes were mismatched or his cloak worn wrong side out; that Bartolomeo studied anatomy with the help of fragments of corpses strewn around his room; and (to shift countries) that Jan Lys would forget to eat or sleep for days on end. Like the Chinese painters I shall soon describe, Pontormo was known to refuse to paint for a social superior but to exert himself, for a miserable price, "for some low and

common fellow." And there was a gang of young painters in Florence who pretended, says Vasari, to live like philosophers, but who in fact lived "like swine and brute beasts."

Michelangelo was the image of the artist as genius, torn by guilt, pride, and the longing for perfection. But a different, gentlemanly image of the artist was also in the process of formation, examples of which are Titian, Mantegna, and the learned, graceful Raphael. By the seventeenth century, the artists' presence at court and the wide acceptance of their dignity won them a growing number of ennoblements. Bernini was famous for his conviviality, his brilliant conversation, and his aristocratic manner, which could be leavened by an aristocratic wrath. Rubens, man and painter, was a phenomenon. His will to paint was tremendous, and his paintings, composed like torrents intertwined, were viscerally profuse and fleshly. Yet he lived an equable, orderly life, and he was tolerant, learned, acute, and charming enough to make him a natural aristocrat, aware of his own worth, and a valuable diplomat. In the Rome and Venice of the seventeenth and eighteenth centuries, artists not infrequently became members of aristocratic households and lived on the salaries their patrons gave them. The artists' self-portraits show them as men of the cultured world, serene and perhaps complacent. The unserene, independent exception was Salvator Rosa (1615–1673), who craved to be artistically independent and famous. A prospective patron was turned away with the words, "I do not paint to enrich myself, but purely for my own satisfaction. I must allow myself to be carried away by the transports of enthusiasm and use my brushes only when I feel rapt."

All the while, the old word *genius,* meaning "guiding spirit," was undergoing a marked change. By degrees it was applied to one's nature or particular gift or spiritual characteristics; and there were or came to be nuances that made the word usable for a person's spontaneous inventiveness or, in contrast to reason, the person's natural spontaneity. Diderot was preoccupied with the idea of geniuses, who would always be, he said, the glory of their nations and the benefactors of mankind. He found genius mysteriously beyond judgment and beyond even imagination. In a certain mood, he praised "extravagance" and the possibly

157

creative virtues of inattentiveness, distraction, excessiveness, extravagant comparison, and the ability to spin out fictions, in short, the "enthusiasm" that "if not madness is close to it."

The belief in genius was a disbelief in the usefulness of imitation and sometimes of academic study. Edward Young's *Conjectures on Original Composition*, published in 1759 and immediately translated, with great effect, into German, attacked the "meddling ape imitation," guessed that there had been many geniuses innocent of both reading and writing, and claimed that "genius sometimes owed its greatest glory" to the absence of learning. Someone else added that "original genius" was more characteristic of primitive than civilized periods, and someone, asking "Did ever any good painter arise from an academy?" answered his rhetorical question with a rhetorical "Never." Blake added his idiosyncratic voice in favor of Imagination, Genius, and Infinity. Yet the artists, influenced by their education and the craftsmanship they had painstakingly acquired, usually refused to believe that inspiration and intellect, or imagination and the rules of craftsmanship, could not be joined in a civilized harmony. This is not to say that the romantic appeal of genius and inspiration had been subdued. Byron became the object of a cult as wide as the literature of Europe, and European thinkers, especially the Germans, took to Romanticism as naturally as Japanese cranes to their dances.

I am not sure of the exact links between the doctrine of genius or inspiration and that of art for its own sake. However, if it is assumed that the inspired person reveals something mysteriously profound or ecstatically intense that lies, like a mystical experience, beyond reason or science, the inspired creation becomes the end rather than the means of life. Uselessness, in the ordinary sense, then becomes a recommendation, as we see from Gautier's words in 1834: "Only those things that are altogether useless can be truly beautiful; anything that is useful is ugly, for it is the expression of some need, and the needs of man are base and disgusting, as his nature is weak and poor."

This statement is a pathological exaggeration of a partial truth. Expressed more moderately, it becomes the desire of esthetes such as Walter Pater to flee the abstractions of the intellect and search for their opposite in the deep, pure esthetic experience that is life's supreme gift. In a later, more moderate guise, it becomes the esthetics of "significant form."

Though I am not at the moment dealing with China or Japan, I should

like to add in an aside that I sense something like the doctrine of art for art's sake in the "pure talk" of the third to sixth century Taoists. Their witty badinage is a similar protest against the measurement of everything by its social utility. The theoretical goal, "emptiness" or "nonactuality," resembles the goal pursued by a Mallarmé on a different theoretical background. If the measured, austere tranquillity of a Japanese tea ceremony is seen not as serving life, but as demanding life as a sacrifice to the ceremony, then it too bears a psychological resemblance; for everywhere that it appeared, the doctrine of art for art's sake could become the fanatical doctrine of life for art's sake.

From the late eighteenth century, art tends to become a passion and obligation like those of religious penitents. We hear this voice of art in the letter written by Asmus Jacob Carstens to the Prussian minister who had canceled his grant: "I renounce all those benefits, preferring poverty, an uncertain future, and perhaps an infirm and helpless old age, with my body already showing signs of illness, in order to fulfill my duty to humanity and my vocation to God."

This letter, written in 1796, breathes a spirit like that of the letter written by Anselm Feuerbach in 1861 to his mother: "The only thing I really am is a painter through and through; my restlessness has lessened more and more and I can say that I could sacrifice my life to art."

With this sacrificial ideal in mind, Hans von Marées wrote in 1882:

> I would call a born artist that man whose soul has been endowed with an ideal by nature, right from the start, and for whom this ideal takes the place of truth; he believes in this unreservedly, and his life's work will consist in bringing it forth for the contemplation of others and in the absolute realization of it in himself.

The change in artists' self-appraisal is evident in their self-portraits. In Italy, the first surviving, unquestionable self-portrait of an artist is Benozzo Gozzoli's, painted about 1460. It is obviously difficult for a painter to paint himself without betraying by his stare that he is the subject, and Gozzoli's seriously questioning look detaches him from the crowd in which he is set. In Italy, it was only towards the end of the century that artists became the independent subjects of their pictures. Lorenzo Ghi-

berti, who wrote what was, in Europe, the first autobiography of an artist, portrayed himself in painting with a lively, ironical expression. As I have said, eighteenth-century artists were likely to depict themselves formally, decorated, perhaps, with their noble patrons' awards. Romantic artists, whose self-appraisal was more affected by thoughts of immortality and less by the formal marks of status, were apt to paint themselves dressed with Byronic negligence, in an easy, informal pose, and with a hint of dreaming melancholy in their faces.

The height of the artist's aim and the importance he attributed to himself or his task were reflected in public adulation of a sort that had been reserved in ancient Rome or Baroque Italy for musicians and other virtuosos of performance. This is not the place to name all the Romantic heroes, beginning perhaps with such a stubbornly individualistic prototype as Beethoven and continuing with such others as Byron, Delacroix, Chopin, and Liszt. Their adultation went to extraordinary extremes, of which I shall recall only the adoring ladies who snipped off bits of Liszt's hair, collected his cigar butts, and gathered the dregs of his coffee in glass phials.

The growing Romantic stress on inspiration and its bearers was echoed, especially in literature, by a stress on dreams and on irrationality, melancholy, and madness. Like a Siberian shaman or a Plains Native American, the European writer learned to look inward to dreams as the source of the more-than-rational truth. Sometimes, as in Charles Nodier's *La Fée aux miettes,* published in 1832, the dreamlike subject of a book could be represented by its dreamlike structure. In an essay written the year his book was published, Nodier urged poets to make better use of their dreams, the source of the world's myths and religious images. Only in the intermittent death that is sleep, he said, are we able to draw the map of the imaginable universe. In sleep, sheltered from the artificial personality that society has constructed for us, each of us reposes in his own essence, for "it is certain that sleep is not only the most powerful, but also the most lucid of thought."

The connection with melancholy and madness goes back to the ancient Greeks, notably to Plato, who believed that the insane man's poetry was naturally superior to the sane man's, and to the psychosomatic speculations attributed to Aristotle. According to these speculations, great men, madmen, and imbeciles share a melancholic nature—all great

men are likely to be subject to depression or its opposite, excessive excitement, and poets are sometimes the better for their madness; but the accomplishment of great men and poets is usually the result of their success in causing their anomaly to express itself "in a well-balanced and beautiful way."

In the eyes of the Neoplatonists of Florence, these speculations gave Plato's belief its scientific basis. The leading thinker among them, Marsilio Ficino (1433–1499), added that melancholics, the only persons capable of the divine mania, were "saturnine," that is, born under the ambivalent planet Saturn. Ficino contended with the melancholy from which he himself suffered by exercising, living carefully, and listening to music, but the Greek view led him to see his affliction as an advantage.

The association between greatness and melancholy having been confirmed, great artists, even the equable Raphael, were described as melancholic, and the disputable truth that great men were melancholics was converted into the certain falsehood that melancholics were great. It is said that in the sixteenth century "melancholic behavior" became fashionable among those who wanted to wear the aura of greatness. Melancholy as fashion can of course be hard to distinguish from the reality, but reality did make its unmistakable appearance. The German Romantic Caspar David Friedrich was really sensitive, imaginative, and melancholy. Victor Hugo was deeply moved by the real insanity of his brother Eugène. Gérard de Nerval, who was convinced that dreams could open the invisible world to him, was hospitalized and finally hanged himself. Balzac, himself both realistic and mystically inclined, gave the protagonist of *Louis Lambert* a precisely described schizophrenia and granted him the ability to see into hidden things. Other novels of the period, including *La Fée aux miettes,* granted the same ability to madmen and those close enough to them to understand them. Hamlet became a symbol of the creative discomfort of the soul in a life unsuited to it, said Victor Hugo. He added, with a measure of self-portraiture, that the life of the artist, a Hamlet, was interwoven of reality and dreams, a combination that, for all its strangeness, was after all the reality in which we existed. According to Hugo, one might almost consider Hamlet's brain to be a formation made of different layers, one of suffering, one of thought, and one of dreams: "It is through this layer of dreams that he feels, comprehends, learns, perceives, drinks, eats,

frets, mocks, weeps, and reasons. There is between him and life a transparency—the wall of dreams; one sees beyond it, but one cannot step over it."

Rimbaud represented both the poet's attraction to madness and his escape from it. Proposing to derange his senses in order to become the suffering, all-experiencing seer, he hoped that this superhuman ubiquity would make him one with the universe from which he felt himself too radically disjoined. To free poetry from reason and prosaic experience, he practiced hallucination and walked through the city somnambulating. However, while still a writer, he repented, as he showed when he wrote in a rough draft that he now hated mystical enthusiasms and stylistic extravagancies ("Je hais maintenant les élans mystiques et les bizarreries de style").

I do not now want to enter into the controversy on the health or neurotic or psychotic tendencies of "geniuses," but only to point out that the connection between mental illness and genius became widely accepted among laymen, artists, writers, and certain philosophers (Kierkegaard and Schopenhauer) and psychiatrists (Moreau de Tours, Lombroso, Kretschmer, and Lange-Eichbaum). Lange-Eichbaum, who made an extensive, dictionarylike list of creative "geniuses," in a sense reversed the old verdict, because he held that there were sociological reasons for applying the word. His position was that people gave the name *genius* to anyone who fitted or fitted himself to the social conventions that defined the status. That is, if geniuses were expected to be disturbed, anyone prominent and disturbed was named a genius, so that the list Lange-Eichbaum compiled was not taken by him to be evidence of anything but the circularity of a preestablished definition and the examples that fitted it.

I have already intimated that the truth is unlikely to be captured in any simple generalization. Whatever the whole truth may be, and whether it is taken in a sociological, statistical, psychopathological, or other sense, it cannot be denied that many writers and artists have shown evident signs of suffering or mental disturbance, and that, in many of these cases, the suffering or disturbance has entered deeply into the fabric of the art. Two examples among fairly recent painters are Munch

and Pascin. An example among writers might be Strindberg, though we do not have direct psychiatric evidence, for no psychiatrist ever examined him in person. His autobiographical novels, which sound schizophrenic, may be conscious exploitation of his suffering—his real "persecution" by people, his insomia, his absinthe-drinking—and his hope that the derangement he elaborated would appeal to French readers, to whom the equation of madness and genius was familiar and plausible. The atmosphere in Sweden was different, and he did not want *Inferno* published there. When *Inferno* appeared, he decided that the book, which he had described in a letter as fiction, should be taken to be fact, and he made retrospective corrections in his diary to make the diary more dramatic and alarming and more similar to the book. Yet Strindberg did sometimes suffer from a persecution mania, he did have visual and auditory hallucinations, and his conscious exploitation of his condition in order to create literature and "write the misery out" of himself still left him, whether clinically insane or not, a clear example of a writer who transposed mental disturbance into art. Among the more clear instances of such transposition, Artaud comes easily to mind.

Since I have already given relevant examples, I shall content myself by adding one from China, of the poet Li Ho (A.D. 791–817), whom I know mainly from a single book, from which I shall paraphrase. To preface my account of him, I remind readers unfamiliar with Chinese poetry that it exhibits a great deal of sadness. In China, those who wrote poetry were troubled by what troubles us, the precariousness and brevity of life; but the situation of most Chinese poets was different from that of most Western poets. Chinese poets were often officials sent by government policy far from their homes, and then, like Western diplomats, repeatedly shifted. As a rule, their lives were governed by the hope of official success and the fear of official disgrace. A good deal of drinking was indulged in. The strain of such lives must have increased the oppressiveness of the feeling that life was too brief. Of those who failed to get government posts or avoided them out of hatred for the government, I have spoken and shall speak again.

Sad as Chinese poets often were, the sadness of Li Ho was exceptional. The intensity of his poetry, which is also exceptional, draws on the sadness. He fits the Western, not Chinese, stereotype of the poète maudite. His great misfortune, difficult for a European to appreciate, was to have missed government office, and his literary fame only accen-

tuated the depth of his humiliation. Using the excuse that his dead father's name violated a family taboo, government officials did not even allow him to sit for an examination. From then until his untimely death seven years later, he was a man ravaged by disappointment. Allowed to take another, minor examination and given a minor post, he wrote poetry that was all sadness. In his words, "My whole heart is sad and withered as a dying orchid."

Described as thin and frail, Li would leave his house at dawn and ride out on a colt, his servant following him. When inspiration struck, he would write poetry and drop it into the servant's bag. At nightfall, he would go home and work what he had written into a finished poem. Every day went like this, unless he was blind drunk or in mourning. Once he had finished a poem he did not care what became of it.

Unlike most Chinese poems, those of Li have the wildness and extravagance that Chinese critics describe in the words "weird," "astonishing," and "demonic." Afraid of death and attracted to it, Li uses images studiously avoided by Chinese, poets or not, because taken to be unlucky —images of ghosts, demons, spirits, bones, blood, tombs, corpses. His imagination, which is visual, creates a stacatto of images. The reader's difficulty in relating image to image and in understanding the metaphors makes his poetry enigmatic and modern. The illness, probably consumption, that his verse betrays and the sensual, despairing intensity with which he keeps hold of the moment recall another consumptive genius, Keats.

Although a great deal of detail could be added to illustrate the change in the perception of art and artist in Europe, I think that the transition from distant to recent past has been shown sufficiently—the sequel, the present *terminus ad quem*, has been sketched in the initial chapters of this book.

Like all other histories, the history of art is rife with stereotypes, which are hard and in a final sense impossible to disentangle from reality. Their final disentanglement is impossible for reasons that philosophers have made clear, but also for the reason that the public and the artists themselves tend to accept stereotypes. The traits assigned to the stereotypes are not simply invented in accord with the passing situation.

However roughly, they fit the human condition and coincide with universal tendencies, including those that rest on art's biological basis. I do not say this on purely theoretical grounds, but on the grounds that much the same phenomena occur in very different cultural contexts. The only plausible explanation is that there is a human need to create traditions and an equal need, expressed in the creative individuals I have been describing, to be stubbornly individual and make egocentric intrusions into the balanced calm that tradition is meant to preserve. The myth and something of the reality of the artist-hero recur at many times and places: the portent before his birth; the portent of his genius and his genius itself, god- or nature-given; his rapid, spontaneous progress; his heroic and perhaps magical feats; and not infrequently his clashes with authoritative persons or conventions. All this is important because it reflects a significant part of the less mythical reality, and because the myth has played a role in shaping that reality.

When I disregard the historical complexity of the issue and think subjectively, it seems to me that the truth in the myth is not hard to understand. If the egocentric artist is to succeed, he must, as Freud put it, modify his dreams to disburden them of whatever repels strangers and make it possible for them to share those dreams with him. If the artist succeeds in doing this, he wins the honor, power, and love that he had at first won in his imagination alone.

This explanation, which I take to be incomplete but approximately true, is accentuated in modern egocentric art in ways that Freud himself did not approve and might not have clearly foreseen. Egocentric art has often proved to be more direct, personal, and, in Freud's sense, repulsive than his definition allows. Instead of discouraging the artist's open egocentricity, others admire and encourage it, so that the artist becomes the symbol of the success that is attained by means of open and intense self-interest. Such self-interest is related to both the difficulties the egocentric artist faces and the gratifications he enjoys. Because his importance to himself and others lies in his self-interest and, in a sometimes tortuous sense, his self-gratification, he is permitted to be bohemian or careless of the feelings or rights of others. To the extent that this is so, it is easy and expedient for the artist to adopt a way of life as free as possible of repressions or obligations, for it is this way of life that represents the gratification his admirers gain from him. However, to live by this way, to remain intensely close to himself and use this closeness for his own

and others' gratification, he must remain intensely close to whatever in himself is unpleasant, frightening, ambivalent, and genuinely dangerous. That is, he is likely to be kindling internal flames. Kindling them, he accentuates the neurotic or psychotic potentialities of his nature; or in other words, in learning to shed his inhibitions, he reveals traits that, good as they may be for his art, are otherwise unpleasant or pathological and likely to frighten him into self-punishment, silence, or suicide.

It seems that a usual condition for artistic or other creation is loneliness experienced and overcome by the use of one's body, imagination, or intellect, a use by which one turns to oneself for the company that is missing. This absorption in one's own company, which becomes necessary for satisfying communication with others, makes it difficult for the artist to pay much attention to the experience of others. Unless he is using the experience of others to feed his art, his perception of them will be blunted, or he will perceive them only as he needs and wills and not in terms of their experience of themselves. Because he is often cut off from others and mostly dependent on himself, his loneliness acquires a nature peculiar to persons such as himself: he is lonely when his communication with himself is blocked; lonely when he cannot be as deeply himself as is necessary for him to be original and accepted as such by others; lonely when others stop reacting to his experiences or stop admiring him or his work; and lonely when he is reduced to paying much attention to others, especially if they are, except for his loneliness, uninteresting to him.

There are many ways of seeing the act of creation. One of the most usual and useful compares it with birth. The kind of artist I am considering gives birth to a series of emotional surrogates for himself or parts of himself, or for whole or partial ideals of himself. These are consciously or unconsciously meant to assert his power, assuage his pain, show him to others at or beyond his best, and, as far as possible, assure his immortality. Every serious birth of a work of art is difficult, and the reaction of others to it must affect the artist's emotions and self-esteem. In many cases the failure of the work of art is a death and inspires mourning. If the artist is set on making works of art as different from one another as possible, he is likely to be troubled by the repetition he cannot avoid, which expresses what is fixed in his personality, the old child-part of himself, from which whatever his efforts he cannot separate himself. Yet if he tries and to some extent succeeds in separating himself,

166

that too may be a kind of death with a kind of mourning to mark and accentuate it. The separation may also be from a previously adopted ideal, so that the turning to a new subject or style is an admission, perhaps, of the death of the ideal previously meant to show the artist's perfection by his ability to embody it in works of art.

My interpretation of the egocentricity of egocentric artists is, as I have said, subjective, and I should therefore like to supplement it with the results of a study of young artists, beginning with their years in art school. This study, *The Creative Vision*, by Getzels and Csikzentmihalyi, shows the young artists to have been deeply engaged in self-exploration. As one of them said, "I want to know what I am doing, trying to express myself emotionally. I want to draw what is in me, not what there is." Another said, "I know the feelings I want to convey, but not the real reasons. All my works are related in the sense that they are areas of myself, facets of my personality."

To judge by the study, there is a good deal of truth in the stereotyped picture already in Vasari of the artist as someone "withdrawn, introspective, independent, imaginative, unpredictable, and alienated from community expectations." The study shows that the bohemian life appealed to the young artist not because it promised dissipation, but because it promised the freedom to work as one wanted and to gain the great intrinsic rewards provided by art. Put abstractly, the themes of the artists' work were such as rebellion, loneliness, and jealousy; but even when the artists were able to put them into clear words, these themes seemed to yield their meaning, acquire their form, or approach their solution much more effectively in the media of art. The work required them to be sensitive to their inner states and to that extent narcissistic. As the study made clear, the emotional and cognitive equilibrium the artists were searching for was a continuation and substitution for childhood play. Less depended on intelligence, conventionally defined, than on sensitivity, self-sufficiency, intuition, and other traits shared by the artists.

The study also found that "most artists feel alienated from the work they produce." None of the artists studied was satisfied with his paintings. One of the most successful found his own and those of his friends

167

to be "hideously ritualistic," and contemporary art for the most part "distressing." The abstract style appeared to him too easy, impersonal, and empty, an art as a whole too bound up in itself. "Artists," he said, "are not inspired by art any longer but only by one another."

Having given a subjective explanation of egocentricity in art and having repeated the views of a relevant study, I should like to draw the argument together by means of a list of traits that may be ascribed to the egocentric artist. The traits are:

1. The artist's identification of the work as his own, as evidenced by (a) insistence on its uniqueness and (b) impatience with stress on the style or school to which it may be attributed;

2. The artist's pride and competitiveness, as evidenced by (a) the desire or claim to be superior, (b) the refusal to imitate others (except perhaps in order to improve them), (c) the claim to priority in the use of a style, subject, or esthetic quality of any kind, (d) the refusal to accept the conditions laid down by anyone else, and (e) the refusal sometimes to accept money or other material compensation;

3. The artist's claim to higher inspiration, as evidenced by (a) individual methods of inviting or sustaining inspiration, (b) impatience with detailed critical analysis or description of his work, (c) destruction of early, preliminary, or clumsy work;

4. The artist's emphasis on the spontaneity of his work, as evidenced by (a) the favoring of rapid, sketchy, or impulsive work, (b) interest in the activity more than in its product, and (c) possible antagonism to careful, carefully finished, or elaborate work;

5. The artist's investment of intense emotion in his work, as evidenced by (a) obsessive concern with his work; (b) personal (not ritual) insistence on solitude and secrecy; (c) extreme self-appraisal—extreme self-doubt, extreme depression, extreme self-praise, and the angry destruction or proud enshrining of his work; and (d) style or content that is unrestrainedly emotional

or unrestrainedly personal, at its extreme the willing simulation or exploitation of pathological states of mind.

This is a formidable list of traits. Some can no doubt characterize traditional artists. Pride, shame, depression, and a degree of obsessiveness characterize artists of all sorts, as they do all human beings. Some traits may conflict with others. For example, the desire to destroy preliminary work may conflict with the preference for work that is rapid or sketchy. Not many artists of any kind persistently refuse to accept material compensation, especially if its size enhances their (traditional or egocentrically intense) pride. I doubt if there is any artist who combines all these traits, though Michelangelo comes surprisingly close—he did not in principle regard sketchy work as more than a preparation for art, but he is famous for leaving masterpieces the unfinished condition of which enhances them in our eyes. I am certainly not constructing an "ideal type" of egocentric artist, but only suggesting that traits of the kind I have listed, especially when combined, mark one side of the very real antithesis between traditional and egocentric attitudes in art. I must again repeat that the reality of the antithesis should not lead us to overschematize a life in which theoretically impossible unions are so often consummated.

To broaden the application of the traits I have listed, I should like to say something about the development of art in China, which I choose because it has been recorded with such relative fullness. After I have finished with China, I shall add evidence from India and from "primitive" art.

The development of art in China does not parallel that of the West, where art was closely linked to anatomy and mathematically conceived perspective and where the human body, divinized, eroticized, copied exactly, or expressively distorted, remained at the center of art for so long. As I have shown by example in the chapter on tradition, the sensitization of art in China—its ability to be a sensitive expression or incarnation of human states of being—was related less to figure painting and portraiture than to the rendering of trees, rocks, bamboos, and

169

other landscape-fragments or wholes; for the sensitization was allied with the victory of landscape over figure painting. The result was that a landscape painted with certain techniques and in a certain frame of mind came to represent the painter's inner reality no less and sometimes more than the outer reality, the mountains and water, of which it was the ostensible record.

It is convenient to begin with the fullest of the early sources of the history of Chinese painting, Chang Yen-yüan's *Record of All Famous Painters,* which was finished in A.D. 847. Chang observes that painting originated in the very same pictographs as writing, and "being of the same substance" and made by the same use of the brush, it deserves, he implies, the same traditional respect. Following Taoistic precepts, experience, or both, Chang insists that the genuine artist succeeds when he is not conscious of the mechanics of his art, so that "the hand does not stiffen, the mind does not freeze up, and the painting becomes what it becomes without one's realizing how it becomes so." Although we cannot be sure how to interpret the ideas of Chang and other early writers on art, the vitality they speak of seems to be cosmic, and it seems that the calligrapher or painter can draw it into his work rather as the lightning rod can draw the discharge of lightning into the earth. The cosmic vitality the painter draws (the pun is exact) is both personal and impersonal. That is to say, the cosmic vitality is not personified, but some men can summon it up more easily than others and seem to possess or be possessed by it—the difference need not be clear.

It was important for those interested in painting to share in the prestige of calligraphy, which was recognized earlier as a high art and was signed centuries, it appears, before painting were. Calligraphy began with the near-magical aura of the medium by which the revered past had been recorded. It also had an advantage over painting that was important to anyone sensitive to esthetic tension and balance, or interested in reading the esthetic or, as current ideas made plausible, the moral nature of the calligrapher. The advantage was the direct result of the nature of Chinese writing. When a Chinese character is made, or rather drawn, the direction of the brush's motion and the order of the strokes making up the character are fixed by convention. The viewer can therefore follow the sequence of the calligrapher's brush-movements from stroke to stroke and character to character. Because he, the reader, also draws such characters, he can reexperience the movements of the brush, its

swiftness and slowness, tension and relaxation, rapprochements and estrangements, and other, nameless, characteristics. Esthetically, tension-ally, graphologically, the reader experiences the writer and sees the man in the work and the work in the man.

At first, in Chang Yen-yüan, the vitality of spirit-consonance, the *ch'i-yün*, that made art alive was supposed to be confined in painting to representations of men, demons, and divinities; but by the eleventh century, landscape had lost its inferior status. It, too, was regarded as exhibiting vitality as such and the particular vitality and character of its painter; and because this was so, the painting's external accuracy could be minimized in favor of its inward truth.

One of the great agents of the change in favor of landscape and inwardness was the poet-calligrapher (and politician) Su Shih (1036–1101), also known as Su Tung-p'o. Influenced by the old microcosmic-macrocosmic analogy, Su Shih and his friends felt that in painting bamboos and landscapes they were painting themselves. On a friend's wall Su wrote a poem saying that when he, Su, drank, his intestines sprouted bamboos and his liver and lungs forced rocks and bamboos onto the friend's snow-white wall. It was only natural for Su to write in another poem, "To judge a painting by its verisimilitude shows the mental level of a child."

For reasons that were at once political, social, and esthetic, the trend established by Su Shih gathered force. By the time of the Yüan Dynasty (1276–1322) it had succeeded in weakening much of the tie between the faithfulness of paintings to appearance and their emotional, imaginative, and kinesthetic qualities. Calligraphic "wrinkles," *ts'un*, made painting into a form of writing, in the sense that the painters used them to spread a varying calligraphic intensity, a touching both personal and intense, over the surfaces of their paintings. To justify themselves, to band to-gether more effectively in isolation from the government whose legiti-macy they denied, and to renew themselves by means of esthetic experi-mentation, they made a new choice of heroes from their cultural past and developed their rather extreme principles. Some of their prinicples are clearly egocentric in the terms I have proposed: expression is individ-ual, the style of a painting mirroring the artist's nature; the showy qualities of art, the carefulness of its execution, its decorative colors, its virtuosity, must be replaced by more inward, personal, sketchy, "awk-ward," genuinely expressive qualities; and professionalism, with its

showiness, shallowness, and surrender to mercenary values, must be given up.

The reverence of these Yüan artists for the past was their inescapably Chinese traditionalism; but their choice and exploitation of heroes was radical and personal and, in this sense, egocentric. This past-present, radical-traditional whole was summed up, as I have explained, in Tung Ch'i-ch'ang, who lent it much of the power that was to make it such an effective form of traditionalism.

The amateur-professional distinction runs through the whole of later Chinese art. To the pioneering amateurs it was based on the principle that true art and professionalism were opposites, because the professional was working for the sake of money and was subject to the taste of whoever paid him. It therefore became important to amateurs *not* to sell their art. In contrast, giving art away, in particular to those fit to appreciate it, was blameless; and if a friend or relative who got a picture as a gift decided to sell it, this did not reflect on the integrity of the artist. The result was that a great deal of art was freed from the direct pressure of patrons and marketplaces, and the artist was free, in theory and often in reality, to express himself in perfect accord with his own nature.

The contrast with Western artists is interesting. Although Western artists preferred in the end to regard themselves as inherently individual and esthetically free, almost all of them remained subject to the demands of the marketplace, as they remain today. Cézanne did not need to sell his pictures and Van Gogh could not; but almost all serious painters and sculptors were and are frankly professional—a teacher of art remains a professional—though poets, for all their need to publish, may be more in keeping with the Chinese notion of amateurism. I therefore suspect that a resurrected Chinese scholar-artist would look down on Western artists, even the radical ones, as essentially mercenary. The fact that the usual scholar-artist made his living from his salary as a government official or the income from his land did not change the theoretical purity of his art. However, the purity of motive, surely adhered to by its strong-minded or fanatical believers, was not adhered to consistently by many of the artists; and face, pretension, or social sensibility usually became more important than the presence or absence of material reward.

The "pure," the "amateurs," came from a different, prouder kind of family. Their teachers were others of their kind, and their practical experience was dependent on their study and copying of old masterpieces not necessarily authentic. The professionals were likely to be the sons of professionals. Their training was that of an apprentice in a regional workshop, which followed a regional tradition and produced whatever illustrations or portraits buyers demanded. The amateurs often seem to have suffered, as we can tell from the surviving evidence, from ordinary amateurishness, for which their nobility of purpose and familial advantages did not provide an adequate remedy; while the professionals seem often to have suffered from their repetitive tasks and their lack of sensitivity or ambition. As might be assumed, some of the theoretical amateurs in fact sold their art. The most fastidious among them adhered to the convention of an exchange of gifts. More professional "amateurs" could use "ghost painters" whose work they signed. Ironically, the noncommercial convention of amateur art could increase its monetary value. Modern scholars more influenced by what they read than by what they saw—not nearly enough was available for the seeing—were apt to be partisans of the amateurs, for it was they who had written the theory and criticism on which the history of art was so heavily based.

In spite of Chinese decorum, the eccentric poet or artist was a culturally familiar figure and, if able, was respected by his cultural peers. The three artists I have chosen to conclude this section on Chinese art, Ni Tsan, Kung Hsien, and Tao-chi, were all eccentrics and all artists who remained defiantly themselves. To each of them, external resemblance was less important than vitality, quality of brushwork, and structure. These qualities are sometimes stressed by them to the point that one thinks of their painting, in Western terms, as gentle hybrids of expressionism and abstraction, or, better, of English watercolor paintings and the nonexistent but easily imaginable school of Abstract Impressionism.

Ni Tsan (1301–1374) suffered from the loneliness that follows the death of those on whom we depend emotionally. He was three when his father died, and a series of other deaths left him at about the age of twenty-two, though harried by grief, in charge of the affairs of his rich family. His melancholy, he wrote in a poem, drove him to degrading habits; and he had to spend his time bowing humiliatingly to government clerks. "In the old days I bathed in the glow of parental love/ but now I am as a weak seedling in the bitter snow."

173

Up to about the age of forty, Ni lived among the indulgences that only a rich Chinese esthete could afford: ancient jades, bronze cauldrons, paintings, specimens of calligraphy, musical instruments, and very many books; and, outside, pavilions, ornamental trees, flowers, and strangely pitted rocks. The wealth that made all this possible also allowed Ni to express his great, sometimes spontaneous generosity. The compulsive cleanliness he exhibited was surely a defense against the emotional pain he had undergone. He perfumed everything he wore, washed himself till, I imagine, his skin grew stiff and sore, washed the tiles between his potted plants, had his trees washed, and had the seats of unfastidious visitors washed as soon as they left. But all this clean luxury was abandoned. When he was about forty, the rule and probably the taxes of the "barbarian" government led him to sell or disperse his property, and he spent most of the latter part of his life—he died at seventy-three— traveling around a large area of China in a houseboat, which was filled with books, scrolls, and implements for tea-making and painting. Sometimes he left the boat to live with friends or in a Buddhist monastery. He ended his life as a proud, laconic roamer of lakes and mountains. Even during his lifetime, his paintings became famous enough to enhance the status of their owners and incur the perverse flattery of forgers.

Ni's landscapes are repetitive variations of the same basic composition, undramatic, sparsely and palely brushed, background and foreground almost cut off from one another, withdrawn "remnants of mountains and residual waters." This was the style that scholars came to designate with the old term *i*, "untrammeled," not now in the sense of "wild," but in the sense of "disengaged" and so "independent." Asked why there were no people in his landscapes, Ni answered that he did not know that there was anyone around in the world. To his carefully chosen friends, he simply gave his pictures; but when a general sent him painting-silk, money, and a request for a painting, Ni answered angrily, "I have never been a painting teacher at the beck and call of the lords and princes." What he called painting was nothing more than letting the brush run loose, he said, and his bamboos were nothing, he said, but an expression of his freedom. Why should anybody argue whether his bamboos looked real or not? Soon, after they had been handled for a while, somebody might look at them and see them as hemp-stalks or reeds. "Even I would not be able to insist that they were

174

bamboos, so how on earth could anyone else who sees them manage to decide?"

The second eccentric, individualistic painter I should like to describe is Kung Hsien (c.1617–1689). Born of a poor family, he remained poor because of pride and patriotism, the first preventing him from kowtowing to protectors and the second from making his peace with the Manchu government. Searching for true culture, he and his friends wanted to study the classics, revive the old forms of writing, and prove themselves the worthy heirs of antiquity. Eventually he settled in the suburbs of Nanking, where he lived by teaching painting and selling paintings. Limiting himself to his hut and garden, he avoided the marketplace. In the words of a contemporary, he dreaded people, hid his footsteps, and was grateful to the goodwill of only tigers and wolves. Always poor, he wrote, "Even in my old age I still scheme at getting a living." When he died his family was too poor to pay for his coffin. A friend who happened to be passing through the city at the time settled his affairs, collected his writings, and adopted his orphaned children.

At first, Kung accepted Tung Ch'i-ch'ang's view that a painter should make a personal synthesis of earlier approved styles, but he grew to aim at a sharper, more extreme style, one that came from facing nature directly and made the experience of a painting and of nature the same. Critical of the artistic dullness of the craftsmen and the instability, the vacillating eclecticism, of the scholars, he aimed at art in which originality and stability would interpenetrate and constitute one another.

As I shall say later, Kung's painting shows emphases that can be ascribed to European influence. Somewhat as in Van Gogh, nature is simplified, stylized, and subjected to a deep overriding rhythm; but unlike Van Gogh and like Ni Tsan, Kung always left people out. Some of his paintings have a somber inky depth that resulted from the application, it has been said, of as many as seven varying layers of ink. In Chinese painting, his density and depth are extraordinary. We know from his sketchbooks that his approach to art was analytic, and it is therefore fitting that the first-published section of the famous analytic textbook of painting, *The Mustard Seed Garden Repertory of Painting*, was compiled by one of his students. However, system was joined in him with proud originality. He wrote of himself as a poet, "He spits out his heart and digs out his marrow before he is finished; only afraid that one

word might fall into someone else's trodden path." Once he recommended himself with the words, "There has been nobody before me and there will be nobody after me." Although he had students, he was right, and no one we know of continued his art.

The third of the individualists I should like to describe is Tao-chi (1641–c. 1720). Soon after his birth China was conquered by its Manchurian invaders. The Emperor committed suicide, and Tao-chi's father, a member of the imperial family, tried to take over the throne, but was captured and executed by a rival. Tao-chi, then a little boy, was saved by a servant, who fled with him to Buddhist monastery, where like many others they escaped by becoming new persons, that is, by shaving their heads, adopting new, Buddhist names, and becoming Buddhist monks. "Tao-chi" is one of Tao-chi's Buddhist names, the Chinese usually referring to him by the name Shih-t'ao, meaning "Stone Waves."

When Tao-chi was about nine, he and his friend left the monastery and for ten years wandered by foot and by boat over a large part of China. To judge by his own words, he turned to painting in order to develop his self-reliance. In a colophon probably of 1679, he wrote: "Being by nature lazy, and so often ill, I almost felt like burying my brushes and burning my inkstone. . . . Then quietly, and all by myself, I walked by the Chu-chai studio and saw some original works by Ni Tsan. . . . As my eyes passed over the paintings, my soul followed."

Tao-chi could make his living only by painting. This was no longer a matter for great shame for a scholar, yet Tao-chi felt anxious and somewhat demeaned. He wrote on an album leaf that professionalism might become his downfall. Although he hated to paint on silk or to make large hanging scrolls, he felt he had no choice, and he wrote to a client that he agreed to paint a decorative screen, for which his style was unsuited, only because he needed the money. Complaining in a way reminiscent of Michelangelo, his letters discuss his fees, his ill health, and the great strain of stretching large panels and climbing ladders in order to paint.

Almost as eminent a calligrapher as a painter, Tao-chi mastered many scripts and, like others of the Chinese I have discussed, looked on calligraphy and painting as one and the same. His calligraphy is a constant fluctuation of thick and thin, its subtle expressiveness modulated between the flare of the horizontals and the diagonals.

It was perhaps because he was aware of the richness of the past and

because he wanted to rise above eclecticism and conflict and be simply, freely himself that he wrote that for him there was no style. This had the air of a boast, but he may have meant, like de Kooning, that there had been so many styles that style had disappeared or should disappear from painting. In the following chapter I shall summarize Tao-chi's artistic creed, which is a declaration of independence. He was ready to say, "Following old rules is death to mind and eye," but followed these words, so grating on conservative Chinese ears, with a characteristically Chinese poetic flourish, "For the immortals ride on the wind, and flesh and bone compel the appearance of divine spirit." His "no method," with brushwork sedulously unsystematic, has been seen as introducing incoherence into Chinese painting. His self-emancipation, goes the criticism, left Chinese painters without a clear direction in which to move. The freedom to separate from the past had in it the usual hint of death.

In India, perhaps the first reference to an individual sculptor goes back to the second century B.C. An inscription of that date speaks of the Devadinna, excellent among youths and skilled among sculptors, who loves Satnuka. A sculptor of the sixth century A.D. inscribes his sculpture, which is said to be masterly, with no more than, "This is carved by Dinna." Dasoja, evidently prouder, entitles himself the "Smiter of the Crowd of Titled Sculptors"; and his son Chavanna is a veritable Shiva, a sculptor-god. Chikka Hampa, a king's sculptor, is named "Champion Over Rival Sculptors." Literary sources single out particular artists for praise and in one case show how an art-loving king receives the announcement of the arrival of an extraordinary painter.

When the artistic ability of kings and princes is described, it is hard to distinguish between the truth and the hyperbole due their rank. It is a fact, however, that some kings were celebrated for their learning and creative ability. King Mahendravarman I, of the seventh century, has a rock-cut temple attributed to him and is called "a tiger among painters." King Bhoja, an encyclopedic spirit of the eleventh century, is also reputed to have been an architect; and King Someshvara, of the same century, wrote a detailed discussion of architecture, iconography, painting, literary criticism, and so on.

It would not be difficult to add names, but even if I did, the list would

177

remain miscellaneous and unimpressive. Yet the names serve to show that the Indian artist was not invariably anonymous or modest.

In Tibet, artists' names often appear on temple frescoes, sometimes with praise for their skill. Since painting was an act of devotion, it was only right that the painter's name should appear; but holy pride, too, is pride. In literature we sometimes find artists named as particularly gifted. An example is the many-sided Mikyo Dorje, of the sixteenth century, who carved a self-portrait out of stone. Another example is Tödrupgyatso, whom the Fifth Dalai Lama considered "the supreme painter." It is also relevant to our theme that Tibet has had groups of "mad" bards, who have sung, danced, and clowned, to everyone's amusement, but often in protest against the establishment, including the religious orders.

In speaking of the artists of India's "medieval" period I have already mentioned those of Mughal India. Artists who served at the courts of the native Rajput rulers could become well-known locally, and research has uncovered a considerable number of names and styles attached to them. This is true, to give an instance, of the Kangra court, whose art, beginning toward the end of the eighteenth century, is a lyrical celebration of love and the beauty of women.

The writers of India, who are more often named than its sculptors and painters, have left some autobiographical fragments. From such fragments we learn that the novelist-poet Bana, of the early seventh century, lost his mother when he was very young and his father when he was fourteen. After mourning his father for a while, he tells us, he led a dissipated life, but learned calm, regained his prestige at court, and finally returned to home and tranquillity. Dandin, who lived about a century later, also tells us that he lost his parents early in life. As was traditional among young writers, he wandered abroad for years and was able to study in foreign countries. We can sense these writers as individuals, as we can the poet Pushpadanta, who, lacking everything but ability, was humiliated at the first court at which he served and withdrew to the life of a wandering ascetic.

Seduced by the habits of Indian rhetoric, Indian poets fell into the habit of praising themselves and one another. Writing some time about the beginning of the tenth century, the poet Abhinanda gathered his best superlatives and praised the poet Rajeshekhara as a source of companionship, storehouse of conversation, purveyor of charm for love, con-

noisseur of fine speech, abode of beauty, source of gentle song, and tree on the hill of justice. Out of Western reticence, I have omitted some of the praises, but add the cry, "Rajeshekhara, my friend!" with which the poet ends.

In India, writers sometimes complained (of course) of the reaction of the public. Dharmakirti complained that though he weighed word and sense alike, the public only sneered. The poet-playwright Bhavbhuti, of the eighth century, complained of "those who scorn me in this world," but understanding that "time is endless and the world is wide," looked forward in his imagination to the day when someone able to appreciate him would be born. Dharmakirti complained or perhaps boasted that his artistic integrity had left him isolated as a writer:

How now, am I alone? Ah yes, I see:
the path which the ancients opened up by now is overgrown
and the other, that broad and easy road, I've surely left.

When Indian estheticians like Abhinavagupta, of whom more later, claimed that the poet was capable of numinous experience comparable with that of the mystic, they came close to the stereotype of the "mad" poet. There is at least one passage in Indian esthetics in which the connection between poetic inspiration and "madness" is made. Poetry has little to do with sanity, the passage says. The heart of the poet is like an immeasurably deep lake of esthetic emotion. When it is filled, the poet "becomes as if possessed by a planet, as if mad, and finally he pours out poetry, and turns the listener, the sensitive reader, into the same sort of madman as he has become."

Such a passage is most unusual in Indian esthetics; but to strengthen my case I should like to recall the proud, romantic folk-poets of India, among them the Pardhans, whom I have cited as examples of spontaneous art.

Given the great variety of "primitive" societies, I cannot pretend to know to what degree egocentricity is or is not usual in their art. It does obviously occur, however. I shall content myself with one example each from Australia, Polynesia, and Melanesia (more narrowly, New Guinea),

179

and then go on to Africa, which, thanks to research done there, provides more numerous and better developed examples.

The Australian Aboriginal example is that of the Songman, who inherits his position from his father or uncle. Without the Songman's permission, which must be recompensed, no one can sing any of his heritage of songs or those that he himself has created in words, music, and dance. Dancers, some of whom are highly esteemed, may introduce their variations, because they and the musicians are eager to exhibit their own creative power; but the Songman remains a model of individuality and originality.

The Polynesian example I have chosen is that of the professional who belonged to the entertainers' group, the *arioi*. Performances of the *arioi*, who traveled from place to place, contained songs, speeches, recitations, and wrestling and sometimes fighting. Each performance, whether concerned with mythology, history, or love, began with songs and dances and ended with a dance. The performers, who gave great pleasure to the crowds that watched them, were applauded everywhere. Both songs and dances were decidely sexual, and the victors in a performance-contest chose the most attractive of the women spectators for their private reward.

My New Guinea example is the woodcarver of the Asmat region. He is a villager like everyone else, but related in spirit to the culture hero who was the creator of man, the first drummer, the first woodcarver, and the great headhunter. In every village there are some people with a connoisseur's attitude to woodcarving, and they are able to evaluate the local carver and name the more important carvers of neighboring villages. Good craftsmanship is always an important criterion, but some of the carvers are clearly distinguished by their daring and imagination.

My African examples begin with storytelling and music. What I should like to report about storytelling—or rather storytellers—is taken from a study carried out in Benin. The investigator concludes that storytellers there, whose performance is believed to attract "witches" and "spirits of the night," are socially isolated, live troubled lives, and are mostly introverted.

For music, I draw my examples from the Bala, who live in what is now the Republic of Zaire, and the Tiv, a Nigerian tribe. Among the Bala, musicians neither work in the fields nor do other work expected of ordinary men. Parents do not want their children to become musicians,

and musicians themselves usually say that their profession is not a desirable one. Yet musicians are said to be born to music, and to need and want to play it. In keeping with their role as weak, eccentric, but socially necessary persons, they tend to be drinkers and spendthrifts.

Among the Tiv, who are known as warriors and singers and dancers, most songs are regarded as the creation of an individual. It is assumed that composers of songs are slow-moving and meditative. Some of them become musicians because they were born blind or lame. Others seem to have decided to become musicians as the result of a personal misfortune. One Tiv composer generalized and said that composers are different because they praise people in order to get money from them, but they are also never at rest, "their minds are always working like a clock to bring about a new song, always restless." Another composer reported that women who love the composers' songs just leave their homes and follow them. A third, who confirmed the sexual attractiveness of songs, said that although praise was very important to him, he was most pleased by the marriage that song brought him, because at first he was left alone. "Now," he said, "it seems that the world wants me again." Still another composer, defining what made a composer good, said: "If he can convert the hearts of the people to experience the same situation that he has experienced, then he is a good composer."

My examples of egocentric carvers are drawn from the Sisala of northwest Ghana; from the Bangwa of west Cameroon; and from the Dan, Kran, and Gola, all of Liberia.

For the Sisala, we have a careful report on the sculptor Ntowie (c. 1910–1957), recognized by himself and others as the "first carver." His success, which led to public recognition, inspired others to become carvers; and he was the model of success arrived at by someone who was more than a conformist. He was described as having been a lazy boy, who preferred to hide himself and carve instead of farming. Once, it was said of him, he was punished severely, ran away for a time, and then came back with human figures so beautifully carved that the elders of his lineage assumed that the bush spirits had inspired him. Thereafter he was never ridiculed but encouraged to continue carving. He was so well regarded that persons from other clans commissioned sculptures from him, his work was found in many villages, and a surprising number (fourteen) of his sculptures remain, "a remarkable fact considering the public's minimal demand for wood sculpture."

Among the Bangwa, there are hardly any typical artists. Some of them do conventional work while others are original. Some are well integrated into society, while others, wastrels and philanderers, fit an egocentric stereotype. One of those who fits is Atem, equally devoted to carving and drink. The money he earns from carving a mask goes into drink, which he shares with his friends. Unlike most Bangwa men, he does not care for status or material comfort. He belongs among the Bangwa carvers who are remembered for their wit and their self-willed way of life.

In Liberia, in the Dan and Kran area, the greatest artist known during the past two generations was Zra. Old and sick as he was when an anthropologist came to visit him, he rose at once and said, "If anyone calls here, it can only be for me." He explained:

> I am called Zra. Zra means 'God.' People gave me this name because I am able, like God, to create such beautiful things with my own hands. If you see a particularly beautiful carving anywhere in the land, whether a mask or a rice-spoon, and another carver claims it, it is a lie. All the beautiful pieces were made by me. I was born with this ability. No one showed me how to carve. No, no one in my family knew how to carve.

Zra said that he had been so famous that even the chiefs of hostile tribes had invited him to come and carve for them. He would then send a message asking them to build him a fine hut in the bush where he could work. When the hut was finished, he would move there with his favorite wife and an apprentice. "From what I earned with my carving," he recalled, "I bought many women. . . . I gave them to my sons and nephews, who in turn worked my farms with these women."

Tompieme, a carver who lived in a neighboring area, loved carving and spent most of his time at it; and he composed and sang music. He had been inspired to become a carver by the request of his dead brother, who had appeared in a dream and asked him to work, as he had taught him, at the smithy. Tompieme bought an adze and the following night his brother came again in a dream and commanded him to carve a Kagle mask, and from that day he kept on carving. He took up blacksmith's work too. Before he would carve, he would look at the chosen block of wood, he said, and would see the carving in it. He declared proudly, "I do not carve to earn something, but mainly for my fame. My name will

not be lost when I die. My apprentice Ge will also tell of me when I am dead."

Perhaps the most striking report of the egocentricity of African carvers concerns the Gola of western Liberia. It is possible that the traits described are the result of modern conditions; but, lacking a sufficient historical background, we can see no further than the anthropologist at the time he made his observations. The anthropologist W. L. d'Azevedo, reports that the sculptors themselves emphasize that they want to become known for the masterpieces they carve. Like skilled musicians and dancers, expert Gola carvers are as much distrusted as admired. This ambivalent attitude is nourished by their independence, because, to the discomfort of ordinary tribesmen, they have become relatively free of their families and communities.

Famous Gola artists—singers, dancers, storytellers—compete for attention at ceremonies and festivals. Some have become legendary because of their ability to create songs, because of their well-known lovers, or because of the supernatural inspiration they claim. Singers, who are often childless, claim that it is their tutelary spirits who have made them barren. The carvers who believe that their ideas come from dreams inspired by a spirit-friend claim that their work is superior to that of nondreaming carvers. Professional carvers questioned by the anthropologist usually said that they had chosen carving against the will of their families, such talent being supposed to weaken family loyalty. One carver reported that his father had destroyed the tools he had made for himself. Others reported that they had run away to tolerant relatives or had become apprentices in secret. Their urge to carve, they claimed, could not be resisted, and it was a competitive urge, to carve so as to excel any rival. Even when the carver was a relative conformist, there was a consistent expression of "the theme of misunderstanding and the lonely pursuit of a beloved craft."

Because masks are essential to the ceremonies of the womens' secret associations, the women may court a famous carver with money and, if necessary, stories say, with an especially chosen seductress. A carver is said to be by nature generous to children and women friends. Like his person, his work appears both heroic and eccentric. "As the child of society his work is a kind of eternal 'play' but his playthings are more-than-lifelike symbols which awaken disturbing thoughts and values which lie for the most part dormant in culture."

I cannot abandon the subject of African egocentricity without reporting on an apparently rather new art form of the Ibos of eastern Nigeria. This art, which honors the dramatic festival of regeneration, the Mbari, requires the building of a *mbari*-house with clay sculptures of animals, men, gods, and monsters. The moving spirit in the process of construction, "the person of skill," combines the qualities of architect, sculptor, and even priest. Although *mbari*-artists are guided by the work of their predecessors, they and their clients prize originality and agree that each artist works according to the dictates of his own will. Artists of the same generation are fiercely competitive. "No man admits to a superior; few acknowledge equals." As one of the artists said, "The thing that spurs me on is my willingness to make my work more beautiful than that of any other artist." However, if one takes the *mbari*-artists at their word, most of them are more interested in financial reward than in self-expression.

CHAPTER SIX

The Esthetic Universal

Now the end. First I described the state of contemporary art and the causes for it, especially increased knowledge; then the presumably universal grounding of art in biology and art's presumably universal traditionalism and egocentrism; and now I have to draw the threads of my argument together and fulfill the promise with which I began, which is a partial but presumably universal esthetics, one that applies to European, Indian, Chinese, "primitive," and other art. Comparisons so broad of matters so distant from one another in time, space, and culture must always face the criticism that the distance makes the attempt to compare futile if not misleading. I have dealt with this criticism, for the most part implicitly, in many of the preceding pages; but I should like to begin this last chapter, in which the process of comparison is carried to its extreme, with a brief, direct, and general answer to the general criticism.

My defense, previously a demonstration by example, is an attack on exaggerated, self-defeating regard for context. A little reflection should persuade us that understanding is injured if we confine it to the appreciation of the nuances that make works of art or anything else unique.

The opposite, generalizing by taking things out of context, is essential not only to abstract learning but to life itself. When we take things intellectually out of their immediate context, we merely continue what happens at every moment of our lives, when perception makes out and memory confirms that some one thing or event resembles some other. If not for our perceptual ability to disregard differences, our experience would never become cumulative, we should never learn from it, because there are *always* differences between *all* experiences we undergo. The question is not whether the differences exist, because they do, but whether we should make anything of them; and the answer often lies in the conscious or unconscious decision to pay no attention to them or the particularity of their particular context, or to put it otherwise, to use only those criteria of identity and difference that fit our need at the time, that is, to intuit, discover, or hypothesize the context that is most pertinent to our need.

If we human beings know or have learned of objects of thought that remain always identical with themselves and subject to absolute rules of comparison, the objects are those of mathematics. Physics, too, is deeply abstract in this sense. When we turn to biology, however, and beyond it to culture, everything shows itself to be different from everything else. Examined with care, even identical twins are observed to be different, at times grossly so. For that matter, it is reasonable to hold that a person in different situations or at different times is quite clearly different from what he was—a view that can be held without any Buddhist, Humean, or other self-estranging assumptions: a human being plays different roles, develops, responds in ways that surprise even himself, and shows the effects of an imperfect integration. To put it very briefly, everything biological, from human being to bacterium, is profoundly different from the atomic and subatomic particles that make it up.

However (when is there not a however?) all this about difference is no reason to forget how profoundly and pervasively similar everything is. The profound and pervasive similarity among biological individuals is shown by mathematics, physics, biochemistry, ethology, and the social sciences. If not for the pervasive lines of similarity running through existing things, everything, assuming it could at all exist, would be an unimaginable chaos. Profoundly different though a human being may be from subatomic particles, he is profoundly like them, even identical with

them, in the sense that they make him up, and the discovery of the likeness and connection is the endless work of science.

Considerations such as these lead me to insist that any objects of thought can be legitimately compared. There is no general abstract question of the legitimacy. The question is only whether a given comparison has led to anything intellectually useful, pleasurable, or enlightening. It may turn out not to have met this natural demand; but its failure ought not to be assumed a priori. A far-reaching comparison is best looked on as an experiment that can be judged to have succeeded or failed only after it has been made. The cultural distance it spans makes the challenge the greater and the success, if it comes, the more interesting. It is clear however, that whatever the success of the comparison, it is always made in some context, if only that which expresses the purpose of the maker of the comparison. Important as it is for us to be aware of contexts in their full complexity, we should not allow our interest in them to stand in the way of distant and radical comparison. An insistence on context is too often a refuge from analysis. It prevents a more than instinctive understanding of even context and individuality. The parochialism it encourages is itself a form of misunderstanding, intellectually little but myopia raised to the status of a virtue.

I say these things in my defense because my argument rests on the artificial but, to my mind, necessary separation of the universal from the local elements in art.

Having argued for the legitimacy and possible usefulness of taking things out of context, I turn to what I call "the esthetic universal." I think that to recognize such a universal is to begin to solve the most pressing general problem of esthetics. I say "to recognize" rather than "to discover" because I lay no claim to be a discoverer, and because I hope only to bring to clearer light what everyone apprehends at least vaguely.

"The esthetic universal" should not be taken in too Platonic a sense. It is not a kind of constitutive Idea the quantity of which makes a work of art more or less good, as the quantity of sugar in food makes it more or less sweet. Nor does the esthetic universal as I mean it give any direct measure of the esthetic value or importance of a work of art. It is just

that in the human condition that makes art both universal and indispensable. Both a power and a need, it can be grasped, according to one's intellectual preferences, as biological, sociological, psychological, metaphysical, or esthetic. It can be seen in the light of any or all of these preferences because it is so general and basic and because it is rooted in our biological nature and, rooted there, makes possible our most distinctively human accomplishments, joining the animal in us with the human in its most imaginative, concentrated, powerful, and subtle expressions.

To speak of the importance of such an esthetic universal is not at all to belittle that which is simply local in art. I fully believe that an accurate, more or less intuitive grasp of the nuances of art must be based on intimate acquaintance, just as the accurate, more or less intuitive grasp of the nuances of emotion must be based on intimate acquaintance, such as that which develops within the family.

What I am saying about the essentially local nature of the nuances of art holds true as well of art theory and esthetics. Their life, too, resides as much in their detail, their historical or emotional coloration, as in the basic need or problem that animates them and the neutral abstractions into which they can be translated. Works of art and esthetic theories are alike in living in determinate places at determinate times—it is only there and then that they are most fully themselves. Yet that which is universal in art, the animating need or problem or the neutral abstractions translating them, allows us to see art everywhere as an extensive series of variations of the same themes, and therefore as having a deep genuine likeness. Local understanding alone is by nature restricted to a narrow angle of vision, and its detail is so accurate and grasped with such sensitive intuition just because of the restricted (and therefore concentrated) experience of its local judges. Local judging can be the closest of all in its grasp of detail, but is apt to be the most myopic.

The characterization I shall make of the esthetic universal, though meant to be independent of my own preferences in art, can be translated into a hope. Contemporary art is what we ourselves have created, either directly as artists or indirectly by our preferences or acquiescence in the preferences of others. It has an irreplaceable immediacy, an unforseeable, energizing quality. It engages us in the excitement of creation, the

incompleteness of the present, the impenetrability of the future. It is ourselves looking at what we make of our problems, thoughts, fantasies, ambitions, and selves. Not surprisingly, some of it turns out to be trivial, and much of it uncomfortable. The triviality and even discomfort of art are not new and cannot be escaped; yet what I and others find hardest to accept is its tendency to become extreme in its primitivism or primitive in its extremism. I have acknowledged the ubiquity of the trickster and his essential role in human culture. As I have said, he is the marginality that must appear at the center if the center is to stand firm, the doubt the expression of which makes it possible to maintain dogmas and institutions as if no doubt existed, the rebel who makes compliance possible because not fatally burdensome. Yet in art the margin is now very often impossible to distinguish from the center, the doubt becomes the dogma and the institution, and the artist rebels not (speaking sociologically) to make a difficult compliance possible but to make rebellion itself into the standard form of compliance. The opposites that once completed one another by their enlacement have become too nearly indistinguishable.

This condition, in the visual arts particularly, the weakening or breaking down of our tradition, has had many causes, some of which have been discussed. I have been struck by the effect of the sheer quantity of knowledge that we now command. It appears that this knowledge, which has been the unmitigated joy of the scholar, has been both the joy and confusion of the spectator and the joy and bane of the artist. The artist is best off and worst off, the simultaneous presence of the art of every time and place stimulating him without end, but making it extraordinarily hard for him to find his direction and, once he has found it, to persevere and mature in it. Such wisdom as art history has taught us has enabled us to live more comfortably in art's past than in its present. Aware above all of change, we confine ourselves to the applause of each current success in turn, take refuge in a sociable but often thoughtless hedonism, and wait for the historian, who is better at description and classification than judgment, to sort things out.

Yet though much of our loss of a common art tradition stems, as I see it, from the increase in our knowledge, it is possible that if we become more attentive to this knowledge, more analytical and sensitive, we can gain something that will serve us somewhat like a tradition and allow us to find our direction somewhat more easily. I say this because I believe

that beneath the chaos of different artists, schools, periods, countries, and cultures, we can find analogous sensitivities, and that these sensitivities, grasped in their likenesses and differences, will allow us to understand art in a deeper, stabler, more comprehensive way. This should be the more true if we concern ourselves seriously with the non-Western cultures. Having long since ceased to think that they are alien, I find it difficult to suffer the prejudice that still takes them to be no more than an exotic curiosity or a source of devices by which Western artists have broken with their own past.

I do not assume that a more comprehensive understanding will enable us to settle our esthetic disputes by an appeal either to facts or to sensitivities. Esthetic disputes, like others, are an indispensable expression of life. Yet it is possible to make them an occasion for learning as well as self-assertion. I mean that it is possible to gain insight into their subsurface reasons and to develop more resilient sensitivities in art, more tolerant in some ways and demanding in others, than we now possess. To live in the esthetic present is essential to art; but to live there alone, cut off from all the past, is seriously dehumanizing. When fashion shuts one of the artist's eyes and rebellion or arrogance the other, he becomes blind; and although a blind artist can surely be an interesting one, his art, like his person, expresses the fact that he is maimed, too imprisoned within himself. Not everything Chinese pleases me, but I wish we could adopt something of the Chinese attitudes I have described: the rebel in art resembled the conformist in knowing his predecessors, whose brush-compositions he performed on silk or paper as if performing classical music, employing his skill and temperament to repeat the great artists of the past—that is, to internalize their particular kinds of vitality and in this way to keep their accomplishments alive in his own. Nothing of the great past was ever wholly lost in the creative present.

Perhaps the circle can be squared a little. Perhaps instead of pursuing the volatile present alone or, in its place, the mirage of an absolute, more-than-traditional power of judgment, we can take part in the creation of a new tradition whose locale is the face of the earth, and whose memory assimilates all the previously separate memories of the different old traditions. Or perhaps I am only asking for the acceleration of a process that is already occurring, the transformation of all the histories of art into a single, enormously rich history, a record that can lend the art that is being created a context wide and deep enough to stabilize it

190

somewhat—so much will be known to have been done before that everyone will be able to profit from the sensitivities of predecessors, everyone will have the beginnings of a tradition for himself, and every work of art will possibly be both traditional enough to start from others' experiences and new enough to express the present individual. Tung Ch'i-ch'ang shifted about stylistically a good deal in the beginning, and his dogmatism shows his defensiveness; but at a moment when painters suffered from an embarrassment of traditional sources, he aimed to establish a "great synthesis" and ended in "imitations" that seem to have been as distant from their originals as Picasso is in his variations on David, Delacroix, Velasquez, and Manet. While I have not seen enough of Tung in the original to form an independent view of his abilities, he used his artistic past to arrive at himself, with a power sufficient to impress artists who were not always sheep following the leader who happened to be there. Perhaps, absorbed into what we shall one day recognize as the unqualifiedly human tradition, we shall succeed in building on the past again, even if only loosely, and grasp nuances against a background the variation of which will make their individuality the more clear. Maybe because we do not yet have it, I should like the artistic equivalent of Walt Whitman's great single tradition of poetry, when "the verse of all tongues and ages, all forms, all subjects, from primitive times to our own day inclusive—really combine in one aggregate and electric globe or universe."

Put abstractly, my position is that we have created a false and damaging antithesis between an objective and a subjective attitude towards art. The old view that art should by nature express objective, eternal, traditional values has had its recent advocates, of whom I have named a few; but they have not impressed the far more numerous advocates of a subjective, perpetually self-renewing, practically traditionless art. These two extremes are better for argument than understanding. If the kind of analysis I am undertaking is even approximately correct, art is neither simply objective nor subjective, but both. Its objective character results from biological and psychological likenesses between individuals, and from the analogous methods by which all communities, unique though they are, have tried to preserve their unity. The subjectivity of art is of course its ability to give direct expression to the nature of the individual and to arouse the equally subjective reaction of other individuals. It should be clear, however, that objective and subjective, or, as I under-

191

stand them, traditional and individualistic, require one another in order to retain the power of which they are capable. This is so because, as I have said, the function of art to unite the individuals who make up a community is also its function to distinguish them from one another. In its formally emotive language, art also says, "I belong to this communal role I am exhibiting, and this role belongs to me, in my own person and style."

The unification I am suggesting of artistic traditions and sensitivities is generalized from the already numerous episodes of cultural contact, some of them no doubt destructive, but others surely enriching. Instead of attempting an encyclopedic survey, I should like to reverse the emphasis of a previous chapter and give examples of the influence, fruitful and not, of European on Chinese and Japanese art.

The missionaries to China in the late sixteenth and seventeenth centuries came equipped with religious paintings. Some of the missionaries were themselves painters, a few of them served as such in the Emperor's studio, and now and then they had converts who were or became painters. It is reasonable to suppose that it was the influence of this European art that caused portraiture, long consigned to artisans, to be taken up again by persons who looked on themselves as artists. The artist Tseng Ching (1568–1650) was not only a portraitist, but an extraordinarily realistic one by Chinese standards. A contemporary source describes his portraits as "like images reflected in a mirror" and explains that the faces "would glare and gaze, knit their brows or smile, in a manner alarmingly like real people. . . . When one stood looking at such a face one forgot both the man and oneself in a moment of spiritual comprehension." Tseng's technique of adding "tens" of washes on washes also suggests European influence; but it is interesting that the praise of realism is justified, Chinese fashion, by its ability to induce self-forgetfulness and spiritual comprehension.

Tseng is said to have had many followers. Unfortunately, of the two styles attributed to him, heavy and light, only examples of the light survive, and they are in a predominantly Chinese manner. Later, in the Ch'ing dynasty, not only did more evidently European-type portraits appear, but also European-influenced landscapes. We learn of such land-

192

scapes from the description of a painter who served in the Imperial
Studio toward the end of the seventeenth century, at a time when the
Emperor favored missionaries as painters and astronomers. The painter
I am referring to, Chia Ping-chen, was versed in topography and astro-
nomical measurement, knowledge that must have helped him to achieve
his reported ability to paint striking effects of depth—mountain ranges
showing enormous distances—daylight, and mist. The description con-
tinues with praise for "the Western method" employed by Chia:

> The Western method excels in painting shades. It dissects the
> picture into minute parts to distinguish *yin* from *yang,* front and
> back, slanting and upstanding, long and short, and applies colors
> either light or heavy, bright or dark, according to the distribution
> of shades. Therefore, viewed from a distance, figures, animals,
> plants and houses, all seem to stand out and look rounded.

Another of the Emperor's court-painters, Men Ying-chao used West-
ern light and shade to make realistic pictures of the Imperial collection
of ink-slabs. The Emperor himself considered Giuseppe Castiglione, the
missionary painter, as the equal of the great Chinese painters and with-
out a rival as a painter of horses. But Western-type painting depended
on Imperial patronage and vanished when it was withdrawn.

The mutual criticism of Chinese and European was naturally derived
from their traditional values. Even Wu Li, a painter converted to Chris-
tianity, was not impressed by the European ability to represent distances
by special rules of light and shade, or by their brushwork, or their
painstaking attempts at realism. The European criticism of Chinese
painting was usually that it lacked perspective, shadows, and knowledge
of human anatomy. Yet it was a Jesuit who wrote that the paintings in
the Imperial palace had "a great deal to teach our painting as to the way
to treat a landscape, to paint flowers, to render a dream palpable, to
express passions, etc."

The disfavor into which European painting fell reflected that into
which Christianity fell. It should also be remembered that the painting
missionaries had been forced into a very reluctant compromise with
Chinese standards, and their mixed style, thought foreign and vulgar by
Chinese connoisseurs, was also ridiculed by Europeans. Nevertheless it
is becoming apparent that there was a palpable European influence on
certain able Chinese painters who remained distinctively Chinese. These

painters, of the early seventeenth century, lived in or near Nanking. One of them, Wu Pin (active 1576–1616) became a court artist and is likely to have seen the European paintings and illustrated books presented to the Emperor in 1601. His style might have been derived from Chinese sources; but a near-contemporary writes that "he never followed old models, but always depicted real scenery." His landscapes struck viewers with amazement, and the extraordinary claim was made that he had painted them directly from nature. The angles from which he viewed the landscapes, the way he cut off structures and trees, his use of reflections in water, and his rainy or cloudy skies, sunsets, and chiaroscuro, all suggest European influence.

Other painters of about the same time show characteristics that are likely to have stemmed from or been accentuated by European pictures they encountered. I have already described Kung Hsien, whose very forceful landscapes have been taken to argue an acquaintance with European engravings. A similar acquaintance is likely to have helped Chang Hung (1577–c.1652) to make landscapes that were thought mysteriously natural. They do have an unusually empirical quality, a new attempt to paint as if from a European kind of perspective, dominated by a single viewpoint, and new ways of dotting to represent forms. His departures from Chinese tradition, which influence Chinese critics to rank him low, do not deter a European historian of Chinese art from ranking him high.

The meeting of East and West in Japanese art was rather different. There was a brief episode in the second half of the sixteenth century when things Portuguese—diet, clothing, words—came into fashion among both merchants and warriors. Whether or not he had been converted, a fashionable Japanese might wear a driftwood rosary, a crucifix, or the like. But this episode was cut short, the Christians were persecuted, and Japan remained isolated until the seventeenth century, when it was opened to Europe again, and when Western knowledge, under the name of Dutch Studies, was taken up. The influence of Western art extended to the science-oriented scholars and to some painters.

The "Dutch Scholar" Shiba Kokan (1738–1818) represents the partisan of everything Western, including art. He began as a successful artist

in the Japanese style, but curiosity and reforming zeal led him to redis-
cover the forgotten European methods of engraving and etching and
then to turn to Western oil painting. Ironically, his complete conversion
from his own well-mastered style did not lead to a genuine mastery of
the Western style, although he did achieve an attractive serenity. Once
converted, Shiba Kokan was adamant that art must represent reality just
as our eyes grasp it, and as only Western techniques could show it. "If
pictures do not portray objects accurately," he said, "they are neither
admirable nor useful." He contended that, compared with Western
painting, Japanese painting was child's play. Although in the end he gave
up Dutch Scholarship and reverted to Taoism and Zen, it is for his
Westernism that he is remembered.

As Shiba Kokan represents the partisan of the West, Maruyama
Okyo, a painter in the Kano style, represents the attempt at a compro-
mise. His pictures, favorites with some of the early admirers of Japanese
art, now appear too sweet. His compromise denatured both his Japanese
heritage and his adopted Europeanism and did not have the vigor possi-
ble to hybrids. I make this criticism somewhat hesitantly, because Okyo's
pictures reflect his pleasure in life, while his insistence on observing the
living things he painted animated the painting of his time and led to
many charming descendants.

In contrast with Kokan and Okyo, Hokusai (1760–1849) exemplified
the undeniably creative borrower. Full of curiosity, he took whatever he
wanted from wherever he found it. His desire was to grasp the living
quality of everything he drew, which meant for him the grasping of "the
bone structure of birds, fish, animals, and insects." When young he
experimented with European projection and perspective, and he edu-
cated himself to understand both European and Sino-Japanese shading,
which are, he wrote, "as different as front and back" and equally
important. Judged by Hokusai's own standard of creating "life and
death in everything one paints," his not very considered fusion was
successful. The fundamental nature of the criterion is the measure of the
importance of the success.

The clashes, compromises, and fusions among the art of different cul-
tures return us to the problem of the relativity of esthetic judgment, this

time in the context of the standards of one culture against those of another. There was a time not long ago when it was usual to doubt that non-Western cultures, especially "primitive" ones, had clearly esthetic standards, that is, standards clearly distinguished from religious and practical ones. Again, I am in no position to summarize what all or most "primitives" think; but I have said enough to show that it is simply an error to assume that "primitives" never think in conscious esthetic terms. French anthropologists who have studied certain African languages (of the Wolof of Senegal, Bambara of Mali, Susu of Guinea, and others) have found that they do have words for "good to look at" or "esthetic." But researchers have gone far beyond a study of vocabulary. The Yoruba, we now know, hold an ideal of balance or "coolness," and so do the Gola. The criteria of the Dan are more intuitive than verbalized, but are clear in practice, in a preference, for example, for vertical symmetry and a characteristic balance and rhythm of a statue's masses, surfaces, and lines. It is these criteria that a Dan sculptor is trying to satisfy when he stops and holds his work at arm's length while squinting at it or holding it, like modern European artists, upside down. The Ashanti add to the criteria of balance and symmetry those of the lightness or fineness of lines in a carving and of a smooth surface. The Fang, too, demand smoothness, and ensure that a figure has vitality by the exactness with which arm matches arm, leg matches leg, and breast matches breast. Although local or traditional standards vary as they do, I do not recall any that are indulgent to poor craftsmanship. As should be obvious, there is complete awareness of the difference between the proportions of a sculpture and of a living human being. It is just that realistic proportions are not usually considered appropriate or beautiful. As an Ibo said to an anthropologist, "Long necks are always beautiful; you will admit that yourself." Generalizing, the Ibo artist Ugo said, "Nobody will try to make a *mbari* figure look like a human being. It will turn out very ugly."

Sometimes an anthropologist reports that his judgment and that of the "primitives" he is investigating, or of the connoisseurs among them, coincide. This has been said of the Bayaka and Dan. Elderly BaKwele have been found to agree in general with advanced art students from New Haven. Sometimes disagreement predominates. Australian Aborigines are said to have disagreed in the ranking of their art with students from the University of Sydney, and West Africans and Englishmen to

196

disagree in the ranking of West African designs. Amusingly, the connoisseurs of an African tribe commented that some of their tribal work cherished in a Western museum was very poor, as they could see from the photographs they were shown.

Still more complicated situations arise when "primitive" art is affected by Western demand, training, or other influence. The bark paintings and the carvings of Australian Aborigines at Yirrkala in Arnhem Land continue to look traditional although made for sale under the protection of missionaries. Twentieth-century Haidas, of the Northwest coast of Canada, have produced, for sale, impressive, mostly traditional Haida art, and have analyzed and defended it impressively. The prints and soapstone carvings of the Eskimos of the Canadian Arctic are in an untraditional style, developed under the care of a Canadian artist. Edmund Carpenter, an anthropologist who loves the old Eskimo life and spirit, denounces this art as a reduced, painfully un-Eskimo variant of the work of Henry Moore. My own opinion is that Carpenter's love for the old has blinded him to the forcefulness of this art, which for all its untraditional form has distinctly Eskimo virtues.

To those who find "primitive" authenticity only in what has not been touched by Western hands or minds, the work of Suzanne Wenger and her Yoruba collaborators should prove especially troublesome. While she lived in Vienna, she painted mythological themes in an Expressionistic style. Her art was exhibited along with that of Klee, Mondrian, and Arp. When she fell in love with the Yoruba, she took it upon herself to revitalize their tradition. She became a cult priestess and with the help of Yorubas, some of them previously traditional sculptors, she rebuilt traditional shrines and created an art, quite unlike that of Yoruba tradition, in the service of Yoruba tradition. In doing so she was repaying the African influence on European art with her Expressionistic variant of the European-African-Oceanic.

Influence and payment and repayment go in unsuspected directions. Colin McPhee studied music in Bali, where he organized a group of children into a traditional orchestra. Balinese music influenced his own, which influenced that of John Cage and others, some of whom, such as Lou Harrison, have composed new gamelan music; and I am sure that John Cage has already or will soon influence some Balinese composer. The American Steve Reich has studied Balinese gamelan playing in the United States, Indian music and dancing in India, and African drumming

in Africa; and there are other comparable instances. Conversely, the "Afro-jazz" of southern Africa and the West African "highlife" incorporate American jazz, which is to say, reincorporate the African element of American jazz as time and American experience have changed it.

It is hard to attempt a description of what is universal in art without falling into unhelpful abstractions. Not having the desire to gather a systematic assortment of truisms, I shall, as usual, give examples; and my answers will be more by intimation than by system.

We are reluctant to believe that a work of art cannot retain its full artistry when out of its environment and separated from its native justification. The fact is, however, that what our museums cherish has not only faded and cracked, but has been denuded of much of its exact expressiveness. Yet our belief that the art remains also has a basis in fact, since we are not only members of families and local and larger cultures, but all human beings and, as such, all primates. The similarities between apes and human beings are genetic, physiological, sensory, psychological, and social. It seems that apes and human beings may have the same general preferences for color; human beings in many cultures are known to prefer red and blue; as I have reported, an infant of eight weeks may already show signs of preference for red; and the rough universality that holds true for color vision may hold true for other aspects of vision and other senses. Granted that elementary sensation and perception, including at least some preferences, are alike among human beings, granted that human emotions are much alike, and granted that different cultures invent similar modes of response, the perceptual and social overlap among cultures should reflect itself in an immediate or potential esthetic overlap. It should therefore not be surprising if a sensitive outsider would respond to art in a way not unlike an insider. If sensitive and receptive, people from alien cultures can learn one another's principles. Being abstract, the principles cause less difficulty than their application, which requires a delicate balance among different principles and is harder to articulate. The principles of Yoruba esthetics, although applied in a peculiarly Yoruba way, show the coincidence I have pointed out with the principles of the ancient Greeks. Furthermore, the Yoruba principles, which have been clarified in some detail, are not

alien to us in even a single instance; nor are the general principles of Chinese or Indian art. True, there have been differences enough to create a long initial blindness; but this blindness was not shared by every observer, and sometimes there have been mitigating circumstances. The Chinese who disdained European paintings had not been shown any that were very good by European standards, so that a possible intuitive sympathy was hindered. Furthermore, compared with Chinese brushwork, most European brushwork was really gross or expressionless, and the European exceptions were not available in China. Yet the example of the Nanking painters shows that it was possible to appreciate and assimilate European techniques and principles.

The reaction of Picasso and his friends to African sculpture is instructive. To them, the sculpture was as anonymous culturally as it was personally. The cultural nakedness of the sculpture must have been part of its liberating effect, which could be exerted in the context of European art as if it were there that the sculpture naturally belonged. Before African sculpture had been studied, how could a European have known that the sculpture of an Ashanti man with both hands on its stomach was meant to show the humiliation that comes from having to take food from enemies? How could an uninstructed European have known that the careful balance and siting of the eyes of a Yoruba mask shows that it was not portraying anyone corrupt or criminal; or that a closed mouth meant composure and bared teeth meant impudence—except if the teeth were the two beautifully sharpened ones that indicate beauty?

By local African standards, the sculptures that aroused the enthusiasm of Picasso and his friends may or may not have been good. There are many ways in which an African sculptor can dull the expressiveness of his own tradition as his own tribal companions see it. The sculptures Picasso himself owned are now said by a critic to have been mediocre or worse. Yet what the French artists saw was really there. That is, the African masks, whether well or badly made by African standards, might have been as conservative in their own cultural terms as the European art that Picasso was revolting against; but there was a great contrast, which could be put to revolutionary use, between the African and European traditions, for the African showed a powerful esthetic and psychological vitality in its masks' un-European deviations from a human face. Picasso saw the controlled boldness of the mask-cutter, the forceful geometrization, and, as he later confessed, the magic—not of one as

compared with other African masks, but of the African tradition compared with that current in Europe. Having a will of his own, Picasso was taken with this strong-willed art that could help him to cut through the softness his own tradition had developed, and he cut with his brush as the African sculptor did with his adze.

In much the same way, a person ignorant of Chinese art may respond to the mastery of the brush he senses even in a painting inferior by Chinese standards, his response being relative to the brushwork of the European, not the Chinese, tradition, and relative to the sensitivity that neither starts nor stops at a cultural borderline. Furthermore, an artist with his own strongly rhythmic impulses may be helped by the rhythms generally inherent in Chinese art to break with those he feels have bound him too tightly.

Out of context, a work of art must lose its subtlety, but it retains a proto- or pancultural expressiveness, like the art of the child or, more primitively, of the ape. Briefly, art does have common esthetic or protoesthetic values. The usual difficulty in grasping them is that they have been so qualified by context and convention that they can be clearly understood for what they are only *after* context and convention have been clearly understood.

The search for what is common to art shows in art's mirror what is common to mankind. It reveals that behind everything there is the need for what might be called "fusion." To make what I am saying plausible, I shall begin with some words on !Kung sociability, and then suggest by varied examples that the need for fusion is universal.

This time, the !Kung's interesting characteristic is their extraordinary loquacity, which makes their encampment sound like a brook the endless murmuring of which is punctuated by shrieks of laughter. Their talkativeness wards off loneliness and rejection, to which they are extremely sensitive, and wards off (though it sometimes also provokes) the rage the consequences of which they know too well. Their talk, interspersed with lyrics, rhythmical games, and dancing, is a current of sociability in which ordinary prose leads into and out of stylized eddies of art. The crises of encampment life generate even greater volumes of sound. A particularly exciting or dangerous event arouses "volcanic eruptions of sound,"

which an anthropologist describes as "the greatest din I have ever heard human beings produce out of themselves." The eruption or din, lasting perhaps ten minutes, is a kind of spontaneous great vocal happening. It reminds me of the uncoordinated coordination of instruments or voices we find in our recent music. The verbal eruption and the uncoordinated coordination are attempts, like the traditional ones of tricksters, to set up a barrier of chaos between themselves and a greater chaos.

The constant chatter and occasional verbal eruptions of the !Kung constitute a style of life very different from those of African tribes, such as the Bambara and Dogon, that value silence and blame "speech without a path and without seeds." It is also very different from those of Native American tribes, in which attentiveness and dignity are emphasized. As a Lakota chief said, in the old days children were taught to sit still and enjoy their stillness: "They were taught to use their organs of smell, to look when there was something to see, and to listen intently when all seemingly was quiet. . . . A pause giving time for thought was the truly courteous way of beginning and ending a conversation."

To use our own style-names, !Kung eruptions are Expressionistic, while Native American reticence is Minimalistic. In either style—the chattering and explosive, or the silent and controlled—the members of the group fuse themselves into a single pattern of expression, of which art, especially in the form of ritual, is the most concentrated element. The pattern of sociability is the substratum, the basal fusion, in which the higher fusions of art take shape.

In one of its aspects, the need for fusion leads to a denial that the arts are essentially separate from one another. A poem is then a picture, a statue, a musical composition, an emotion or complex of emotions, the truth, the cosmos reflected in a microcosm. In Europe, the artist who expressed himself equally in different media was a well known phenomenon. In the fourteenth century there was Guillaume de Machaut, poet, musician, and storyteller (and churchman and diplomat); in the Renaissance there were men such as Ghiberti and the fabulously many-sided Alberti; and in the Romantic period, when the ideology was favorable, there were multiply talented men such as Blake, E. T. A. Hoffmann, composer, critic, and storyteller (and for years, like the standard Chinese

artist, a government official), and the poet-painter Rossetti. In China, the calligrapher-painter-poet was a widely-accepted ideal. The ideal was embodied in Wang Wei in the eighth century, in Su Shih (Su T'ung-p'o) in the eleventh, and in the fifteenth in the trio of Shen Chou, his pupil Wen Cheng-ming, and Wen's friend T'an Yin.

A poem involving Su T'ung-p'o illustrates multiple fusion interestingly. The subject of the poem is a picture painted jointly by Su and Li Kung-lin (Li Lung-mien) and named *Herdboy with Bamboo and Rock*. The poem, preceded by the authors' introduction, reads:

> Su T'ung-p'o painted a clump of bamboo and a fantastic rock. Li Kung-lin added a slope in the foreground and a herdboy riding a water-buffalo. The picture, full of life, has inspired these playful verses:

> *Here's a little craggy rock in a wild place, shadowed by green bamboo.*
> *A herdboy, wielding a three-foot stick, drives his lumbering old water-buffalo.*
> *I love the rock! Don't let the buffalo rub his horns on it!*
> *Well, all right—let him rub his horns—but if he gets too rough he'll break the bamboo.*

The poetry has turned into prose in English, but it remains an effective instance of multiple fusion. Painted by two friends and commented on (on its surface) in a poem by a third, the literal subject is love for a rock, modified by sympathy for a buffalo, modified by sympathy for bamboo. The metaphorical subject is the hardness, the resistance to time and weather, of the rock, the more flexible resistance of the bamboo, and the interdependence of natural things. The basic subject is the activity and feeling of the three friends, each united with the others and with nature, and all with those who then or later would see the picture and read the poem. The basic subject, in other words, is fusion, of art with art, friend with friend, and art with reality.

In every art, the desire for fusion is hard and in the last analysis perhaps impossible to distinguish from the desire for love, though love inter-

woven with other emotions, not excluding hate. Like the other arts, painting and sculpture, with which I have been most concerned, deal with the love the artist feels for the subject of his art, his love for things in general, and his love for the activity of creating, which is the sum of the other loves that his art embodies and makes accessible. For this generalization I offer the testimony of four European artists: Michelangelo, Bernini, Van Gogh, and Kirchner.

In his biography by Condivi, Michelangelo, who is taken to have been responsible for its tone and content, is described in words strongly tinged with Neoplatonism. Some people think ill of Michelangelo, the biography says, because they cannot understand the love of beauty of the human body except as lascivious. But Michelangelo's love is all encompassing and pure:

> He has loved not only human beauty but everything beautiful in general: a beautiful horse, a beautiful dog, a beautiful landscape, a beautiful mountain, a beautiful forest, and every place and thing which is beautiful and rare of its kind, admiring them all with marveling love and selecting beauty from nature as the bees gather honey from flowers, to use it later in his works. All those who have achieved some fame in painting have always done the same.

These sentiments of Michelangelo are attuned to his art but are too simple for it. An eloquent commentator says that stone was Michelangelo's life, triumph, and defeat: "He carved it for seventy-five years. He was born and died with it. In the very process of bringing shapes out of the 'hard and Alpine stone' he could find the metaphors of life, love, and death, discern the will of God and foresee redemption."

Michelangelo's frequent inability to finish his work shows that the redemption he foresaw was not always one he could give a body to; but his failure charged the work with the force of his struggle. It was the struggle that, at the end of his life, turned the *Rondanini Pietà* into an uncharacteristic renunciation of the body. In the process of carving and recarving this last, unfinished attempt to fuse Mother and Son, each, in a mutual giving of birth, was made out of what had been the other.

The great sculptor and architect Bernini worked at sculpture as tirelessly as Michelangelo:

> 'Let me be, I am in love,' he would say when he was asked to rest, and such was his concentration that he seemed to be in

ecstasy. It appeared . . . that the force to animate the marble was projected from his eyes. Before the angels in Sant' Andrea delle Fratte all this is credible.

Van Gogh's love was more openly directed at human beings, with whom he hoped to be joined by means of his painting. He understood that he had often been rejected; but he kept reassuring himself in the language of his art, saying, in effect, "I, Vincent have not been rejected and cast off but am beloved by and united with those I love." His work excited him and made him forget his loneliness. "The worse I get along with people," he said, "the more I learn to have faith in nature and concentrate on her." As the Chinese put their endurance into rocks, resilience into bamboos, and old age into twisted trees, Van Gogh translated what he felt about strength, dependence, and company into the limbs, trunks, and relationships of trees. He paired sun and moon like people, and complementary colors like couples that "complete each other like man and woman." Out of the desire for fusion he loved others, himself, the world, and his work. "How rich in beauty art is," he wrote. "If one can only remember what one has seen, one is never empty or truly lonely, never alone." Even if it were true, he wrote, that he was nothing, an eccentric, disagreeable man, he wanted to show what there was in the heart of such an eccentric man, a nobody; for his ambition was founded less on anger than on love, more on serenity and less on passion. In spite of his frequent misery, he went on, he felt a calm pure harmony and a music within himself.

It was much in the same vein that Ernst Ludwig Kirchner, the German Expressionist, wrote that his work came out of the longing for loneliness and the desire to show love:

> I was always alone, the more I ventured among men, the more I felt my loneliness. . . . I did not have the art of becoming warm in people's company. That is fate, and perhaps one of the major reasons for my becoming a painter. Art is a good way to show one's love for men, without inconveniencing them.

The desire for fusion, as I have been calling it, can be directed primarily toward persons or toward impersonal nature. Often, as in the examples

204

I have offered, it is directed toward both. Though it is present every-where in its many forms, I limit myself to some Chinese and European instances.

For China, I cite an essay written by the most famous of Chinese calligraphers, Wang Hsi-chih, who lived during the fourth century A.D., and a treatise by the seventeenth-century painter Tao-chi, that is Shih-t'ao, of whom I have already written.

Wang's essay was the preface to thirty-seven poems written by a select, influential group of men who had met for a traditional ceremony of purification. The preface recalls the ceremony as a time of perfect communion. The air was clear, the breeze gentle, the conversation, interspersed with drinking and the composition of poetry, was altogether free, and the companions entered fully into one another's feelings. Look-ing up, they saw the vastness of the heavens, looking down, the riches of the earth. The memory makes Wang call out, "What perfect bliss!" The companions were attuned to one another, prosaically and poetically, and to the universe.

Wang goes on to explain that no one in the group was unreflective or insensitive to art. These were the kind of people who, in their journey through life, could "draw upon their inner resources and find satisfac-tion in a closeted conversation with a friend." Then Wang grows mel-ancholy, remembers death, and remembers that young men are some-times cut off in their prime. But then he finds consolation in the sharing in poetry of even melancholy sentiments, and he says, "Even when circumstances have changed and men inhabit a different world, it will still be the same causes that induce the mood of melancholy attendant on poetical composition." He concludes, with every author's hope for sympathy, "Perhaps some reader of the future will be moved by the sentiments expressed in this preface."

Tao-chi's thought is related, in a typically Chinese style, to the source of nature. He calls what we may term his ontology of art the "one-stroke" (or "oneness of stroke" or "one-strokedness"), which is his expression for the inherent fusion of things, their common source and overwhelming affinity within nature and, if the difference need be marked, between nature and true art. He says, using not the common speech of the Ch'an Buddhists, with whom he had once cast his lot, but the elliptical language of the literati: "To have method, one must have transformations. Transformations, then, yield the method

of no-method. Painting is the great way of the transformation of the world."

To Tao-chi, the transformation is equivalent to self-realization. What he wants in his theory and his painting is something at once general and particular, vague and definite, easy and difficult, humble and universal. The very simplicity of his thought is meant to parallel and share the dynamism of the single stroke, as in the Chinese "one," with which the child is first taught to write, and which remains, in all its nuances and powers, the test that distinguishes the strong and genuine master of calligraphy or painting from the weak or false. This simple, fundamental stroke is also the horizontal line of the *Book of Changes,* the identity implying that the brushstroke in painting, like the symbol of the *Book,* is a form of the creation of the universe. The stroke is also assumed to be implied by Confucius in the *Analects,* when he says that his Way is that of the One that embraces the universal, or in another translation, "There is one single thread binding my way together."

Tao-chi therefore says boldly:

A single stroke which identifies with universality can clearly reveal the idea of man and fully penetrate all things. Thus the wrist seizes reality, it moves the brush with a revolving movement, enriches the strokes by rolling the brush hairs, and leaves them unbounded by any limitations.

The wrist, to which the universe is attached as cause and as effect of the activity of true painting, is apt to seize the otherwise so elusive reality-in-itself.

As I have said earlier, it is natural to suppose that this bold ontology of art was an answer to the confusion of styles and profusion of knowledge that puzzled or intimidated students of calligraphy and painting. Tao-chi's solution, the methodless method that engenders method, and the method that, so obtained, embraces all methods, recalls the "nonbeing" that in the *Tao Te Ching* engenders being, which engenders heaven and earth and all they contain.

For Chinese artists, Tao-chi's book on method was a powerful statement of the need for creativity by way of fusion and fusion by way of creativity.

Like China, Europe has had an uncountable number of instances. I might begin with the letter in which Mozart said to his father that when the audience did not feel with him what he was playing, he got no pleasure from the music; or with the first lines of Whitman's "Song of Myself": "I celebrate myself, and sing myself,/ And what I assume you shall assume,/ for every atom belonging to me belongs to you." However, to keep within feasible limits, I shall confine myself, for Europe, to a few moderns: the Norwegian painter Edvard Munch, the German painter Emil Nolde, the American poet William Carlos Williams, and the Austrian composer Arnold Schönberg.

Munch, for the most part a tortured person whose life had been spent, in his own words, "walking by the side of a bottomless chasm, jumping from stone to stone," wrote plainly, "All in all, art results from man's desire to communicate with his fellows." Although he came to believe in a hidden force of life, in the statement I am quoting he went on to say that when an artist paints a landscape, it is his feelings that are crucial, and nature is only the means for conveying them. "Whether the picture resembles nature or not is irrelevant, as a picture cannot be explained; the reason for its being painted in the first place was that the artist could find no other means of expressing what he saw."

Nolde, although a different kind of person, was equally preoccupied with the precarious sanity of artists, and he helped get material for Hans Prinzhorn, the pioneering student of the art of psychotics. Nolde felt painting to be both attractive and dangerous. Lying on his back and gazing for hours at a successful picture, merging with the picture as if he had no existence separate from it, he felt an "incomparable joy," but he also felt that this joy threatened him with the possibility of annihilation, for he fused with the things he contemplated and made. He wrote, "When I am painting with utmost intensity, I find that I have lost my voice. . . . As soon as I slack off, my voice comes back."

Nolde most disliked the people closest to him, and loved, along with creation as a whole, the human beings he did not know. In his own words:

Human beings are, nearly all of them, the artist's enemies, and his friends and near relations are the worst. He is like a man shunning the light, and they are like policemen with a lantern. He is like a man with the devil in his bones and God in his heart. Who can

207

conceive the enmity and conflict of such powers? The artist lives behind walls, in a timeless state, seldom on the wing, and often withdrawn into his shell. He loves to watch strange things that go on in the depths of nature, but he also loves bright, clear reality, moving clouds, flowers that bloom and glow, the whole of creation. Unknown human beings are his friends, people he has never met, gypsies and Papuans—such people carry no lanterns.

Of Williams I retain only a brief, touching description of his last days, when a stroke had paralyzed his right arm and deprived him of the ability to speak. All the same, he continued to write. "Sickness and age drove him to create. 'When you're through with sex, with ambition, what can an old man create? Art, of course, a piece of art that will go beyond him into the lives of young people, the people who haven't the time to create. The old man meets the young people and lives on.' "

Arnold Schönberg tried, at least sometimes, to create a relationship with others by crying out in pain or confessing failure. He suffered from both public and personal rejection, the public as a result of his musical radicalism, and the personal as a result of his wife's abandonment—she left him for a friend, who committed suicide not long afterwards. His art, reflecting his life, had the isolated, unrecognized artist as its theme, and the failed self. In *Pierrot Lunaire* the artist is the tragic clown, and in *Jacob's Ladder* both technique and text say, "Redeem us from our isolation!"

To put it generally, without any particular art, artist, or culture in mind, art is the attempt to remain individual in expression while merging or fusing with what is beyond the individual. Separateness is insisted on, and symbiosis with persons or with nature. Dickens, who restricted himself to humanity, was extraordinarily individual, but his need for symbiosis with his audience was so great that, knowing the danger—his heart had weakened—he went on with his readings, to his death.

The desire to fuse is also evident in what the artist feels to be inspiration, which relates him to something beyond himself and makes him, though the originator, an intermediary as well, the channel for a message the urgency of which has vitalized him and used him to become visible,

audible, or palpable in the human world. In the West, the history of artistic inspiration begins in Greece at the very beginning, with Homer, and never ends. Although painters and sculptors may have been regarded for long periods as craftsmen with no great need for inspiration, poets have always in principle been regarded differently. Hume and the others who claimed that beauty existed only in the eye of the beholder do not seem to have weakened the belief in inspiration. When Stravinsky lectured on the poetics of music, he argued that inspiration was subordinate to the artist's calculation and speculation. Inspiration, he said, was a state caused by the emotional disturbance of the artist as he was discovering, step by step, what the still unknown work of art was to be. Yet this interesting form of depreciation, which seems to me to concede almost as much as it takes away, has been no more influential than preceding ones, and the idea that art, or good art, must be inspired, remains as widespread as ever.

The only point I want to make about inspiration is that belief in it has been so nearly universal that whatever the vagueness of the concept, the power, exhiliration, surprise, disclosure, or gratitude to which we give the name must have been inherent in the experience of those who created and even only appreciated art. It has therefore been implicated in the nature itself of art—whether or not art has a distinctive nature in a scientific or philosophically analytical sense, it has a nature in the experiential sense of the intense self-focusing that is necessary to draw out of oneself some forming power or material object that one may never have known was there, so to speak, until it disclosed itself.

I have been using the idea of fusion to characterize the tendency in art to go beyond the limited impulse, the limited aspect of life, and the limited or limiting self. Before I go on to what I have called "the esthetic universal," I should like to supplement the idea of fusion with two related ideas, that of oscillation and that of equilibrium.

Oscillation is like fusion in that it joins different things. The likelihood that a preference in art will change into its opposite suggests that preferences are symmetrical with one another, and that their alternation or mutual relationship over a period of time is more important than either of them alone. In fact, the whole history of art seems to be made

of alternations or oscillations between extremes. Greek, Indian, and Chinese and Japanese art have all gone through historic stages that can be described in European terms as a movement from a stiff archaism to a supple, balanced classicism, to a swirling baroque, to a highly rhythmical and decorative rococo.

The extremes between which art tends to oscillate include those I have been calling attention to, the pair of spontaneity and habit or deliberation, and the pair of tradition and individualism or egocentricity. Among other such extremes there are simplicity and complexity, seriousness and playfulness, realism and abstraction, and literalism and symbolism. Each extreme calls up the other and coexists with it at least as a potentiality. As I have shown, the cultures that serve as models of traditionalism harbor artists who do not fit the humble, reverent, anonymous stereotype. Likewise, the cultures that serve as models of symbolic art show a tendency to produce realistic art.

I take realistic art as my example. Convention says that it was the Greeks who made it possible, that it reached its ancient heights in the portrait sculpture and perhaps the painting of the Hellenistic Greeks and Romans, and that it developed to its stylistic extreme in Europe during and after the Renaissance. But realism in painting and especially sculpture has shown itself at many other times and places, from which the stereotypes of art history have excluded it. More precisely, there was realistic art in Africa, the northwest coast of America, Egypt, China and Japan, and, I am sure, other places.

To begin with Africa, portrait sculpture there is not unusual, and it becomes portraiture in our sense when, as photographs show, it bears a clear resemblance to its subjects. Weightier evidence is given by the old life-sized heads of the kings, the Onis, of the city-state of Ife. Like the Ife heads, the memorial statues of Bangwa chiefs are meant as true portraits. As for the northwest coast of America, many statues and masks from there have lifelike traits. The ability of the northwest coast Native Americans to carve realistically is demonstrated by an old replica of a dead man's head and a portrait bust, carved in 1860, of the Englishman George Reid.

In ancient Egypt, the phrase "statue after life" implies the desire to make portraits; and the mummies of some New Kingdom pharaohs prove that their statues were in fact portraits, though idealized ones. But Egyptian realism went further. A single ancient death mask has been

recovered. In addition, the masks found in the workshop of Thutmose, Akhenaten's sculptor, are so realistic that Egyptologists have taken them to be either life masks or death masks. Close examination shows them to have been neither; but they are astonishingly realistic and astonishingly devoid of any of the marks of Egyptian stylization. It seems that Egyptian art was quite capable of denying itself.

The evidence from India is essentially literary. It tells of the arrangement of marriages in which the participants first set eye on one another in the form of portraits painted by woman specialists. The evidence from China and Japan is more varied and interesting. Anecdotes like ancient Greek ones tell of a *trompe-l'oeil* fly that people tried to brush off the scroll on which it had been painted, and flowers so realistic that they attracted bees. Accuracy of course required the close study of nature. Li Kan (1245–1320) loved bamboos and spent a great deal of effort in studying their species, growth, age, and quality. Another artist of the same period, Huang Kung-wang (1269–1354), who was interested in the changing effects of light, advised artists to carry brushes with them and immediately to sketch any striking bit of scenery, to be used to add life to studio-made pictures. Reasonable as it is to suppose that Chinese painters might sketch from nature, the only surviving sketchbook of a famous painter is Tung Ch'i-ch'ang's, which disregards formulas and explores the natural shapes of trees and rocks. Some artists, sure that the spirit of things was best captured by fidelity to their outward forms, were in their own styles finicky realists. Others wanted to be so true to fact that they insisted that characters in paintings should wear historically accurate clothing.

Chinese tradition required that portraits be made of ancestors. Ch'an portraits had another purpose. Given to disciples as a sign of favor, they were painted with the economical exactness of caricature. Surviving examples in Japan have stereotyped figures but carefully individualized heads. In Japan, portraits were made of the Ch'an (Zen masters), sometimes marked by strongly individual traits. In the twelfth and thirteenth centuries there were also painters who specialized in court portraits, called *nise-e*, meaning "lifelike" or "realistic." In later Japan, realism was not uncommon. Okyo Maruyama sketched from nature, as I have said, as did Ogata Korin, the seventeenth-century master of decorative painting, and many others of their times. Sosen Mori (1747–1821), who specialized in monkeys, deer, and other animals, is said to have lived in

the mountains for three years in order to learn to paint monkeys in their natural surroundings.

As oscillation requires opposites to succeed one another, equilibrium requires their simultaneous presence. The greater the number of opposites or the stronger the opposition between them, the stronger the force needed for their union, and the more powerful, therefore, whatever equilibrium is achieved. Like many others (like Nietzsche, who said that harmony should ring out of every discord) I believe that one of the best criteria for the depth of art is the extent to which powerful opposites are held in equilibrium. Michelangelo's art is a self-evidently powerful equilibrium; Bach fuses German, Italian, and French music and holds an impressive, affecting equilibrium between polyphony, harmony, and melody; and Beethoven stretches, departs from, and returns to classical forms, everywhere intensifying musical equilibria by threatening them. Such artists with the ability to create powerful equilibria are likely to have drawn the necessary power from their inner conflicts or ambivalence.

Chinese art makes frequent and conscious use of principles of equilibrium. The principles became evident in calligraphy before painting. In an essay attributed to Ts'ai Yung, of the second century A.D., calligraphy is grasped as a process of checking, balancing, and redirecting, so that going to the left begins by going to the right. An essay attributed to Wang Hsi-chih pictures the calligrapher as a general using his brush to fight on a paper battlefield. Wen Cheng-ming's *Seven Junipers of Ch'angshu,* which I have spoken of earlier, is such a battle fought by a line of interlocking trees. Wen's later, less openly dramatic *Cypress and Old Rock* ties its tensions into a stubby knot.

Although African music is so distant from the Chinese, it is as much an art of equilibrium as Chinese calligraphy. The rhythms of African music, each often individually simple, define one another by the tension between them. The musicians play around missing beats, which the audience supplies—even a coordinating time-line is played in syncopation—and must keep the audience in a state of "cool," that is, composed, excitement. When the rhythms are working well together, they prove to the Africans that music, like wisdom, can keep the balance

between pleasure and excitement on the one hand, and morality and decorum on the other. The best drummers and best dancers are old men who have learned to express their own rhythms but coordinate them with those of others. Their music is personal, free, yielding, responsive, complex, clear, and mature. Therefore it is beautiful.

Before I continue with my argument, let me go back, recapitulate, and anticipate. All art, I have said, expresses the need of the individual to live beyond himself. At every level, even the prehuman, the expressive act, which reaches its most concentrated form in art, carries the message, "This is what I am like," the *I* referring less to external than to internal, pervasive, or deep characteristics, those that in human beings we are inclined to consider spiritual. This message has a natural extension, which can be put as an appeal or demand, and which can be made with any of an infinite number of degrees of insistence. The extension of the message is, "Sympathize with me, empathize with me, identify with me, resemble me, join me, or at least pay attention to me, as I really am, as I may play some important role in your life." Art can appear to be ethically neutral; but it issues an incessant moral invitation, or makes an incessant moral demand, which is exactly individual, but which has far-reaching social implications.

Together with the invitation or demand, there is something in art, pertaining to its essence, that I think of as a subtle emotion. I do not know what to name the emotion, though it would be consistent with what I have written to see it as the emotion that directs us towards fusion. I might also see it as the desire for self-enlargement or self-transcendence, or conversely, self-diminution or self-recession. In the language of Plato and Plotinus, it is the desire to participate and to be participated in. This desire or emotion underlies the philosophy of Plato and Plotinus, variations of which characterize most of Western esthetics. It underlies what has been called the dynamism of African thought, the belief in the immanent energy in all things that is entered into and intensified by means of art. It underlies mystically oriented Indian esthetics, according to which art causes a state of emotional identification with the protagonist of a play or poem, a state so powerful that the ego is broken through and a unique calm pervades the spectator, auditor, or

reader. And it also underlies the Chinese esthetic principle that art is a tonic pulsation by which individual and universal life are joined.

The resemblance among the different esthetic traditions is basic enough to prompt me to name it "The Esthetic Universal." To document the resemblance I begin with our own European or Western tradition, not only because it is dominant in our minds, but because its history is best known to us. A rich tradition, it is filled with nuances of different sorts and rife with disagreements in principle and in detail. Yet it seems to me that the dominant impulse in esthetics is the one that comes from Plato and Plotinus, and I shall call it, for short, the Neoplatonic. In the case of Plato, I am not referring to his polemic against the making of images, with which Plotinus agreed in refusing to allow anyone to make his portrait. I am obviously referring to Plato's belief that love of the beauties of the body leads to love of those of the soul, and love of those of the soul to the vision of everlasting beauty. As for Plotinus, I am referring to his dominant attitude toward beauty and art, and to his belief that the artist could grasp a sublime archetype:

> The arts do not simply imitate what they see; they go back to the *logoi* from which nature derives; and . . . they do a great deal in themselves: since they possess beauty they make up for what is defective in things. Phidias did not make his Zeus from any model perceived by the senses; he understood what Zeus would look like if he wanted to make himself visible.

To Plotinus, the mind of the artist shares the nature of the creative *Nous,* the form taken by the One or Good, which is in itself utterly impossible to grasp. Beauty, says Plotinus, is Form, and even more than Form, is Life, for which reason badly proportioned but living faces have more beauty than symmetrical but lifeless ones. To him, true beauty is the radiance cast upon the world by the Good or One, the source of the world's existence and beauty, or rather of its beautiful existence, because existence is beautiful as such, in exact proportion to its intensity, which is the degree of its closeness to the One. Beauty in itself is therefore formless. The experience of lovers shows this. The lover is really in love only when the impression made on him goes beyond his senses and

enters his undivided soul. "His first experience was love of a great light from a dim gleam of it. For Shape is a trace of Something without shape, which produces shape, not shape itself."

Medieval esthetics was always closely related to the Neoplatonic themes. The Renaissance requirement of anatomy and perspective did not change the dependence on Neoplatonism. It is true that Alberti, like other theorists of the early Renaissance, was not a transcendentalist, and he and others like him contented themselves with an emphasis on harmony, proportion, and the addition of ideal to merely human beauty. But Marsilio Ficino, a thoroughgoing, erudite Neoplatonist, defined beauty as a "victory of divine reason over matter" and as "radiance from the face of God." Neoplatonic theories like his became prominent in art theory from the second half of the sixteenth century, the artist being he who gave nature a more-than-natural perfection. Michelangelo accepted Plotinus's view that the sculptor revealed the beauty already inherent in the stone. The earlier comparison of the artist with God was extended and allowed the artist himself some measure of divinity.

It would be pointless to continue with an abbreviated history of European esthetics or to list all the many artists, writers, and musicians who showed the influence of Neoplatonism. The secularism induced by science was often allied with or tinged by mysticism; and beginning in the late nineteenth century, Neoplatonic ideas were varied and reinforced with those imported from India by Schopenhauer, the Theosophists, and others. The dissolution of matter into energy gave physics itself a possibly mystical cast—the creators of twentieth-century physics, Einstein, Bohr, Schrödinger, and Dirac, expressed views compatible with mysticism or explicitly mystical: Einstein identified himself Spinozistically with the universe; Planck adopted a Kant-like thing-in-itself; Bohr favored contradictories in a way reminiscent not only of Kierkegaard but of negative theology and Neoplatonism; Schrödinger was an open Vedantist; and Dirac made a Neoplatonic equation of truth with beauty. Certainly mysticism remained common among artists. The German Expressionists voiced mystical opinions, and so, in their distinctive voices, did the Surrealists. Of the pioneering abstract artists, Kupka was mystical in the name of Orphism, Malevich in the name of Suprematism, Kandinsky in the name at first of the Blue Riders, Mondrian in the name of De Stijl or Neo-Plasticism, Ozenfant and Jeanneret in the name of Purism, and so on.

I have spoken briefly of Malevich's mysticism in an earlier chapter. To illustrate the importance of mysticism for the creators of abstract art, I add a word on Kandinsky and Mondrian. Neither of them would have agreed with the once influential formalism of Roger Fry, according to which art was only itself, nothing but the relationships between forms. On the contrary, Kandinsky and Mondrian valued art, especially abstract art, for its metaphysical content.

Kandinsky, like certain religious Russians, and like the Rosicrucians and Theosophists, all of whom influenced him, believed that mankind was approaching a utopian era. He assumed that abstraction could be helpful because it expressed transcendental ideas. With the Theosophists, he held that thoughts and feelings give off vibrations that the initiated could see, and, with them, that every color was a spiritual tone and every color combination a spiritual harmony; and he took it to be the artist's function to create "vibrations" in the spectator. His desire to awaken the ability to experience the spiritual as such was so strong that in a letter he suggested that brush and canvas could be given up and paintings created by spiritual irradiation alone.

Mondrian was influenced by a Theosophist when he was still a young man, and in time he joined the Dutch Theosophical Society, of which he remained a member. The reasoning of the Dutch mystic M. H. J. Schoenmakers was also precious to him. In a notebook of 1914, Mondrian made the assumption that the horizontal line was femininity (and the sea), and the vertical line was masculinity. The artist, he said there, made use of both the horizontal and the vertical and was happy, complete, and asexual. Later, in *Plastic Art and Pure Plastic Art,* he said that vertical and horizontal lines expressed the two opposing forces whose reciprocal actions were "life." He too was convinced that humanity could accelerate its progress by acquiring a truer, more mystical vision of reality. He said, "Plastic art discloses what science has discovered: *that time and subjective vision veil the true reality. . . . If we cannot free ourselves, we can free our vision.*"

There are very many mystical or semimystical statements by recent or contemporary artists. Among the members of the New York School, at least Reinhardt, Pollock, Rothko, Still, and Newman, had mystical inclinations. I shall rest content with the statement made by Karel Appel in 1978. When he painted, he said, past and future disappeared:

216

The canvas is ready to be beyond consciousness. Just be. Beyond the human dualities . . . Only in this nondual work together with my painting I lose myself, my body also. In my painting the form becomes vibrations, it enters the formless form, formless existence that I paint—vibrations of color.

Even in this necessarily abbreviated account I have tried to preserve a little of the local color of European esthetics. The conclusion I mean to draw is simple: the thought of European estheticians and artists has been strongly tinged with mysticism, and when it has attempted to go deep, has been predominantly mystical. The lesson to be drawn from this conclusion is one that I will postpone until I argue that esthetics everywhere has tended to be mystical.

With European esthetic thought as a background, I go on to the thought of those whom for lack of a better term we call "primitives." I should have liked to deal with them as a group, but, as before, I feel that it is so unprofitable to make untested generalizations on so varied a group that I prefer to restrict myself to the Africans. Even so, I feel caught between different periods in social anthropology. Not very long ago, when anthropologists generalized more carelessly than they now do, they made liberal use of such terms as *animism* and *mana* to characterize all "primitive" thought—I myself have used the perhaps too empty *dynamism* for African thought. Since then, anthropologists have grown more critical and intellectually demanding. But even if I restrict myself to Africans, one problem remains intractable: there are so few really detailed and plausible descriptions of the thought of particular African groups (some three thousand tribes have been distinguished) that every generalization on the thought of all of them must be suspected of arbitrariness. Even though African archeology and history are serious, developing fields of research, the study of African thought has no historical depth. We rely, as we have to, on descriptions couched in the anthropological present, which reflect the time when the anthropologist did his actual fieldwork, or often his reconstruction of the "old times," before the culture in question had lost its presumed authenticity. We tend to assume, with at

217

least the earlier anthropologists, that we can understand each group as if it had fixed and uniform attitudes, and not as a collection of different individuals with its internal differences, tensions, and changes. Nevertheless, I think that something ought to be said, even if suspect and oversimple, to make the final comparison more complete.

Africans themselves, as represented by contemporary writers, usually believe in and try to formulate a common Africanness. Some look back to a golden time of warm, wise, spontaneous African "primitivity." In contrast, the distinguished dramatist and essayist Wole Soyinka holds that African character has a tragic element, because it is a fusion, symbolized by the god Ogun, of creation and destruction. A third, satirical view is that expressed by Yambo Ouologuem, who laughs bitterly at any idealization of Africans. Attacking the romantic German anthropologist Leo Frobenius (1837–1938) and, by implication, the Senegalese thinker Sheikh Anta Diop, he pictures one Shrobenius, who, supplied with fake artifacts and equally fake symbolism, at once astounds his countrymen and exploits the African's hunger for the white man's praise, praise that sinks the Africans deeper into their misery and leaves them unified only by politics, greed, hypocrisy, and violence.

Yet there is agreement as well as difference. Everyone, Western (and now African) anthropologist and African writer, seems to agree that African individuals are strongly bound to their group and feel that they are part of the unity created, in the one direction, by their ancestors, and, in the other, by their still-unborn descendants. The Africans are conscious of the same unity of generations that marks the old cultures of India and China. Like the members of other traditional cultures, they do not accept the Western belief that love is an end in itself and not a means of continuing the ancestral line.

One safe generalization on African art is that much of it is intended to ensure fertility, the germination of seeds and multiplication of animals and human beings. Birth, growth, death, and birth again, constitute an endless but delicately balanced process. In order not to impair this balance, a sculptor must make a ritual apology to the spirit of the tree he cuts down. If he did not apologize, nature would be injured and would injure.

To give this safe generalization the support of a few varied examples, I cite the Dogon once again; the Tshokwe of Angola; and the Bambara of Mali.

The Dogon believe that everything is maintained by the force of its vitality, its *nyama,* which is impersonal and unconscious and distributed among plants, animals, human and supernatural beings, and other beings. The vitality of an individual is composed of the different vitalities received from father, mother, and ancestors. Constituted of these, his own vitality is enriched, diminished, or simply altered, by the experience he undergoes. As I have said earlier, all the elements of the universe are in symbolic correspondence, the correspondences expressing and governing every technique and instance of growth or creative activity. The understanding of art is in terms of the play of interrelated vitalities—the correspondences themselves are too complicated to repeat.

Tshokwe myth, ritual, and art are deeply concerned with hunting and with human fertility. This concern is especially clear in the nature and use of the statuettes known as *hamba.* Hunters take the statuettes along to receive the blood of the game they kill. The power of the statuettes depends as much on the hunter's potency as on his skill. When a hunter feels that he is weakening from age, he hands his statuettes on to his heir. If he fails to do this, the villagers will grow ill and perhaps die, the game will disappear from the forest, and the manioc will not germinate.

The Bambara are farmers, and their rites have to do with the seasons and farming. As the Bambara grow older, they progress from one cult association to another. Chronologically, the first of these associations is for boys under the age of fourteen. A word on its ritual will hint at the Bambara's use of art. The boys' masked dance acts out a drama in which man is a great seed that falls to the ground, becomes fruitful, and is killed by the Flail. The dance as a whole symbolizes the life-qualities that man draws from the grain and the sun, and that they, in turn, draw from him.

African art is usually a performance or, like masks and other ritual objects, meant for performance, and it demands the reciprocity of the persons involved: art and audience give one another the encouragement they need in order to invent and participate in invention. The reciprocity is also one between human beings and the capricious forces that inhabit and surround them. These forces are caught, invigorated, deployed, and absorbed by ritual art, that is, the sounding of its music, the symbolism of its masks, the gestures of its dancers, its incantations, its story. Art is the style in which the powers are mingled and balanced and the visible

219

and invisible are encouraged to enter into a more empathic, life-giving intimacy.

In India, the craftsmen's manuals had a clearly religious background, but they were mostly compressed, matter-of-fact directions, without philosophical justification or expansion. Yet the art of these craftsmen was nourished by the old Indian feeling that the energy of the universe is a breath or a breathing, *prana,* evident in any instance of motion, change, transmutation, or life. Indian sculpture and the remnants of its early paintings have a sense of inherent energy. The sculptured figures, flexible, rhythmic, round-limbed, and sensuous, are often set among twining creepers and often touch or lean on trees, as if to take in their life from the trees' life, from the ground. This energy or life expresses the fertility of nature, the sculptured forms of which include invitingly beautiful women, amorous couples, copulating couples, and phallus-shaped gods, not to speak of the phallus itself. It is no doubt because the sculpture reflects danced ceremonial that the figures are so often fixed in the attitudes of Indian dance. This relation of sculpture to dance and therefore to music makes it easier to generalize about Indian art. There is in fact an old text that says that to understand the rules of painting one must understand those of dancing, and to understand those of dancing one must know music. The basis of music is singing, and therefore, climactically, "He who knows the art of singing is the best of men and knows everything."

Esthetics of a more articulated, philosophical kind began to develop in India about the fourth or fifth century A.D. and remained creative until about the eleventh or twelfth. To begin with, it was a poetics of the drama, and its adherents were writers using a Sanskrit already known only to the learned. These often proud, self-conscious men (an occasional woman among them) did not connect their art with the activities of the craftsmen who made stone or metal images. They were at first mostly interested in the ornamental effects of language, and their criticism is likely to strike us as too limited to classification. Their view was that poetic ornamentation aroused poetic moods or particular kinds of esthetic emotion, as we may freely translate the Indian term *rasa.* The primary meanings of *rasa* are *juice, flavor, essence.* In poetics, its mean-

ing was extended to poetic moods or emotions, the essences or flavors of life. The resulting theory had a living relationship to art in the sense that poet-dramatists such as Kalidasa, Bana, and Bhavbhuti were familiar with it.

It was a great step forward in Indian esthetics when the idea of esthetic emotion, *rasa,* was connected with that of suggestion or overtone, *dhvani.* The theory connecting them rested on a distinction between three levels of meaning of words or sentences: the primary or literal, the secondary or contextual, and the tertiary or suggestive. The new theorists related the concepts of *rasa* and *dhvani* hierarchically. They held that *rasa* was to *dhvani* as *dhvani* to poetry, or, in other words, that esthetic emotion was the essence of suggestion and suggestion the essence of poetry, or, in reverse, that poetry was based on suggestion and suggestion on esthetic emotion. Although created to explain poetry and drama, the theory could in principle be applied to other arts, and illustrations were drawn from music.

Given the theory of suggestion, it became easier to grasp the uniqueness of poetry and to understand the poetic effect of puns, to which Sanskrit poetry is peculiarly adapted, ambiguity, irony, paradox, and the like. The theorists began with a conventional list of basic emotions or emotional tendencies, namely, love, humor, pathos, violence, heroism, fear, loathesomeness, and wonder. To these eight basic emotions the suggestion-theorists added a ninth, tranquility. Together, the eight or nine emotions were assumed to constitute the substratum of human experience. (I am reminded of the European theory of "affections," including anger, excitement, grandeur, heroism, contemplation, and mystical exaltation, which Baroque musicians and musical theorists took to express their aims. I am reminded as well that such a painstaking observer of young children as the psychologist Carroll Izard, of the University of Delaware, has revived the theory that everyone begins life with a number of basic discrete emotions.)

Each basic emotion, the Indian theorists say, has a parallel esthetic emotion or *rasa.* The difference between them is that the basic emotion arises and is expressed in real (bodily, temporal) life, while the esthetic emotion, though depending for its existence on the basic one, is detached from the circumstances of everyday, real life and from biological and psychological drives. The esthetic emotion or *rasa* may be said to be delocalized or depersonalized, or, to put it positively, to be universalized.

If so, the whole state of mind of the reader of a poem or spectator of a play may be said to be in a sense delocalized, depersonalized, or generalized.

The estheticians of suggestion, among whom the tenth-century philosopher Abhinavagupta (Abhinava, for short) was the most distinguished, had much to say on the poet's technique and knowledge, but I concentrate on the main point, which is the effect of poetic technique and knowledge: universalization. It is universalization that distinguishes esthetic from ordinary experience. Ordinary experience is dominated by the law of cause and effect and saturated with desire and pain, pain occurring when the mind is dissatisfied with what it has or is. However, in art, that is to say poetry and drama, ordinary experience is reduced to responses to memories, and these memories are so vague and objectless, so purged of actual desire or pain, that they yield the pure and finally ineffable pleasure of art. Esthetic experience, says Abhinava, "opens like a flower born of magic," without any relationship in time or space, or with the practical life that precedes or follows it.

Such esthetic detachment is possible because our response in art, basically our identification with the hero, is sympathetic and not selfish. The identification fails to become esthetic if it is too personal, in modern terminology too narcissistic, or if it is too concentrated within the individual self. By this esthetics, art requires one to be as much out of as in oneself and as much in as out—to be completely out of oneself in a positive sense is to have an unqualifiedly mystical and not merely esthetic experience.

In Abhinava's eyes, the accomplishment of the true poet is so great that he can be compared to the God whose will creates the world. He says, "In the shoreless world of poetry, the poet is the unique creator. Everything becomes transformed into the way he envisions it." By means of the poet's genius, the pleasure of the spectator or reader grows so great, so far beyond that of ordinary experience, that his ego is temporarily transcended and he enters into the unique state of emotion called "tranquility." This state is too pleasant and subjective to be unqualifiedly mystical; the mystical needs purification, which is painful. Yet the tranquility of true esthetic experience is very nearly (and sometimes perhaps the same as) mystical experience. This is because in esthetic tranquility we come into contact with the memory of the primeval unity of man and universe, that is, with the primeval

spontaneous expression of overflowing bliss that is the creative source of the universe.

Abhinava's philosophy, much of which was elaborated later than his esthetics, accepted the world as real and not, as often in the Vedanta, unreal. To Abhinava, who was a follower of Shiva, the world was understood to be the manifestation of the pure self or supreme consciousness, or in my term, objective subjectivity that contains but transcends all differences, and that cannot be put into words, perceived, or conceived, but only realized.

Different as its expression may be, I think that the general affinity of this Indian view with that of African "dynamism" and even more with Neoplatonism is easy to recognize. I must caution the reader that Indian estheticians were as contentious as any other; yet there is no doubt of the commanding stature and lasting effect of Abhinava on Indian esthetic thought. Traditionally educated scholars, pandits, often say that it was Abhinava who turned poetics into a science. He fits the role in India that I have assigned to Plotinus in the West.

To approach Chinese esthetic thought somewhat closely, I shall concentrate in the beginning on the all-important concept of *ch'i*. Its early meanings include *vapor, breath, exhalation,* and *life-spirit. Ch'i* is not at all abstract because it is, among other things, the very air we breathe. The source of our life, it disperses when we die; in anger we swell with it; and in old age we shrink as it diminishes. As universal energy, present everywhere in different concentrations, it came in time to be regarded as not only the life in things, but also that into which solid things condense and dissolve.

The concept of *ch'i* plays an important role in the theory of every Chinese art. In literature, its chief function is as the rhythmic force that impels, changes speed, connects, and gives unity. Elusive as it is, it can be captured if one shares the tension-creating twists and turns by which words are related. As in Herder and other Europeans, the piece of literature is considered to be a living organism, and perhaps to the Chinese, unlike the Europeans, a literally living one.

For calligraphy and painting, the concept of *ch'i* was most used in combination with *yün,* meaning "reverberation" or "resonance." *Ch'i-*

yün may therefore be translated, as it often is, "reverberation of the life-breath." In the first of the famous canons of Chinese art, enunciated by Hsieh Ho in the late fifth century A.D., this phrase was coupled with another, *sheng-tung*. The whole may be translated as "the reverberation of life-breath, that is, the creation of movement," or as "the reverberation of the life-breath creates life-movement."

It seems that in the early course of the development of Chinese art-theory, *ch'i-yün* was used to mean the life-force of the objects being depicted, the force the painter aimed to capture; but the phrase could take on moral overtones, and it came to mean the vital creative force of the universe, in which everything took part. The presence of *ch'i* in art was then equivalent to the presence in it of the vital spirit of the universe, the *tao*.

Chinese esthetics, based on this idea of the unifying vital spirit, tended to specify its subprinciples as polar opposites. Tung Ch'i-ch'ang emphasized such compositional principles as "opening and closing" *(k'ai-ho)*, "void and solidity" *(hsü-shih)*, and "frontality and reverse" *(hsiang-pei)*. Ideas like these, real or ostensible clarifications of earlier ones, continued to be elaborated on. Always, in China, the work of art is regarded as an organism, and there is the sense of forces that give life by their harmonized opposition within and between the parts that make up the whole. Always there are expansion and contraction, alternation of dense and rare and closed and open, excessiveness restrained and want supplied, and, if one sees sharply enough, individual and universe contained within one another. As Shen Tsung-hsien said in the eighteenth century, everything both expands and contracts, "from the revolution of the world to our breathing."

To end this series of references to Chinese esthetic principles, I should like to cite the seventeenth-century critic Wang Fu-chih, who did not believe in the impossible effort to hold everything poetic under conscious control. Poetry, he insisted, is more concerned with life than with literature as such, for it is a continuation of the processes of the universe as human consciousness interacts with it; and so poetry helps to recreate the human-universal bond that too many persons have broken.

Wang is surely referring to two doctrines of the Neo-Confucians: that the human mind and nature are identical, and that the virtue of "humanity" should be widened to fit this identity. In a famous essay of 1527,

the Neo-Confucian philosopher Wang Yang-ming wrote, in both a traditional and new vein, that when a person sees a child about to fall into a well, he cannot avoid alarm and sympathy; and much the same happens when he hears and sees birds and beasts about to be slaughtered; and he cannot help feeling pity when he sees plants broken and destroyed. Evidently, the same humanity that joins him with the child joins him with the birds, beasts, and plants. True, even plants are living things and so open to fellow-feeling; but the shattering of tiles and stones also gives him a feeling of regret, which shows that his humanity unites him with tiles and stones as well. "This means that even the heart of the small (unlearned) man must have this humanity which unites him (potentially) to all things." So, transcending itself, the human heart becomes one with anything and everything, and thereby shows itself to be, essentially, its innate consciousness of the good *(liang-chih)* that is the very force of goodness that unites the cosmos—in Neo-Confucianism, like Neoplatonism, Oneness and Goodness are identical.

Having said what I have about Chinese art theory, I feel impelled to add something Japanese, because much as the culture of Japan draws upon and merges with that of China, it has its own voice, or, rather, voices. A relevant Japanese concept is that of *yugen,* that which, unseen and indescribable, lies below the perceived surface of things. In a twelfth-century description it is "an overtone that does not appear in words, a feeling that is not visible in form," the kind that makes tears come to our eyes when we experience an autumn evening though it has neither color nor voice.

The great seventeenth-century Japanese poet Matsuo Basho explained to a disciple that poetry required the poet to abandon his objectivity, meaning his separateness, and become emotionally close to nature. He said, "Learn about the pine from the pine, learn about the bamboo from the bamboo." In his discipline's interpretation, to learn meant to enter into the object. "Then if its essence reveals itself and moves you, you may come up with a verse." But if the words do not naturally come out of the object, object and self will remain separated, and the emotion described will not have achieved sincerity.

The most simple, direct, and moving statement on the nature of poetry is found in the preface to the *Kokinshu,* a tenth-century anthology:

Japanese poetry has its seeds in the human heart, and takes form in the countless leaves that are words. So much happens to us while we live in this world that we must voice the thoughts that are in our hearts, conveying them through the things we see and the things we hear. We hear the bush warbler singing in the flowers or the voice of the frogs that live in the water and know that among all living creatures there is not one that does not have its song. It is poetry that, without exerting force, can move heaven and earth, wake the feelings of the unseen gods and spirits, soften the relations between man and woman, and soothe the spirit of the fierce warrior.

It seems to me that the various esthetic concepts or attitudes that I have just finished describing—the Neoplatonic or otherwise mystical ones of Europe; the fertility-seeking, community-binding dynamism of Africa; the dramatic art leading to the rapt identification and releasing equanimity of India; the interlocking vital forces of China; and the indescribable overtones of Japan—all have something in common, common and important enough to be grasped as the esthetic universal. This universal is related to the modern German concept of *Einfühlung,* translated by the English neologism *empathy,* whose mystical sources are in Herder, Novalis, and others. Empathy, however, is less than mystical, for it is simply the outward projection of one's consciousness causing other persons or objects to be experienced as if oneself. An exponent of empathy in this sense, Theodor Lipps (1851–1914), defined it as "the objectified enjoyment of the self," and he came close to the Indian attitude. Among European artists, the Expressionists in particular were influenced by the theory of empathy, which justified them in assimilating the subjects of their art to their own emotions. The view I have been expressing can be taken to be a culturally embracing variant of the theory of empathy, although I am not conscious of having derived it from any one source.

However this may be, I go back to my earlier statement that there is something in art, pertaining to its essence, that I think of as a subtle emotion, one perhaps of self-enlargement, but also, conversely, of self-diminution. Here, in this emotion, bird and human being join. I am referring to whatever it is in a person, like singing in a bird, that connects

him in emotion with another, and that attenuates the boundary between him and anyone and anything else. It is that which allows and encourages the individual to escape the threat of isolation and to feel himself integrated into the society of others or the society of the universe. The whole purpose of the emotion, if it is merely that, is to give a deeply inward response that is directed outward—to go above, below, through, and beyond the individual, in time, space, and nature. It is an emotional-intellectual bridging; and it is a sensuously apprehensible, non- but sub-mystical and quasi-moral hope or demand.

I think as I say this of a disorderly personal collection of responses in which all distinctions of time, place, and culture are forgotten. I think of the Fulani, the Africans who say after a time in the bush, "Solitude is killing me here," who need the constant presence of those with whom they share love, but who can ordinarily only sing, not say, that they need the love of others. I think of the Indian poet and the Indian mystic— Amaru losing himself in a woman ("She, she, she, she is right here . . . is right there") and Shankara losing himself in Shiva's Self ("i am not mind . . . not ear, tongue, nose, eye . . . I AM . . . AWARENESS AND JOY"). I think of the Chinese, who are always painting and writing that they need solitude and that they need friendship in order to escape solitude. I remember the fifteenth-century painter Shen Chou making a painting for a friend and writing on it in a poem that in the mountains above the river (the physical, the painted, the poetic river) they sensed their lasting friendship. I remember Van Gogh, unable to live with human beings but painting in order to prove that, all the same, he could love them. I remember Thomas Mann writing to his future wife Katia that his existence had been cold and impoverished, organized purely to display art and only to represent life, and pleading with her to affirm, justify, and fulfill him and be his wife and savior, the plea being put, like his art and as a specimen of it, in writing. I remember Stephen Spender's idea that every writer is secretly writing for a parent, a childhood teacher, or the like, and explaining that to write is to have faith that in art one can be even more than oneself. I remember the contemporary photographer Burk Uzzle saying of his pictures, "They are me, they are my pictures. My work is my visible love," and another photographer, Jill Freedman, saying, "A photograph is a shared experience. It's, 'Hey, look at this.' " I remember the painter Clyfford Still writing, "When I expose a painting I would have it say, 'Here I am: this is my presence, my feelings, myself!'"

I remember the painter Robert Motherwell saying that the experience of a work of art is, like making love, a contact "determined precisely by its form." I remember Barnett Newman saying that he hoped that his painting would give someone else, as it gave him, "the feeling of his own totality, of his own separateness, of his individuality, and at the same time of his connection to others, who are also separate." I remember and summarize all these and all the other reactions that might be added, in two simple, anonymous lines from an anthology compiled in Japan in the tenth century:

If I love and keep on loving,
can we fail to meet?

The emotion I am referring to runs through all expressive behavior, but it is at its most concentrated in art, the object of which is to externalize internality in as effective a way as possible. With all the emphasis at my command, I say that this emotion, though essential to art, is not sufficient for it. Art in the full sense can be characterized but cannot be given a very useful definition because it is implicated in too many things and too hard to separate from them, because it is present in every form we give our acts. Art is by nature inexhaustibly local and variable, and not at all as bare as an abstraction or as the obscure emotion that I have spoken of and almost tried to name. Yet though this emotion, which I have called the universal of art, is inexhaustibly far from explaining all of art, little of importance in art can be understood unless it is kept in mind. The reason is that art in all its forms is always the instinctive and the willed antithesis of loneliness, which has as many antidotes as it has varieties. However, art is more than a protean antidote to loneliness. As I have said, it exhibits the deep forms of individual and culture; opposes anarchy and apathy by the force with which it stabilizes and arouses; opposes stasis by the force with which it creates, disrupts, and recreates the human order; and insists quietly or shrilly, on a human response.

I have used two lines from a Japanese poem to express the quality, essential to art, of searching to be intimate with someone else even unknown. I end with a Japanese folktale to illustrate how art can immerse itself even in disappointment in life without surrendering to it.

The tale goes this way:

Long ago there was a young bachelor. One winter night during a heavy snowstorm he thought he heard someone outside. He opened the door and saw an unknown young woman, who had fallen in a heap by the door. He helped her into the house. She was beautiful, and he took her as his bride. Soon she grew well and strong and they lived together happily; but as spring approached and the weather became warmer, she gradually grew thinner and thinner and her health began to fail. One day the man's friends came to a party. As they were drinking *sake* and eating, the man called to his wife, but she did not answer. Wondering what was the matter, he went to the kitchen and saw that there was nothing there but the wife's kimono lying in a pool of water in front of the stove.

That is the whole tale. The woman was what the Japanese call a snow woman, and she had, it is plain, melted away. The story is doubly sad. It is sad because it reminds us that much of life is composed of dreams, like the beautiful young woman, that melt away; and it is sad because it leads us to reflect that we too vanish like the dream-woman, leaving only some transient physical traces.

For our purposes, the story can function as a parable, its lesson being, as I construe it, that interest in life is maintained by imagining its variations, the most interesting of which answer our vital needs, such as the young man's need for a wife, especially of the kind a story can so easily grant him—young, beautiful, and otherwise ideal. But the very story that expresses this need and varies life so as to satisfy it, also expresses the disappointment that life brings, a disappointment all the more severe because life had been imagined young and beautiful. The story therefore says, implicitly, that the art it exemplifies is illusionary and to be taken as still another of life's disappointments and a reaffirmation that loneliness is not really countered by dreams, whether of ideal wives or anything else. Life, it says, is a vale of disappointment deepened by any attempt to imagine the contrary. This negative conclusion is counterbalanced, however, by the ability of the tale to state the negative with positive effect. Art dissolves much of our sadness and loneliness in the pleasure of shared emotion. The pleasure of making up and telling the tale, which is the pleasure of inventing and sharing art, creates a current of feeling that runs, in physical or imaginative contigu-

229

ity, from teller to hearer and from one hearer to another and so demonstrates how the artist arouses vitality by his concentrated act of sharing.

The tale I have repeated is an example of the simplest and most unpretentious kind of art, and its effect is relatively easy to analyze. A greater work of art has a correspondingly greater, deeper, more complicated effect; but it resembles the tale in using the senses and the imagination to relieve our separateness, which is so often the most troublesome of our difficulties. Art ties us together with filaments of imagination and entangles us more deeply in our humanity. It inscribes our space, inward and outward, with the transformations of life. It is our fusion with the world by means of our fusion with one another, and our fusion with one another by means of our fusion with the world. It is sensual, abstract, immediate, distant, clear, and enigmatic. I have explained it as best I can, but I know that I have left it still enigmatic. The enigma, like the explanation, always renews itself.

References

When there are a number of references, they are given in alphabetical order. An exception is made in the case of a direct quotation or close paraphrase, the source of which is given first, regardless of alphabetical order. For the sake of the interested reader, alternative sources are often given.

C H A P T E R O N E . K n o w l e d g e , t h e G r e a t L e v e l e r

page
 4. "this modern stuff": Cummings, p. 157.
 4. "If I'd had to look": Battock, p. 156.
 4. ambitious young artist: Getzels and Csikszentmihalyi.
 4. Jasper Johns: Crichton.
 5. "I decided": Crichton, p. 27.
 5. speak of his past: Crichton, p. 20.
 5. desires and wishes: Crichton, p. 19.
 5. "Every day": Warhol (2), p. 181.
 5. goes down a street: Crichton, p. 19.
 5. his notebooks say: Crichton, p. 21.

5. "I saw evidence": Tomkins (2), p. 142.

5. "that only a real primitive": Holt, p. 178.

5. "I wanted to annihilate": Frankenstein, p. 157.

5. "Once I've finished": Pradel, p. 28.

6. Malevich: Chipp, pp. 341–46; Stangos, pp. 138–39; Vallier; Zhadova.

6. Raphael, Rubens: Chipp, p. 342.

6. Whiteness became an equivalent: Zhadova, pp. 58, 284ff.

6. in 1923: Zhadova, p. 125, note 63.

6. Rodchenko: Elliot; Karginov.

6. "last paintings," "murder," three primary colors: Elliot, pp. 57, 53–54.

7. Rauschenberg: Tomkins (2), pp. 71–72, 269; Sandler (2), pp. 175–76.

7. Reinhardt: Lippard.

7. Klein: Restany (1), (2).

7. Irwin: Wechsler.

8. a researcher claims: Peyser, p. 248.

9. difficulties faced by the artist: Getzels and Csikszentmihalyi.

9. Bribery: Burnham.

9. artists find it painful: Getzels and Csikszentmihalyi, pp. 189–90; Burnham, pp. 8–9,

9. Degas hated: Dunlop, p. 122.

9. Ad Reinhardt insisted: Lippard, p. 124.

10. Andy Warhol . . . did not hesitate: Warhol and Hackett, p. 21.

10. "He did not know": Seldes, p. 101.

10. "It seems ridiculous": Crichton, p. 54.

10. "a continuous renewal"; "For me to renew myself": Dumur, p. 81.

13. Chinese tradition . . . overwhelming: Sullivan (3), p. 144.

13. great collections: Li (5), col. 1, p. 81.

13. struggle with own tradition: Murck.

13. deliberate eclecticism: e.g., Clapp, p. 89.

14. proud egalitarianism: Lynn.

14. conscious eccentricity: Barnhart (2), Edwards (2); ch. 5 below.

14. Kao Ch'i-p'ei: Sullivan (3), p. 160.

15. laws of perspective: Edgerton.

16. "He who despises painting": I. Richter (2), pp. 216, 195.

16. photography: Daval (1); Hudson; Scharf.

16. seventeenth-century Dutch art: Alpers.

16. testimony of eye and camera: Feininger (1), pp. 14ff.; Rock.

16. independence of interpretive will: Barthes; Kozloff, ch. 1.

17. reproductions . . . hard to distinguish: Newhall (1964 ed.), p. 104; Scharf, pp. 188–89.

17. Baudelaire denounced: Scharf, pp. 89ff; Newhall (1982 ed.), p. 82.

17. Delacroix: Newhall (1982 ed.), p. 82; Scharf, pp. 89ff.

17. if a man of genius: Scharf, p. 90.

17. corrected errors of vision: Scharf, p. 89.

17. Millet: Scharf, pp. 66ff.

17. Degas: Dunlop, pp. 207–8; Scharf, pp. 138ff., 277ff.

18. "The idea": Scharf, p. 197.

18. "Given the existence of photography": Scharf, p. 197.

18. "Today photography": Scharf, p. 197.

18. "The invention of photography": Scharf, pp. 197–98.

18. "We know at least": Ashton (3), p. 109.

18. Duchamp's paintings: Scharf, pp. 199–201.

18. Bacon: Scharf, p. 170.

18. sheer richness: Darius (historical scientific photographs); Feininger (2); Francis and Jones (pictures of the earth from space); Marten et al.; Murdin and Malin.

19. "to free his thoughts": Scharf, p. 236.

20. Couture: Boime (2).

20. Ruskin on Orcagna . . . : Haskell (2), p. 4.

20. Apollo Belvedere: Haskell and Penny.

20. "the most admired piece of sculpture": Alsop, p. 3.

20. "unspiritual," "a public nuisance": Haskell (2).

20. "Before another generation was out": Haskell (2), p. 6.

21. Michelangelo, Titian . . . : Alsop, pp. 3–4.

21. old master after old master: Haskell (2), pp. 114–15.

21. Jugendstil . . . Botticelli: Haskell (2), pp. 113–14.

21. In the Metropolitan Museum": Haskell (2), p. 116.

22. "Those who are absent": Leslau and Leslau, p. 19.

22. Dürer: Alsop, pp. 6–7; Bernal, pp. 130–31.

22. Rembrandt: Haak, pp. 262–63.

22. official of the Dutch East India Company: Boxer, p. 173.

22. disparagers: Gallagher, p. 22 (for China); Mitter, pp. 115–16 (for India).

22. manias: Glasenapp; Honour (1), p. 56; Schwab, ch. 3; Sullivan (2), pp. 90ff.

23. "We the undersigned": Mitter, p. 270.

23. Havell: Mitter, pp. 272–77.

23. Coomaraswamy: Mitter, pp. 277–81.

23. Beardsley, Klimt, Schiele: Dorival, p. 68; Whitford, p. 239.

23. Japanese prints: Berger; Dorival; Ives; Sullivan (2); Wichmann (1), (2).

23. Rousseau: Berger, pp. 21–22; Dorival, pp. 33, 34.

23. Millet: Dorival, pp. 33–34.

24. Degas: Adhémar and Cachin, p. 82; Berger, pp. 13–17; Ives; Dorival; Wichmann (2), pp. 202–7.

24. Monet: Berger, pp. 78–93; Dorival.

24. Van Gogh: Berger, pp. 130–48; Dorival; Jaffé; Wichmann (1) pp. 52–61; Wichmann (2), pp. 288–90.

24. "I envy the Japanese": letter end of Sept. 1888, in Van Gogh, p. 296 — see also pp. 19–20.

25. Toulouse-Lautrec: Berger, pp. 200–14.

25. Bonnard, Vuillard, Cassatt: Berger, pp. 214–17; Ives; Dorival.

25. "Idols," pelts, ivory: Fraser; B. Smith.

25. Cook expressed admiration: B. Smith.

25. "A European would have been ashamed": B. Smith, p. 89.

25. "There is no art": Fraser, p. 26; on Ruskin see Mitter, pp. 238–48.

25. Gauguin: Goldwater (2), pp. 63–85; Newton, pp. 36–37; Schmalenbach; Selz (2), pp. 288–89; Varnedoe (2); Wadley.

26. African art: Paudrat (1).

26. Ensor, Kirchner: Elderfeld, pp. 109–10; Goldwater (2), ch. 4; Paudrat (1), pp. 456–57.

26. Vlaminck, Derain . . . : Laude, p. 476; Newton, p. 37; Rubin (2); Selz (1), p. 109; Willett (1), p. 35.

26. Picasso: Goldwater (2), ch. 5; Rubin (2), (3).

26. "It is more beautiful": Flam (1), p. 214 — reported by Francis Carco.

26. It is argued that: Rubin (2), pp. 17ff.

26. Max Jacob insisted: Fraser, p. 32.

26. "I understood what": Malraux (1), p. 16; Malraux (2).

26. Expressionists: D. E. Gordon; Schneckenburger (2).

26. Nolde: Selz (2), pp. 124–29, 289.

26. Roger Fry: Goldwater (2), p. 36.

27. Fry . . . did not see much: R. Fry.

27. Oceanic . . . Surrealists: Maurer; Newton, pp. 34, 41; Peltier.

27. Picasso to Mawalan: Stubbs, p. 97.

28. *The Blue Rider:* Selz (2), p. 22.

28. Pollock, Newman, Motherwell . . . : Hobbs and Levin, pp. 13–16, 42–43, 58–61, 94, 96, 112, 114; Sandler (1), pp. 3, 65; Varnedoe (1).

29. Moore: James; H. Moore.

29. His first year in art school: James, p. 33.

29. "rather stupid love": James, p. 157.

29. "grand and full": James, p. 157.

30. "It seems to me that this conflict": James, pp. 42–43.

30. Chinese painting: James, p. 93.

30. "I would give anything": James, p. 74.

30. "limitless variety": James, p. 72.

30. Morris Graves: Sullivan (2), p. 253.

31. Isamu Noguchi: Hunter, esp. p. 100; Sullivan (2), pp. 150–52.

31. Mark Tobey: Bowen; Sullivan (2), pp. 151–52; Yamada, pp. 303–5.

31. "Standing as I am here": Bowen.

31. "I'll make no claim": Yamada, p. 304.

31. Zao Wou-ki: *Free China Weekly; Free China Review;* Sullivan (2), pp. 171, 179–80, 193.

31. "You cannot imagine": *Free China Weekly,* p. 39.

32. "My paintings have become identified": *Free China Weekly,* p. 40.

32. Tsing-fang Chen: Tsing-fang Chen.

32. "East and West lived side by side": Tsing-fang Chen, p. 2.

34. very techniques of art: Lipman and Marshall.

34. by way of parody: Lipman and Marshall.

34. "To see other *periods:* H. Foster.

34. Paolozzi: Finch, pp. 87–88.

35. Bacon: J. Russell (1), p. 50.

35. "so personally did he feel": Gray, p. 240.

35. "I'm just making the last painting": Lippard, p. 158.

35. "I have learned a lot": H. Rosenberg (2), p. 145.

35. "I can open almost any book": H. Rosenberg (2), p. 38.

35. "there is no style": H. Rosenberg (2), p. 145.

CHAPTER TWO. Prehuman Intimations

38. bird songs and calls: Armstrong (4); Burton; Catchpole; Jellis; Nottebohm; Thorpe (2), (4); Tyne and Berger, ch. 5.

38. Peter Marler's cockerels: Gurin, p. 120.

38. sixteen infant swamp sparrows: Marler and Peters.

39. Rather as a child: H. Gardner (2), pp. 144–57; Gurin, pp. 124–25; Thorpe (5).

39. "You might think": Gurin, p. 125.

39. a certain European blackbird: Jellis, pp. 196–200.

39. Bach suite: of the gigue of Suite No. 3 in D. See Hall-Craggs, pp. 376–77.

39. learn to sing: Armstrong (4), pp. 44–48; Hinde (4), pp. 19–27; Jellis, pp. 116–23; Konishi and Nottebohm.

39. captive young chaffinch: Jellis, p. 120; Konishi and Nottebohm, pp. 39–41.

40. small . . . large repertoire: Armstrong (4), pp. 39–42; Jellis, pp. 200–204; Nottebohm, pp. 296–302; Thorpe (3), p. 4.

40. vireos: W. S. Smith, pp. 418–19.

40. "intimacies of sexual motivation": Mulligan and Olsen, p. 183.

40. greater number of distinct sounds: Greenwalt, p. 236; Jellis, p. 37; Thorpe (2), p. 4; but Donaghey writes (1985) that the bird's ear "may not be specialized for high speed of response as once thought."

40. dialects: Armstrong (4), ch. 6; Baptista and Morton; Jellis, ch. 7; Kroodsma et al.

41. bird display: Armstrong (2); Caryl; Hinde (2); "Courtship" and "Ritualization" in McFarland (2).

41. dances have been classified: Armstrong (2), p. 199.

41. male and female crane: Armstrong (2), p. 196; Dorst, vol. 1, pp. 205–6.

41. Japanese cranes: Britton and Hayashida.

41. birds of paradise: Gilliard.

41. shimmering ornaments: Gilliard, p. xviii.

41. bowerbirds: Donaghey, Frith, and Lill; Gilliard; H. Simon.

42. "It was the Bower-bird": Graves, p. 27.

42. paint and repaint: Gilliard, pp. 348–49; H. Simon, p. 111.

42. a certain description: Sielman, in von Frisch, p. 243.

42. "a yellow orchid" Sielman, in von Frisch, pp. 243–44; see Gilliard, p. 314.

42. "I see no reason": A. J. Marshall, *Bower Birds,* London, 1954, in Griffin (2), p. 136.

43. consummatory value: Gilliard, p. 351; H. Simon, p. 110.

43. one romantic-sounding case: H. Simon, p. 125; but see Borgia.

43. the satin bowerbirds: Borgia.

43. male hummingbirds: W. S. Smith, p. 165; B. K. Snow, p. 295.

43. lek: Batten; Halliday, p. 81; D. W. S. Snow (1).

43. explaining ornithologists: Krebs; Wiens, pp. 223–25.

44. sage sparrows: Wiens, pp. 209, 227.

44. statistical artifacts: Verner; Wiens.

44. very burdensomeness of the wings: Batten, p. 84; Halliday, pp. 76–78; Ridley, p. 531.

44. recorded song of male canaries: Cherfas (3).

45. the objector: Scruton, pp. 79–81, 83.

45. automatic or "instinctive": Hinde (1), ch. 2; Stettner and Matyniak.

45. birds' hyperstriatum: McFarland (2), p. 44; Stettner and Matyniak.

45. birds' intelligence: McFarland (2), pp. 315–16; Thorpe and Krebs; Stettner and Matyniak.

45. song-controlling area: Hinde (3), pp. 172–74; R. E. Webster, p. 384.

46. African grey parrot: Griffin (1), p. 163; Griffin (2), p. 64; J. A. Serpell.

46. emotion: Griffin (3) (see "emotions" in index); McFarland (1), pp. 525–31; McFarland (2), pp. 149–52.

46. brain waves: Evans, pp. 128–33; Griffin (1), pp. 202–4; McFarland (2), p. 141; Snyder.

46. experiment with monkey: by L. Vaughn, cited in Snyder, pp. 396–97.

48. great deal of variation: Catchpole; Hinde (4) (see "individual variation" in index); Jellis, pp. 196–97; W. J. Smith, pp. 417–19; Wiens.

48. individuality of birdsong: Falls, pp. 218–19, 228–29; Jellis, ch. 8; D. K. Scott.

48. "That's Mozart!": reference lost.

48. "Birds alone": Lebrecht, p. 327.

48. value in and for itself: W. J. Smith, p. 291.

49. imitate sounds: Armstrong (4), pp. 54–57, ch. 5; Bonner, pp. 119–20; Jellis, pp. 175–85; Thorpe (4).

49. to develop their intimacy: Halliday, pp. 114–15; W. J. Smith, pp. 437–41, 446–55.

49. "the most beautiful human object": Menuhin and Primrose, p. 7.

50. sexual needs: on nude in art see Clark (1); Hudson; Walters; on Victorian sexuality and art see R. Jenkins, ch. 8.

50. caressed the marble flesh: Elsen (2), pp. 151, 163.

50. "I paint with my penis," "heart and loins": Walters, p. 315.

50. Picasso: M. M. Gedo; Kahnweiler et al., esp chs. by Reff and Boggs.

50. Gill: Yorke, pp. 39, 109–10, 101, 43.

50. "white smoothness": Yorke, p. 43.

50. Clergue: Hudson, pp. 20–21.

50. "Photography is the sublimation": J. B. Hall, "Introduction" in White.

50. Tyrtaeus: Fränkel, pp. 154–55.

50. "My body serves the mission": Liu and Lo, p. 43.

50. Native North Americans: Driver, p. 200; Feest, p. 28.

51. bird duet: Armstrong (4), p. 180; Hooker and Hooker; Jellis, p. 186; Thorpe (3).

51. when one member of a pair is absent: Thorpe (3), p. 222.

51. captive Australian magpies: Hooker and Hooker, p. 203.

51. "bird assemblies": Jellis, pp. 189–90.

51. African drummers: Chernoff.

51. Eskimos: Driver, p. 198; see following chapter.

51. Tanzanians: Chadwick and Chadwick, p. 158.

51. Polynesian poets: Chadwick and Chadwick, pp. 415, 462.

51. Sanskrit poets: Auboyer (1), p. 246; Keith, pp. 41, 53; on Indian painters, Sivaramamurti (4), pp. 6, 9, 21.

51. Chinese poets: Owen (3), ch. 7.

51. Japanese poets: Brouwer and Miner, pp. 195–97, 234, 238–40, 249–55, 291, 320–21; Sato, p. 11.

51. Japanese winners of poetry contests: Brouwer and Miner, pp. 234, 238.
51. took two poetic roles: e.g., Brouwer and Miner, pp. 239–40.
51. *renga:* Kato (2), vol. 1, pp. 294–98; Miner; Sato.
51. ten thousand responses: Sato, p. 18.
51. Saikaku: Kato (2), vol. 2, p. 94.
52. musicians and artists criticize one another: Carner; Duncan; and see biographies of the musicians and artists involved.
52. Schönberg and Stravinsky were at such odds: Peyser, p. 94.
52. Boulez on Schönberg, Stravinsky, Cage, Stockhausen: Peyser pp. 9, 76; and see index.
52. "animal waiting for the kill": Peyser, p. 85.
52. Leonardo and Michelangelo: Liebert, pp. 110, 182.
52. El Greco on Michelangelo (in comments on Vasari's history): Brown, p. 130.
52. Blake said of Titian: Erdman, p. 530, from Blake's preface to his "Descriptive Catalogue of Pictures."
52. Cézanne of Gauguin: reported by Emile Bernard in Cachin, p. 326.
52. Whistler on Cézanne . . . : Abse, p. 280; Bell, p. 82.
52. Ruskin of Whistler (and Michelangelo and Rembrandt): Bell, pp. 75, 77.
53. "every artist needs a platform": Hamill, p. 40.
53. "I've got a book coming out": Hall, p. 28.
53. sexually less acceptable: Baptista and Morton; Kroodsma et al., pp. 117–27.
53. literature of India: Dave.
53. crane dances: Armstrong (2), pp. 208–14; Armstrong (3), pp. 74–75; Britton and Hayashida, pp. 38–41.
54. Alcman: Fränkel, p. 162.
54. borrowings of music: Jellis and Hall-Craggs; see also Buxton on "Birds in Poetry," and, generally, Armstrong (1), (3).
54. birdsong-imitations lower than originals: Nichols, p. 56.
54. human impulse to collect and display: Alsop; Rochberg-Halton.
54. bowerbird, crow . . . : W. J. Smith, pp. 258–60, on "tokens."
55, Native Americans: Driver, p. 140; Ebin, p. 35; see also Brain (2), pp. 90–92, on head-shaping.
55. Bambara: Brain (1), p. 83; Ebin, p. 36.
55. African hairstyles: Balandier and Maquet, "Adornment"; Paulme, pp. 17–18.
55. Initiation rites: Balandier and Maquet, "Body."
55. *arioi:* Williamson, p. 123.
55. Bororo Fulbe: Brain (1), pp. 56–57; Paulme, p. 13.
55. Mt. Hagen: Strathern; Strathern and Strathern.

55. big men: Strathern and Strathern, pp. 6, 62.

55. conformity: Strathern and Strathern, p. 11.

55. sexual attraction: Strathern and Strathern, p. 90.

55. symbols of sexual attraction: Strathern, p. 32.

55. "that when men dance": Strathern, p. 31.

55. Southeastern Nuba: Faris; Riefenstahl.

56. the apes: Desmond; Hamburg and McCown; Jolly; MacKinnon (1); Passingham; Reynolds.

56. sense the world: W. A. Mason; Passingham, ch. 2.

56. facial and bodily expression: Goodall, ch. 13; Lawick-Goodall (3); Terrace, p. 86; Van Hoof.

56. "a market in sex": De Waal, p. 207.

56. pigmy chimpanzees: R. Kane; Raeburn; MacKinnon (1), ch. 5.

57. sort by function: Gillian; Goodall, ch. 2; Jolly, pp. 386–93; Passingham, pp. 235–43; Premak and Premak, pp. 125–28; see also W. A. Mason.

57. a "true" language: Fouts and Budd; Harré and Reynolds; McFarland (1), ch. 26; Passingham, ch. 8; Ristau and Robbins; Savage-Rumbaugh and Rumbaugh; Sebeok; Seyforth; Terrace; Umiker-Sebeok and Sebeok.

57. deceive on purpose: Desmond, pp. 198–205; Griffin (2), pp. 71–72; Jolly, p. 443; Quiatt; Kummer, pp. 118–20; McFarland (1), pp. 500–1; Menzel, p. 368; Ristau and Robbins, pp. 322–23; Terrace, pp. 151–53.

57. pulling real toys: Hayes.

57. monkey experiment: by Nick Humphrey, a Cambridge zoologist, in Sparks (2), p. 274.

58. recognize photographs of themselves: Desmond, p. 114, ch. 8; Reynolds, p. 174; on picture recognition generally, W. A. Mason, pp. 282–83.

58. mirror images: Desmond, pp. 171–75; Essock-Vitale and Seyforth; Jolly, pp. 394–96; Terrace, p. 147; E. O. Wilson (1), pp. 26–27.

58. "apes and men": W. A. Mason, in Desmond, p. 175.

58. young orangutan: Sandved and Emsley, p. 23.

58. call of the gibbon: Gittins; Kavanaugh, pp. 177–78; MacKinnon (1), pp. 193–94.

58. "rain dance": Lawick-Goodall (1), pp. 58–59; see also MacKinnon (1), p. 195.

58. trot rhythmically: observed by W. Köhler (1921), in Armstrong (2), p. 205.

58. decorating themselves: Reynolds, pp. 117, 176.

58. stamping and pirouetting: Reynolds, p. 182.

58. "I remember watching Fifi": MacKinnon (1), p. 90.

58. scribbled . . . traced marks: MacKinnon (1), p. 90; see also Glaser, on chimpanzee scribbling.

58–9. Moja and Koko: Desmond, pp. 104–105; Winner, pp. 177–78; see also Reynolds, p. 175, on Toto.

59. Nim: Terrace.

59. three-dimensional constructions: Terrace, p. 115.

59 Morris: Morris (2).

59. "Next day": Morris (1), p. 182.

60. Congo and Betsy . . . exhibited: Morris (1), pp. 184–86.

60. "The hand of the chimpanzee": Morris (1), p. 188.

60. Picasso, Miro: Morris (1), p. 188.

61. A psychologist undertook: Hussain (1965), in Child, p. 880; see also Morris (2), p. 25, on ape paintings diagnosed as human.

61. "Congo and I": Morris (1), p. 206.

62. Each ape has its own expressive style: Morris (2), pp. 38–39.

62. cannot be distinguished from human: Morris (2), pp. 24–25.

63. evidence of its beating heart: Luce, pp. 37–38, 40; *Science* 213 (Aug. 7, 1981), p. 679; *Time* (Aug. 15, 1983); Youcha.

63. a hydrophone: *Time* (Aug. 15, 1983).

63. music over noise: as shown by the psychologist Anthony DeCasper, of the University of North Carolina, and his associates.

64. children's drawing and painting: Bernson; H. Gardner (1), (2); Goodnow; Kellogg; Kramer; Winner.

64. the same everywhere: Jahoda and McGurk.

64. argues for similarity: Anastasi and Foley.

65. Hopi village and American city: Havighurst and Neugarten, ch. 7.

65. same basic plastic language: Arno Stern, in Depouilly, p. 522.

65. Central Australian children: Strehlow, p. 46; see also Munn, ch. 3, pp. 61–64.

65. Eskimo girls: Himmelheber (1), p. 44.

65. children do not draw . . . pass through stages: Alexander Alland, in Winner, p. 167.

65. fits his scribble: Morris (2); Kellogg, ch. 3.

66. approximate circles: Goodnow, pp. 35–40; Kellogg, ch. 8.

66. about three years old: Kellogg, chs. 4, 5.

66. arguably abstract: Kellogg, pp. 60–63.

66. Sepik of New Guinea: Forge (1), pp. 177, 197.

66. age of four: Kellogg, ch. 12.

66. progresses: Goodnow, ch. 6.

67. may complain: Golomb, p. 31.

67. man himself: Golomb; Kellogg, ch. 11, pp. 158–77.

67. circle or oval: Golomb, pp. 2, 13.

67. "thinghood": Golomb, p. 13.

67. linear models: Golomb, p. 22.

67. parsimonious: Goodnow, pp. 150–52; Kellogg.

68. own graphic devices: Goodnow, chs. 3, 5; Kellogg; Kramer.

68. kind of line . . . color he prefers: Child, pp. 894, 868–69; Kreitler and Kreitler, chs. 3, 5; Winner, pp. 109, 139.

68. conclusions of one study: Alschuler and Hattwick; see summary in Pickford, pp. 214–18.

69. *The Innocent Artists:* Baker.

69. "It's from my imagination": Baker, p. 39.

70. autistic children: Winner, p. 236; Restak.

70. Nadia: Selfe (1), (2); see also H. Gardner (1), pp. 18–81, (2), pp. 184–91.

70. Chinese girl Wang Yani: *Yani's Monkeys.*

71. to belittle the artists: see H. Gardner (1), p. 120.

72. Egyptian art is "aspective": Schäfer.

72. children as artists: H. Gardner (1), esp. chs. 9, 10; (2), esp. ch. 5.

74. anyone open: e.g., the composer Michael Tippett, Tippett; Doyle, p. 123.

74. "Artists do not stem": Malraux (3), p. 281.

74. "A child paints simply": John Berger (1960), in Sparshott, pp. 571–72, note 36; see also pp. 365, notes 19–21; 640–41, note 23.

75. "It is necessary to grow up": Valéry, vol. 1, p. 372.

75. play: Baldwin and Baldwin; Bekoff, for birds; Berlyne (3); Bruner, Jolly, and Sylva; Fagen; Hassenstein; Huizinga; Jolly (for primates); Loizos (for higher primates); MacKinnon (1), pp. 89–90; Turner (1), on "the human seriousness of play"; E. O. Wilson (2), pp. 164–67.

75. even some primates: Baldwin and Baldwin, pp. 387–88.

76. Borneo orangutans compared with Sumatran: Fagen, p. 74; but MacKinnon (1), pp. 116–17, 127, and (2), p. 45, make this contrast seem excessive.

76. useful not to play: Baldwin and Baldwin, pp. 384–88.

76. playing animal jumbles: Loizos, p. 178.

76. generates and regenerates its forms: Morris (3), p. 209.

77. sucking milk: Thorpe (1), p. 220.

77. love to groom: Hutchins and Barash; Sparks (1).

77. consummatory experience: Hinde (1), pp. 31–33; McFarland (1), pp. 274–75; McFarland (2), "Consummatory Behaviour"; Thorpe (2), pp. 226–27.

77. continues to sing: Hall-Craggs, p. 205.

77. loudspeaker to amplify: experiment by Kroodsma, in Gurin, p. 122.

77. "spring-picture album": Lane.

77. Indian erotic literature: N. N. Bhattacharyya.

78. geniuses of eroticism: N. N. Bhattacharyya; Mervin and Masson; Miller; Siegel; Rawson (1).

78. animals fix traditions: McFarland (1), pp. 514–18; Nishida; E. O. Wilson (2), pp. 168–72.

80. bird on dialect borderline: perhaps better "borderline"; see Kroodsma et al., pp. 107–8.

80. not unlike biological evolution: Ackerman.

81. hybridization-vigor: Schrader, pp. 291–92.

CHAPTER THREE. Spontaneity Pursued

82. Western idea of spontaneous life: G. Boas; Elias; Honour (3).

82. in India: Dimmitt and van Buitenen, p. 38.

82. in China: Watson (3), p. 172 (ch. 16); ch. 6; p. 253 (ch. 23).

82. in Greece: Hesiod, *Works and Days.*

82. Diogenes of Sinope: Dudley, ch. 3.

82. in later Europe: Elliott, pp. 25–27; Hemming, ch. 1.

82. Columbus called: Cohen, pp. 117–18.

82–3. beautiful naked people: Hemming, p. 13.

83. Van Gogh's plan: e.g., letter to Theo ca. Sept. 1888, in Chipp, p. 37.

83. as the nightingale sings: letter of Aug. 11, 1888, in Hammacher and Hammacher, p. 161.

83. Arp's desire: expressed in "Abstract Art, Concrete Art," in Chipp, p. 390.

83. taking of pleasure: Berlyne (1), ch. 8; Turner (1), pp. 28, 33–34, 43.

83. Chopin testified: A. Walker, p. 251, note 22.

83. Menuhin testifies: Daniels, pp. 44–45.

83. novelty-loving animals: Baldwin and Baldwin, pp. 346–58; Berlyne (2), pp. 817–20; Hassenstein, pp. 339–40; Loizos (for higher primates), pp. 187–88, 193–204; McFarland (2), "Exploratory Behavior."

83. boredom: Berlyne (1), ch. 11; Lawick-Goodall (1), p. 151 (for chimpanzee); Meyer, chs. 3, 4 (for music); McFarland (1), "Boredom"; Ostow.

84. young of langurs, squirrel monkeys . . . : Baldwin and Baldwin, pp. 349–50.

84. to become a big cat: reference lost; but see Spector (2), pp. 98–103.

85. "fatten" the narrative: Jordan, p. xv.

85. Indians of the South American rain forest: J. O. Kaplan, pp. 359–60.

85. preliterate poetry or song: Alexandre; Astrow; Balandier; Beier (1); Bierhorst (2); Chadwick and Chadwick; Finnegan (1), (2), (3); Harries; J. Rothenberg (1); Rothenberg and Rothenberg; Schaeffner; Trask.

85. Indians of the South American rain forest: J. O. Kaplan, pp. 359–60.

85. "every Dobuan": Trask, vol. 1, p. xiv.

85. "a people of poets": Trask, vol. 1, p. xiv.

85. Ila and Tonga: Finnegan (1), p. 248; Sachs, pp. 137–38.

86. Nuer: Evans-Pritchard (2), p. 46.

86. among many African: Chadwick and Chadwick, pp. 84, 647–48.

86. as among Polynesians: Chadwick and Chadwick, pp. 239–40, 269–70.

86. To the Tartars: Chadwick and Chadwick, p. 187.

86. "like cascades": Barbeau, pp. 97–98, 145.

86. Andaman Islands: Sachs, p. 138.

86. "She can't dance": Sachs, p. 138.

86. Courtship: Chadwick and Chadwick (for Tartars); For Eskimos: Balikci; Rasmussen (1); Spencer, pp. 173–76.

86. Netsilik Eskimo: Balikci, pp. 140, 185–89.

86. Singing and dancing go on: Rasmussen (1).

86. *The Song of Ulipshiulak's Wife:* Rasmussen (2), pp. 135, 168–89; also Trask, vol. 1, pp. 24–25.

87. difficulties in translating: Bevis; Chapman, e.g., pp. 238, 293; J. Rothenberg (2); Rothenberg and Rothenberg, sec. 5; Tedlock (1).

87. "whenever I pause": trans. F. Densmore, *Chippewa Music,* in J. Rothenberg (1), p. 104.

87. "It is only": Highwater, p. 33.

87. "The odor of death": Highwater, pp. 33–39.

87. the Bantus: Chadwick and Chadwick, pp. 582–83, 598; Lestrade.

88. "The little hut," "The sound of": trans. H. A. Junod, in J. Rothenberg (1), p. 17.

88. "In the sky": trans. A. Garibay, in Bierhorst (2), p. 75, and in Leon-Portilla, p. 95.

88. Bauls of Bengal: Dimock, pp. 251–60.

88. "When I remember": Dimock, p. 252.

88. Chattisgarh: Elwin.

88. "Life in Chattisgarh": Elwin, "Introduction," p. l.

88. likely to be charming: Hivale, pp. 147, 149, 152, 157–58, 221.

89. "Since I saw your thing," "My mind is on fire," "The sun is red," Elwin, pp. 86, 92, 7.

89. The old Yakut women: Chadwick and Chadwick, p. 55; see also p. 187.

89. Melanesia and Micronesia: Trask, vol. 1, p. xiv.

90. southern Sudan . . . South Pacific: Trask, vol. 1.

90. Eskimos: Balikci, pp. 140–42; Spencer, pp. 173–76.

90. The Gilbert Islands poet: Trask, vol. 2, p. 28.

90. serious songs . . . magical force: Spencer, pp. 227–28.

90. old woman diviner: From Rasmussen, in Halifax, p. 30, and Trask, vol. 1, p. xvi.

90. "they take shape": Finnegan (2), p. 81, and Halifax, p. 30.

90. Orpingalik: Rasmussen (4), p. 321; Finnegan (1), pp. 178–83.

90. "Thoughts can wash": Rasmussen (4), p. 321; Finnegan (1), p. 81; J. Rothenberg (2), p. 359.

91. "All my being," "comrades in loneliness": from Rasmussen, in Halifax, p. 163.

91. Chinese calligraphy: Chih-mai Ch'en; T. Yu-ho Ecke (1); Fu et al.

91. "Calligraphy is releasing": T. Yu-ho Ecke (1), "Introduction."

91. the cursive script: Fu, ch. 3; T. Yu-ho Ecke (1).

91. Chang Hsu: Chih-mai Ch'en, p. 92.

92. Huai-su: Chih-mai Ch'en, pp. 92–96.

92. Mi Fu: Chih-mai Ch'en, pp. 114, 120; Fu and Fu, p. 128.

92. "The over-all effect": Chih-mai Ch'en, p. 120.

92. i-pin: Barnhart (2), pp. 372–73; Nelson (for later development); Shimada; Soper (2).

92. "Then, laughing": Shimada, p. 68; Bush and Hsio-yen Shih, pp. 65–66. Wang Hsia was also called Wang Mo and Wang P'o-mo.

92. "extraordinary and fascinating": Ho et al., p. 364.

92. "it is not so deft": Grohmann, pp. 374–75.

92. Chillida: Selz (1), p. 119.

93. "Poetry is where the intent": Liu (1), p. 69.

93. poetry came to him: Schmidt, p. 51.

93. "live method": Schmidt, ch. 3.

93. "What is meant": Schmidt, p. 56.

93. unable to enter: Schmidt, p. 87.

93. "Don't read books!": Schmidt, p. 91.

94. "There is no fixed pattern": Chaves (2), p. 18.

94. "true people": Liu (1), p. 80; Chaves (2), p. 20.

94. "full of true voices": Liu (2), pp. 80–81.

94. "Poetry is only a sudden cry": Liu (2), p. 82.

95. ability of a child-actor: Izutsu and Izutsu, pp. 38–39.

95. "disease" of the skilled: Izutsu and Izutsu, p. 167.

95. to a young boy: Izutsu and Izutsu, p. 163.

95. Rousseau, Wordsworth . . . : Honour (3).

95. "The child sees everything": Baudelaire, vol. 2, p. 690 (my trans.); Abrams (2), p. 417.

95. now conventional praise of children's art: Goldwater (2), pp. 192–215; Shapiro, pp. 58–64.

95. Franz Cizek: Viola; Schorske, pp. 327–28.

96. "When I say to the child": Viola, p. 37.

96. member of the Viennese Secession: Schorske, pp. 327–28.

96. Brücke and Blaue Reiter: Selz (2), pp. 221–22.

96. "the inner resonance: "On the Problem of Form," 1912, in Chipp, p. 166.

96. "You cannot walk": Chipp, p. 167.
96. Matisse argued: Flam (2), p. 148.
96. "Critics are always talking": Ashton (3), p. 164.
96. Klee's borrowings: Plant, pp. 31, 78, 163–66.
96. "as though new born": Goldwater (2), p. 199.
96. "trickling through the brain": Goldwater (2), p. 200.
96. "legend": Plant, p. 181 (note 3 to ch. 2).
97. "Will and discipline": Goldwater (2), p. 201, citing Klee, p. 266.
97. *Child Consecrated to Woe:* Plant, p. 78.
97. *Height:* Plant, pp. 165–66.
97. *Overexcited:* Plant, pp. 166–67.
97. desire to be spontaneous: Goldwater (2), pp. 205–209; Rubin (1), p. 30.
97. sensual immersion: Miro, p. 12.
97. "go down to the beach": Miro, p. 126.
98. "without any apparent effort": Miro, p. 116.
98. missed . . . the genius of childhood: Ashton (3), p. 75 (Picasso 1946, 1966), 76 (to Brassai 1966).
98. a change of wife or mistress: Schiff.
98. did not know where a work would lead him: said by Picasso to Spies, in Spies, p. 49; Ashton (3), pp. 8, 29, 107.
98. "By his eighties": Richardson, p. 284; see also McCully, p. 277.
99. In a frenzy of drawing . . . painter and the woman: M. M. Gedo, pp. 219–22; Schiff, pp. 17–25.
99. "In the end": Ashton (3), p. 78.
99. Style . . . locks the painter: Ashton (3), p. 95.
99. "I thrash around": Ashton (3), p. 96.
99. "You know, it's just like": Ashton (3), p. 111, said about 1965.
99. He does want them: Ashton (3), pp. 7, 15, 34.
99. theatrical soldiers-of-fortune: Schiff; also Ashton (3), p. 98.
99. Raphael-Michelangelo-Degas-Picasso: M. M. Gedo, pp. 232–36; Schiff, pp. 31–40, 49, 55, 59–61, 67.
100. heads of the man and woman: M. M. Gedo, p. 252; Schiff, pp. 50–53.
100. Picasso-Anguish and Picasso-Death: Schiff, p. 67.
100. the child: Ashton (3), p. 104.
100. "I think that men will realize": Frankenstein, p. 147.
100. "Modern art": Terenzio, p. 134.
101. Dubuffet: Cardinal; Franzke.
101. Psychiatric interest: Thévoz, pp. 12–35; Volmat, pp. 198ff.; Volpe and Wiart.
101. Hans Prinzhorn: Prinzhorn.
101. psychotic natives of New Guinea: Billig and Burton-Bradley, p. 198.

102. "constantly on the verge": L. Gordon, p. 123.

102. "wisdom is only to be found": Halifax, pp. 65–66; Rasmussen (3), pp. 52–55.

102. "felt a loud unending scream": Heller, p. 107; see Stang, p. 90.

102. "burning hatred": Schneede, p. 52; see B. E. Lewis, pp. 21, 32–34, 237.

103. organizing themselves in their art: Wadeson, pp. 128–29, 177–78, 194; Winner, pp. 363, 375.

103. Munch, Van Gogh, de Chirico: Billig and Burton-Bradley, pp. 98–114.

103. more diffuse, liberal: Navratil.

103. arouses the same affectations: Thévoz, pp. 12–13.

103. Hsü Wei: Cahill (6), pp. 159–63; G. Ecke, p. 12; Lynn, pp. 333–35.

104. "He wore the ancient sages": Cahill (6), p. 161.

104. "the excitement of ink-and-paper": Cahill (6), p. 162.

104. Chu Ta: *Chu Ta*, "Introduction"; Contag, pp. 17–20; Li (5), vol. 1, pp. 212–13.

105. Another, later biography: Contag, p. 19.

105. "When his father died": Contag, p. 19.

105. "was at once ebullient": Contag, p. 18.

105. His birds: Sickman and Soper, pp. 353–54.

105. His poetry: see Wang Fang-yu, in Watt.

105. Baudelaire . . . ennui: Bersani, pp. 8, 11, 19, 28, 46, 104, 150.

105. "Surrealists . . . de Sade": Short, p. 69.

106. Spontaneity by means of chance: Janson (1), (2).

106. "dream-stones": Callois, pp. 47–53.

106. "shadow walls": Siren (1), col. 1, p. 216 (inc. note 2).

106. striations of gems: Callois, pp. 5ff.

106. Botticelli, Leonardo, Cozens: Gombrich (1), pp. 155–61; Janson (1); Richter (2), p. 85 (Leonardo).

107. "the sound of bells" Richter (2), p. 85.

107. "a great variety": Cozens, p. 25.

107. John Cage: Cage (2); see Tomkins (1), pp. 73–75, 114–15.

107. Robert Rauschenberg: Tomkins (1), pp. 218–19.

107. Dadaist's interest: Foster and Kuenzli; Short.

107. Yoruba folk tale: "Eshu and Death," in Courlander, pp. 75–77.

108. "a confusion of images": Fagg, Pemberton, and Holcombe, p. 58.

108. invisible . . . enormous . . . black-white: Fagg, Pemberton, and Holcombe, pp. 58–92; Pemberton, p. 25.

108. instinctual energy: Fagg, Pemberton, and Holcombe, pp. 58, 92; Pemberton, p. 26.

108. the "trickster" or "clown": Greenblatt; Highwater, pp. 38ff.; S. Thompson, pp. 319–28; Zahan, pp. 143–44, 156; see also Turner (1), (2).

108. "tricks people all the time": Evans-Pritchard (3), p. 29.
109. Azande sympathize: Evans-Pritchard (3), p. 29.
109. Coyote: Hultkranz (1), pp. 34–37; S. Thompson, pp. 319–28.
109. Winnebago's trickster: Radin (3).
109. "It is true that": Radin (3), p. 147.
109. Native North American clowns: Highwater.
109. Pueblo clowns: Highwater, p. 49.
109. Kwakiutl clowns, Navajo clowns, Dakota (Sioux) clowns: Highwater, pp. 46–48.
109. They are Hermes, Loki: Highwater, pp. 48–49; Radin (3).
110. Rituals of cruelty: Goldberg, pp. 106–7.
110. Nam June Paik, Charlotte Moorman: Nyman, pp. 72–73.
110. "charged the word": Ades, p. 116.
110. "I think ambiguity": reference lost.
110. "I am for an art": Johnson, pp. 16–17.
111. In the Gilbert Islands: Trask, vol. 2, p. 28.
111. calls the flowery songs: Trask, vol. 2, p. 281.
111. power-giving inspiration: Hultkranz (1), pp. 75–77; Pettitt, ch. 8.
111. Eskimo poet: Finnegan (1), pp. 81–82.
111. Stockhausen: Cott, p. 25.
111. "I recognize": Rasmussen (4), p. 518; Trask, vol. 1, p. 16.
111–12. *Exposition on Literature (Wen Fu):* Liu (1), p. 73.
112. "Even though this matter": Liu (1), p. 73.

CHAPTER FOUR. Selfless Tradition

114. pejorative associations: Hatch (on relativity of values in American anthropology); R. Wilson (on the rationality of "primitives.")
115. dilemma tales: Bascom (1).
115. Rasmussen . . . Eskimo shamans: e.g., the ideas of the shaman Aua, in Halifax, pp. 114–15, 156–66, from Rasmussen's *Intellectual Culture of the Iglulik Eskimos,* pp. 54–56.
115. "my poem is I-white": "Poem of Alienation," in Moore and Beier, p. 34.
115. "of the possibilities of purely logical deduction": Hallpike, p. 487.
115. "There is no evidence": Hallpike, p. 488.
115. well adapted: Hallpike, p. 489.
115. capable of profundity: Hallpike, p. 491.
115. cannot . . . make out: Wober, pp. 80ff.
115. contrary reports: Jahoda and McGurk, pp. 77–78, 84.
116. "is still in a delicate": Wober, p. 184.
117. Australian "Aborigines": Elkin.

117. the first study: Lee and Devore; see also Konner; R. B. Lee.

117. an anthropologist reports: Ebert.

117. !Kung ability to think: Ione and Konner.

118. "Just as primitive life": Ione and Konner, p. 348.

118. or were recently: R. B. Lee, pp. 147–50; Yellen.

118. "The Dogon who participated": Parin, Morgenthaler, and Parin-Matthey, pp. 464–65.

119. "traditionalism": Needleman.

120. the word by which . . . Ptah: J. A. Wilson, pp. 57–59.

120. Jehovah: Jacob, pp. 127–35; Efros p. 69; Wolfson, pp. 85–93 (on Jewish opposition to a literal view).

120. the *bhuh* by which: Satapatha Brahmana 11.1.6.3. On Speech or Holy Utterance (Vac), see Rig Veda 10.71, 10.125; Ataharva Veda 4.1; and Brihad-aranyaka Upanishad 4.1.2; Gonda (1), pp. 26ff., 182.

120. Syllable, Name, Speech, and Formulation: Gonda (2).

120. Speech . . . says of herself: Rig Veda 10.125.

120. a philosophy of grammar: Sastri, chs. 1, 2.

120. vocal music . . . instrumental music: Bake, pp. 166–69.

120. Among the Navaho: Reichard, p. 288.

120. "There will be no others": Reichard, p. 289.

120. symbolic relations of words: Calame-Griaule, pp. 28, 29, 81.

120. "he who knows the word": Calame-Griaule, p. 26.

120. impregnates self . . . : Calame-Griaule, p. 28.

121. Confucius himself: *Analects* 17.20.1, 8.8, 7.14, 3.25, 7.13, 3.23.

121. reflect human emotions directly: *Book of Rites (Li Chi)*, as in Confucius (3), p. 263.

121. the *ch'in:* Van Gulik (2), (3).

121. The favorite instrument: Bake, pp. 196–99; Van Gulik (3), pp. 41ff.

121. Taoist and Buddhist monks: Bake, pp. 196–99; Van Gulik (3), p. 49.

121. twenty-six kinds of vibrato: Van Gulik (3), p. 41.

121. "The movement of the fingers": Van Gulik (3), pp. 108–9.

122. depend upon a researcher: Chernoff.

122. those who become master drummers: Chernoff, p. 56.

122. the familiarity of the music: Chernoff, pp. 126–27.

122. "When you make some music": Chernoff, p. 61.

122. "As you are beating": Chernoff, pp. 106–7.

122. slight but significant variation: Chernoff, p. 161.

122. His hands guided: Chernoff, pp. 126–27.

122. Building in India: Auboyer (2), pp. 34ff.; T. Bhattacharyya; Rajan.

122. The very earth: Auboyer (2), pp. 34–36; T. Bhattacharyya, ch. 21.

123. the earthly equivalent of . . . Vishvakarma: Auboyer (2), p. 46.

123. "the master will be crippled": Bose, pp. 639–40.

123. Holy images . . . rules: Rao, pp. 36ff.

123. "sharp definition of the muscles": Rao, p. 43.

123. some latitude: Auboyer (2), p. 49.

123. actual measurement: but Banarjea (1), pp. 332–33, speaking of images, says that often the approximation with theory was quite close.

123. Vitruvius: Vitruvius.

123. ruins of every Greek temple: Coulton, pp. 65ff. Explained by Haselberger, p. 118.

124. "Since nature has designed": Vitruvius, p. 73 (bk. 3, ch. 1).

124. Renaissance architects: Norberg-Schulz, pp. 88–91; Wittkower (1).

124. system of Le Corbusier: Norberg-Schulz, p. 92.

124. the sculptural canon has been shown: Iverson, pp. 56–57; Ridgway, pp. 29ff; but see Boardman (2), pp. 18ff.

124. "perfection through many numbers": Pollitt (1), p. 89.

124. "for he did not believe": Cicero, *De Inventione* 2.1.1., in Pollitt (2), p. 156.

125. "ephebism": Kidson, p. 147.

125. representation of the pharaoh: Aldred (2), pp. 69–70.

125. no old age and relatively little disease: Ray, p. 175.

125. Yoruba sculpture: Fagg, Pemberton, and Holcombe; R. F. Thompson (1), (2), (4).

125. Yoruba ephebism: R. F. Thompson (4), pp. 56–59.

126. Shiningly, but not excessively: R. F. Thompson (4), pp. 37–38.

126. the Bassa: R. F. Thompson (2), p. 26.

126. Among the Dan and Kran: Fischer and Himmelheber; Himmelheber (1), (2).

127. "Give me your skill": Himmelheber (2), pp. 85–86.

127. the Senufo: Himmelheber (2), pp. 87–88.

127. In India . . . a craftsman: Coomaraswamy (1), (3); Kramrisch (2); Randhwa (1), p. 116.

127. life-encompassing guilds: Kramrisch (2), p. 20; Majumdar, ch. 1.

127. temple in Konarek: Boner and Sarma, with Das: pp. xli–xliii; Michell, pp. 55–57.

127. In China . . . guilds: Burgess; Sprenkel, pp. 92–96.

128. Japanese craft-guilds: Shimuzu; Takeda, pp. 11–14.

128. In ancient Greece: Burford, ch. 3.

128. In the Middle Ages: Gimpel (1), ch. 5.

128. masterpieces: Cahn.

128. "The candidate shall make": Baxendall, p. 123.

129. the Elema, individual freedom: F. E. Williams (1), pp. 52, 84, 91.

129. "His desire": F. E. Williams (1), p. 52.

129. A seven-year cycle: F. E. Williams (1), pp. 190ff.

129. "tall fantastic figure": F. E. Williams (2), pp. 356–57.

129. "the fashion of our ancestors": F. E. Williams (2), p. 418.

129. the Sigui: Attenborough; Griaule; Griaule and Dieterlin (1), (2).

130. first, primal disobedience: Griaule, pp. 62–63, 147ff.

130. a kind of regional government: Griaule.

130. Yet some woman-masks . . . clever and elegant: Griaule, p. 10.

130. Yoruba . . . constantly dynamic: Fagg, Pemberton, and Holcombe, p. 52.

130. Among the Mano of Liberia: Harley.

130. walk into a turbulent session: Harley, p. 13; see also Brain (1), pp. 149–53.

131. the Rainbow Snake: Charlesworth et al., pp. 31–55, 94–96, 286–88; Eliade, pp. 76–80, 113–16, 154–56; Hiatt (1), pp. 37–50; Poignant, pp. 124–27; Strehlow, pp. 44–45 (on dreamtime); Stubbs, pp. 60–62.

131. vitality of design . . . vitality of song: Munn, pp. 32–44.

132. As late as 1974: Stubbs, p. 62.

132. go back some twenty thousand years: judgment of George Chalpouka, of the Darwin Museum in Australia.

132. ceremonial music . . . oldest: Jones, p. 118.

132. Shiva: Dimmitt and van Buitenen, pp. 148ff.; Kramrisch (1); Sivaramamurti (3).

132. Nataraja, King of the Dance: Banarjea (1), pp. 470ff.; Dimmitt and van Buitenen, p. 73; Sivaramamurti (3), pp. 3, 7, 14.

132. In theological schematism: Banarjea (1), (2); Kramrisch (1), p. 439; Sivaramamurti (3), pp. 23–24.

132. great traditional performances: Dimmitt and van Buitenen, pp. 173ff.; Kramrisch (1), pp. 439–40; Sivaramamurti (3).

132. the Shiva-doctrine of Kashmir: Sivaramamurti (3), pp. 37–38; and see last chapter here, on Abhinavagupta.

132. circle of flames: Sivaramamurti (3), p. 30.

133. "who conceived and fashioned": Sivaramamurti (3), p. 161.

133. the old tree: Barnhart (1); Clapp, p. 67; Lin-ts'an Li.

133. Chuang Tzu: Barnhart (1), p. 9; Watson (3), pp. 29–30, 61–62.

133. Confucian poet . . . Ch'an poet: Barnhart (1), pp. 9–10.

133. At first . . . pine and rock: Lin-ts'an Li, pp. 1–4; Barnhart (1), pp. 10ff.

133. later often of the wintry tree: Lin-ts'an Li, pp. 4–7.

133. old tree with bamboo and rock: Lin-ts'an Li, pp. 7–10.

133. recalled Confucius's statement: *Analects* 9.27; Barnhart (1), p. 15.

133. In Chinese poetry: Barnhart (1), p. 16.

134. Shen Chou and Wen Cheng-ming: Barnhart (1), pp. 23–27; Cahill (6); Clapp, ch. 7; Edwards (1), pp. 119–23, 166–67.

134. somewhat deprecating comment: Cahill (6), p. 259, note 17, which speaks of "the much overpraised scroll in the Honolulu Academy of Art."

134. "Their branches sweep": Barnhart (1), p. 25; Edwards (1), p. 187.

134. Apollo-figures: Boardman (2), pp. 22ff.; Clark (1); Ridgway, ch. 3; Seymour, pp. 4ff.

135. pederasty: Marrou, ch. 3; Walters, pp. 37–57.

135. Christian, Neoplatonic tinge: Chastel, pp. 278ff.

135. "The philosophic love for boys": Chastel, pp. 289ff.; Walters, pp. 112ff.; Wittkower and Wittkower, pp. 169–75.

135. Apollo Belvedere: Honour (2), p. 60.

135. "penetrate into the kingdom": Honour (2), pp. 15 (quoted), 117.

136. To Confucius: *Analects* 307.25.2.

136. To orthodox Confucians: Holzman (1); Owen (1), pp. 3–7; Shih, pp. xxxiv, xl, 21.

136. not always acceptable to poets: Owen (1), ch. 2; Shih, p. xliii.

136. an elegant diversion: Owen (1), pp. 6–7.

136. "decadence" and "lasciviousness": Owen (1), ch. 2.

136. "As times grew remote": Owen (1), p. 15.

137. Carpenters, he said: Liu (1), pp. 91–92.

137. "But if I take": Liu (1), pp. 91–92.

137. Japanese literature felt: Brouwer and Miner, pp. 23, 286–87, 291.

137. "perfects the civilized teaching": Acker (2), p. 61.

137. to warn against evil: Acker (1), p. 74.

137. Chao Meng-fu: Bush (1), pp. 121–24; Cahill (4), pp. 38–46; Chu-tsing Li (1), (4); Lin Yutang, pp. 107–110; Siren (2), pp. 109–10.

137. written on one of his paintings: Chu-tsing Li (1), p. 76.

138. "they quite ignore": Chu-tsing Li (1), p. 76 (diff. trans.).

138. Tung Ch'i-ch'ang: Cahill (1), (5); Fong (3); Pang; Siren (2); Wu (2).

138. "the soul and life," "Willow trees": Siren (2), p. 143.

138. inner logic *(fa):* Ho, p. 119.

138. The Yüan brothers: Ho, p. 124.

138. "the painter who controls": Ho, p. 122.

138. "If one thinks": Fong, in Fong et al., p. 167.

138. A recent historian has argued: Cahill (1), pp. 37–38.

139. forceful rather than beautiful: Ho, p. 44.

139. He constructs his landscapes: Cahill (5), Ho.

139. "dragon veins": Bush (2); Siren (2), pp. 204–5; Whitfield, pp. 185–86.

139. Individual brushstrokes: Cahill (5), p. 176.

139. Tung integrates: Cahill (5), p. 176.
139. Mi Fu or Mi Fei: Ledderose (1).
139. sophistication of forgers: Fong (4); Ledderose (1), p. 38.
139. taken for originals: Ledderose (1), pp. 58–60.
139. a partial creation: Ledderose (1), pp. 92–94.
139. Muhammed ibn Muqlah: Khatibi and Sijelmassi, p. 132.
140. Ch'en Hung-shou: Fong (2), pp. 101ff.
140. "schematic archaism": Fong (2), p. 105.
140. collecting: Van Gulik (1), pp. 29ff.
140. he warns of the calamity: Van Gulik (1), p. 478.
140. "I have come to look": Van Gulik (1), p. 478.
140. "If one does not do": Van Gulik (1), p. 47.
140. "Among all those outer things": Van Gulik (1), pp. 47–48.
141. The classicism of Greece: Pfeiffer (1), Grube; Russell and Winterbottom.
141. "presented to us": Longinus, in Russell and Winterbottom, pp. 475–76.
141. Greeks and Romans adopted: Pfeiffer (1); Grube; Russell and Winterbottom.
141. in the early Renaissance: Burke (1), Pfeiffer (2).
141. European classicism: Pfeiffer (2), Bolgar.
141. Belvedere of the Vatican: Haskell and Penny.
142. his oration: Panofsky (1).
142. "Since the Sculptors of Antiquity": Panofsky (1), p. 171.
142. Winckelmann: Pfeiffer (2), pp. 168ff.
142. Mengs spelled out: Eitner, pp. 30–32.
142. "become possessed of the idea": Discourse 3, in Eitner, p. 39.
142. "By a careful study": Eitner, p. 39.
143. "exemplars of humanity": Discourse 3, in Eitner, p. 39.
143. Roger de Piles graded: J. Rosenberg, pp. 34–47.
143. French Academy: Blunt; Boime (1), pp. 3–15.
143. Ecole des Beaux-Arts: Blunt, pp. 344ff.; Boime (1), pp. 15ff.
144. much copying: Boime (1), pp. 42–43.
144. among them Delacroix: Boime (1), pp. 42–43, 122–23.
144. "It shows the method": Boime (1), p. 94.
144. "Go to the old masters" Boime (1), p. 124.
145. Ruskin made his point: Hewison, pp. 134–38; J. D. Rosenberg, pp. 182–96; see (in criticism) Pye, pp. 47–56.
145. "No human face": J. D. Rosenberg, p. 184.
145. Arts and Crafts movement: Lucie-Smith (2).
145. Bernard Leach and . . . Shoji Hamada: B. Leach.
145. He refused to sign: B. Leach, p. 20.
146. "provided that humility": B. Leach, p. 21.

146. Perfection's very smoothness: B. Leach, pp. 21ff.
146. Soetsu Yanagi: Yanagi.
146. admiration for the Sung ware: Yanagi, pp. 132–35.
146. "sold materials": quotation unidentified.
146. identified with and born of use: Yanagi, p. 197.
146. true, humble craftsman: Yanagi, pp. 197–202.
147. Ananda Coomaraswamy: Lipsey.
147. *Medieval Ceylonese Art:* Coomaraswamy (3).
147. a man in bondage to love: Lipsey, pp. 144ff.
147. "His martial career": Lipsey, p. 286.
148. half-mythical reading: e.g., Coomaraswamy (4).
148. René Guenon: Lipsey, pp. 168ff.
148. Etienne Gilson: Lipsey, p. 172.
148. "I have nothing new": Lipsey, p. 189.
148. "Indian, Egyptian": Lipsey, p. 268.
148. "as long as the tradition": Lipsey, p. 189.
148. the formal element: Coomaraswamy (5), pp. 5–6.
149. a complete self-identification: Coomaraswamy (2); Zimmer, pp. 318–21.
149. "He who would paint a figure": *Convivo,* canzone 3.53–54, in Coomaraswamy (2), p. 9.
149. "of sentient activity: Coomaraswamy (5), p. 17.
149. "heaven and earth are united": Coomaraswamy (2), p. 57.

CHAPTER FIVE. Egocentric Intruders

150. Zuni Indians will be seen: refers to criticisms of Ruth Benedict's *Patterns of Culture,* 1934.
150. Ch'an monk will break off: Welch, esp. pp. 55, 62, 71, 80–88.
151. high in ancient Egypt . . . : for Egypt: Aldred (1), pp. 56, 63; Junker; Kees, pp. 154, 255, 258, 262, 264, 300; W. S. Smith, pp. 226, 228, 297, 299. For India: Dhavalikar, pp. 101–2; for medieval Europe: Gimpel (1), pp. 116–20; Grodecki, pp. 31–32; Harvey; Kraus, p. 200. For Islam: Lewcock, pp. 129–33.
151. "crazy": Frodsham and Hsi, pp. xxvii–xxviii; Holzman (2), pp. 73, 88, 135–36.
151. Shih Chung: Barnhart (2); Cahill (6), pp. 139–53.
151. "who rode around": Barnhart (2), p. 371.
152. bow . . . sword: e.g., Kammer; Suzuki, chs. 4–6.
152. individuality of king's will: Seidel and Wildung, p. 241.
152. Akhenaten: Aldred (1), Redford.
152. evidences of freedom: Assman, pp. 304–7.
152. Bek: Aldred (1), p. 53.

152. new will to distort; Vandersleyen, p. 311.

152. figures' hands: Aldred (1), p. 53.

152. childlike way: Aldred (1), p. 76.

152. breaks through in gestures: Aldred (1), p. 79.

153. "Egyptian art, which seems": Vandersleyen, p. 94.

153. Greek potter . . . : Boardman (1), (2); Burford.

153. individualistic enough: Boardman (1), pp. 12–13, (2); Burford, pp. 202–13.

153. the fourth century: Burford, pp. 203–4; Onians, p. 41; Pollitt (1), pp. 27ff.

153. "Easier to criticize": Burford, pp. 213–14, 212; Pollitt (2), pp. 155, 112, 212–13.

153. "If any man say": Burford, pp. 212–13.

153. "the limits of art": Burford, pp. 212–13; Pollitt (2), p. 160.

153. fell in love: Onians, p. 37; Pollitt (2), pp. 130, 131.

153. compare sculptor's or painter's: Tatarkiewicz, pp. 104–7.

154. Nero and Hadrian, Severus Alexander: J. S. Scott.

154. French . . . unlike Italian: Alsop, pp. 269–70.

154. illuminators of French . . . Spanish: Alsop, pp. 269–70.

154. thousands of medieval artist-artisans: Gimpel (1), p. 185; Kraus; Wittkower (3); Wittkower and Wittkower, pp. 22–23.

154. "How worthy you are": Kraus, p. 185.

154. "God has created": Kraus, p. 185.

154. "prince of scribes": Gimpel (1), p. 110.

154. "In order to avoid": Kraus, p. 187.

154. Painting was ennobled: Papadopoulo, pp. 25–26, 197–98.

155. "theory of the two pens": Minorsky, p. 23.

155. "oh my heart!" Minorsky, p. 111.

155. Sadiqi Bek: A. Welch, pp. 41, 143ff.

155. Hasan Baghdadi: A. Welch, p. 200.

155. "ill-tempered, peevish": A. Welch, p. 200.

155. he was disagreeable: A. Welch, pp. 56–57.

156. still unclear position: Burke (2), p. 85; Martines, pp. 241–46; Wittkower and Wittkower.

156. Masaccio, Gherardi, Bartolomeo: Wittkower and Wittkower, pp. 54–55.

156. Pontormo: Wittkower and Wittkower, pp. 69–70.

157. "like swine": Wittkower and Wittkower, p. 71.

157. Michelangelo: Clements, p. 181; Summers, pp. 34–35, 235ff; and see Michelangelo's sonnets.

157. Titian, Mantegna . . . Raphael: Wittkower and Wittkower, pp. 257–8, 263–70, 91.

157. Bernini: Wittkower and Wittkower, pp. 270–73.

157. Rubens: Baudouin, ch. 15; Warnke, pp. 24–28; Wittkower and Witt-kower, pp. 273–77.

157. members of aristocratic households: Haskell (1), pp. 5, 19–20.

157. artists' self-portraits: Haskell (1), p. 19.

157. Salvator Rosa: Haskell (1), pp. 21–23.

157. "I do not paint": Haskell (1), p. 22.

157. *genius:* art. "Génie" in Ritter, vol. 3, pp. 282–83; Tonelli; Wittkower (2).

157–8. "extravagance," "enthusiasm": art. "Génie" in Diderot; A. M. Wilson, pp. 528–33.

158. "meddling ape imitation": Wittkower (2), p. 306.

158. "genius sometimes owed": Wittkower (2), p. 307.

158. "original genius": William Duff, in Wittkower (2), p. 158.

158. "Did ever any good painter": John Pinkerton, in Wittkower (2), p. 306.

158. Blake: Eaves, pp. 107–109; Wittkower (2), p. 306.

158. Byron: Schenk, p. 148.

158. "Only those things": I. Jenkins, pp. 202–3.

159. "pure talk": e.g., Yu-lan Fung, chs. 19, 20, esp. pp. 231ff.

159. Mallarmé: Goldwater (3), pp. 116–17.

159. "I renounce all": Honour (3), p. 245.

159. "The only thing": Nochlin, p. 152.

159. "I would call a born artist": Nochlin, p. 146.

159. Benozzo Gozzoli: Sleptzoff, p. 130.

159–60. Lorenzo Ghiberti: Sleptzoff, pp. 108–9.

160. Romantic artists: Sleptzoff, pp. 247–49.

160. Liszt: Gill, p. 116; Lebrecht, p. 146.

160. on dreams and on irrationality: Milner, pp. 78–81, 118–19, 149–56; Goldwater (3), ch. 3.

160. Nodier urged poets: Milner, pp. 15–55.

160. "it is certain that sleep": Milner, p. 151.

160. Plato: e.g., *Phaedrus* 245a.

160. attributed to Aristotle: *Problemata* 30.1, quoted in Panofsky (2), p. 165; see B. Simon, pp. 228–31; and see Russell and Winterbottom, pp. 75, 287.

161. Marsilio Ficino: Panofsky (2), p. 165.

161. "melancholic behavior": Panofsky (2), p. 166.

161. Victor Hugo: Milner, p. 151.

161. Gérard de Nerval: Milner, p. 152.

161. Balzac: Milner, p. 152.

161. Hamlet became a symbol: Honour (3), p. 275.

161. "It is through this layer": Honour (3), p. 275.

162. Lange-Eichbaum: Lange-Eichbaum.

163. Strindberg: Sandbach.

163. "write the misery out": Sandbach, pp. 89–90.
163. Li Ho: Frodsham, "Introduction."
164. "My whole heart is sad": Frodsham, p. xxii.
164. "weird," Frodsham, p. xxxviii.
165. artist-hero: Kris and Kurz.
165. as Freud put it: *Introductory Lectures on Psychoanalysis,* conclusion of lecture 23.
165. as free as possible of repressions: Fine, pp. 267–73, 304–5.
165. intensely close to himself: Kohut (1), pp. 2–21, 27–28, 309–10, 316.
167. As one of them said: Getzels and Cziks'entmihalyi, p. 20.
167. Another said: Getzels and Cziksfentmihalyi, p. 20.
167. "withdrawn, introspective": Getzels and Csikszentmihalyi, pp. 38–39.
167. not because . . . dissipation: Getzels and Csikszentmihalyi, p. 216.
167. rebellion, loneliness: Getzels and Csikszentmihalyi, p. 223.
167. narcissistic: Getzels and Csikszentmihalyi, p. 154.
167. substitution for childhood play: Getzels and Csikszentmihalyi, p. 238.
167. "most artists feel alienated": Getzels and Csikszentmihalyi, p. 197.
167. "hideously ritualistic": Getzels and Csikszentmihalyi, p. 197.
170. *Record of All Famous Painters:* Acker (2). See also Bush and Hsio-yen Shih.
170. "being of the same substance": Acker (2), p. 61.
170. "the hand does not stiffen": Acker (2), p. 183.
170. draw it into his work: Soper (1), p. 15.
170. follow the sequence: Ledderose (1), pp. 28–29; page 30, note 92.
171. by the eleventh century: Soper (1), p. 19.
171. On a friend's wall: Lin Yutang, p. 92.
171. "To judge a painting": Lin Yutang, p. 92; Bush and Hsio-yen Shih, p. 224.
171. "wrinkles," *ts'un:* Whitfield, p. 20; Chu-tsing Li (1).
171. Some of their principles: see, e.g., Lee and Ho, pp. 51–52.
173. amateurs: Cahill (2), pp. 32–33.
173. prouder kind of family: Cahill (2), p. 175.
173. ordinary amateurishness: Cahill (2), pp. 262–66.
173. The more fastidious: Cahill (8), "Introduction," pp. 22–23; Cahill (6), pp. 87–88.
173. "ghost painters": Cahill (6), p. 217.
173. Ironically: Cahill (6), p. 217.
173. Ni Tsan: Cahill (4), pp. 114–20; Dolby; Fong et al., pp. 105–29.
173. "In the old days": Dolby, p. 429.
174. lived among indulgences: Fong et al., pp. 105–6.
174. compulsive cleanliness: Dolby; Fong et al., p. 106.
174. when he was about forty: Fong et al., pp. 107–8.

174. enhance the status of their owners: Cahill (4), p. 116.
174. "remnants of mountains": Cahill (4), p. 119.
174. why there were no people: Cahill (4), p. 118.
174. "I have never been a painting teacher": Dolby, p. 431.
174. expression of his freedom: Dolby, p. 86.
174. why should anyone argue: Dolby, p. 86.
174. "Even I would not be able to insist": Dolby, p. 86; see Lin Yutang, p. 112;
Siren (2), p. 111.
175. Kung Hsien: Cahill (3), (4); Kuntze: "Kung Hsien . . . "; Lippe; Wu.
175. Limiting himself: Lippe, p. 23.
175. he dreaded people: "Kung Hsien . . . ," p. 14; Lippe, p. 23.
175. "Even in my old Age": "Kung Hsien . . . ," p. 9.
175. At first, Kung accepted: "Kung Hsien ," p. 19.
175. Critical of the artistic dullness: "Kung Hsien . . . ," pp. 23–24.
175. seven varying layers: Wu, p. 74.
175. his sketchbooks: Wu.
175. "He spits out his heart": Lippe, p. 23.
176. "There has been nobody": Lippe, p. 23.
176. Tao-chi: Cahill (1), ch. 6; Contag, pp. 20–25; Edwards (3); Fong (3); Fu
and Fu; Spence.
176. "Being by nature lazy": Fong (3), p. 29.
176. wrote on an album leaf: Fu and Fu, p. 38.
176. only because he needed the money: Fu and Fu, p. 38.
176. Complaining: Fu and Fu, p. 38.
176. as eminent a calligrapher: Fu and Fu, pp. 40–45.
177. for him . . . no style: see following ch.
177. "Following the rules": Edwards (3), p. 37.
177. goes the criticism: Cahill (1), pp. 219–25.
177. India: Sivaramamurti (1), (2), (4), (5); Taranatha, pp. 347–49, 445–47.
177. "This is carved": J. G. Williams, p. 68.
177. "Smiter": Sivaramamurti (4), p. 21.
177. "Champion": Sivaramamurti (4), p. 21.
177. announcement of the arrival: Sivaramamurti (4), p. 14.
177. "a tiger": Sivaramamurti (4), p. 6; (2), p. 5.
177. King Bhoja: Sivaramamurti (4), p. 7.
177. King Someshvara: Sivaramamurti (2), p. 6; (4), p. 7.
178. In Tibet: Olschak and Wangyal, pp. 11, 41–43; Sivaramamurti (2).
178. an act of devotion: Tucci, p. 111.
178. Tödrup-gyatso: Tucci, p. 111.
178. "mad" bards: Stein, p. 153.
178. Kangra court: Randhwa (2), esp. pp. 22–23.

178. Bana, Dandin, Puspadanta: Warder, pp. 208–13.
178. Abhinanda: Ingalls, p. 443, no. 1714.
179. Dharmakirti complained: Ingalls, pp. 444–45, no. 1726.
179. "those who scorn me": Ingalls, p. 445, no. 1731.
179. "How now": Ingalls, p. 445, no. 1729.
179. numinous experience: Christie, esp. pp. 58–60; Masson and Patwardhan, p. xii.
179. "becomes as if possessed": Masson and Patwardhan, p. xii.
180. the Songman: Elkin, pp. 267–68, 271.
180. the *arioi:* Piddington, ch. 4, esp. pp. 121–30.
180. woodcarver of the Asmat: Anderson, p. 91; Gerbrands, pp. 21–23; Layton, pp. 199–202.
180. the investigator . . . witches: D. Ben-Amos, in El-Hamy.
180. the Bala: Merriam (1).
181. role as weak: Merriam (1), pp. 266–72.
181. The Tiv: Keil.
181. composers . . . are slow moving: Keil, pp. 101–2.
181. "their minds are always working": Keil, p. 119.
181. women just leave their homes: Keil, p. 134.
181. "Now," he said: Keil, p. 134.
181. "If he can convert": Keil, p. 146.
181. "first carver": Nunley.
181. "a remarkable fact": Nunley, p. 70.
182. Among the Bangwa: Brain (1).
182. Atem: Brain (1), p. 266.
182. "If anyone calls here": Himmelheber (1), (2); quote (2), p. 96.
182. "I am called Zra": Himmelheber (1), pp. 171–76; (2) (in English), pp. 96–97.
182. "From what I earned": Himmelheber (2), p. 97; (1), p. 175.
182. Tompieme: Himmelheber (2), pp. 100–5.
182. and the following night: Himmelheber (2), p. 103.
182. "I do not carve": Himmelheber (2), p. 105.
183. the Gola: d'Azevedo (1), (2).
183. wanted to become known: d'Azevedo (1), pp. 134–36.
183. distrusted: d'Azevedo (1), pp. 136, 142; (2), pp. 290–91.
183. tutelary spirits: d'Azevedo (1), pp. 136–39, 143–44; (2), pp. 291–96, 298.
183. against . . . their families: d'Azevedo (1), pp. 141–42; (2), p. 323.
183. One carver reported: d'Azevedo (1), p. 142.
183. Their urge to carve: d'Azevedo (1), p. 142.
183. "the theme of misunderstanding": d'Azevedo (1), p. 143.

183. "As the child of society": d'Azevedo (2), p. 337.
184. the mbari: Cole.
184. "the person of skill": Cole, p. 77.
184. "No man admits": Cole, p. 79.
184. "The thing that spurs me on": Cole, p. 79.

CHAPTER SIX. The Esthetic Universal

191. "great synthesis": Cahill (2), p. 119.
191. as distant from their originals: Cahill (1), pp. 49–53, and esp. 63–64.
191. "the verse of all tongues": Wellek, p. 197; see also Whitman's poem "Old Chants."
192. Influence . . . of European on Chinese art: Sullivan (2), pp. 46–89; Hsiang Ta.
192. Tseng Ching: Cahill (1), pp. 116–20; Cahill (2), pp. 213–14; Hsiang Ta, p. 165.
192. "would glare": Cahill (1), p. 116; Cahill (2), p. 213; Hsiang Ta, p. 164.
192. adding "tens" of washes: Hsiang Ta, p. 164.
192. many followers: Hsiang Ta, pp. 165–66.
193. "The Western method": Hsiang Ta, p. 167.
193. Men Ying-chao: Hsiang Ta, p. 171.
193. Guiseppe Castiglione: Beurdeley and Beurdeley.
193. Wu Li: Beurdeley, p. 147; Hsiang Ta, pp. 172–75 (p. 175 quoted).
193. "a great deal to teach": Beurdeley and Beurdeley, p. 148.
194. "he never followed old models": Cahill (1), p. 94.
194. The angles . . . ; Cahill (1), pp. 75–77; (2), pp. 176–77.
194. Kung Hsien: Cahill (3); Woodson.
194. Chang Hung: Cahill (2), pp. 39–59.
194. wear a driftwood rosary: Okamoto, p. 77.
194. Shiba Kokan: French; Kawakita, pp. 14–25.
194. "If pictures do not portray": French, p. 3.
195. Although in the end: French, pp. 158–59.
195. Maruyama Okyo: Hillier, pp. 15–33; Kawakita, pp. 25–27.
195. observing the living things: Hillier, pp. 19–20.
195. "the bone structures": Kawakita, p. 27.
195. "as different as front": Kawakita, p. 29.
196. "life and death in everything": Kawakita, p. 29.
196. conscious esthetic terms: e.g., Willett (1), pp. 208–22.
196. studied certain African languages; Leiris and Delange, pp. 40–45; Maquet (1).
196. Yoruba "coolness": Thompson (1), pp. 43–45; Willett (1), pp. 212–15.

196. Gola: Willett (1), p. 215.
196. Dan: Willett (1), p. 211.
196. Ashanti: McLeod, p. 178.
196. "Long necks": Cole, p. 180.
196. "Nobody will try": Cole, p. 180.
196. judgment coincide.: Anderson, pp. 197–99; Child, pp. 882–85. Cole, p. 171; Fagg (2), pp. 156–60; Willett (1), pp. 215–20.
196. Elderly BaKwele: Child, p. 885; Willett (1), pp. 216–17.
196. Aborigines disagree, West Africans and Englishmen: Child, p. 83.
197. Yirrkala: N. Williams.
197. Twentieth-century Haidas: Macnair, Hoover, and Neary.
197. Eskimos of the Canadian Arctic: Swinton; Graburn (1).
197. Edmund Carpenter: E. Carpenter (2), (3), and elsewhere; Graburn (1), p. 55.
197. Suzanne Wenger: Beier (2). Colin McPhee: McPhee; Griffiths, p. 37; Roth, pp. 934–35; on Eastern influence generally, see Griffiths, pp. 196–200, and Berendt, pp. 343–53 (on percussion instruments in jazz).
197. John Cage: Griffiths, pp. 37, 67–69.
197. Lou Harrison: Machlis, pp. 554–55.
197. Steve Reich: Griffiths, pp. 177–78.
198. "Afro-jazz" and West African "highlife": Myers (1), pp. 35–38.
198. sensitive outsider: Weber.
199. not good by European standards: Hsiang Ta, p. 176.
199. Ashanti man with both hands: McLeod, p. 18.
199. Yoruba mask: R. F. Thompson, in J. Fry, p. 64.
199. the magic: see account in ch. 3.
200. pancultural expressiveness: Maquet (2).
200. extraordinary loquacity: L. Marshall, p. 351.
200. "volcanic eruptions of sound": L. Marshall, p. 354.
201. Bambara or Dogon: Zahan, pp. 113–14.
201. "speech without a path": Zahan, pp. 113–14.
201. "They were taught": Astrow, p. 39.
202. *Herdboy with Bamboo and Rock:* Chaves (1).
202. "Su T'ung-p'o painted": Chaves (1), p. 86.
203. "He has loved": Condivi, p. 105.
203. "He carved it": Hartt, p. 13.
203. not . . . one he could give a body to: Liebert, pp. 40, 93.
203. *Rondanini Pietà:* Liebert, p. 412.
203. "Let me be": Pope-Hennessy (2), p. 113.
204. "I, Vincent": Wylie and Valenstein, p. 104 (a formulation of the authors, not of Van Gogh himself).

204. "The worse I get along": Lubin, p. 9.
204. "complete each other": Lubin, p. 11.
204. "How rich in beauty": Lubin, p. 252, note 15.
204. Even if it were true: letter, The Hague, 2nd half of July, 1882.
204. "I was always alone": Dube-Heyning, p. 15.
205. "What perfect bliss!": Chang, p. 8.
205. could "draw upon": Chang, p. 8.
205. "Even when circumstances": Chang, p. 8.
205. Tao-chi's thought: Coleman; reviewed by Tong; also see Cahill (1), pp. 187ff., 215–19.
205. "To have method": Shih-tao, ch. 3, in Coleman, p. 48.
206. "There is one single thread": *Analects* 4.15, from Confucius (1).
206. "A single stroke": Shih-tao, ch. 1, in Coleman pp. 115–16; see Ryckmans, pp. 14–18.
206. "nonbeing": *Tao Te Ching*, ch. 40.
207. Mozart to his father: letter of May 2, 1778, in Hildesheimer, p. 91.
207. "walking by the side": Stang, p. 23.
207. "All in all": Stang, p. 15.
207. "Whether the picture resembles": Stang, p. 15.
207. "incomparable joy": Urban, p. 29.
207. "When I am painting": Urban, p. 30.
207. "Human beings are: letter of Oct. 9, 1926, in Urban, p. 34.
208. "Sickness and age": Simpson, p. 307, quoting Williams's "I Wanted to Write a Poem."
208. "Redeem us": Schorske, p. 363.
209. Hume and the others: Gilbert and Kuhn, pp. 235, 244ff.
209. Stravinsky on inspiration: Stravinsky, pp. 50–53.
209. oscillation: see, e.g., Buschor.
210. Africa, portrait sculpture: Himmelheber (1), pp. 46–48.
210. the Onis: Eyo and Willett, e.g., plates 39, 76, 92.
210. Bangwa chiefs; Brain (1), p. 134.
210. northwest coast: Holm, p. 11; King.
210. an old replica: King, p. 44, illus. 34.
210. portrait bust: King, p. 23, illus. 14.
210–11. single death mask, masks found: Aldred (1), pp. 43–47, 180; (2), pp. 69–70.
211. evidence from India: Sivaramamurti (4), 15–16, 18.
211. *trompe-l'oeil* fly: Alsop, pp. 233–34.
211. Li Kan loved bamboos: Barnhart (1), p. 55; Bush and Hsio-yen Shih, pp. 275–78.
211. Huang Kung-wang . . . advised: Chu-tsing Li (1), p. 174.

211. only surviving sketchbook: Barnhart (1), p. 55.
211. historically accurate clothing: e.g.), Yao Tsui (c. 550 A.D.), in Bush and Hsio-yen Shih, p. 31, and Siren (2), p. 222.
211. Chinese portraits (later): Cahill (1), pp. 106, 114–16.
211. portraits of the Ch'an: Kanazawa, pp. 25–29, 36; Mori, pp. 13, 44, 81 (plate 73), 88.
211. *nise-e:* Mori, pp. 90–92.
211. Okyo Maruyama: Kawakita, p. 14.
211. Ogata Korin: Hillier, p. 20.
211. Sosen Mori: Hillier, p. 255.
212. equilibrium: Arnheim, pp. 48–55; Hudson, pp. 44–5.
212. number of opposites: e.g., Hudson, pp. 28, 41.
212. harmony should ring: Wellek, p. 346.
212. Bach fuses: Bukofzer, pp. 302–5.
212. Beethoven stretches: Solomon, pp. 320–21.
212. Ts'ai Yung: Fong (1), pp. 184–85.
212. calligrapher as a general: Fong (1), p. 185.
212. *Seven Junipers, Cypress and Old Rock:* Clapp, pp. 30, 70, 75; Edwards (1), pp. 120–23, 166–67.
212. play around missing beats: Chernoff, pp. 50–51, 113–14.
212. "cool": Chernoff, pp. 139–40, 148; Huet, p. 27.
212. music, like wisdom: Chernoff, pp. 142, 148–50.
213. old men: Chernoff, pp. 148, 166.
214. his polemic: e.g., *Republic* 424, 596ff; *Laws* 656ff., 810–811; as against the *Symposium.*
214. Plotinus: Panofsky (1), pp. 25–32; Pollitt (1), pp. 55–58; Rist, ch. 5.
214. "The arts do not simply": Plotinus 5.8.1, Plotinus, p. 149.
214. Beauty, says Plotinus: e.g., 6.7.22, Plotinus, pp. 74–75.
214. Beauty . . . is . . . formless . . . lovers: Plotinus 6.7.3, Plotinus p. 149.
215. Medieval esthetics: Panofsky (1), pp. 36ff.
215. Alberti: Panofsky (1), pp. 49–52, 58–59.
215. "victory of divine reason": Gombrich (3), pp. 172ff.; Panofsky (1), pp. 53–54; see also Chastel, pp. 102ff.
215. from the second half of the sixteenth century: Panofsky (1), pp. 93–95.
215. Michelangelo accepted: Panofsky (1), pp. 115–16.
215. writers: e.g., Abrams (2), pp. 27, 29, 31, 169.
215. imported from India: Glasenapp; Schwab.
215. Schopenhauer: e.g., *The World as Will and Representation*, para. 34.
215. the Theosophists: B. F. Campbell, pp. 168–71.
215. Einstein, Bohr . . .: Scharfstein (1), (2); Wilbur.

215. German Expressionists: e.g., Vogt, pp. 6–7.

215. Kupka: Spate, pp. 88–89.

216. Kandinsky: Long; Selz (2), pp. 223–33; but see Kandinsky, p. 270.

216. "vibrations": Long, p. 32.

216. in a letter: of 1813, in Roethel, p. 18.

216. Mondrian: Elgar (2), pp. 104–5; Stangos, p. 142; Vallier, pp. 110–29.

216. the horizontal line: Mondrian, p. 13; Elgar (2), pp. 73–75; Seuphor, pp. 117–18.

216. "Plastic art discloses": Mondrian, pp. 14–15.

217. "The canvas is ready": Frankenstein, p. 107.

217. *mana:* see, e.g., Hultkranz (1), pp. 10–14; (2), pp. 39–42.

217. *dynamism:* see, e.g., Fagg (2).

218. Some look back: e.g., Olney, p. 125.

218. Wole Soyinka: Okpewho, p. 243.

218. Yambo Ouologuem: Olney, pp. 243–45, 264–65.

218. Attacking . . . Leo Frobenius: Olney, pp. 243–44.

218. strongly bound to their group: Olney, pp. 57ff., 73; Zahan, p. 47.

218. do not accept: e.g., Olney, pp. 174–75; see also Zahan, p. 10.

219. *nyama:* Calame-Griaule, pp. 35, 81.

219. Tshokwe myth: Brain (1), pp. 34ff.

219. The Bambara: Brain (1), pp. 75–77; Zahan.

219. boys' masked dance: Brain (1), p. 74.

219. African art . . . performance: E.g., Huet; R. F. Thompson (1).

219. between human beings and . . . forces: Zahan, pp. 1, 154, 156.

220. the craftsmen's manuals: Banarjea (1), T. Bhattacharyya; Bose.

220. a breathing, *prana:* Ray, p. 177.

220. "He who knows": Ray, pp. 266–67.

220. a poetics: De (1), (2); Pandey (2); Ramanujan; Warder.

220. *rasa:* Gnoli, pp. 55, 87–96; Ingalls, pp. 13ff.; Masson and Patwardhan, pp. 50–55; Pandey (2), p. 21; Ray, pp. 131ff.

221. Kalidasa, Bana . . . were familiar: Krishnamoorthy, p. xxix; see also Warder, p. 118.

221. *dhvani:* Krishnamoorthy, pp. xxix–xxxiii; Pandey (2), pp. 230–31.

221. *rasa* was to *dhvani:* Krishnamoorthy, p. xxxi.

221. basic emotions: De (1), vol. 2, pp. 21–25; Pandey (2), pp. 17–20.

221. European theory of "affections": see, e.g., Bukofzer, pp. 388–90.

222. Abhinavagupta: Masson and Patwardhan; Pandey (1), (2); Wadia.

222. pain occurring: Gnoli, pp. 87–90; Masson and Patwardhan, pp. 56–57; Pandey (2), p. 144.

222. "opens like a flower": Gnoli, p. xxii.

222. "In the shoreless world": Masson and Patwardhan, p. 12.
222. "tranquillity": Masson and Patwardhan, pp. 130ff; Pandey (2), pp. 196–206.
223. Abhinava's philosophy: Pandey (1), pp. 293ff.
223. *ch'i:* Acker (2), pp. xxviii–xxxiii; Shou Kwan Lui, p. 144; Munkata, pp. 3, 20–21, 24–25.
224. In literature: Pollard, pp. 64–65.
224. *Ch'i-yün;* see esp. Acker (2); Shou Kwan Lui.
224. the vital spirit, the *tao:* Munkata, pp. 20–21, note 13; 25, note 21.
224. "opening and closing," "void and solidity": Fong (5); Fong et al., p. 171.
224. "from the revolution": Bush (2), from Rowley, p. 48.
224. Wang Fu-chih: Siu-kit Wong, pp. 148–50.
224–25. Wang Yang-ming: in a famous essay; see Ching, p. 127.
225. "This means that even the heart": Ching, p. 127.
225. *liang-chih:* Ching, pp. 142–44.
225. yugen: Izutsu and Izutsu, p. 28; Ueda, ch. 4.
225. "an overtone": Sato and Watson, pp. xxxvii–xxxviii.
225. "Learn from the pine": Sato and Watson, pp. xxxviii–xxxix.
225. "Then if its essence": Sato and Watson, pp. xxxviii–xxxix.
226. "Japanese poetry": Sato and Watson, p. 107.
226. Einfühlung: Ewart; Gauss; Perpeet; Podro (2), pp. 104–10; Selz (2), pp. 6–11; Spector (1), pp. 123–27.
266. "objectified enjoyment": Sahakian, p. 194.
227. "Solitude is killing me": Riesman, pp. 220–21.
227. "She, she": Siegel, p. 11.
227. "i am not mind": Siegel, p. 7.
227. Shen Chou: Weng, pp. xxi–xxii.
227. Van Gogh: see, e.g., letter, dated July 19–23, 1882, addressed to Theo.
227. Thomas Mann writing: early June, 1904, in Mann, p. 35.
227. Stephen Spender's idea: "The Making of a Poem," in Ghiselin, pp. 112–25.
227. "They are me": B. Campbell, p. 44.
227. "A photograph": B. Campbell, p. 69.
227. "When I expose": Kuh, p. 10.
228. "determined precisely": Terenzio, p. 40; see also Ashton (2), pp. 8–9.
228. "the feeling of his own": H. Rosenberg (2), p. 246.
228. "If I love": from the Kokinshu, in Sato and Watson, p. 119.
228. a Japanese folktale: "The Snow Wife," in Seki, pp. 81–82.

Bibliography

In view of this book's scope, I have not attempted to compile a full bibliography but have listed only the material I have actually used. The bibliography is what I take to be a balanced selection of general books and monographs, with a leavening of scholarly articles interspersed now and then with a few that were merely timely.

None of the fields I touch on has been static. Ethology, of course, has made great strides in the last two generations in the observation of animals in their natural habitats, in the creation and refinement of hypotheses, and in the assimilation of experimental techniques and findings. In ornithology in particular, there has been a marked change from about 1950, to a more stringently scientific attitude, which requires greater precision in the gathering of information and a more critical assessment of hypotheses; but the earlier, more casual observations remain essential to guide (and misguide) us. Social anthropology has become more sophisticated in its judgments and notably more aware of the historical dimension that it for a time neglected in favor of a usually idealized, static, traditional past. Unfortunately, the increase in sophistication has been accompanied by an increasingly rapid disappearance of the traditional subject-matter, the "exotic" or "primitive" cultures, so that anthropological research is not

infrequently like that carried out in relation to some recently extinct species of animals. In art history and criticism, much has been improved and much remains in flux, but especially remarkable progress has been made in the quality of research into African and Chinese art. The latter research though dealing with a still often poorly understood subject-matter and with nonexistent or questionable originals, has arrived at a density and sophistication comparable to the better research into Western art.

In making use of the literature I have consulted, I have not made the self-defeating attempt to be always exactly up-to-date—old views may be sound ones, and of new views there is no end—but I hope that my pages reflect the genuine progress in research in recent years, though the point is less to reflect the research as such than to unify it into a consistent general image of human art.

Abraham, G. "Images of Motoric Energy." (Review of books on Stravinsky) *Times Library Supplement,* June 17, 1983.

Abrams, M. H. (1). *The Mirror and the Lamp.* New York, 1958.

—— (2). *Natural Supernaturalism.* New York, 1971.

Abse, J. *John Ruskin.* New York, 1980.

Acharya, P. K. (Trans.). *Indian Architecture According to Manasara-Silpasastra.* Bombay, 1927. Renamed *Architecture of Manasara.* Allhabad, 1933 (?).

Acker, W. R. B. (1). (Trans.) *Tao the Hermit; Sixty Poems by Tao Ch'ien.* London, 1952.

—— (2). *Some T'ang and Pre-T'ang Texts on Chinese Printing.* Leiden, 1954.

Ackerman, J. S. "Art and Evolution." In Kepes.

Ades, D. "Dadaism and Surrealism." In Stangos.

Adhémar, J., and Cachin, F. *Degas: The Complete Etchings, Lithographs, and Monotypes.* London, 1974.

Adriani, G., Konnertz, W., and Thomas, K. *Joseph Beuys: Life and Work.* New York, 1979.

Akpabot, S. "Random Music of the Birom." *Africa Arts* 8(2) Winter, 1975.

Alberti, L. B. *Leon Battista Alberti on Painting.* J. R. Spencer (Trans.). New Haven, 1966.

Aldridge, A. O. "Primitivism in the Eighteenth Century." In Wiener.

Aldred, C. (1). *Akhenaten and Nefertiti.* New York, 1973.

—— (2). *Egyptian Art.* London, 1980.

Alexandre, P. "Poetry." In Balandier and Maquet.

Alexandrian, S. *Le Surréalisme et le rêve.* Paris, 1974.

Allen, L. A. *Time Before Morning: Art and Mythology of the Australian Aborigenes.* New York, 1975.

Alpers, S. *The Art of Describing: Dutch Art in the Seventeenth Century.* Chicago, 1983.

Alschuler, R. H., and Hattwick, L. B. W. *Painting and Personality*. 2 vols., Chicago, 1947.

Alsop, J. *The Rare Art Traditions*. London, 1982.

Anastasi, A., and Foley, J. P. "An Analysis of Spontaneous Drawings by Children in Different Cultures." *Journal of Applied Psychology* 20, 1936.

Anderson, R. L. *Art in Primitive Societies*. Englewood Cliffs, N.J., 1979.

André, A. *Renoir*. Paris, 1928 (orig. ed., 1919); quoted in House, p. 16.

Aniakor, C. C. "The Igbo Ijele Mask." *African Arts* 11(4) July 1978.

Appell, W. (Ed.). *Harvard Dictionary of Music*. 2d ed., Cambridge, Mass., 1970.

Armstrong, E. A. (1). "Aspects of the Evolution of Man's Appreciation of Bird Song." In Hinde (4).

——— (2). *Bird Display and Behaviour*. 2d ed., New York, 1965.

——— (3). *The Life and Lore of Birds*. New York, 1975.

——— (4). *A Study of Bird Song*. 2d ed., New York, 1973.

Arnheim, R. *Entropy and Art*. Berkeley, 1971.

Arnold, D. (Ed.). *The New Oxford Companion to Music*. 2 vols., Oxford, 1983.

Ashton, D. (1). *A Fable of Modern Art*. London, 1980.

——— (2). "Robert Motherwell and His Poets." In H. H. Arneson, *Robert Motherwell*. 2d. ed., New York, 1982.

——— (3). *Picasso on Art*. New York, 1972.

Asihene, E. V. *Understanding the Traditional Art of Ghana*. London, 1978.

Assman, J. "Flachbildkunst des Neuen Reiches." In Vandersleyen.

Astrow, M. (Ed.). *The Winged Serpent: An Anthology of American Indian Prose and Poetry*. New York, 1976.

Attenborough, D. *The Tribal Eye*. London, 1976.

Auboyer, J. (1). *Daily Life in Ancient India*. London, 1961.

——— (2). *Introduction à l'étude de l'art de l'Inde*. Rome, 1965.

Bake, A. "The Music of India." In Wellesz.

Baker, C. *The Innocent Artists*. Poole, Dorset, 1980.

Balandier, G. "Literature, Oral." In Balandier and Maquet.

Balandier, G. and Maquet, J. (Eds.). *Dictionary of Black African Civilization*. New York, 1974.

Baldwin, J. D., and Baldwin, J. I. "The Role of Learning Phenomena in the Ontogeny of Exploration and Play." In Chevalier-Skolnikoff and Poirier.

Balikci, A. *The Netsilik Eskimo*. New York, 1970.

Banarjea, L. J. N. (1). *The Development of Hindu Iconography*. 3d ed. (from 2d ed., 1956), New Delhi, 1974.

——— (2). "The Phallic Emblem in Ancient and Medieval India." *Journal of the Indian Society of Oriental Art* 3(1) June 1935.

Bankole, A., Bush, J., and Samaan, S. H. "The Yoruba Master Drummner." *African Arts* 8(2) Winter 1975.

Baptista, L. F., and Morton, M. L. "Song Dialects and Mate Selection in Montane White-Crowned Sparrows." *Auk* 99(3) July 1982.

Barbeau, M. "Tsimshian Songs." In Garfield, Wingert, and Barbeau.

Bargenda, V. W. "Der Inspiration-Begriff in der Aesthetik." In Ritter.

Barnhart, R. (1). *Wintry Forests, Old Trees: Some Landscape Themes in Chinese Painting.* New York, 1972.

———— (2). "The 'Wild and Heterodox' School of Ming Painting." In Bush and Murck.

Barnett, V. E. *Kandinsky at the Guggenheim.* New York, 1983.

Barnstone, E. *Greek Lyric Poetry.* Reprint, New York, 1972.

Barrett, C., and Croll, R. H. *Art of the Australian Aboriginal.* Melbourne, 1943.

Barthes, R. *Camera Lucida: Reflection of Photography.* New York, 1981.

Bascom, W. (1). "African Dilemma Tales." In Dorson.

———— (2). "Creativity and Style in African Art." In Biebuyck (2).

———— (3). "A Yoruba Master Carver." In d'Azevedo (3).

Bateson, P. "Psychology of Knowing Another Side." *New Scientist,* Jan. 22, 1976.

Batten, M. "Sexual Olympics." *Science Digest,* Dec. 1982.

Battock, G. *Super Realism,* New York, 1975.

Baudelaire, C. *Oeuvres complètes.* C. Pichois (Ed.). 2 vols. Paris, 1976.

Baudouin, F. *P. P. Rubens.* New York, 1977.

Baxendall, M. *The Limewood Sculptors of Renaissance Germany.* New Haven, 1980.

Beardsley, M. L., and Dieckmann, H. "Theories of Beauty to the Mid-Nineteenth Century." In Wiener.

Beckett, R. B. (Ed.). *John Constable's Discourses.* Ipswich, 1970.

Beer, C. G. "Study of Vertebrate Communication—Its Cognitive Implications." In Griffin (2).

Beier, U. (1). *African Poetry.* London, 1966.

———— (2). *The Return of the Gods.* Cambridge, 1976.

Bekoff, M. "Play." In Campbell and Lack.

Bell, Q. *Ruskin.* Edinburgh/London, 1963.

Benedict, R. *Patterns of Culture.* Boston, 1934.

Berendt, J. E. *The Jazz Book.* London, 1984.

Berger, K. *Japonismus in der westlichen Malerei 1860–1921.* Munich, 1980.

Berlyne, D. E. (1). *Aesthetics and Psychobiology.* New York, 1971.

———— (2). "Curiosity and Learning." *Motivation and Emotion* 2 (2) June 1978.

———— (3). "Laughter, Humor, and Play." In Lindzey and Aronson.

Bernal, I. *A History of Mexican Archeology.* London, 1980.

Berndt, R. M. *Australian Aboriginal Religion, Fascicle One.* Leiden, 1974.

Bernson, M. *Du gribouillis au dessin.* Neuchatel, 1957.

Bersani, L. *Baudelaire and Freud*. Berkeley, 1977.

Best, E. *The Maori as He Was*. Wellington, New Zealand, 1934.

Beurdeley, C., and Beurdeley, M. *Guiseppe Castiglione*. Rutland, Vt./Tokyo, 1971.

Bevis, W. "American Indian Verse Translation." In Chapman.

Bhattacharyya, N. N. *History of Indian Erotic Literature*. New Delhi, 1975.

Bhattacharyya, T. *The Canons of Indian Art*. 2d ed., Calcutta, 1963.

Biardeau, M. *Théorie de la connaissance et philosophie de la parole dans le brahmanisme classique*. The Hague/Paris, 1964.

Biebuyck, D. P. (1). "Textual and Contextual Analysis in African Art Studies," *African Arts* 8 (3), Spring, 1975.

───── (2). (Ed.). *Tradition and Creativity in Tribal Art*. Berkeley, 1969.

Bierbrier, M. *The Tomb-Builders of the Pharaohs*. London, 1982.

Bierhorst, J. (1). "American Indian Verbal Art and the Role of the Literary Critic." In Swann.

───── (2). *In the Trail of the Wind: American Indian Poems and Ritual Orations*. New York, 1974.

Biernoff, D. "Safe and Dangerous Places." In Hiatt (2).

Billig, O., and Burton-Bradley, B. G. *The Painted Message*. New York, 1978.

Birks, T. *Hans Coper*. London, 1983.

Blair, D. *Samuel Beckett*. London, 1978.

Blake, W. *The Complete Poetry and Prose of William Blake*. D. V. Erdman, (Ed.). Berkeley, 1982.

Blume, F. *Classic and Romantic Music*. New York, 1970.

Blunt, A. *Art and Architecture in France 1500–1700*. 2d ed., Harmondsworth, 1970.

Boardman, J. (1). *Athenian Black Figure Vases*. London, 1974.

───── (2). *Athenian Red Figure Vases*. London, 1975.

───── (3). *Greek Sculpture: The Archaic Period*. London, 1978.

Boas, F. *Primitive Art*. Reprint, New York, 1955.

Boas, G. "Primitivism." In Wiener.

Boase, T. R. *Giorgio Vasari*. Princeton, 1979.

Bohannen, P. (1). "Artist and Critic in an African Society." In Bohannen (2).

───── (2). (Ed.). *The Artist in Tribal Society*. London, 1961.

Boime, A. (1). *The Academy and French Painting in the Nineteenth Century*. London, 1975.

───── (2). *Thomas Couture and the Eclectic Vision*. New Haven, 1980.

Bolgar, R. R. *The Classical Heritage and Its Beneficiaries*. London, 1954.

Boner, A., and Sarma, S. R., with Das, R. P. *New Light on the Sun Temple of Konarka*. Varanasi, India, 1972.

Bonner, J. T. *The Evolution of Culture in Animals*. Princeton, 1980.

Borgia, G. "Sexual Selection in Bowerbirds." *Scientific American,* June 1986.
Bose, P. N. (Ed.). *Silpa-Sastram.* Lahore, India, 1928.
Boulez, P. *Conversations with Célestin Deliège.* London, 1976.
Bowen, B. "Introduction." In *Tobey's 80: A Retrospective.* Seattle, 1970.
Bowie, T. (Ed.). *East-West in Art.* Bloomington, Ind., 1966.
Boxer, C. R. *The Dutch Seaborne Empire.* New York, 1965.
Bradbury, M. (Ed.). *The Novel Today.* London, 1977.
Brain, R. (1). *Art and Society in Africa.* London, 1980.
———— (2). *The Decorated Body.* London, 1979.
Bring, M., and Wayenbergh, J. *Japanese Gardens.* New York, 1981.
Brinker, H. "Ch'an Portraits in a Landscape." *Archives of Asian Art* 27, 1973–74.
Brittain, W. L. *Creativity, Art, and the Young Child.* New York, 1979.
Britton, D., and Hayashida, T. *The Japanese Crane.* Tokyo, 1981.
Brouwer, R. H., and Miner, E. *Japanese Court Poetry.* Stanford, 1961.
Brown, J. "El Greco and Toledo." In J. Brown et al. *El Greco of Toledo.* Boston, 1982.
Brumble, H. D. III. "Indian Sacred Materials." In Swann.
Bruner, J. S., Jolly, A., and Sylva, K. (Eds.). *Play.* Harmondsworth, 1976.
Bruss, E. B. *Beautiful Theories.* Baltimore, 1982.
Bukofzer, M. *Music in the Baroque Era.* London, 1948.
Burford, A. *Craftsmen in Greek and Roman Society.* London, 1972.
Burgess, J. S. *The Guilds of Peking.* New York, 1928.
Burke, P. (1). *The Renaissance Sense of the Past.* London, 1969.
———— (2). *Tradition and Innovation in Renaissance Italy.* London, 1974.
Burnham, S. *The Art Crowd.* New York, 1973.
Burton, R. *Bird Behaviour.* London, 1985.
Buschor, E. *On the Meaning of Greek Statues.* Amherst, Mass., 1980.
Bush, E. (1). *The Chinese Literati on Painting.* Cambridge, Mass., 1971.
———— (2). "Lung-mo, K'ai-ho, and Ch'i-fu." *Oriental Art,* (N.S. 8) 1962.
Bush, S., and Murck, C. (Eds.). *Theories of the Arts in China.* Princeton, 1983.
Bush, S., and Hsio-yen Shih. *Early Chinese Texts on Painting.* Cambridge Mass., 1985.
Busia, K. A. "The Ashanti." In Forde.
Butler, C. *After the Wake: An Essay on the Contemporary Avant-Garde.* New York, 1980.
Buxton, E. J. M. "Poetry, Birds in." In Campbell and Lack.
Cabanne, P. (1). *Dialogues with Marcel Duchamp.* Boston, 1976.
———— (2). *The Brothers Duchamp.* Boston, 1976.
Cachin, F. *Gauguin.* Paris, 1968.
Cage, J. (1). *For the Birds.* Boston, 1981.

270

—————— (2). *Silence*. Middletown, Conn., 1961.

Cahill, J. (1). *The Compelling Image*. Cambridge, Mass., 1982.

—————— (2). *The Distant Mountains*. New York/Tokyo, 1976.

—————— (3). "The Early Styles of Kung Hsien." *Oriental Art,* (N.S. 16.1) 1970.

—————— (4). *Hills Beyond a River*. New York/Tokyo, 1976.

—————— (5). "The Orthodox Movement in Chinese Painting." In Murck.

—————— (6). *Parting at the Shore*. New York/Tokyo, 1978.

—————— (7). (Ed.). *The Restless Landscape*. Berkeley, 1971.

—————— (8). (Ed.). *Shadows of Mt. Huang*. Berkeley, 1981.

Cahn, W. *Masterpieces*. Princeton, 1979.

Calame-Griaule, G. *Ethnologie et langage*. Paris, 1965.

Callois, R. *L'Écriture des pierres*. Paris, 1970.

Campbell, B. (Ed.). *World Photography*. London, 1981.

Campbell, B., and Lack, E. (Eds.). *A Dictionary of Birds*. Staffordshire, 1985.

Campbell, B. F. *Ancient Wisdom Revived: A History of the Theosophical Movement*. Berkeley, 1980.

Campbell, J. *The Way of the Animal Powers*. Vol. 1, San Francisco, 1983.

Cardinal, R. *Outsider Art*. London, 1972.

Carner, M. *Major and Minor*. London, 1980.

Carpenter, E. (1). (Ed.). *Anerca* (Eskimo poems). Toronto, 1959.

—————— (2). "Image Making in Arctic Art." In Kepes.

—————— (3). "They Became What They Beheld." In Csaky.

Carpenter, R. *Greek Sculpture*. Chicago, 1960.

Caryl, P. G. "Ritualization." In Campbell and Lack.

Cassirer, E. *The Philosophy of the Enlightenment*. Boston, 1951.

Catchpole, C. K. "Vocalization." In Campbell and Lack.

Chadwick, H. M., and Chadwick, A. K. *The Growth of Literature*. Vol. 3, London, 1940.

Chandra, P. *On the Study of Indian Art*. Cambridge, Mass, 1983.

Chang, H. C. *Chinese Literature 2: Nature Poetry*. Edinburgh, 1977.

Chapman, A. (Ed.). *The Literature of the American Indians*. New York, 1975.

Charlesworth, M., et al. (Eds.). *Religion in Aboriginal Australia*. Queensland, Australia, 1984.

Chastel, A. *Art et humanisme à Florence au temps de Laurent le Magnifique*. Paris, 1959.

Chattopadhyaya, D. (Ed.). *Taranatha's History of Buddhism in India*. Simla, India, 1970.

Chaves, J. (1). "Some Relations between Poetry and Painting in China." In Watt.

—————— (2). (Trans.). *Pilgrim of the Colours: Poems and Essays by Yüan Hung-Tao and His Brother*. New York/Tokyo, 1978.

———— (3). "The Panoply of Images." (On the Kung-an school.) In Bush and Murck.

Ch'en, Chih-mai. *Chinese Calligraphers and Their Art*. London, 1966.

Chen, Tsing-fang. "Towards a Universal Approach: Is East-West Convergence at Hand?" Ninth International Conference on the Unity of the Sciences (International Cultural Foundation), Miami Beach, Nov. 27–30, 1980.

Chen, Yu-shih. "The Literary Theory and Practice of Ou-yang Hsiu." In Rickett.

Cherfas, J. (1). "Learning to Go Cheep." *New Scientist*, May 17, 1979.

———— (2). "Singing in the Brain." *New Scientist*, May 24, 1979.

———— (3). "I Sing Therefore I Am." *New Scientist*, May 31, 1979.

Chernoff, J. M. *African Rhythm and African Sensibility*. Chicago, 1979.

Chevalier-Skolnikoff, A., and Poirier, F. E. (Eds.). *Primate Bio-Social Development*, New York, 1977.

Child, I. L. "Esthetics." In Lindzey and Aronson.

Ching, J. *To Acquire Wisdom: The Way of Wang Yang-ming*. New York, 1976.

Chipp, H. *Theories of Art*. Berkeley, 1969.

Christie, E. "Indian Philosophers on Poetic Imagination (Pratibha)." *Journal of Indian Philosophy* 7 (2) June 1977.

Christine, B. *Mystic Art of Ancient Tibet*. London, 1973.

Chu Ta: Selected Paintings and Calligraphies. Exh. cat. Vassar College Art Gallery. Poughkeepsie, N.Y., 1973.

Clapp, A. de C. *Wen Cheng-ming*. Ascona, Switzerland, 1975.

Clark, K. (1). *The Nude*. Harmondsworth, 1956.

———— (2). *The Romantic Rebellion*. London, 1973.

Clements, R. L. *Michelangelo's Theory of Art*. New York, 1961.

Cohen, J. M. (Trans.). *The Four Voyages of Christopher Columbus*. Harmondsworth, 1969.

Cole, H. E. *Mbari*. Bloomington, Ind., 1982.

Coleman, E. J. *Philosophy of Painting by Shih Tao*. The Hague, 1978.

Colombo, J. R. (Ed.). *Poems of the Inuit*. Ontario (?), 1981.

Condivi, A. *The Life of Michelangelo*. A. S. Wohl (Trans.). Baton Rouge, La., 1976.

Confucius. *Analects*. (1). D. C. Lau (Trans.). Harmondsworth, 1979.

———— (2). J. Legge (Trans.). Reprint, New York, 1971.

———— (3). Lin Yutang (Trans.). *(The Wisdom of Confucius)*. New York, 1938.

Contag, V. *Chinese Masters of the 17th Century*. London, 1969.

Coomaraswamy, A. K. (1). *The Arts and Crafts of India and Ceylon*. London, 1913.

———— (2). "The Intellectual Operation in Indian Art." *Journal of the Indian Society of Oriental Art* 3 (1) June 1935.

———— (3). *Medieval Sinhalese Art*. 2d ed., New York, 1956.

272

———— (4). *The Religious Basis of the Forms of Indian Society*. New York, 1946.

———— (5). *The Transformation of Nature in Art*. Cambridge, Mass., 1935.

Cornet, J. *Art of Africa*. London/Brussels, 1971.

Cott, J. *Stockhausen: Conversations with the Composer*. London, 1974.

Coulton, J. J. *Greek Architects at Work*. London, 1977.

Courlander, H. *Tales of Yoruba Gods and Heroes*. New York, 1973.

Cozens, A. *A New Method of Landscape*. Reprint, London, 1977.

Cowart, J. *Roy Lichenstein 1970–1988*. London, 1981.

Crichton, M. *Jasper Johns*. New York, 1977.

Crook, J. H. "Functional and Ecological Aspects of Vocalization in Birds." In Hinde (4).

Csaky, M. (Ed.). *How Did It Feel?* London, 1979.

Cummings, P. *Artists in Their Own Words*. New York, 1979.

Curtius, E. R. *European Literature and the European Middle Ages*. New York, 1953.

Damas, D. (Ed.). *Handbook of North American Indians. Vol. 5, Arctic*. Washington, D.C., 1984.

Daniels, R. *Conversations with Menuhin*. London, 1980.

Dahlhous, C. *Esthetics of Music*. Cambridge, 1982.

Darius, J. *Beyond Vision*. New York, 1984.

Daval, J.-L. (1). *Photography*. Paris, 1982.

———— (2). *Skira Annual No. 5*. Geneva, 1979.

Dave, K. N. *Birds in Sanskrit Literature*. Delhi, 1985.

Davies, J. B. *The Psychology of Music*. London, 1978.

D'Azevedo, W. L. (1). "Mask Makers and Myth in Western Liberia." In Forge (2).

———— (2). "Sources of Gola Artistry." In d'Azevedo (3).

———— (3). (Ed.). *The Traditional Artist in African Societies*. Bloomington, Ind., 1973.

De, S. K. (1) *History of Sanskrit Poetics*. Reprint, 2 vols. in 1, Calcutta, 1977.

———— (2). *Sanskrit Poetics as a Study of Aesthetics*. Berkeley, 1963.

De Bary, W. T. "Neo-Confucian Cultivation and the Seventeenth Century." In W. T. de Bary (Ed.). *The Unfolding of Neo-Confucianism*. New York, 1975.

Delange, J. *Arts et peuples de l'Afrique noire*. Paris, 1967.

Depouilly, J. D. "Enfants." In Laclotte.

Desai, D. *Erotic Sculpture of India*. New Delhi, 1975.

Desmond, A. *The Ape's Reflexion*. London, 1979.

Deuchler, F. *Gothic Art*. New York, 1973.

Deutsch, E. *Studies in Comparative Aesthetics*. Hawaii, 1975.

De Waal, F. *Chimpanzee Politics*. London, 1982.

Dhavalikar, M. K. "Sri Yugdhara—A Master-Artist of Ajanta." *Artibus Asiae* 31, 1969.

Diderot, D. *Oeuvres philosophiques*. P. Vernière (Ed.). Paris, 1961.

Dieterlin, G. (Ed.). *Textes sacrés d'Afrique noire*. Paris, 1965.

Dimmitt, C., and van Buitenen, J. A. B. *Classical Hindu Mythology*. Philadelphia, 1978.

Dimock, E. C., Jr., et al. *The Literatures of India*. Chicago, 1974.

Dolby, A. W. E. "Ni Tsan, Unconventional Artist of the Yuan Dynasty." *Oriental Art, N.S.* 19 (4) Winter 1973.

Dolhinow, P. "At Play in the Fields." In Bruner, Jolly, and Sylva.

Donaghey, R. H. "Hearing and Balance." In Campbell and Lack.

Donaghey, R. H., Frith, C. B., and Lill, R. "Bowerbird." In Campbell and Lack.

Dorival, B. "Ukiyo-e and European Painting." In Yamada.

Dorst, J. *The Life of Birds*. 2 vols., London, 1974.

Dorson, R. M. (Ed.). *African Folklore*. New York, 1972.

Douglas, M. "The Lele of Kasai." In Forde.

Doyle, C. L. "The Creative Process." In J. P. Strelka (Ed.). *Literary Criticism and Psychology*. University Park, Pa., 1976.

Drewal, M. T. "Projections from the Top in Yoruba Art." *African Arts* 11 (1) Oct. 1977.

Driver, W. "Music and Dance." In H. W. Driver. *Indians of North America*. 2d ed., Chicago, 1977.

Dube-Heyning, A. *E. L. Kirchner, Graphik*. Munich, 1961.

Dudley, D. R. *A History of Cynicism*. London, 1937.

Duerden, D. *The Invisible Present: African Art and Literature*. New York, 1975.

Dumur, G. *Nicolas de Staël*. New York, 1976.

Duncan, R. *Critics' Gaffes*. London, 1983.

Dunlop, I. *Degas*. London, 1979.

Durkheim, E., and Mauss, M. *Primitive Classification*. London, 1963.

Eaves, M. *William Blake's Theory of Art*. Princeton, 1982.

Ebert, J. I. "Ellison's Cow." *Science 81*, Dec.

Ebin, V. *The Decorated Body*. London, 1979.

Ecke, G. *Chinese Painting in Hawaii*. 3 vols., Honolulu, 1965.

Ecke, T. Yu-ho. (1). *Chinese Calligraphy*. Boston, 1971.

——— (2). "A Reconsideration of 'Ch'uan-mo-i-hsieh,' the Sixth Principle of Hsieh Ho." *Proceedings of the International Symposium on Chinese Painting 1970*. Taipei, 1972.

Edgerton, S. Y. *The Renaissance Discovery of Linear Perspective*. New York, 1975.

Edwards, R. (1). *The Art of Wen Cheng-ming (1470–1559)*. Exh. cat. University of Michigan Museum of Art. Ann Arbor, 1976.

———— (2). "The Orthodoxy of the Unorthodox." In Spence.

———— (3). "Tao-chi the Painter." In Spence.

Efros, I. I. *Ancient Jewish Philosophy*. Detroit, 1964.

Egudu, R., and Nwoga, D. *Igbo Traditional Verse*. London, 1973.

Ehrenzweig, A. *The Hidden Order of Art*. London, 1967.

Einon, D. "Rats at Play." *New Scientist,* March 20, 1980.

Einstein, A. *Music in the Romantic Era*. London, 1947.

Eitner, L. *Neoclassicism and Romanticism 1750–1850*. Englewood Cliffs, N.J., 1970.

Elderfeld, J. *The "Wild Beasts": Fauvism and Its Affinities*. New York, 1976.

Elgar, F. (1). *Cézanne*. London, 1969.

———— (2). *Mondrian*. London, 1968.

El-Hamy, H. Review of D. Ben-Amos, *Sweet Words: Storytelling Events in Benin. African Arts* 10 (1) Oct. 1976.

Eliade, M. *Australian Religions*. Ithaca, 1973.

Elias, J. A. "Art and Play." In Wiener.

Elkin, A. P. *The Australian Aborigines*, Garden City, N.Y., 1964.

Elkin, A. P., Berndt. C., and Berndt, R. *Art in Arnhem Land*. Chicago, 1950.

Elliot, D. (Ed.). *Rodchenko and the Arts of Revolutionary Russia*. New York, 1979.

Elliott, J. H. *The Old World and the New*. London, 1970.

Ellis, C. J., et al. "Classification of Sounds in Pitjantjatjara-Speaking Areas." In Hiatt (2).

Elsen, A. E. (1). *Modern European Sculpture*. New York, 1979.

———— (2). *Rodin*. New York, 1963.

Elwin, V. *Folk Songs of Chattisgarh*. Bombay, 1946.

Erdman, D. V. (Ed.). *The Complete Poetry and Prose of William Blake*. Rev. ed., Berkeley, 1982.

Essock-Vitale, S., and Seyforth, R. M. "Intelligence and Social Cognition." In Smuts et al.

Etzkorn, K. P. "On the Sphere of Social Validity in African Art." In d'Azevedo (3).

Evans, C. *Landscapes of the Night*. London, 1983.

Evans-Pritchard E. (1). *A History of Anthropological Thought*. New York, 1981.

———— (2). *The Nuer*. London, 1940.

———— (3). *The Zande Trickster*. London, 1967.

Ewart, O. "Einfühlung." In Ritter.

Eyo, E., and Willett, F. *Treasures of Ancient Nigeria*. New York, 1980.

Fagen, R. "Horseplay and Monkeyshines." *Science 83,* Dec. See the same author's *Animal Play Behavior,* New York, 1981.

Fagg, W. (1). "The African Artist." In Biebuyck (2).

———— (2). "In Search of Meaning in African Art." In Forge (2).

Fagg, W., Pemberton J., 3rd, and Holcombe, A. (Eds.). *Yoruba Sculpture of West Africa*. New York, 1982.

Falck, R., and Rice, T. (Eds.). *Cross-Cultural Perspectives in Music*. Toronto, 1982.

Falls, J. B. "Functions of Territorial Song in the White-Throated Sparrow." In Hinde (4).

Faris, J. C. *Nuba Personal Art*. Toronto, 1972.

Feest, C. "The Arrival of Tribal Objects in the West from North America." In Rubin (4).

Feininger, A. (1). *Photographic Seeing*. London, 1974.

———— (2). *Roots of Art*. London, 1975.

Finch, C. *Image as Language: Aspects of British Art* 1950–1968. London, n.d.

Fine, R. *A History of Psychoanalysis*. New York, 1979.

Finney, G. L. "Harmony or Rapture in Music." In Wiener.

Finnegan, R. (1). "Literacy and Literature." In Lloyd and Gay.

———— (2). *Oral Poetry*. London, 1978.

———— (3). *The Penguin Book of Oral Poetry*. London, 1978.

Firth, R. "Tikopia Art and Society." In Forge (2).

Fischer, E. "Dan Forest Spirits: Masks in Dan Villages." African Arts 11 (2) Jan. 1978.

Fischer, E., and Himmelheber, H. *Die Kunst der Dan*. Zürich, 1976.

Flam, J. D. (1). "Matisse and the Fauves." In Rubin (4).

———— (2). (Trans.) *Matisse on Art*. Oxford, 1973.

Fong, Wen. (1). "Addenda." In Whitfield.

———— (2). "Archaism as a 'Primitive' Style." In Murck.

———— (3). "Introduction" and commentaries to *Returning Home: Tao-chi's Album of Landscapes and Flowers*. New York, 1976.

———— (4). "Orthodoxy and Change in Early-Ch'ing Landscape Painting." *Oriental Art* (N.S. 16.1) Spring, 1970.

———— (5). "The Problem of Forgeries in Chinese Painting." *Artibus Asiae* 25, 1962.

———— (6). "Tung Ch'i-ch'ang and the Orthodox Theory of Painting." *National Palace Museum Quarterly* 2, 1967–68.

Fong, Wen C., et al. *Images of the Mind*. Princeton, 1985.

Fontein, J., and Hempel, R. (Eds.). *Propyläen Kunstgeschichte: China, Korea, Japan*. Berlin, 1968.

Forde, D. (Ed.). *African Worlds*. London, 1954.

Forge, A. (1). "Style and Meaning in Sepik Art." In Forge (2).

———— (2). (Ed.). *Primitive Art and Society*. London, 1973.

Fortes, M. "Tallensi Children's Drawings." In Lloyd and Gay.

Fortune, R. *Sorcerers of Dobu*. Reprint, New York, 1963.

Fossey, D. "Development of the Mountain Gorilla. . . ." In Hamburg and McCown.

Foster, A., and Kuenzli, R. (Eds.). *Dada Spectrum*. Madison, Wis./Iowa City, 1979.

Foster, H., "The Problem of Pluralism." *Art in America,* Jan. 1982, p. 10.

Fouts, R. S., and Budd, R. L. "Artificial and Human Language Acquisition in the Chimpanzee." In Hamburg and McCown.

Fowlie, R. *Rimbaud*. Chicago, 1965.

Frampton, K. "De Stijl." In Stangos.

Francis, P., and Jones, P. *Images of the Earth*. London, 1984.

Frank, E. *Pollock*. New York, 1983.

Fränkel, H. *Greek Poetry and Philosophy*. Oxford, 1975.

Frankenstein, A. (Ed.). *Karel Appel*. New York, 1980.

Franzke, A. *Jean Dubuffet*. Basel, 1976.

Fraser, D. "The Discovery of Primitive Art." In Otten.

Free China Review, March 1982. "The Agony of Chao Wouki."

Free China Weekly, Feb. 6, 1983. "Chinese Concept in Modern Art" (on exhibit of Zao Wou-ki, National Museum of History in Tapei, Jan. 1983).

French, C. L. *Shiba Kokan*. New York/Tokyo, 1974.

Freud, S. *Introductory Lectures in Psychoanalysis*. London, 1933 (orig. 1916).

Fried, M. (1). *Absorption and Theatricality*. Berkeley, 1980.

———— (2). "Art and Objecthood." In G. Battock (Ed.). *Minimal Art*. New York, 1968.

Friedman, B. H. *Jackson Pollock*. London, 1972.

Frodsham, J. D. *The Poems of Li Ho 791–817*. London, 1970.

Frodsham, J. A., and Hsi, C. *An Anthology of Chinese Verse*. Oxford, 1975.

Fry, J. (Ed.). *Twenty-Five African Sculptures*. Ottawa, 1978.

Fry, R. *Last Lectures*. London, 1939.

Fu, S. C. Y., et al. *Traces of the Brush: Studies in Chinese Calligraphy*. New Haven, 1977.

Fu, M., and Fu, S. *Studies in Connoisseurship*. Princeton, 1973.

Fung, Yu-lan. *A Short History of Chinese Philosophy*. New York, 1964.

Gablik, S. *Magritte*. London, 1977.

Gallagher, L. J. *China in the Sixteenth Century*. New York, 1953.

Gangoly, O. C. *Ragas and Raginis*. Bombay, 1948.

Gardner, H. (1). *Artful Scribbles*. New York, 1980.

———— (2). *Art, Mind, and Brain*. New York, 1982.

———— (3). "Do Babies Sing a Universal Song?" *Psychology Today,* Dec. 1, 1981.

——— (4). *Frames of Mind*. New York, 1983.
Gardner, M. (1). *Logic Machines and Diagrams*. 2d ed., Chicago, 1982.
——— (2). *Science, Good, Bad and Bogus*. London, 1983.
Garfield, V. W., Wingert, P. S., and Barbeau, M. *The Tsimshian: Their Arts and Music*. New York, 1951.
Gaugh, H. F. *De Kooning*. New York, 1983.
Gauss, C. E. "Empathy." In Wiener.
Gedo, J. E. *Portraits of the Artist*. New York, 1983.
Gedo, M. M. *Picasso: Art as Autobiography*. Chicago, 1980.
Geelhaar, C. *Paul Klee and the Bauhaus*. Bath, 1973.
Geist, S. "Brancusi." In Rubin (4).
Gerbrands, A. A. "Art and Artist in Asmat Society." In M. C. Rockefeller (Ed.). *The Asmat of New Guinea*. New York, 1967.
Getzels, J. W., and Csikszentmihalyi, M. *The Creative Vision*. New York, 1976.
Ghiselin, G. (Ed.). *The Creative Process*. Berkeley, 1952.
Gilbert, K. E., and Kuhn, H. *A History of Aesthetics*. Bloomington, Ind., 1953.
Gill, D. (Ed.). *The Book of the Piano*. Oxford, 1981.
Gillian, D. J. "Ascent of Apes." (On chimpanzee reasoning by analogy.) In Griffin (2).
Gilliard, E. T. *Birds of Paradise and Bower Birds*. London, 1969.
Gillon, W. (1). *Collecting African Art*. London, 1979.
——— (2). *A Short History of African Art*. New York, 1984.
Gimpel, J. (1). *Les batisseurs des cathédrales*. Paris, 1958.
——— (2). *The Medieval Machine*. London, 1979.
Gittins, P. "Hark! The Beautiful Song of the Gibbon." *New Scientist*, Dec. 14, 1978.
Glasenapp, H. von. *Das Indienbild deutscher Denker*. Stuttgart, 1960.
Glaser, D. J. "Transcendence in the Vision of Barnett Newman." *Journal of Aesthetics and Art Criticism*, Summer 1982.
Glaser, H. S. R. "Differentiation of Scribbling in a Chimpanzee." In H. Kummer. *Behavior*, vol. 2 of *Proceedings of the Third International Congress of Primatology*. Basel, 1971.
Glaze, A. J. *Art and Death in a Senufo Village*. Bloomington, Ind., 1981.
Gnoli, R. *The Aesthetic Experience According to Abhinavagupta*. Rome, 1956.
Goetz, H. *Studies in the History, Religion and Art of Classical and Medieval India*. Wiesbaden, 1974.
Goins, J. F. "American Indian Poetry." In Preminger.
Goldberg, R. *Performance*. London, 1979.
Goldwater, R. (1). "Judgments of Primitive Art, 1905–1965." In Biebuyck (2).
——— (2). *Primitivism in Modern Art*. Rev. ed., New York, 1937.
——— (3). *Symbolism*. London, 1979.

Golomb, C. *Young Children's Sculpture and Drawing.* Cambridge, Mass. 1971.

Gombrich, E. H. (1). *Art and Illusion.* 2d ed., London, 1962.

—— (2). *The Sense of Order.* Oxford, 1979.

—— (3). *Symbolic Images.* Oxford, 1972.

Gonda, J. (1) Die Religionen Indians. vol. 1, Stuttgart, 1960.

—— (2). *Some Observations on the Relations Between "Gods" and "Powers" in the Veda.* . . . The Hague, 1957.

Goodall, J. *The Chimpanzees of Gombe.* Cambridge, 1986.

Goodman, N. *Ways of Worldmaking.* Hassocks, Sussex, 1978.

Goodnow, J. *Children's Drawing.* London, 1977.

Gorcyra, D. A., Garner, P. H., and Fouts, R. S. "Deaf Children and Chimpanzees: A Comparative Sociolinguistic Investigation." In Key.

Gordon, D. E., "German Expressionism." In Rubin (4).

Gordon, L. *Eliot's Early Years.* Oxford, 1977.

Gottlieb, C. *Beyond Modern Art.* New York, 1976.

Gould, J. L., and Gould, C. G. "The Insect Mind: Physics or Metaphysics?" In Griffin (2).

Gowing, L. "Renoir's Sentiment and Sense." In House.

Graburn, N. H. H. (1). "Eskimo Art." In Graburn (2).

—— (2). (Ed.). *Ethnic and Tourist Arts.* Berkeley, 1976.

Graham, A. C. *Two Chinese Philosophers.* London, 1958.

Graves, R. *Poems 1965–1968.* London, 1968.

Gray, C. *The Russian Experiment in Art 1863–1922.* London, 1962.

Greenblatt, S. "Filthy Rites." *Daedalus,* Summer 1982.

Greenwalt, C. H. "How Birds Sing." In B. W. Wilson.

Greenwood, J. J. D. "Sexual Selection." In Campbell and Lack.

Greig-Smith, P. "Avian Ideal Homes." *New Scientist,* Jan. 2, 1986.

Griaule, M. *Masques Dogons.* Paris, 1932.

Griaule, M., and Dieterlin, G. (1). "The Dogon." In Forde.

—— (2). *Le renard pâle.* Paris, 1965.

Griffin, D. R. (1). *Animal Thinking.* Cambridge, Mass., 1984.

—— (2). *The Question of Animal Awareness.* Rev. ed., New York, 1981.

—— (3). (Ed.) *Animal Mind—Human Mind.* Berlin, 1982.

Griffiths, P. *Modern Music,* New York, 1954.

Grohmann, W. *Paul Klee.* New York, 1954.

Grodecki, L. *Gothic Architecture.* New York, 1977.

Gross, G. E. and Rubin, I. A. "Sublimation, the Study of an Instinctual Vicissitude." *Psychoanalytic Study of the Child,* vol. 27. London, 1973.

Grube, M. A. *The Greek and Roman Critics.* London, 1965.

Guénon, R. "Oriental Metaphysics." In Needleman.

Gurin, J. "Bird's Songs Are More Than Music." Smithsonian 13 (4) July 1982.

Haak, B. *Rembrandt*. New York, 1969.

Halifax, H. (Ed.). *Shamanic Voices*. New York, 1979.

Hall, D. *Remembering Poets*. New York, 1977, 1978.

Hall-Craggs, J. "The Aesthetic Content of Bird Song." In Hinde (4).

Halliday, T. *Sexual Strategy*. Melbourne, 1980.

Hallpike, C. R. *The Foundations of Primitive Thought*. Oxford, 1979.

Hamburg, D. A., and McCown, E. R. (Eds.). *The Great Apes*. Menlo Park, Cal., 1979.

Hamill, P. "Rock of Ages." *New York* (magazine), Oct. 18, 1982.

Hamilton, H. *Painting and Sculpture in Europe 1880–1940*. Rev. ed., Harmondsworth, 1972.

Hammacher, A. M., and Hammacher, R. *Van Gogh*. New ed., New York, 1982.

Hammerstein, R. "Music as a Divine Art." In Wiener.

Handelman, D. "The Ritual Clown." *Anthropos* 76 (3/4) 1981.

Hanson, D. T. "Photography: Straight or on the Rocks?" (conversation with Max Kozloff). *Aperture* 89, 1982.

Harley, G. W. "Masks as Agents of Social Control in Northeast Liberia." *Pages of the Peabody Museum,* Harvard University, 32 (2) Cambridge, Mass., 1950.

Harré, R. and Reynolds, V. (Eds.). *The Meaning of Primate Signals*. Cambridge, 1984.

Harries, L. "African Poetry." In Preminger.

Hartmann, E., van der Volk, B., and Oldfield, M. "A Preliminary Study of the Personality of the Nightmare Sufferer: Relationships to Schizophrenia and Creativity." *American Journal of Psychiatry* 138 (6) 1981.

Hartt, F. *Michelangelo: The Complete Sculptures*. New York, 1968.

Harvey, F. *The Master Builders: Architecture in the Middle Ages*. London, 1971.

Harvey, P., and Greenwood, P. "Birds through Space and Time." *New Scientist,* April 10, 1930.

Haselberger, L. "The Construction Plans for the Temple of Apollo at Didyma." *Scientific American,* Dec. 1985.

Haskell, F. (1). *Patrons and Painters*. Rev. ed., New Haven, 1980.

——— (2). *Rediscoveries in Art*. London, 1976.

Haskell, F., and Penny, N. *Taste and the Antique*. New Haven, 1981.

Hassenstein, B. "Learning and Playing." In B. Grizmek (Ed.). *Grizmek's Encyclopedia of Ethology*. New York, 1977.

Hatch, E. *Culture and Morality*. New York, 1983.

Havighurst, R. J., and Neugarten, B. L. (Eds.). *American Indian and White Children*. Chicago, 1955.

Hay, J. "The Human Body as a Microcosmic Source of Macrocosmic Values in Calligraphy." In Bush and Murck.

Hayes, C. "The Imaginary Pulltoy." In Bruner, Jolly, and Sylva.

Heftrich, E. "Absolute Art." In Ritter.

Heller, R. *Edvard Munch: The Scream.* London, 1973.

Hemming, J. *Red Gold: The Conquest of the Brazilian Indians.* London, 1978.

Henricks, R. G. (Trans.). *Philosophy and Argumentation in Third-Century China: The Essays of Hsi-K'ang.* Princeton, 1983.

Henze, A. *Ernst Ludwig Kirchner.* Stuttgart/Zürich, 1980.

Hewison, R. *John Ruskin.* Princeton, 1976.

Hiatt, L. R. (1). "Swallowing and Regurgitating in Australian Myth and Rite." In Charlesworth et al.

———— (2). (Ed.). *Australian Aboriginal Concepts.* Canberra, 1978.

Highwater, J. *Ritual of the Wing: North American Indian Ceremonies, Music, and Dances.* New York, 1982.

Hildesheimer, W. *Mozart.* New York, 1982.

Hillier, J. *The Uninhibited Touch: Japanese Art in the Shijo Style.* London, 1974.

Himmelheber, H. (1). *Eskimokünstler.* Eisenach, 1953.

———— (2). *Negerkunst und Negerkünstler.* Braunschweig, 1960.

———— (3). "Technique and Personality of African Sculptors." In M. Mead, J. A. Bird, and H. Himmelheber (Eds.). *Technique and Personality.* New York, 1963.

Hinde, R. (1). *Biological Bases of Human Social Behavior.* New York, 1974.

———— (2). "Display." In Campbell and Lack.

———— (3). *Ethology.* London, 1982.

———— (4). (Ed.). *Bird Vocalizations.* Cambridge, 1969.

———— (5). *Non-Verbal Communication.* Cambridge, Mass., 1972.

Hivale, S. *The Pardhans of the Upper Narbada Valley.* Bombay, 1946.

Ho, Wai-kam. "Tung Ch'i-ch'ang's New Orthodoxy and the Southern School Theory." In Murck.

Ho, Wai-kam, et al. *Eight Dynasties of Chinese Painting.* Cleveland, 1980.

Hobbs, R. G., and Levin, G. *Abstract Expressionism: The Formative Years.* New York, 1978.

Hodos, W. "Some Perspectives on the Evolution of Intelligence and the Brain." In Griffin (2).

Holbrook, D. "Creativity in Children's Writing and Contemporary Culture." In B. Ford (Ed.). *The New Pelican Guide to English Literature.* Vol. 8, *The Present.* Harmondsworth, 1983.

Holm, B. *Northwest Coast Indian Art.* Seattle, 1965.

Holt, H. (Ed.). *The Writings of Robert Smithson (1938–1973).* New York, 1979.

Holzman, D. (1). "Confucius and Ancient Chinese Literary Criticism." In Rickett.

——— (2). *Poetry and Politics: The Life and Works of Juan Chi* (A.D. 210–263). Cambridge, 1970.

Honour, H. (1). *Chinoiserie*. New York, 1961.

——— (2). *Neo-Classicism*. Harmondsworth, 1968.

——— (3). *Romanticism*. London, 1979.

Hooker, T., and Hooker, B. I. "Duetting." In Hinde. (4).

Hornig, G. "Inspiration." In Ritter.

Hountondji, P. J. *African Philosophy: Myth and Reality*. London, 1983.

Hsiang Ta. "European Influences on Chinese Art in the Later Mind and Early Ch'ing Period." In Watt.

House, J. "Renoir's Worlds." In *Renoir,* exh. cat. of Art Council of Great Britain. M. Raeburn (Ed.). New York, 1985.

Hudson, L. *Bodies of Knowledge: The Significance of the Nude in Art*. London, 1982.

Huet, M. *The Dance, Art, and Ritual of Africa*. New York, 1978.

Hughes, R. *The Shock of the New*. New York, 1981.

Huizinga, J. *Homo Ludens*. London, 1949.

Hultkranz, A. (1). *The Religions of the American Indians*. Berkeley, 1979.

——— (2). *The Study of American Indian Religions*. New York, 1984.

Hunter, S. *Isamu Noguchi*. New York, 1978.

Hutchins, M., and Barash, D. P. "Grooming in Primates." *Primates* 17 (1) April 1976.

Immelmann, K. "Behaviour, Development of." In Campbell and Lack.

Ingalls, D. S. (Trans.). *An Anthology of Sanskrit Court Poetry*. Cambridge, Mass., 1965.

Ione, N. B., and Konner, M. J. "!Kung Knowledge of Animal Behavior." In Lee and Devore.

IRCAM (Institute de Recherche et de Coordination Acoustique/Musique) brochure. Paris, 1974.

Iverson, E. "The Canonical Tradition." In J. R. Harris (Ed.). *The Legacy of Egypt*. London, 1971.

Ives, C. F. *The Great Wave*. New York, 1974.

Izutsu, R., and Izutsu, F. *The Theory of Beauty in the Classical Aesthetics of Japan*. The Hague, 1981.

Jacob, E. *Theology of the Old Testament*. London, 1958.

Jaffé, H. "Vincent van Gogh's Suche nach dem heiteren Leben in japanischen Holzschnitt." In Wichmann (2).

Jahoda, G., and McGurk, H. "The Development of Picture Perception in Children from Different Cultures." In A. Wagner and H. W. Stevenson (Eds.). *Cultural Perspectives on Child Development*. San Francisco, 1982.

James, F. C., and McCulloch, E. E. "Data Analysis and Design of Experiments in Ornithology." In Johnston.

James, P. (Ed.). *Henry Moore on Sculpture*. London, 1966.

Janson, H. (1). "Chance Images." In Wiener.

——— (2). *16 Studies*. New York, 1973.

Jay, P. (Ed.). *Primates*. New York, 1968.

Jean, M. *Histoire de la peinture surréaliste*. Paris, 1959.

Jellis, R. *Bird Sounds and Their Meaning*. London, 1977.

Jellis, R. F., and Hall-Craggs, J. M. "Music, Birds in." In Campbell and Lack.

Jenkins, I. "Art for Art's Sake." In Wiener.

Jenkins, R. *The Victorians and Ancient Greece*. Cambridge, Mass, 1980.

Joachimides, C. M., and Rosenthal, N. (Eds.). *Zeitgeist: International Art Exhibition Berlin, 1982*. New York, 1983.

Johansson, G. "Visual Motion Perception." *Scientific American*, June 1975.

Johnson, H. *Claes Oldenburg*. Harmondsworth, 1971.

Johnston, R. F. (1). "Preface." In Johnston (2).

——— (2). (Ed.). *Current Ornithology*, vol. 2. New York, 1985.

Jolly, A. *The Evolution of Primate Behavior*. 2d ed., New York, 1985.

Jones, A. A. "Australia, Australian Aboriginal Music." In Arnold.

Jordan, Z. P. "Foreword." In A. J. Jordan. *Tales from Southern Africa*. Berkeley, 1978.

Jullien, R. *Les Mouvements des arts du romantisme au symbolisme*. Paris, 1970.

Junker, H. *Die gesellschaftliche Stellung der ägyptischen Kunstler im Alten Reich*. Vienna, 1959.

Kahnweiler, D.-H., et al. *Picasso: 1881–1973*. London, 1973.

Kammer, R. *Zen and Confucius in the Art of Swordsmanship*. London, 1978.

Kanazawa, H. *Japanese Ink Painting*. Tokyo, 1979.

Kandinsky, N. *Kandinsky et moi*. Paris, 1978.

Kane, P. V. *History of Sanskrit Poetics*. 3rd ed., Delhi, 1961.

Kane, R. "A Pilot Study on the Ecology of Pygmy Chimpanzees, *Pan Paniscus*." In Hamburg and McCown.

Kaplan, J. *Walt Whitman*. New York, 1961.

Kaplan, J. O. In R. Cavendish (Ed.). *Legends of the World*. London, 1982.

Karginov, G. *Rodchenko*. London, 1979.

Kato, S. (1). *Form, Style, Tradition: Reflections on Japanese Art and Society*. Tokyo, 1981.

——— (2). *A History of Japanese Literature*. Vols. 1, 2, London, 1979, 1983.

Kavanaugh, M. *A Complete Guide to Monkeys, Apes, and Other Primates*. London, 1983.

Kawakita, M. *Modern Currents in Japanese Society*. New York/Tokyo, 1961.

Kees, H. *Ancient Egypt*. London, 1961.

Keil, C. *Tiv Song*. Chicago, 1979.

Keith, A. B. *A History of Sanskrit Literature*. London, 1920.

Kellogg, R. *Analyzing Children's Art*. Palo Alto, 1971.

Kenny, A. *The God of the Philosophers*. Oxford, 1979.

Kepes, G. (Ed.). *Nature and the Art of Motion*. New York, 1975.

Kernan, J., and Tyson, A. *The New Grove Beethoven*. London, 1983.

Key, M. R. (Ed.). *Nonverbal Communication Today: Current Research*. Berlin, 1982.

Khatibi, A., and Sijelmassi, M. *The Splendour of Islamic Calligraphy*. London, 1976.

Kidson, P. "The Figural Arts." In M. I. Finley (Ed.). *The Legacy of Greece*. Oxford, 1981.

King, J. C. H. *Portrait Masks from the Northwest Coast of America*. London, 1979.

Kirby, P. "The Musical Practices of the Bushmen." *Bantu Studies* 10, 1936; cited in M. Schneider. "Primitive Music." In Wellesz.

Kischkewitz, H. *Egyptian Drawings*. London, 1972.

Klee, F. (Ed.). *The Diaries of Paul Klee*. Berkeley, 1969.

Yves Klein: 1941–1962: Selected Writings. London (Tate Gallery), 1974.

Kohut, H. (1). *The Analysis of the Self*. New York, 1971.

——— (2). *The Restoration of the Self*. New York, 1977.

Kokoschka, O. *My Life*. London, 1974.

Konishi, M., and Nottebohm, F. "Experimental Studies in the Ontogeny of Avian Vocalization." In Hinde (4).

Konner, M. *The Tangled Wing: Biological Constraints on the Human Spirit*. New York, 1982.

Kozloff, M. *Photography and Fascination*. Danbury, N.H., 1979.

Kramer, E. *Art as Therapy with Children*. New York, 1971.

Kramrisch, S. (1). *The Presence of Siva*. Princeton, 1981.

——— (2). "Traditions of the Indian Craftsman." In M. Singer (Ed.). *Traditional India*. Philadelphia, 1959.

Kraus, H. *The Living Theatre of Medieval Art*. London, 1967.

Krebs, J. R. "Behaviour, History of." In Campbell and Lack.

Kreitler, H., and Kreitler, S. *The Psychology of the Arts*. Durham, N.C., 1972.

Krige, J. D., and Krige, E. J. "The Lovedu of the Transvaal." In Forde.

Krupat, A. "The Indian Autobiography." In Swann.

Kris, E., and Kurz, O. *Legend, Myth, and Magic in the Image of the Artist*. New Haven, 1979.

Krishnamoorthy, K. (Trans.). *Anandavardhana's Dhvanaloka*. Dharwar, India, 1974.

Kroeber, K., and Walling, W. *Images of Romanticism: Verbal and Visual Affinities*. New Haven, 1978.

Kroodsma, D. E., et al. "Vocal Dialects in Nuttall's White-Crowned Sparrow." In Johnston (2).

Kubler, G. *The Shape of Time*. New Haven, 1962.

Kuh, K. "Clyfford Still." In J. P. O'Neill. *Clyfford Still*. New York, 1979.

Kummer, H. "Social Knowledge in Free-Ranging Primates." In Griffin (3).

"Kung Hsien: Theorist and Technician in Painting." *The Nelson Gallery and Atkins Museum Bulletin* 4 (9) 1969.

Kuntze, H. *Kung Hsien*. Cologne, 1965.

Kupka, K. *Dawn of Art*. New York, 1962.

Kuspit, D. B. "Authoritarian Aesthetics and the Elusive Alternative." *Journal of Aesthetics and Art Criticism*, Spring, 1983.

Laclotte, M. (Ed.). *Petit Larousse de la Peinture*. 2 vols., Paris, 1979.

Lane, R. "The Shunga in Japanese Art." In Rawson.

Lange-Eichbaum, W. *Genie, Irrsinn und Ruhm*. Munich/Basel, 1956. (The characteristic position of the author is softened by editors in later editions.)

Lannoy, R. *The Speaking Tree*. London, 1971.

Laude, J. "Die französiche Malerei und die 'Negerkunst.'" In Wichmann (2).

Lawick-Goodall, J. van. (1). *In the Shadow of Man*. London, 1971.

———— (2). "Mother Chimpanzees' Play with Their Infants." In Bruner, Jolly, and Sylva.

———— (3). "A Preliminary Report on Expressive Movements and Communication in the Gombe Stream Chimpanzees." In Jay.

Lawton, T. *Chinese Figure Painting*. Washington, D.C., 1973.

Layton, R. *The Anthropology of Art*. London, 1981.

Leach, B. *The Potter's Challenge*. London, 1976.

Leach, E. "Of Ecstasy and Rationality." In Csaky.

Lebrecht, N. *The Book of Musical Anecdotes*. London, 1985.

Leclant, J. (Ed.). *L'Egypte du crépuscule*. Paris, 1980.

Ledderose, L. (1). *Mi Fu and the Classical Tradition of Chinese Calligraphy*. Princeton, 1979.

———— (2). "Subject Matter in Early Chinese Painting Criticism." *Oriental Art* (N.S. 19.1) Spring, 1973.

Lee, E. E., and Fong, Wen. *Streams and Mountains Without End. Artibus Asiae*, Supplementum 14, 1955.

Lee, R. B. *The Dobe !Kung*. New York, 1984.

Lee, R.B., and Devore, I. (Eds.). *Kalahari Hunter-Gatherers*. Cambridge, Mass., 1976.

Lee, S. E. (1). *Chinese Landscape Painting*. Cleveland, 1962.

———— (2). *The Colors of Ink*. New York, 1974.

—— (3). *A History of Far-Eastern Art.* 4th ed., New York, 1982.

—— (4). *Reflections of Reality in Japanese Art.* Cleveland, 1983.

Lee S. E., and Ho, Wai-kam. *Chinese Art Under the Mogols.* Cleveland, 1968.

Lee, S. G. M., and Mayes, A. R. *Dreams and Dreaming.* Harmondsworth, 1973.

Lefèvre, C. *Pays Dogon.* Paris, 1972.

Leiris, M. "The Artist and the Model." In Kahnweiler et al.

Leiris, M., and Delange, J. *Afrique noire.* Paris, 1967.

Leon-Portilla, M. *Pre-Columbian Literatures of Mexico.* Norman, Okla., 1969.

Leslau, C., and Leslau, W. *African Proverbs.* New York, 1976.

Lestrade, G. "Traditional Literature." In Schapera.

Lévi-Strauss, C. *The Way of the Masks.* London, 1983.

Levy, J. "Mental Processes in the Nonverbal Hemisphere." In Griffin (3).

Lewcock, R. "Materials and Techniques." In G. Michell (Ed.). *Architecture of the Islamic World.* London, 1978.

Lewis, B. E. *George Grosz.* Madison, Wis., 1971.

Lewis, W. *The Demon of Progress.* Chicago, 1955.

Li, Chu-tsing. (1). *The Autumn Colors on the Ch'iao and Hua Mountains: A Painting by Chao Meng-fu.* Ascona, Switzerland, 1965.

—— (2). "The Bamboo Paints of Chin Nung." *Archives of Asian Art* 27, 1973–74.

—— (3). "*Rocks and Trees* and the Art of Ts-ao Chih-po." *Artibus Asiae* 23, 1961.

—— (4). "Stages of Development in Yüan Landscape Painting." *National Palace Museum Bulletin* 4(2) May–June 1969; 4(3) July–Aug. 1969.

—— (5). *A Thousand Peaks and Myriad Ravines: Chinese Paintings in the Charles A. Drenowatz Collection.* 2 vols., Ascona, Switzerland, 1974.

—— (6). *Trends in Modern Chinese Painting.* Ascona, Switzerland, 1979.

Li, Lin-ts'an. "Pine and Rock, Wintry Tree, Old Tree and Bamboo and Rock: The Development of a Theme." *National Palace Museum Bulletin* 4(6) Jan.–Feb. 1970.

Licht, F. *Goya and the Origins of the Modern Temper in Art.* New York, 1979.

Liebert, R. S. *Michaelangelo: A Psychoanalytic Study of His Life and Images.* New Haven, 1983.

Lin, Shen-fu. *The Transformation of the Chinese Lyrical Tradition.* Princeton, 1978.

Lin Yutang. *The Chinese Theory of Art.* London, 1967.

Lindzey, G., and Aronson, A. *The Handbook of Social Psychology.* 2d ed., vol. 3. Reading, Mass., 1969.

Lipman, J., and Marshall, R. *Art About Art.* New York, 1978.

Lippard, L. R. *Ad Reinhardt.* New York, 1981.

Lippe, A. "Kung Hsien and the Nanking School." *Oriental Art* (N.S. 2) Spring–Winter, 1956.

Lipsey, R. *Coomaraswamy*. Princeton, 1977.

Liu, J. Y. (1). *Chinese Theories of Literature*. Chicago, 1975.

—— (2). (Trans.) *Major Lyricists of the Northern Sung*. Princeton, 1974.

Liu, J. Y. and Lo, I. Y. (Eds.). *Sunflower Splendor*. Garden City, N.Y. 1975.

Lloyd, B. *Perception and Cognition: A Cross-Cultural Perspective*. Harmondsworth, 1972.

Lloyd, V., and Gay, J. *Universals of Human Thought*. Cambridge, 1981.

Loehr, M. (1). "Art-Historical Art." *Oriental Art*, (N. S. 16.1) Spring, 1970.

—— (2). *The Great Painters of China*. Oxford, 1980.

—— (3). "Individualism in Chinese Art." *Journal of the History of Ideas* 22(2) April–June 1961.

—— (4). "Phases and Content in Chinese Painting." *Proceedings of the International Symposium on Chinese Painting*. Taipei, 1972.

Loizos, C. "Play Behaviour in Higher Primates: A Review." In Morris (4).

Lokke, K. E. "The Rome of Sublimity in the Development of Modernist Aesthetics." *Journal of Aesthetics and Art Criticism*, Summer 1982.

Long, R.-C. W. *Kandinsky*. Oxford, 1980.

Longinus. "On Sublimity." In Russell and Winterbottom.

Lubin, A. J. *Stranger on the Earth: A Psychological Biography of Vincent van Gogh*. New York, 1972.

Luce, G. G. *Biological Rhythms in Human and Animal Physiology*. New York, 1971.

Lucie-Smith, E. (1). *Art in the Seventies*. Oxford, 1980.

—— (2) *The Story of Craft: The Craftsman's Role in Society*. Oxford, 1980.

Lui, Shou Kwan. "The Six Canons of Hsieh Ho." *Oriental Art* (N.S. 17) Summer 1971.

Lumsden, C. J., and Wilson, E. O. *Promethean Fire*. Cambridge, Mass., 1983.

Lynn, R. J. "Alternate Routes to Self-Realization. . . . " In Bush and Murck.

Lynton, R. *The Role of Modern Art*. Oxford, 1980.

McCully, M. (Ed.). *A Picasso Anthology*. Princeton, 1982.

McFarland, D. (1). *Animal Behaviour*. London, 1985.

—— (2). (Ed.). *The Oxford Companion to Animal Behaviour*. Oxford, 1981.

Machlis, J. *Introduction to Contemporary Music*. 2d ed., London, 1980.

MacKinnon, J. (1). *The Ape Within Us*. London, 1976.

—— (2). "Reproductive Behavior in Wild Orangutan Populations." In Hamburg and McCown.

McLeod, M. D. *The Asante*. London, 1981.

Macnair, P. L., Hoover, A. L., and Neary, K. *The Legacy: Tradition and Innovation in Northwest Coast Indian Art*. Vancouver/Seattle, 1984.

McPhee, C. *A House in Bali*. London, 1947.

Maddock, K. "The World Creative Powers." In Charlesworth et al.

McNeish, J., and Simmons, D. *Art of the Pacific*. New York, 1980.

Maeda, R. J. (1). "*Chieh-hua*: Ruled-line Painting in China." *Ars Orientalis* 10, 1975.

——— (2). *Two Twelfth Century Texts on Chinese Painting*. Ann Arbor, 1970.

——— (3). "The 'Water' Theme in Chinese Painting." *Artibus Asiae* 33(4) 1971.

Majumdar, R. C. *Corporate Life in Ancient India*. Calcutta, 1918.

Malcolm, J. *Diana & Acton: Essays on the Aesthetic of Photography*. Boston, 1980.

Mallayya, N. V. "Some Modern Critics and Ancient Texts on the Aesthetic Value of Hindu Images." *Journal of the Indian Society of Oriental Art* 10, 1942.

Malraux, A. (1). "Foreword" to *The Nelson A. Rockefeller Collection: Masterpieces of Primitive Art*. New York, 1978.

——— (2). *Picasso's Mask*. New York, 1976.

——— (3). *The Voices of Silence*. Garden City, N.Y., 1953.

Mann, T. *Letters of Thomas Mann*. Vol. 1, *1889–1941*. London, 1970.

Maquet, J. (1). "Art by Metamorphosis." *African Arts* 12(4) Aug. 1979.

——— (2). *The Aesthetic Experience*. New Haven, 1986.

Margolis, J. *Art and Philosophy*. Atlantic Highlands, N.J., 1980.

Marler, P., and Peters, S. "Structural Changes in Song Ontogeny in the Swamp Sparrow *Melospiza Georgiana*." *Auk* 99(3) July 1982.

Marrou, H. I. *A History of Education in Antiquity*. London/N.Y., 1956.

Marshall, C. "Towards a Comparative Aesthetics of Music." In Falck and Rice.

Marshall, L. "Sharing, Talking, and Giving." In Lee and Devore.

Marten, M., et al. *Worlds Within Worlds*. London, 1977.

Marti, M. P. *Les Dogon*. Paris, 1957.

Martindale, A. *The Rise of the Artist in the Middle Ages and the Renaissance*. London, 1972.

Martines, L. *Power and Imagination: City-States in Renaissance Italy*. New York, 1979.

Mashek, J. *Marcel Duchamp in Perspective*. Englewood Cliffs, N.J., 1975.

Mason, S. *Short Lives*. London, 1981.

Mason, W. A. "Environmental Models and Mental Modes: Representational Processes in the Great Apes." In Hamburg and McCown.

Masson, J. L., and Patwardhan, M. W. *Santarasa and Abhinavagupta's Philosophy*. Poona, 1969.

Matthäus, M. "Kreativität." In Ritter.

Maurer, E. "Dada and Surrealism." In Rubin (4).

Mencius. (1). J. Legge (Trans.) Reprint, New York, 1970.

———— (2). D. C. Lau (Trans.) Harmondsworth, 1970.

Menuhin, Y., and Primrose, W. *Yehudi Menuhin Music Guides: Violin and Viola.* London, 1976.

Menzel, E. W., Jr. "Communication of Object-Locations in a Group of Young Chimpanzees." In Hamburg and McCown.

Merriam, A. P. (1). "The Bala Musician." In d'Azevedo (3).

———— (2). "On Objections to Comparison in Ethnomusicology." In Falck and Rice.

Mervin, W. S., and Masson, J. M. (Trans.). *Sanskrit Love Poetry.* New York, 1977.

Messenger, J. C. "The Carver in Anang Society." In d'Azevedo (3).

Meyer, L. B. *Music, the Arts, and Ideas.* Chicago, 1967.

Michelangelo. *Life, Letters, and Poetry.* G. Butt and P. Porter (Trans.). Oxford, 1987.

Michell, G. *The Hindu Temple.* London, 1977.

Miller, B. S. *The Hermit and the Love-Thief.* New York, 1978.

Milner, M. *Le Romantisme,* vol. I. Paris, 1973.

Miner, E. *Japanese Linked Poetry.* Princeton, 1979.

Minorsky, V. (Trans.). *Calligraphers and Painters: A Treatise by Qadi Ahmed, Son of Min-Munshi, c. A.H. 1015/A.D. 1606.* Freer Gallery Occasional Papers. Washington, D.C., 1959.

Miro, J. *Catalan Notebooks.* Presented by G. Picon. Geneva, 1977.

Mitchell, D. *The Language of Modern Music.* New ed., London, 1976.

Mitter, P. *Much Maligned Monsters: History of European Reactions to Indian Art.* Oxford, 1977.

Mondrian, P. *Plastic Art and Pure Plastic Art.* New York, 1945.

Montaigne, M. de. *The Complete Works of Montaigne.* D. Frame (Trans.). Stanford, Cal., 1957.

Montet, P. (1). *Eternal Egypt.* New York, 1964.

———— (2). *Everyday Life in Egypt in the Days of Rameses the Great.* London, 1958.

Moore, G., and Beier, U. (Eds.). *The Penguin Book of Modern African Poetry.* 3rd ed. (retitled), Harmondsworth, 1984.

Moore, H. *Henry Moore at the British Museum.* London, 1981.

Mori, H. *Japanese Portrait Sculptures.* Tokyo, 1977.

Morris, D. (1). *Animal Days.* New York, 1981.

———— (2). *The Biology of Art.* New York, 1962.

———— (3). *Manwatching.* London, 1977.

———— (4). (Ed.). *Primate Ethology.* London, 1967.

Morrison, B. "Notes on the Grand Romantic Virtuosos and After." In Gill.

Mote, F. W. (1). "The Arts and the 'Theorizing Mode' of the Civilization." In Murck.

——— (2). "Confucian Eremitism in the Yüan Period." In A. F. Wright (Ed.). *The Confucian Persuasion.* Stanford, Cal., 1960.

Mountford, C. P. *Records of the American-Australian Scientific Expedition to Arnhem Land, I: Art, Myth and Symbolism.* Melbourne, 1956.

Mukerjee, R. *The Flowering of Indian Art.* Bombay, 1964.

Müller-Braunschweig, H. "Psychopathology and Creativity." *The Psychoanalytic Study of Society,* vol. 6, 1975.

Mulligan, J. A., and Olsen, K. C. "Communication in Canary Courtship Calls." In Hinde (4).

Munkata, K. *Ching-Hao's "Pi-fa-chi." A Note on the Use of the Brush. Artibus Asiae* Supplementum 31. Ascona, Switzerland, 1974.

Munn, N. D. *Walbiri Iconography.* Ithaca, 1973.

Munsterberg, H. *Dragons in Chinese Art.* New York, 1971.

Murck, C. F. (Eds.). *Artists and Traditions: Uses of the Past in Chinese Culture.* Princeton, 1976.

Murdock, P. G. *Atlas of World Cultures.* Pittsburgh, 1981.

Murdin, P., and Malin, D. *Colours of the Stars.* Cambridge, 1984.

Myers, H. (1). "African Music." In Arnold.

——— (2). "American Indian Music." In Arnold.

Nahm, M. C. "Creativity in Art." In Wiener.

Nakata, Y. *The Art of Japanese Calligraphy.* New York/Tokyo, 1973.

Navratil, L. "Art-Bridge Between Normality and Psychosis." *Du 9,* 1979.

Needleman, J. (Ed.). *The Sword of Gnosis.* Baltimore, 1979.

Nelson, S. E. "I-p'in in Later Chinse Painting Criticism." In Bush and Murck.

Newhall, B. *The History of Photography.* Rev. eds., New York, 1964; New York/Boston, 1982.

Newton, D. "Primitive Art." In *The Nelson A. Rockefeller Collection: Masterpieces of Primitive Art.* New York, 1978.

Nichols, R. *Messiaen.* London, 1975.

Nishida, T. "Local Traditions and Cultural Transmission." In Smuts et al.

Nochlin, L. (Ed.). *Realism and Tradition in Art 1848–1900.* Englewood Cliffs, N.J., 1966.

Norberg-Schulz, C. *Intentions in Architecture.* Cambridge, Mass., 1965.

Nottebohm, F. "Vocal Behavior in Birds." In D. S. Faner, J. R. King, and K. C. Parkes (Eds.). *Avian Biology,* vol. 5. New York, 1975.

Nunley, J. W. "Ntowie: Sisala Carver." *African Arts* 12(1) Nov., 1979.

Nyman, M. *Experimental Music: Cage and Beyond.* New York, 1974.

O'Flaherty, W. D. (Trans.). *Hindu Myths.* Harmondsworth, 1975.

Okamoto, Y. *The Namban Art of Japan.* New York/Tokyo, 1972.

Okpewho, I. *Myth in Africa: A Study of Its Aesthetic and Cultural Relevance.* Cambridge, 1983.

Olney, J. *Tell Me Africa: An Approach to African Literature.* Princeton, 1973.

Olschak, B. C., and Wangyal, G. T. *Mystic Art of Ancient Tibet.* London, 1973.

O'Neill, J. P. (Ed.). *Clyfford Still.* New York, 1979.

Onians, J. *Art and Thought in the Hellenistic Age.* London, 1979.

Ortiz, A. (Ed.). *Handbook of North American Indians.* Vol. 9, *Southwest.* Washington, D.C., 1979.

Osborne, H. *Abstraction and Artifice in Twentieth-Century Art.* Oxford, 1979.

Ostow, M. *The Psychology of Melancholy.* New York, 1970.

Otten, C. M. (Ed.). *Anthropology and Art.* Garden City, N.Y., 1971.

Owen, S. (1). *The Poetry of the Early T'ang.* New Haven, 1977.

———— (2). *The Great Age of Chinese Poetry: The High T'ang.* New Haven, 1981.

———— (3). *The Poetry of Meng Chiao and Han Yü.* New Haven, 1975 (not consulted).

Paine, S. (Ed.). *Six Children Draw.* London, 1981.

Pal, P. *The Art of Tibet.* Berkeley, 1983.

Pandey, K. C. (1). *Abhinavagupta.* 2d ed., Varanasi, India, 1963.

———— (2). *Comparative Aesthetics, Vol. 1: Indian Aesthetics.* Banaras, 1950.

Pang, M. Q. "Tung Ch'i-ch'ang and His Circle." In Cahill (8).

Panofsky, E. (1). *Idea.* Columbia, N.C., 1968.

———— (2). *The Life and Art of Albrecht Dürer.* 4th ed., Princeton, 1955.

Papadopoulo, A. *Islam and Muslim Art.* New York, 1979.

Paret, P. *The Berlin Succession.* Cambridge, Mass., 1982.

Parin, P., Morgenthaler, F., and Parin-Matthey, C. *Les Blancs pensent trop: 13 entretiens psychanalytiques avec les Dogons.* Paris, 1966. (German original, Zürich, 1963).

Passingham, R. *The Human Primate.* Oxford, 1982.

Paudrat, J.-L. (1). "The Arrival of Tribal Objects in the West: From Africa." In Rubin (4).

———— (2). "Negative Rezeption traditioneller afrikanischer Kunst im 19. Jahrhundert." In Wichmannn (2).

Paulme, D. "Adornment and Nudity in Tropical Africa." In Forge.

Paulsen, R. *Literary Landscape: Turner and Constable.* New Haven, 1982.

Peltier, P. "The Arrival of Tribal Objects in the West from Oceania." In Rubin (4).

Pemberton, J. "Eshu-Elegba: The Yoruba Trickster-God." *African Arts* 9(1) Oct. 1975.

Perpeet, W. "Einfühlungsästhetik." In Ritter.

Perrins, S. M., and Middleton, A. L. A. (Eds.). *The Encyclopedia of Birds.* London, 1985.

Pettitt, G. A. *Primitive Education in North America.* Berkeley, 1946.

Peyser, J. *Boulez.* New York, 1976.

Pfeiffer, R. (1). *History of Classical Scholarship.* London, 1968.

—— (2). *History of Classical Scholarship 1300–1850.* London, 1976.

Pickin, L. "China." In Wellesz.

Pickford, R. W. *Psychology and Visual Aesthetics.* London, 1972.

Piddington, R. *Essays in Polynesian Ethnology.* Cambridge, 1939.

Pines, M. "Love Songs and Bird Brains." *Psychology Today,* June 1983.

Pippet, G. "Teaching Wood-Carving at Achimota." In M. E. Sadler (Ed.). *Arts of West Africa.* London, 1935.

Plant, M. *Paul Klee: Figures and Faces.* London, 1978.

Plotinus. A. M. Armstrong (Trans.). London, 1953.

Podro, M. (1). *The Critical Historians of Art.* New Haven, 1982.

—— (2). *The Manifold in Perception.* New Haven, 1982.

Poignant, P. *Oceanic Mythology.* London, 1967.

Poirier, J. *Encyclopédie de la Pléiade, Ethnologie régionale, I, Afrique—Océanie.* Paris, 1972.

Polakoff, C. "Crafts and the Concept of Art in Africa." *African Arts* 12(1) Nov., 1978.

Pollard, D. *"Ch'in* Literary Theory." In Rickett.

Pollitt, J. J. (1). *The Ancient Greek View of Art.* New Haven, 1974.

—— (2). *The Art of Greece.* Englewood Cliffs, N.J., 1965.

Pope-Hennessy, J. (1) *The Portrait in the Renaissance.* London, 1966.

—— (2). *Italian High Renaissance and Baroque Sculpture.* 2d ed., London, 1970.

Powell, R. *The Social Behavior of Monkeys.* Harmondsworth, 1974.

Poynor, R. E. *The Ancestral Art of Owo, Nigeria.* Ann Arbor, 1980 (authorized facsimile).

Pradel, J.-L. (Ed.). *World Art Trends 1982.* New York, 1983.

Prakash, V. *Khajuraho.* Bombay, 1967.

Premak, D., and Premak, A. I. *The Mind of an Ape.* New York, 1983.

Preminger, A. (Ed.). *Princeton Encyclopedia of Poetry and Poetics.* 2d ed., Princeton, 1974.

Prinzhorn, H. *Artistry of the Mentally Ill.* New York, 1972.

Pye, D. *The Nature and Art of Workmanship.* London, 1971.

Quiatt, D. "Devious Intensions of Monkeys and Apes." In Harré and Reynolds.

Raabe, P. (Ed.). *The Era of Expressionism.* London, 1974.

Radin, P. (1). "Primitive Literature." In C. Laird (Ed.). *The World Through Literature.* New York, 1951.

—— (2). *Primitive Man as Philosopher*. New York, 1927.

—— (3). *The Trickster*. New York, 1956.

Raeburn, P. "An Uncommon Chimp." *Science 83*, June.

Rajan, K. V. S. *Indian Temple Styles*. New Delhi, 1970.

Ramanujan, A. K. "Indian Poetics." In Dimock et al.

Randhwa, M. S. (1). *Bahsoli Painting*. New Delhi, 1959.

—— (2). *Kangra Valley Painting*. New Delhi, 1966.

Rao, T. A. G. *Talamana or Iconometry*. Calcutta, 1920.

Rapoport, A. *House Form and Culture*. Englewood Cliffs, N.J., 1969.

Rasmussen, K. (1). *Eskimo Poems*. T. Lowenstein (Trans.). Pittsburgh, 1973.

—— (2). *Intellectual Culture of the Copper Eskimos*. Copenhagen, 1932.

—— (3). *Intellectual Culture of the Hudson-Bay Eskimos*. Copenhagen, 1930.

—— (4). *The Netsilik Eskimos: Social Life and Spiritual Culture*. Copenhagen, 1931.

Rawson, P. (1). "India." In Rawson (2).

—— (2). (Ed.). *Erotic Art of the East*. London, 1973.

Ray, N. *An Approach to Indian Art*. Chandigarh, 1974.

Redford, D. B. *Akhenaten*. Princeton, 1984.

Reichard, G. A. *Navaho Religion*. Vol. 1, New York, 1950.

Restak, R. "Islands of Genius." *Science 82*, May.

Restany, P. (1). *Le Nouveau Réalisme*. Paris, 1978.

—— (2). *Yves Klein*. New York, 1982.

Reynolds, V. *The Apes*. New York, 1971.

Richardson, J. "Picasso: A Retrospective View." In McCully.

Richter, H. *Dada Profile*. Zürich, 1961.

Richter, I. (1). *Paragone: A Comparison of the Arts by Leonardo da Vinci*. London, 1949.

—— (2). *Selections from the Notebooks of Leonardo da Vinci*. London, 1952.

Rickett, A. A. (Ed.). *Chinese Approaches to Literature from Confucius to Liang Ch'i-ch'ao*. Princeton, 1978.

Ridgway, B. S. *The Archaic Style in Greek Sculpture*. Princeton, 1977.

Ridley, M. "Sexual Dimorphism." In Campbell and Lack.

Riefenstahl, L. *The Last of the Nuba*. London, 1973.

Riesman, P. *Freedom in Fulani Social Life*. Chicago, 1977.

Rimbaud, A. *Oeuvres complètes*. Vol. 1, A. Adam (Ed.). Paris, 1972.

Rist, J. *Plotinus: The Road to Reality*. Cambridge, 1967.

Ristau, C. A., and Robbins, D. "Cognitive Aspects of Ape Language Experiments." In Griffin (3).

Ritter, J. (Ed.). *Historisches Wörterbuch der Philosophie*. Basel, 1971–.

Ritzenthal, R. E., and Ritzenthal, P. *The Woodland Indians of the Western Great Lakes*. Garden City, N.Y., 1970.

Robinson, G. W. (Trans.). *Poems of Wang Wei.* Harmondsworth, 1973.

Rochberg-Halton, E. *The Meaning of Things.* Cambridge, 1981.

Rock, I. *Perception.* New York, 1984.

Rockwell, J. *All American Music in the Late Twentieth Century.* New York, 1983.

Roethel, H. K. *Kandinsky.* Oxford, 1979.

Rogers, R. *Metaphor: A Psychoanalytic View.* Berkeley, 1978.

Rosenberg, H. (1). *The De-definition of Art.* New York, 1978.

—— (2). *De Kooning.* New York, 1973.

Rosenberg, J. *On Quality in Art.* Princeton, 1967.

Rosenberg, J. D. (Ed.). *The Genius of John Ruskin.* London, 1979.

Rosenthal, M. *The Painter and His Landscape.* New Haven, 1983.

Roth, A. "Indonesia." In Arnold.

Rothenberg, A. *The Emerging Goddess.* Chicago, 1979.

Rothenberg, J. (1) (Ed.). *Technicians of the Sacred.* New York, 1968.

—— (2). "Total Translation." In Chapman.

Rothenberg, and Rothenberg, D. (Eds.). *Symposium of the Whole.* Berkeley, 1983.

Routh, R. *Stravinsky.* London, 1975.

Rowell, M. *Jean Dubuffet.* New York, 1973.

Rowland, B. (1). *The Art and Architecture of India.* Rev. ed., Harmondsworth, 1967.

—— (2). *Art in East and West.* Cambridge, Mass., 1954.

Rowley, G. *Principles of Chinese Painting.* Princeton, 1947.

Rubin, W. (1). *Miro in the Collection of the Museum of Modern Art.* New York, 1973.

—— (2). "Modernist Primitivism: An Introduction." In Rubin (4).

—— (3). "Picasso." In Rubin (4).

—— (4). (Ed.). *"Primitivism" in 20th Century Art: Affinity of the Tribal and the Modern.* New York, 1984.

Russell, D. A., and Winterbottom, M. (Trans.). *Ancient Literary Criticism.* London, 1972.

Russell, J. (1). *Francis Bacon.* Rev. ed., London, 1979.

—— (2). *The Meanings of Modern Art.* London, 1981.

Ryckmans, P. *Les "Propos sur la Peinture" de Shitao.* Brussels, 1970.

Sachs, C. *The Wellsprings of Music.* Reprint, New York, 1977.

Sackenheim, F. (Trans.). *The Silent Zero in Search of Sound . . .* (anthology of Chinese poems). New York, 1968.

Safadi, W. S. *Islamic Calligraphy.* London, 1978.

Sahakian, W. S. *History and Systems of Psychology.* New York, 1975.

Sakanishi, S. (1). (Trans.). *An Essay on Landscape Painting by Kuo Hsi*. London, 1935.

—— (2). (Trans.). *The Spirit of the Brush* (Chinese painters A.D. 317–960 on nature). London, 1939.

Sandbach, M. "Introduction" to Strindberg. *Inferno*. Harmondsworth, 1979.

Sandler, I. (1). *Abstract Expressionism*. London, 1970.

—— (2). *The New York School*. New York, 1978.

Sandved, K. B., and Emsley, M. *Rain Forests and Cloud Forests*. New York, 1979.

Sastri, G. *The Philosophy of Word and Meaning*. Calcutta, 1959.

Sato, H. *One Hundred Frogs: From Renga to Haiku to English*. New York/Tokyo, 1983.

Sato, H., and Watson, B. (Eds.). *From the Country of Eight Islands: An Anthology of Japanese Poetry*. Seattle, 1981.

Savage-Rumbaugh, S. E., and Rumbaugh, D. A. "Ape Language Research is Alive and Well: A Reply." *Anthropos* 77 (3/4) 1982.

Savile, A. *The Test of Time*. Oxford, 1982.

Schacht, R. *Nietzsche*. London, 1983.

Schaeffner, A. "Song." In Balandier and Maquet.

Schäfer, H. *Principles of Egyptian Art*. London, 1974.

Schapera, J. (Ed.). *The Bantu-Speaking Tribes of Southern Africa*. London, 1937.

Scharf, A. *Art and Photography*. London, 1968.

Scharfstein, B.-A. (1). *Mystical Experience*. Oxford/New York, 1973.

—— (2). "On the Structural Resemblances in Ultimate Religious, Philosophical and Scientific Thought." In R. L. Rubenstein (Ed.). *Modernization*. Washington, D.C., 1982.

Schenk, H. G. *The Mind of the German Romantics*. Garden City, N.Y., 1969.

Scheub, H. "Introduction" to A. J. Jordan (Ed.). *Tales from Southern Africa*. Berkeley, 1978.

Schiff, G. *Picasso: The Last Years 1963–1973*. New York, 1983.

Schiller, F. *On the Aesthetic Education of Man*. E. Wilkinson and L. A. Willoughby (Trans.). Oxford, 1967.

Schmalenbach, W. "Gauguin's Begegnung mit der Welt der Naturvölker." In Wichmann (2).

Schmidt, J. D. *Yang Wan-li*. Boston, 1978.

Schneckenburger, H. (1). "Die 'afrikanische Proportion.' " In Wichmann (2).

—— (2). "Bemerkungen zur 'Brücke 'und zur 'primitiven' Kunst." In Wichmann (2).

Schneede, U. M. *George Grosz*. London, 1979.

Schneider, M. "Primitive Music." In Wellesz.

Schopenhauer, A. *The World as Will and Representation*. E. F. J. Payne (Trans.). 2 vols., reprint, New York, 1966.

Schorske, C. *Fin-de-siècle Vienna*. New York, 1981.

Schrader, D. "The Evolutionary Development of Science." *Review of Metaphysics* 134, Dec. 1980.

Schwab, R. *La renaissance orientale*. Paris, 1950.

Scott, D. K. "Recognition, Individual." In Campbell and Lack.

Scott, J. S. "Roman Music." In Wellesz.

Scruton, R. *The Aesthetics of Architecture*. London, 1979.

Sebeok, T. A. Review of F. Patterson and E. Lindner, *The Education of Koko*. *Times Literary Supplement*, Sept. 10, 1982.

Seidel, M., and Wildung, D. "Rundplastik des neuen Reiches." In Vandersleyen.

Seki, K. *Folktales of Japan*. Chicago, 1963.

Seldes, L. *The Legacy of Mark Rothko*. New York, 1978.

Selfe, L. (1). *Nadia: A Case of Extraordinary Drawing Ability in an Autistic Child*. London, 1977.

———— (2). "Nadia Chomyn." In Paine.

Selz, P. (1). *Chillida*. New York, 1986.

———— (2). *German Expressionistic Painting*. Berkeley, 1957.

Serpell, J. A. "Parrots." In Perrin and Middleton.

Serpell, R. *Culture's Influence on Behaviour*. London, 1976.

Seuphor, M. *Piet Mondrian*. New York, 1957.

Seyforth, R. M. "Vocal Communication and Its Relation to Language." In Smuts et al.

Seyforth, R. M., et al. "Communication as Evidence of Thinking." In Griffin (3).

Seymour, C., Jr. *Sculpture in Italy 1400 to 1500*. Harmondsworth, 1966.

Shapiro, M. *Modern Art: 19th and 20th Centuries*. New York, 1978.

Sharpe, R. A. *Contemporary Aesthetics*. New York, 1983.

Shih, V. Yu-chung. (Trans.). *The Literary Mind and the Carving of Dragons*, by Liu Hsieh. New York, 1959.

Shimada, S. "Concerning the I-p'n Style of Painting." *Oriental Art*, N.S. 7 (2) Summer 1961; 8 (3) Autumn 1962: 10 (1) Spring 1964.

Shimuzu, Y. "Workshop Management of the Early Kano Painters, ca. A.D. 1530–1600." *Archives of Asian Art* 34, 1981.

Short, R. *Dada and Surrealism*. London, 1980.

Shostak, M. "A !Kung Woman's Memories of Childhood." In Lee and Devore.

Sickman, L., and Soper, A. *The Art and Architecture of China*. Rev. ed., Harmondsworth, 1971.

Siegel, L. *Fires of Love, Waters of Peace*. Honolulu, 1983.

Sielman, H. *Lockende Wildnis*. Vienna, 1970.

Silverman, F.-W. "The Twentieth Century." In L. Rosenstiel (Ed.). *Schirmer History of Music*. New York, 1982.

Simon, B. *Mind and Madness in Ancient Greece*. Ithaca, N.Y., 1978.

Simon, H. *The Courtship of Birds*. London, 1977.

Simpson, L. *Three on the Tower: The Lives and Works of Ezra Pound, T. S. Eliot, and William Carlos Williams*. New York, 1975.

Siren, O. (1). *Chinese Painting*. Vols. 1–3, London, 1956.

—— (2). *The Chinese on the Art of Painting*. Peiping, 1936.

Sivaramamurti, C. (1). *The Art of India*. New York, 1977.

—— (2). *Indian Sculpture*. New Delhi, 1961.

—— (3). *Nataraja in Art, Thought, and Literature*. New Delhi, 1974.

—— (4). *The Painter in Ancient India*. New Delhi, 1978.

—— (5). "Sanskrit Sayings Based on Painting." *Journal of the Indian Society of Oriental Art* 2 (2) Dec. 1934.

Sleptzoff, L. M. *Men or Supermen? The Italian Portrait in the Fifteenth Century*. Jerusalem, 1978.

Sloane, J. C. *French Painting Between the Past and Present: Artists, Critics, and Traditions from 1848 to 1870*. Princeton, 1951.

Smith, B. *European Vision and the South Pacific 1768–1850*. Oxford, 1960.

Smith, C. S. "Structural Hierarchy in Science, Art, and History." In J. Wechsler (Ed.). *On Aesthetics in Science*. Cambridge, Mass., 1978.

Smith, L. *The Japanese Print since 1900*. London, 1983.

Smith, W. J. "Religion and Art in Africa." *African Arts* 13 (4) August 1980.

Smith, W. S. The *Art and Architecture of Ancient Egypt*. Rev. ed., Harmondsworth, 1981.

Smuts, B. B., et al. *Primate Societies*. Chicago, 1987.

Snow, B. K. "Hummingbird." In Campbell and Lack.

Snow, D. W. S. (1) "Lek." In Campbell and Lack.

—— (2). *The Web of Adaptation: Bird Studies in the American Tropics*. London, 1976.

Snyder, F. "Towards an Evolutionary Theory of Dreaming." In Lee and Mayes.

Solomon, M. *Beethoven*. New York, 1977.

Soper, A. C. (1). *Kuo Jo-Hsü's Experiences in Painting*. Washington, D.C., 1951.

—— (2). "Shih K'o and the I-p'in." *Archives of Asian Art* 29, 1975/76.

—— (3). *Textual Evidence for the Secular Arts of China in the Period from Liu Sung through Sui (A.D. 420–618)*. Ascona, Switzerland, 1967.

Sparks, J. (1). "Allogrooming in Primates: A Review." In Morris (4).

—— (2). *The Discovery of Animal Behaviour*. Boston, 1982.

Sparshott, F. *The Theory of the Arts*. Princeton, 1982.

Spate, V. "Orphism." In Stangos.

297

Spector, J. J. (1). *The Aesthetics of Freud*. New York, 1972.

———— (2). *The Death of Sardanapoulos*. London, 1974.

Spence, J. *The Painting of Tao-chi*. Exh. cat. Museum of Art, University of Michigan. Ann Arbor, 1967.

Spencer, R. F. *The North Alaskan Eskimo*. Reprint, New York, 1976.

Spender, A. "The Making of a Poem." In B. Ghiselin (Ed.). *The Creative Process*. Berkeley, 1946.

Spies, W. *Focus on Art*. New York, 1982.

Sprenkel, S. van der. *Legal Institutions in China*. London, 1962.

Staal, F. "Mantras and Bird Songs." Unpublished (1984) essay.

Stanley-Baker, J. "The Development of Brush Modes in Sung and Yüan." *Artibus Asiae* 39 (1). Reprint, Ascona, Switzerland, 1977.

Stang, R. *Edvard Munch*. New York, 1979.

Stangos, N. (Ed.). *Concepts of Modern Art*. Rev. ed., London, 1981.

Stein, R. A. *Tibetan Civilization*. London, 1972.

Stettner, L. J., and Matyniak, K. A. "The Brain of Birds." *Scientific American*, June 1968.

Strand, M. (Ed.). *Art of the Real: Nine American Figurative Painters*. New York, 1983.

Strathern, A. "Introduction" to *Man as Art: New Guinea*, photographs by M. Kirk. New York, 1981.

Strathern, A., and Strathern, M. *Self-Decoration in Mount Hagen*. Toronto, 1971.

Stravinsky, I. *Poetics of Music*. Cambridge, Mass., 1947.

Strehlow, T. G. H. "The Art of Circle, Line, and Square." In Berndt.

Stubbs, D. *Prehistoric Art of Australia*. New York, 1974.

Sullivan, M. (1). *Chinese Landscape Painting in the Sui and T'ang Dynasties*. Berkeley, 1982.

———— (2). *The Meeting of Eastern and Western Art*. London, 1973.

———— (3). *Symbols of Eternity: The Art of Landscape Painting in China*. Stanford, Cal., 1979.

———— (4). *The Three Perfections: Chinese Painting, Poetry, and Calligraphy*. London, 1974.

Summers, D. *Michelangelo and the Language of Art*. Princeton, 1981.

Suzuki, D. T. *Zen and Japanese Culture*. Princeton, 1959.

Swann, B. *Smoothing the Ground: Essays on North American Oral Literature*. Berkeley, 1983.

Swinton, G. *Sculptures of the Eskimo*. Greenwich, Conn., 1972.

Sze, Mai-mai. *The Mustard Seed Garden Painting Manual*. Princeton, 1963.

Takeda, T. *Kano Eitoku*. Tokyo, 1957.

Tao Te Ching. D. C. Lau (Trans.). Harmondsworth, 1963.

Taranatha. *History of Buddhism in India*. Chattopadhyaha (Ed.). Simla, India, 1970.

Tashjian, D. "New York Dada and Primitivism." In Foster and Kuenzli.

Tatarkiewicz, E. *A History of Six Ideas*. The Hague, 1980.

Tausk, P. *Photography in the 20th Century*. London, 1980.

Taylor, B. *Constable*. 2d ed., London, 1975.

Tedlock, D. (1). "On the Translation of Style in Oral Narrative." In Swann.

———— (2). "Zuni Religion and World View." In Ortiz.

Terenzio, S. *Robert Motherwell and Black*. London, 1980.

Terrace, H. S. *Nim*. London, 1980.

Thévoz, M. *Art Brut*. Geneva, 1976.

Thompson, R. F. (1). *African Art in Motion*. Berkeley, 1974.

———— (2). *Black Gods and Kings*. Berkeley, 1971.

———— (3). *Flash of the Spirit: African and Afro-American Art and Philosophy*. New York, 1983.

———— (4). "Yoruba Artistic Criticism." In d'Azevedo (3).

Thompson, S. *The Folktale*. Berkeley, 1946.

Thorpe, W. H. (1). *Animal Nature and Human Nature*. London, 1974.

———— (2) *Bird Song*. Cambridge, 1961.

———— (3). "Duet-Singing Birds." In B. W. Wilson.

———— (4). "Mimicry, vocal." In Campbell and Lack.

———— (5). "Vocal Communication in Birds." In Hinde (5).

Thorpe, W. H., and Krebs, I. R. "Learning." In Campbell and Lack.

Tippett, M. K. "Feelings of Inner Experience." In Csaky.

Tisdale, G., and Bezzola, A. *Futurism*. London, 1977.

Tobey's 80: A Retrospective. Seattle, 1970.

Tomkins, C. (1). *Ahead of the Game*. New York, 1965.

———— (2). *Off the Wall*. Garden City, N.Y., 1980.

Tonelli, G. "Genius from the Renaissance to 1770." In Wiener.

Tong, P. K. K. Review of Coleman. *Journal of Aesthetics and Art Criticism*, Fall 1977.

Trask, W. R. *The Unwritten Song: Poetry of the Primitive and Traditional Peoples of the World*. 2 vols., London, 1967, 1969.

Trevarthan, C., and Grant, F. "Infant Play and the Creation of Culture." *New Scientist*, Feb. 22, 1979.

Trotter, R. J. "Baby Face." *Psychology Today*, Aug. 1983.

Tseng Yu-Ho. *Some Contemporary Elements in Classical Chinese Art*. Honolulu, 1963.

Tucci, G. *Tibet*. London, 1967.

Turner, V. (1). *From Ritual to Theatre: The Human Seriousness of Play*. New York, 1982.

———— (2). *The Ritual Process*. Ithaca, 1977.

Tyne, J. V., and Berger, A. J. *Fundamentals of Ornithology*. 2d ed., New York, 1976.

Ueda, M. *Literary and Art Theories in Japan*. Cleveland, 1967.

Umiker-Sebeok, J., and Sebeok, T. A. "Clever Hans and Smart Simians: The Self-fulfilling Prophecy and Kindred Methodological Pitfalls." *Anthropos* 76 1/2 1981.

Urban, M. *Emil Nolde: Landscapes*. London, 1970.

Valéry, P. *Cahiers*. 2 vols., Paris, 1973, 1974.

Vallier, D. *L'art abstrait*. Paris, 1967.

Vandersleyen, C. (Ed.). *Das Alte Agypten*. Berlin, 1975.

Van Gogh, V. *The Letters of Van Gogh*. M. Roskill (Trans.). London, 1963.

Van Gulik, R. H. (1). *Chinese Pictorial Art as Viewed by the Connoisseur*. Rome, 1958.

———— (2). *Hsi Kiang and His Poetical Essay on the Lute*. New ed., Tokyo, 1969.

———— (3). *The Lore of the Chinese Lute*. Tokyo, 1940.

———— (4). *Sexual Life in Ancient China*. Leiden, 1961.

Van Hoof, J. "Facial Expressions." In McFarland (2).

Varnedoe, K. (1). "Abstract Expressionism." In Rubin (4).

———— (2). "Gauguin." In Rubin (4).

Venkateswaran, C. S. "Rajasekhara and His Kavya-Mimamsa." *The Journal of Oriental Research* 37 (1–4) 1971.

Verner, J. "Assessment of Counting Techniques." In Johnston.

Viola, W. *Child Art and Franz Cizek*. Vienna, 1936.

Vitruvius. *The Ten Books on Architecture*. M. H. Morgan (Trans.). Reprint, New York, 1960.

Vogel, A. (Ed.). *For Spirits and Kings: African Art from the Tishman Collection*. New York, 1981.

Vogt, P. *The Blue Riders*. Woodbury, N. Y., 1980.

Vogt, P., et al. *Expressionism*. New York, 1980.

Volmat, R. *L'art psychopathologique*. Paris, 1956.

Volpe, C., and Wiart, C. "Malades mentaux (expression picturale des)." In Laclotte.

Von Einem, H. *Michelangelo*. London, 1973.

Von Frisch, K. *Animal Architecture*. London, 1975.

Wadeson, H. *Art Psychotherapy*. New York, 1980.

Wadia, P. S. "The Aesthetic Nonnaturalism of Abhinavagupta—a Non-Aristotelian Interpretation." *Philosophy East and West,* Jan. 1981.

Wadley, N. (Ed.). *Noa Noa: Gauguin's Tahiti*. Oxford, 1985.

Waldman, D. *Mark Rothko, 1903–1970*. New York, 1978.

300

Waley, A. *Yüan Mei*. London, 1956.

Walker, A. (Ed.). *Frédéric Chopin*. 2d ed., London, 1979.

Walker, J. *Constable*. New York, 1978.

Walters, M. *The Male Nude*. Harmondsworth, 1979.

Warder, A. K. *Indian Kavya Literature*. Vol. 1, Delhi, 1972.

Warhol, A. (1). *For the Birds*. London, 1975.

—— (2). *From A to B and Back Again*. London, 1975.

Warhol, A., and Hackett, P. *POPism: The Warhol 60's*. New York, 1983.

Warner, E., and Hough, G. *Strangeness and Beauty: An Anthology of Aesthetic Criticism 1840–1910*. Vol. 1, Cambridge, 1983.

Warnke, M. *Peter Paul Rubens*. Woodbury, N.Y., 1980.

Watson, B. (1). (Trans.). *Chinese Lyricism*. New York, 1971.

—— (2). (Trans.). *Chinese Rhyme-Prose*. New York, 1968.

—— (3). (Trans.). *The Complete Works of Chuang Tzu*. New York, 1968.

Watt, J. C. Y. (Ed.). *The Translation of Art: Essays in Chinese Painting and Poetry*. Hong Kong, 1976.

Wauthier, C. *The Literature and Thought of Modern Africa*. 2d ed., London, 1978.

Weber, M. J. (Ed.). *Perspectives: Angles on African Art*. New York, 1987.

Webster, R. E. "Nervous System." In Campbell and Lack.

Webster, T. B. L. *Athenian Culture and Society*. London, 1973.

Wechler, J. (Ed.). *Cézanne in Perspective*. Englewood Cliffs, N.J., 1975.

Wechsler, L. *Seeing Is Forgetting the Name of the Thing One Sees: A Life of Contemporary Artist Robert Irwin*. Berkeley, 1982.

Weiss, P. "Kandinsky in Munich." In *Kandinsky in Munich: 1896–1914*. Exh. cat. Guggenheim Museum. New York, 1982.

Welch, A. *Artists for the Shah: Late Sixteenth-Century Painting at the Imperial Court of Iran*. New Haven, 1976.

Welch, H. *The Practice of Chinese Buddhism*. Cambridge, Mass., 1967.

Wellek, R. *A History of Modern Criticism 1750–1950*. Vol. 4, Reprint, Cambridge, 1983.

Wellesz, E. (Ed.). *The New Oxford History of Music: I, Ancient and Oriental Music*. London, 1957.

Weng, Wan-go. *Chinese Painting and Calligraphy*. New York, 1978.

Weng, Wan-go, and Boda, Yang. *The Palace Museum*. New York, 1982.

Wentinck, C. *Moderne und primitive Kunst*. Freiburg, 1974.

White, M. *Rites and Passages*. New York, 1978.

Whitfield, R. *In Pursuit of Antiquity*. Rutland, Vt./Tokyo, 1969.

Whitford, F. *Japanese Prints and Western Painters*. London, 1977.

Wichmann, S. (1). *Japonisme*. London, 1981.

—— (2). (Ed.). *Weltkulturen und moderne Kunst*. Munich, 1972.

Widdess, D. R. "Indian Music." In Arnold.

Wiener, P. (Ed.). *Dictionary of the History of Ideas.* New York, 1968–74.

Wiens, J. S. "Song Pattern Variation in the Sage Sparrow (Amphispiza Belli): Dialects or Epiphenomena?" *Auk* 99 (2) April 1982.

Wilbur, K. *Quantum Questions.* Boulder, 1984.

Willett, F. (1). *African Art.* London, 1971.

——— (2). "An African Sculptor at Work." *African Arts* 11 (2) Jan. 1978.

——— (3). Review of Thompson (2). *African Arts* 12 (1) Nov. 1978.

Williams, F. E. (1). *Drama of Orokolo.* Oxford, 1940.

——— (2). *Orokaiva Society.* London, 1950.

Williams, J. G. *The Art of Gupta India.* Princeton, 1982.

Williams, N. "Australian Aboriginal Art at Yirrkala." In Graburn (2).

Williamson, R. W. *Essays in Polynesian Ethnology.* London, 1939.

Wilson, A. M. *Diderot.* New York, 1972.

Wilson, B. W. (Ed.). *Birds.* San Francisco, 1980.

Wilson, E. O. (1). *On Human Nature.* Cambridge, Mass., 1978.

——— (2). *Sociobiology.* Cambridge, Mass., 1975.

Wilson, J. A. "Egypt." In Frankfort, H., et al. (Eds.). *The Intellectual Adventure of Ancient Man.* Chicago, 1946.

Wilson, R. (Ed.). *Rationality.* Oxford, 1970.

Wilton, A. *Turner and the Sublime.* Toronto/New Haven, 1980.

Winner, E. *Invented Worlds: The Psychology of the Arts.* Cambridge, Mass., 1975.

Wiredu, K. *Philosophy and an African Culture.* Cambridge, 1980.

Wittkower, R. (1). *Architectural Principles in the Age of Humanism.* London, 1962.

——— (2). "Genius: Individualism in Art and Artists." In Wiener.

——— (3). *Sculpture.* London, 1977.

Wittkower, R., and Wittkower, M. *Born Under Saturn: The Character and Conduct of Artists.* London, 1963.

Wober, M. *Psychology in Africa.* London, 1975.

Wolfert, R. "Chinese Music." In Arnold.

Wolfson, H. A. *Repercussions of the Kalam in Jewish Philosophy.* Cambridge, 1979.

Wong, Siu-kit. "Ch'ing and Ching in the Critical Writings of Wang Fu-chih." In Rickett.

Woodson, Y. "The Problem of Western Influence." In Cahill (8).

Worms, E. A., and Petri, H. "Les religions primitives d'Australie." In H. Neverman, E. A. Worms, and H. Petri. *Les religions du Pacifique et d'Australie.* Paris, 1972.

Wu, N. I. (1). "The Chinese Pictorial Art, Its Format and Program." In Watt.

——— (2). "The Evolution of Tung Ch'i-ch'ang's Landscape Style. . . ." In *Proceedings of the International Symposium on Chinese Painting,* National Palace Museum, Taipei, 18–24 June, 1970.

——— (3). "Intellectual Movements Since the Teaching of Wang Yang-Ming." *Philosophy East and West* 23 (1/2) Jan./April 1973.

Wu, W. "Kung Hsien's Style and His Sketchbooks." *Oriental Art* (N.S. 16.1) Spring, 1970.

Wylie, A. S., and Valenstein, A. F. "Between a Hostile World and Me: Organization and Disorganization in Van Gogh's Life and Work." In W. Muensterberger and L. B. Boyer (Eds.). *The Psychoanalytic Study of the Child.* New Haven, 1979.

Yamada, C. F. (Ed.). *Dialogue in Art: Japan and the West.* Tokyo, 1976.

Yanagi, S. *The Unknown Craftsman.* Tokyo, 1972.

Yani's Monkeys. Beijing (Foreign Languages Press), 1984.

Yegoyan, A. A. "Culture, Consciousness, and Problems of Translation." In Hiatt (2).

Yellen, J. "Bushmen." *Science 85,* May 1985, pp. 41–48.

Yip, Wai-lim. (Trans.). *Hiding the Universe: Poems by Wang Wei.* New York, 1972.

Yorke, M. *Eric Gill: Man of Flesh and Blood.* London, 1981.

Youcha, G. "Life Before Birth." *Science Digest,* Dec. 1982.

Yu, P. *The Poetry of Wang Wei.* Bloomington, Ind., 1980.

Zahan, D. *The Religion, Spirituality, and Thought of Traditional Africa.* Chicago, 1979.

Zhadova, L. A. *Malevich.* London, 1982.

Ziegfeld, W. (Ed.). *Education and Art.* Paris, 1983.

Zimmer, H. *The Art of Indian Asia.* Vol. 1, New York, 1955.

Zimmerman, D. R. "Probing Mysteries of How Birds Can Navigate the Skies." *Smithsonian* 10 (3) June 1979.

Zuckerkandl, V. *Man the Musician.* Princeton, 1973.